Women on Screen

Women on Screen

Feminism and Femininity in Visual Culture

Edited by

Melanie Waters

Introduction, selection and editorial matter © Melanie Waters 2011 Individual chapters © Contributors 2011

All rights reserved. No reproduction, copy or transmission of this publication may be made without written permission.

No portion of this publication may be reproduced, copied or transmitted save with written permission or in accordance with the provisions of the Copyright, Designs and Patents Act 1988, or under the terms of any licence permitting limited copying issued by the Copyright Licensing Agency, Saffron House, 6-10 Kirby Street, London EC1N 8TS.

The authors have asserted their rights to be identified as the authors of this work in accordance with the Copyright, Designs and Patents Act 1988.

First published 2011 by PALGRAVE MACMILLAN

Palgrave Macmillan in the UK is an imprint of Macmillan Publishers Limited, registered in England, company number 785998, of Houndmills, Basingstoke, Hampshire RG21 6XS.

Palgrave Macmillan in the US is a division of St Martin's Press LLC, 175 Fifth Avenue, New York, NY 10010.

Palgrave Macmillan is the global academic imprint of the above companies and has companies and representatives throughout the world.

 ${\it Palgrave}^{\circledR} \ and \ {\it Macmillan}^{\circledR} \ are \ registered \ trademarks \ in \ the \ {\it United States}, \ the \ {\it United Kingdom, Europe and other countries}.$

ISBN 978-0-230-22965-5 hardback

This book is printed on paper suitable for recycling and made from fully managed and sustained forest sources. Logging, pulping and manufacturing processes are expected to conform to the environmental regulations of the country of origin.

A catalogue record for this book is available from the British Library.

A catalog record for this book is available from the Library of Congress.

10 9 8 7 6 5 4 3 2 1 20 19 18 17 16 15 14 13 12 11

Printed and bound in Great Britain by CPI Antony Rowe, Chippenham and Eastbourne

Contents

Ack	nowledgements	vii
Notes on Contributors		viii
Introduction: Screening Women and Women on Screen <i>Melanie Waters</i>		1
Par	rt I Generations	
1	Nancy Meyers and "Popular Feminism" Kathrina Glitre	17
2	"I'm nothing like you!" Postfeminist Generationalism and Female Stardom in the Contemporary Chick Flick Shelley Cobb	31
3	Alias: Quality Television and the New Woman Professional Rosie White	45
4	The Horrors of Home: Feminism and Femininity in the Suburban Gothic <i>Melanie Waters</i>	58
Paı	rt II Sex and Sexuality	
5	Bad Girls in Crisis: The New Teenage Femme Fatale <i>Katherine Farrimond</i>	77
6	Butch Lesbians: Televising Female Masculinity Helen Fenwick	90
7	"Challenging and Alternative": Screening Queer Girls on Channel 4 Martin Zeller-Jacques	103
Par	rt III Makeovers	
8	Under the Knife: Feminism and Cosmetic Surgery in Contemporary Culture Stéphanie Genz	123

9	Imperialist Projections: Manners, Makeovers, and Models of Nationality Brenda R. Weber	136	
10	Femininity Repackaged: Postfeminism and Ladette to Lady Angela Smith	153	
11	Performing Postfeminist Identities: Gender, Costume, and Transformation in Teen Cinema Sarah Gilligan	167	
Part IV Violence			
12	Return of the "Angry Woman": Authenticating Female Physical Action in Contemporary Cinema <i>Lisa Purse</i>	185	
13	Negotiating Shifts in Feminism: The "Bad" Girls of James Bond Lisa Funnell	199	
14	"A Caligula-like despot": Matriarchal Tyranny in The Sopranos Anna Gething	213	
15	A Pathological Romance: Authority, Expert Knowledge and the Postfeminist Profiler <i>Lindsay Steenberg</i>	225	
Inde	ex	237	

Acknowledgements

This book would not have been completed without the hard work and dedication of all the contributors, to whom I am immensely grateful. In addition, I would like to thank Christabel Scaife, Felicity Plester, and Catherine Mitchell at Palgrave for their advice and patience, and my colleagues at the Department of Humanities at Northumbria University for enabling the completion of this project. I would also like to acknowledge the people who have kept me amused during the editing process, especially Helena Barron, Kati Hall, Emma Hogarth, Becky Munford, Tomos Owen, Catherine Souter, Anne Whitehead, and Mark Gillingwater. Special thanks goes to Stacy Gillis for her involvement in the initial organization and administration of this project.

Finally, many thanks to Judith, Les, and Keith Waters, and to Jen Kennerley, for all their encouragement and good humour, and to Paul Crosthwaite, for being a constant source of delight and inspiration.

Notes on Contributors

Shelley Cobb is Teaching Fellow in Literature and Film at the University of Southampton. Currently, she is writing a book entitled *Making Her Move: Women, Adaptation and Post-Feminist Filmmaking*. She has published on film adaptation, Jane Campion, and celebrity culture.

Katherine Farrimond is a doctoral student at Newcastle University. Her thesis maps the articulations of the femme fatale in contemporary cinema. Her major research interests are feminist theory and representations of gender and sexuality in Hollywood film. Her essay, "'Mom! You Look So Thin!': Constructions of Femininity Across the Space-Time Continuum", appears in the collection *The Worlds of Back to the Future: Critical Essays on the Films* (2010).

Helen Fenwick is a Ph.D. student in English Literature at Newcastle University, where her work focuses on the sexual politics within Neo-Victorian novels and their televisual and filmic adaptations.

Lisa Funnell has a Ph.D. in Film Studies from Wilfrid Laurier University. Her work has been accepted for publication in *The Quarterly Review of Film and Video* and *The Journal of Popular Culture*, and she has contributed a chapter to the forthcoming collection *Asian Popular Culture* (2010).

Stéphanie Genz is Senior Lecturer in Media and Culture at Edge Hill University. She specializes in contemporary gender and cultural theory. Her book publications include *Postfemininities in Popular Culture* (2009), *Postfeminism: Cultural Texts and Theories* (2009), and *Postfeminist Gothic: Critical Interventions in Contemporary Culture* (2007).

Anna Gething is a part-time Lecturer in English at Bath Spa University. Her research focuses on contemporary women's writing, gender studies, postcolonial writing, and the senses in literature. She has recently contributed to Feminism, Domesticity and Popular Culture (2008), Rites of Passage in Postcolonial Women's Writing (2010), and The Encyclopedia of Literary and Cultural Theory (2010). Forthcoming publications include a

book chapter on women, history and imagination in Kate Grenville's historical fiction, an article on the gendering of smell in literature, and a monograph study of the writing of Kate Grenville.

Sarah Gilligan is Lecturer in Media at Hartlepool College of FE, UK. Her interdisciplinary research tocuses on the ways in which costume, fashion, and gadgets are self-consciously used in contemporary popular culture to construct visual narrative discourses of gendered identities. Recent and forthcoming publications include work on star-celebrity fashion icons (Grace Kelly, James Bond, Will Smith, Gwyneth Paltrow), contemporary costume cinema, and sci-fi cinema. She is also currently developing a monograph entitled Transforming Identity: Gender and Clothing in Contemporary Cinema.

Kathrina Glitre is Senior Lecturer in Film Studies at the University of the West of England, UK. She is the author of Hollywood Romantic Comedy: States of the Union 1934-65 (2006) and Starring Cary Grant: Casting and Performance in Classical Hollywood Film (2010), and the co-editor of Neo-Noir (2009).

Lisa Purse is Lecturer in Film in the Department of Film, Theatre & Television at the University of Reading. Her research interests focus on the relationship between film style and the politics of representation in post-studio mainstream and independent US cinema, and she has published a number of essays on digital effects in film. She is the author of "Reading the Digital" in the *Close-Up* series (Wallflower, 2011), and is currently completing a book on contemporary US action cinema.

Angela Smith lectures in Language and Culture at the University of Sunderland. She has published in the areas of gender, politics, media discourses, and children's fictions, and is currently writing The Language of Journalism: A Multi-Genre Approach (2011).

Lindsay Steenberg is Lecturer in Film and Television Studies at the University of East Anglia. She has published on the subject of violence in cinema, the postfeminist martial artist, the forensic gaze, and the works of filmmaker Guillermo Del Toro. Her doctoral thesis focused on female investigators and forensic science in contemporary crime thrillers, and her wider research interests include representations of gender and violence in postmodern and postfeminist media culture.

Melanie Waters is Senior Lecturer in Modern and Contemporary Literature at Northumbria University. She has published essays on feminist theory, popular culture, and twentieth-century women's poetry, and is the author of a forthcoming monograph on the contemporary gothic. She is also the co-author of *Feminism and Popular Culture* (2012) and the co-editor of *Poetry and Autobiography* (2011).

Brenda R. Weber is Associate Professor in Gender Studies at Indiana University, where she teaches courses in gender and popular culture, celebrity studies, masculinity, and theories of the body. She is the author of Makeover TV: Selfhood, Citizenship, and Celebrity (2009) and Women and Literary Celebrity in the Nineteenth Century: The Transatlantic Production of Fame and Gender (2011).

Rosie White is Senior Lecturer in English at Northumbria University. Her research interests include Michèle Roberts, women spies, and women in television comedy. Her monograph, *Violent Femmes: Women as Spies in Popular Culture*, was published by Routledge in 2008.

Martin Zeller-Jacques is a postgraduate student in the Department of Theatre, Film and Television at the University of York. He specializes in studies of contemporary television narrative and maintains related research interests in gender and sexuality across a range of television and film genres.

Introduction

Screening Women and Women on Screen

Melanie Waters

Women on Screen provides a new critical overview of the representation of women and girls in contemporary television and cinema. In doing so, it builds on recent analyses of the relationship between feminism, femininity, and popular culture by Imelda Whelehan, Joanne Hollows, Diane Negra, Yvonne Tasker, and Angela McRobbie in order to shed light on the particular issues that swirl around on-screen portrayals of embodied female identity. Intervening in established and emerging debates about postfeminism, the 15 chapters in this book investigate the roles accorded to feminism and femininity in late twentieth- and early twenty-first-century depictions of women's lives and ask why certain configurations of femininity – especially configurations of femininity that second wave feminism would seem to have rendered redundant or inappropriate – are not only persistent but also valorized within popular forms of visual culture.

Central to the examination of women on screen in this book is an analysis of the concept of screening itself: to be on screen, after all, is to have been subjected, already, to processes of screening. While the term "screening" typically denotes the practical processes of showing and viewing – the means by which the visual texts referenced in this collection are presented to, and consumed by, the public – it likewise refers to the systems of selection that inform the production and reception of these texts. In the first place, the chapters here are interested in the "screening" systems that lie behind the representation of women in any cultural text. In other words, they aim to focalize the decision-making strategies by which certain constellations of femininity are deemed appropriate (or otherwise) at particular historical moments, while also exploring how such judgements might be informed by feminist anxieties and/or anxieties about feminism. Secondly, they are

committed to an analysis of how portrayals of women in female-centred texts are "screened" within the space of feminist critical scholarship: What kinds of visual texts are screened within (and screened out of) this kind of scholarship? How are the attributes of women on screen identified, isolated, and delineated by feminist critics? What kind of value is apportioned to these various attributes, and why? In essence, then, "screening" simultaneously accounts for the showing and viewing of visual texts, as well as the processes by which particular images of women and girls are created or concealed, promoted or suppressed, then vetted and examined.

As I have already suggested, the precise ways in which women are screened in film and on television are illuminated by – and might also illuminate – ongoing debates about the relationship between feminism and femininity. As Charlotte Brunsdon notes in a 2005 article, it has become something of a commonplace within feminist discourses to characterize this relationship as "complex" and "contradictory" (113). While the contributors featured here acknowledge that such terms remain apposite to critical considerations of women on screen, the collection as a whole strives to avoid the critical impasse at which the use of such terms can leave us - an impasse where, it seems, any and every representation of female experience is understood as "vexed" or "ambivalent", and where feminism itself is regarded as an objective political standard against which popular constructions of femininity are measured and, invariably, denigrated or dismissed. Women on Screen seeks to move beyond this impasse by recognizing that the relationship between feminism and femininity – just like the relationship between any diverse ideological groupings – is always and already complicated, not least as a result of the various meanings which are ascribed to these respective terms. The chapters that follow, then, understand complexity and ambivalence as hallmarks of contemporary female-centred texts, but do so as a starting point for thinking about their wider implications. Rather than falling into the trap of using a "politically correct feminist identity" to render "other feminine identities... 'invalid' " (Brunsdon, 1991, 379), we wish to highlight how such critical manoeuvres have come to operate within existing scholarship and draw attention to the ways in which they can both limit and redefine the terms of feminist debates about visual culture. At the same time, Women on Screen aims to recuperate to the realm of feminist scholarship those areas of women's representation that such strategies tend to "screen out". We are, then, looking to uncover new layers of complexity within contemporary cultural texts, rather than implying that their complexity resides

solely in their negotiation of the relationship between feminism and femininity.

Postfeminism

At the heart of this collection lies a deep and necessary engagement with postfeminism and the various critical controversies by which it is orbited. Since the term began to acquire cultural currency in the early 1980s, feminist theorists have argued spiritedly over its meaning and usefulness, while trying to delineate its potential implications for critical and historical accounts of feminism.¹ For a number of thinkers in the 1980s and early 1990s, the concept of postfeminism invited interpretation alongside the media's increasingly antagonistic treatment of, or backlash against, the feminist agenda. As Brenda Polan contended in The Guardian in 1988, the endeavour of postfeminism to render itself nominally distinct from "older" incarnations of feminism – through its "post" prefix – indicates that it is not merely symptomatic of the backlash, it "is the backlash" (qtd. in Faludi 15; emphasis added). This proposal is significant in that it not only foregrounds the status of second wave feminism and postfeminism as discrete and monolithic movements (with postfeminism auguring a clear and deliberate break with the goals and politics of the second wave), but also indicates that postfeminism is a historically locatable reaction to the former – an idea which, as we shall see, is carried through into critical approaches to postfeminist cultural texts.

The "anti-feminist backlash" to which Polan refers is, of course, the subject of Susan Faludi's 1991 bestseller Backlash: The Undeclared War Against Women. Elaborating on Polan's logic, Faludi argues that the term "post-feminism" is part of a re-branding strategy, one of the means by which the media in the 1980s endeavoured to signpost the "past-ness" of feminism, using it to conjure up a "new story" for a "younger generation who supposedly reviled the women's movement" (14). Although she identifies postfeminism as a 1980s phenomenon, however, Faludi uses the term flexibly to denote other historical eruptions of antifeminist sentiment, and traces the initial emergence of postfeminism back to the American media's treatment of feminist organizations in the 1920s. As Faludi's varied usage implies, the prefixation or "posting" of feminism is open to wide and wild interpretation, depending on one's understanding of "post" – namely, whether "post" is viewed as designating a rejection of, continuity with, or ambivalence towards the feminism(s) by which it is predated.²

As Imelda Whelehan observes, the "post" prefix implies the functional inadequacy of "feminism" as a term; though this, she makes clear, does not guarantee the distinctiveness of feminism and postfeminism:

"New" and "post" are prefixes added to the term "feminism" when the writer or speaker wants to make it clear that they have a certain antagonism to the term, because of the connotations it generates, or because feminism by itself is seen to be inadequate to their own definition.... [A]ll imply that the word feminism is not enough to embrace their own political programmes or personal agendas, and that it has been manipulated to certain ends from which they want to exclude themselves. But as with most additions of prefixes, the central concept remains the same, so that "new" and "post" imply cosmetic changes rather than radical rethinking. Feminism is portrayed as a territory over which various women have to fight to gain their ground; it has become so unwieldy as a term that it threatens to implode under the weight of its own contradictions. (77–78)

These semantic ambiguities are alluded to more explicitly by Diane Negra in What a Girl Wants (2008). Situating postfeminism firmly within the cultural landscape of the 1990s and early 2000s, Negra shows how it operates as a "widely-applied and highly contradictory term [which] performs as if it is commonsensical and presents itself as pleasingly moderated in contrast to a 'shrill' feminism" that it regards as "rigid, serious, anti-sex and romance, difficult and extremist" (2). Although postfeminism is routinely associated with the negative characterizations of feminism that Negra here describes, the frequent signposting of its seemingly "contradictory" applications implies its status as a more complex and elastic phenomenon. In this vein, Genz, one of the contributors to this book, has remarked on the extraordinary number of terms – including "Girl Power", "popular feminism", and "do-me feminism" – that have been used in conjunction and/or interchangeably with postfeminism in recent years. For Genz, this polysemy not only liberates postfeminism from any fixed or singular definition but also speaks to its cultural currency, establishing its existence "as a conceptual entity in its own right". According to Genz, then, postfeminism need not be a "negation [or] sabotage" of feminism; rather, the "post" prefix may instead designate "reliance and continuity" or even "a contradictory dependence on and independence from the term that follows it" (18–19).

Perhaps the most salient, and least controversial, feature of postfeminism is its inextricability from popular, and particularly visual, culture. From Naomi Wolf's investigation into how mainstream images of female beauty shape women's social experiences in The Beauty Myth (1991) to the analyses of the impact of "raunch culture" on the behaviour and aspirations of young women in Ariel Levy's Female Chauvinist Pigs (2006) and Natasha Walter's Living Dolls (2010), the discourses of postfeminism are, increasingly, only intelligible within the context of the contemporary visual iconography by which we, as global citizens, are perpetually bombarded.

If the term "visual culture" can encompass everything from fine art, photography, and architecture to film, television, advertising, and digital media, its particular value lies in its gesturing towards the interpenetration of different visual forms and codes as a hallmark of postmodern culture, as well as in its recognition of the growing predominance of visual media over verbal/textual forms of communication within the mediasphere. These factors are especially significant in a collection of this kind, which focuses predominantly (though not exclusively) on film and television produced in the United States and the United Kingdom since 1990. Such contemporary texts, after all, are always and already marked by the issues of cross-mediation to which the term "visual culture" pertains. In using it, then, I hope to speak directly to the particularities of the current cultural moment, while at the same time telegraphing the persistence of links between feminist discourse and issues of female visibility - links which are writ large in everything from Laura Mulvey's seminal psychoanalytical account of women-on-screen in "Visual Pleasure and Narrative Cinema" (1975) and Susie Orbach's delineation of the overweight female body in Fat is a Feminist Issue (1978), to Carol Dyhouse's recent work on fashion and femininity in Glamour: Women, History, Feminism (2010).

Feminism and popular culture

As Joanne Hollows and Rachel Moseley have observed, feminism is difficult to conceptualize outside of the popular: "apart from women actively involved in the second wave of feminism in the 1960s and 1970s, most people's initial knowledge and understanding of feminism has been formed within the popular and through representation" (2). Even so, like other political campaigns of the time, the second wave was – and is – regularly "conceived of as a social movement that was 'outside' of, and

frequently oppositional to, the dominant culture" (4). In other words, it is assumed to take place in a hypothetical "real" space that lies, impossibly, beyond the sensationalizing tentacles of the mainstream media. Still, even the women who were "actively involved" in the second wave were eminently preoccupied with the issue of women's representation in the media. As is clearly evidenced in some of feminism's key texts. such as Simone de Beauvoir's The Second Sex (1949), Betty Friedan's The Feminine Mystique (1963), and Kate Millett's Sexual Politics (1970), the second wave's social agenda was guided precisely by anxieties about representation, relating particularly to the circulation of "unrealistic" and "misleading" images of women in popular magazines, advertising. literature, television, and film.³ Over the course of *The Second Sex*, for example, De Beauvoir traces gender inequality through a discussion of the roles occupied by women within the popular imaginary, from the witches, wicked stepmothers, and damsels-in-distress of common folklore to the modern-day Cinderellas of Hollywood cinema (in the films of Orson Welles and Edmund Goulding), and the complicated, conflicted women who populate the novels of D. H. Lawrence and Virginia Woolf. Friedan, with a background in journalism, was likewise concerned with the prescriptive models of domesticated womanhood that were offered up in post-war culture, exploring the conservative gender politics of the articles and short fiction that constituted the stock-in-trade of popular women's magazines like Ladies Home Journal, McCalls, and Good Housekeeping during the 1950s.4 A few years later, in 1970, Kate Millett's Sexual Politics drew attention to the misogynistic dimensions of fiction by Henry Miller and Norman Mailer,⁵ while Germaine Greer's *The Female* Eunuch (1970) dissected the persistence of various feminine stereotypes across a widening spectrum of popular media.

The second wave thus maintained an interest in investigating the ways in which "real" or authentic womanhood has been distorted or elided within popular culture, while also viewing its agenda, in part, as a means of correcting these perceived representational injustices. For this reason, it is necessary for contemporary scholars to acknowledge and interrogate the tendencies within some existing scholarship to imply the existence of feminism(s) beyond the realm of representation. After all, as Hollows and Moseley suggest, such criticism "assumes that feminism, or the feminist, can tell us about popular culture, but does not examine what popular culture can tell us about feminism" (1). Given the inextricability of feminism and popular culture, any unilateral reading of the kind that Hollows and Moseley describe is destined to be partial and misleading. Part of the aim of this collection, then, is

to foreground the extent to which feminism, femininity, and popular forms of visual culture constitute a dynamic and influential nexus of activity. In this spirit, it seeks to focalize the potential limitations of conceptual frameworks that rely exclusively on straightforward distinctions between different "species" of feminism. Stacy Gillis and Rebecca Munford have already highlighted the potential restrictions imposed by the use of the wave paradigm, which tends to construct a monolithic account of each "wave" of feminist activity and in doing so "lends power to backlash politics and rhetoric" (177). As we will see, the backlash logic that Gillis and Munford identify with the wave paradigm is inscribed in many of the texts with which Women on Screen is concerned. In line with Gillis and Munford, the chapters here query the anchoring of particular conceptual models in presumptions about feminist conflict and inter-generational disagreements, while also acknowledging the ways in which such models continue to inform creative and critical configurations of contemporary female identities.

The chapters

The chapters here are divided into four discrete but interlocking parts: "Generations": "Sex and Sexuality": "Makeovers": and "Violence". These parts reflect some of the key concerns by which popular representations of feminism and femininity are striated, but they also offer a framework for conceptualizing the dominant preoccupations of feminist media criticism at the start of the twenty-first century. While drawn together by a shared awareness of the extent to which postfeminist texts and contexts have been shaped by a particular issue – be it generational conflict, female sexuality, embodied identity, or gendered violence the chapters in each part are marked by their sustained engagement with broader questions of power and visibility. Such questions are, after all, critical to considerations of the "postfeminist canon" and, more specifically, to the interrogation of postfeminism's exclusionary tendencies – most conspicuously apparent in its "limited race and class vision" (Tasker and Negra 14–15) – with which Women on Screen is necessarily concerned.

The first part of this book, "Generations", explores the ways in which generational models of feminism have informed fictional and critical approaches to feminine identities in popular culture. Each author acknowledges the role that such paradigms have played in shaping scholarly analyses of feminism and/or femininity, while endeavouring to show how they might also undermine or reduce the complexity of

these representations. Glitre and Cobb, for example, show how chick flicks dramatize feminist debates about independence and empowerment through the representation of women's personal and/or familial relationships. Focusing on the comedies of writer and director Nancy Meyers, Glitre argues that the evolution of these debates can be (re)viewed through reference to changing approaches to the figure of the working woman. From Goldie Hawn's society-girl-turned-soldier in *Private Benjamin* (1980) to Helen Hunt's high-flying advertising executive in *What Women Want* (2000), Glitre shows how Meyers' chick flicks register shifting attitudes to women in the workplace, while interrogating the persistence of the heterosexual romance motif in the wake of such shifts. In particular, she queries the use of the romantic resolution as a means of resolving the raft of dilemmas that the working woman presents.

The working woman is equally central to Cobb's investigation of the twenty-first-century chick flick. Demonstrating how feminist intergenerational conflict is often figured through the portrayal of antagonistic relationships between older and younger women, Cobb contends that chick flicks like *Monster-in-Law* (2005) and *The Devil Wears Prada* (2006) routinely use the mature career woman as a visual shorthand for feminism that is selfish, anti-familial, outmoded, and generally ineffective in the context of contemporary Western societies. With close reference to their individual star personae, Cobb shows how the casting of baby-boomer female actors – like Jane Fonda and Meryl Streep – opposite their younger counterparts – namely Jennifer Lopez and Anne Hathaway – is used as a means of signalling the final, triumphant displacement of second wave feminism's "old", selfish careerism by "new" family-oriented models of postfeminist identity.

If the chick flick speculatively proposes a different, and emotionally fulfilled, future for the postfeminist woman, then this is, perhaps, challenged within certain types of quality American television. Redeploying the term "New Woman" to refer to female professionals in film and television at the end of the twentieth century and the beginning of the twenty-first, White discusses the politics of empowerment through close reference to the representation of working woman in *Alias* (2001–06). Accounting for the vexed positioning of women within the context of the New Economy, White analyses Jennifer Garner's portrayal of Sydney Bristow – the "empowered" New Woman spy – through the lens of the show's approach to the ageing female professional. In this way, White shows how the sinister machinations and betrayals of the older women in *Alias* are used to symbolize a potential – if undesirable – future for the New Woman professional, thus highlighting the persistence of

gender inequality with the global capitalist system, as well as the limited options that are available to the successful career woman as she gets older

My own chapter, finally, shows how the trope of haunting has been used in recent feminist discourses to symbolize the spectral status of second wave feminism in contemporary culture. With this as a starting point, I investigate the representation of feminine identities in contemporary female-centred television fictions. Placing a special focus on the tensions between women, maternity, and domesticity, I analyse the extent to which mainstream representations of gender are haunted by anxieties about femininity and show how this is inscribed in a range of shows, from Desperate Housewives (2004-) and Mad Men (2007-) to Medium (2005-) and Ghost Whisperer (2005-10).

The second part, "Sex and Sexuality", begins with Katherine Farrimond's investigation of ways in which the compelling figure of the femme fatale has been re-appropriated and modified within contemporary cinema. Establishing the principal characteristics of the femme fatale through reference to the classic film noir of the 1940s and 1950s. Farrimond shows how her mystery, allure, and sexual maturity have been adapted to the figure of the teenage girl. Given the teenage girl's usual marginalization or infantilization within popular culture, Farrimond interrogates the extent to which her reformulation as an intelligent, worldly, and sexually experienced antagonist - as it takes place within the thriller and neo-noir genres – might be indicative of her agency and her inherent threat to patriarchal systems of power.

Helen Fenwick returns the focus to quality television and the representation of female masculinity in The L Word (2004-09) and The Wire (2002–08). Over the course of her chapter, Fenwick traces the elusive presence of the butch lesbian within popular culture, and draws attention to the ways in which racial markers and the discourses of transgenderism are traditionally used to impose order on this otherwise renegade figure. As Fenwick goes on to explain, representations of lesbian relationships tend to pivot on a butch/femme dynamic in which the butch partner is black or mixed race, while the femme to whom she is coupled is lighter-skinned or white. Although this intricate tethering of butchness and blackness is progressively re-negotiated within The Wire, Fenwick signposts the remaining taboo of the white butch lesbian, acknowledging the threat this figure poses to white masculinity as one of the key justifications for her continued invisibility.

Martin Zeller-Jacques is also concerned with issues relating to the representation of sexuality on the small screen. Shining a critical light on the Channel 4 Corporation's public service remit, which spells out its commitment to the production of "challenging and alternative" content that reflects the diversity of the British population, Martin analyses the increased visibility of lesbians within Channel 4 programming. Orienting this analysis around popular "post-lesbian" shows like *Sugar Rush* (2005–06) and *Skins* (2007–), Maz queries the formulation of teen lesbianism in particular, and considers the extent to which such content might be considered "challenging" or subversive when it tends to be so rigidly contained within the "hegemonic structures of family and friendship".

The chapters by Stéphanie Genz, Brenda R. Weber, Angela Smith, and Sarah Gilligan offer various theorizations of the ongoing prevalence of the makeover in contemporary film and television. The surgical modification of the female body – as it takes place in an ever-expanding raft of popular makeover shows, including *The Swan* (2004–05), *Extreme Makeover* (2002–05), and *Ten Years Younger* (2004–) – is used by Genz as a basis for investigating the intersections and divergences of femininity, beauty, agency, and choice. Bringing new light to bear on the modern culture of *chirurgia decoratoria*, in which the individual is encouraged to remodel herself in the pursuit of social status, sexual desirability, and personal contentment, Genz views makeover television in relation to the "paradox of choice" that Rosemary Gillespie identifies as a hallmark of postfeminist culture (79).

According to Brenda R. Weber, the term "affective domination" can assist in bringing some of the contradictions and ironies by which makeover shows are riven into sharper focus. Used to denote the strategies of shaming and support that are deployed by the makeover "experts" in order to gain social mastery of the participant, the concept of "affective domination" provides a framework for thinking about the trajectory of the transformation narrative. Reflecting particularly on American Princess (2005–07) and Australian Princess (2005), Weber shows how the makeover is presented as a positive means of reconciling the participant's outer appearance with his or her inner subjectivity. She exposes, moreover, the irony of the fact that it is the woman who submits most wholeheartedly to the affective domination who is situated as the most empowered.

Smith's chapter views the makeover show in light of the postfeminist media phenomenon of "Girl Power" and the contemporaneous moral panic about teenage behaviour in British society. With close reference to the *Ladette to Lady* (2005–) franchise – a UK reality show in which young, hard-drinking, promiscuous, rebellious young women are refashioned as dress-making, flower-arranging "ladies" – Smith questions the politics

of postfeminism and its putative valorization of traditional models of domesticated femininity.

Taking account of the proliferation of makeover shows in Anglo-American television schedules, Sarah Gilligan explores the transformation narrative as an enduring staple of feminine popular culture. From Hollywood classics such as Now Voyager (1942) and My Fair Lady (1964) to contemporary programming like Gok's Fashion Fix (2008–09), Gilligan establishes the rootedness of the transformation narrative in processes of consumerism and feminization. If a number of cultural texts trade on the premise that a woman's conformity to contemporary notions of "ideal" femininity will enable her to achieve the twin prizes of masculine approval and heterosexual romance, then some contemporary teen films generate a "postfeminist space" within which the female protagonists are permitted to experiment with identity more freely. In films like She's All That (1999), Gilligan argues, the centrality of vintage and homemade clothing to the "making over" of the protagonist implicates her in an endless cycle of (re)fashioning femininity that speaks, ultimately, to the performativity of gender identity.

This collection concludes with a section on "Violence", in which Lisa Funnell, Lisa Purse, Anna Gething, and Lindsay Steenberg explore the role that aggression and physicality have played in the construction of new feminine and feminist identities.

Funnell discusses the ways in which anxieties about feminism and feminist women are registered in the changing depiction of female villainy within the James Bond film franchise. As Funnell explains, if the Bond films of the 1960s speak to second wave feminism through their representation of powerful, sexually liberated "bad" women – who are, ultimately, punished for their perceived disobedience – then the female villains of the 1990s and 2000s are best understood as the Bond film's response to "Girl Power" and the broader discourses of postfeminism. Stressing the franchise's (often antagonistic) engagement with feminist politics, Funnell shows how the female villain is used variously as a means of challenging and/or (re)asserting Bond's masculine authority. In addition, however, she argues that some of Bond's female adversaries also function as figures through which new, empowered feminine identities can be productively envisioned and critiqued.

Lisa Purse is likewise interested in addressing shifts in the representation of empowered (or disempowered) feminine identities on the big screen. Establishing the "angry woman" as a staple of the rape-revenge and slasher cycles of the 1970s, Purse attempts to make sense of the recent reappearance of this traumatized, aggressive figure in films such

as Kill Bill (2003-04), Monster (2003), and Hard Candy (2005). Reading the representation of the "new" angry woman in relation to that of her would-be sisters – namely, the postfeminist action heroines of popular film series like The Matrix, Resident Evil, and X-Men - Purse shows how the active female body is ascribed different meanings in different cultural contexts. For Purse, then, the postfeminist action heroine has come to constitute the acceptable face (and body) of female empowerment in the twenty-first century; white, heterosexual, and demonstrably feminine, her physical prowess is routinely spectacularized and sexualized, without being explained through reference to her gender. Her "angry" counterpart, by contrast, exhibits a physical agency that is rationalized explicitly through reference to her motives, which are clearly gendered (usually relating to rape or maternal instinct). In the course of unpacking these differences, Purse situates the new angry woman as a "return of the repressed" – a dramatic re-materialization of female rage and aggression that is strategically disavowed in mainstream representations of the "action babe".

For Anna Gething, HBO's gangster drama *The Sopranos* (1999–2007) offers an interesting take on the relationship between femininity and violence. Establishing the ass-kicking, wise-cracking fantasy heroine as the prime exponent of female violence in contemporary television and film fictions, Gething examines *The Sopranos'* creative reinterpretation of gendered brutality. In particular, she considers the show's positioning of the ageing, physically impaired matriarch as the agent of aggression which – though psychological rather than physical – is as damaging in its long-term effects as any of the tortures inflicted by the male mobsters in the series.

Retaining a focus on representations of active and/or professional female identities, Lindsay Steenberg brings a critical light to bear on portrayals of the postfeminist criminal profiler in recent television and film fictions. As Steenberg explains, such fictions tend to centralize the relationship between the male serial killer and the female profiler, trading heavily on its predatory and eroticized dimensions. Taking into account the gendered nature of serial violence, Steenberg examines the ways in which the "pathological romance" between the killer and the profiler functions to enhance the latter's expertise, while also placing her in a situation where both her professionalism and her physical safety are compromised. In this way, Steenberg argues, the female expert is used to reflect a stubborn "postfeminist" scepticism about the ambitious woman who prioritizes her career over her femininity.

Covering a spectrum of feminist perspectives and drawing on a wide range of critical and cultural theory, this collection is intended to expand the parameters of existing debates about the plotting of modern female identities in the Western imaginary. The kinds of identities addressed here are broadly reflective of those with which postfeminist culture is predominantly preoccupied; as white, middle-class, heterosexual femininities continue to occupy positions of high visibility within mainstream cinema and television, then, so these femininities form the basis of many of the chapters that follow. This book is also, however, responsive to current shifts in representation and criticism. The recent mainstreaming of queer identities and storylines in contemporary programming and film has, for example, generated an urgent need for new critical investigations into the portrayal of non-heterosexual sexualities and the impact of these portravals on adjacent representations of women and girls. This need is addressed here by the likes of Fenwick and Zeller-Jacques, who explore the construction of non-heterosexual identities in television fictions like The Wire, Sugar Rush, and Skins fictions which have yet to be exposed to any sustained feminist scrutiny. Women on Screen is also interested in the role that class, age, race, and ethnicity have to play in shaping contemporary femininities: How do these factors interact in order to produce new female identities? How do they enhance or diminish women's visibility and/or power? How, if at all, are these factors implicated in the spectacularization or minstrelization of particular female identities? While the contributors to this book are attentive and responsive to the issues of class, age, race, and ethnicity - and to the kinds of questions mentioned above - the usual practical constraints of time and space apply, meaning that this collection is always and already a starting point for further discussions. Certainly, there remains a great deal of critical work to be done in these areas, and an ever-growing multitude of texts – and textual identities – to be accounted for. Through reference to some of these texts and some of these identities, Women on Screen seeks to add new fuel to the fires of feminist debate, reassessing the scope of popular culture and critical scholarship in the expanding mediascape of the twenty-first century.

Notes

1. As Stéphanie Genz reflects, much of the controversy about postfeminism has centred on the implications of the "post" prefix - namely, whether it heralds the success, failure, or irrelevance of the second wave agenda in the late twentieth century. While some scholars hyphenate the term (as in "postfeminism") or parenthesize the prefix (as in "(post)feminism") in order to signal its discontinuity with feminism and/or its dubious status as a term in its own right, it remains unhyphenated here (unless it appears as part of a direct quotation). This is not to disregard the very valid reasons for hyphenation or parenthesization, but simply as a means of indicating the fact that these debates – which are addressed consistently throughout this book – are now so thoroughly inextricable the term that they form a vital part of its meaning. For more on this, see Genz 18–26.

- 2. For more on the "post-ing" of feminism, see Genz 18–26.
- 3. See De Beauvoir (1949), Millett (1970), and Greer (1970).
- 4. De Beauvoir's attempts to delineate the cultural mythologization of femininity are sustained throughout *The Second Sex*, but are analysed with particular vigour from 171 to 282.
- 5. See Millett 294-335.

Works cited

Brunsdon, Charlotte. "Feminism, Postfeminism, Martha, Martha, and Nigella". *Cinema Journal* 44.2 (Winter 2005): 110–16.

——. "Pedagogies of the Feminine: Feminist Teaching and Women's Genre". *Screen* 32.4 (1991): 364–82.

De Beauvoir, Simone. *The Second Sex.* 1949. Ed and trans. H. M. Parshley. London: Vintage, 1997.

Faludi, Susan. Backlash: The Undeclared War Against Women. London: Vintage, 1992.

Friedan, Betty. The Feminine Mystique. London: Penguin. 1992.

Gillespie, Rosemary. "Women, the Body and Brand Extension in Medicine: Cosmetic Surgery and the Paradox of Choice". Women and Health 24.4 (1996): 69–85.

Gillis, Stacy, and Rebecca Munford. "Genealogies and Generations: The Politics and Praxis of Third Wave Feminism". *Women's History Review* 13.2 (2004): 165–82.

Greer, Germaine. The Female Eunuch. 1970. London: Paladin, 1976.

Hollows, Joanne. *Feminism, Femininity and Popular Culture.* Manchester: Manchester University Press, 2000.

Hollows, Joanne, and Rachel Moseley. Feminism in Popular Culture. London: BERG, 2005.

Millett, Kate. Sexual Politics. 1970. London: Virago, 1977.

Negra, Diane. What A Girl Wants: Fantasizing the Reclamation of Self in Postfeminism. London: Routledge, 2008.

Tasker, Yvonne, and Diane Negra. Introduction. *Interrogating Postfeminism*. Ed. Yvonne Tasker and Diane Negra. Durham, NC: Duke University Press, 2007. 1–25.

Whelehan, Imelda. *Overloaded: Popular Culture and the Future of Feminism*. London: Women's Press, 2000.

Part I Generations

1

Nancy Meyers and "Popular Feminism"

Kathrina Glitre

Nancy Meyers has an exceptional career. While many women in Hollywood struggle to sustain employment, Meyers has worked steadily for 30 years, from co-writing and co-producing films such as *Private Benjamin* (1980) and *Baby Boom* (1987) with her then-husband, Charles Shyer, to becoming probably the most commercially successful female writer-producer-director in the history of Hollywood. *What Women Want* (2000) is the highest-grossing romantic comedy ever, earning \$374,111,707 worldwide, while *Something's Gotta Give* (2003), *The Holiday* (2006), and *It's Complicated* (2009) all broke the \$200,000,000 barrier (*Box Office Mojo*). Despite this success (or perhaps because of its commercial nature), Meyers has attracted little critical and academic attention, even within feminist film studies. This is particularly surprising given that Meyers's films are centrally concerned with that icon of the postfeminist era – the independent (white, middle-class) woman with a successful professional career.

By exploring Meyers's work, I want to unpack the relationships between feminism, postfeminism, popular culture, and pleasure, in order to consider the problems that "popular feminism" might pose for feminist politics. There are three interrelated, but distinct, meanings embedded in my understanding of "popular feminism":

- 1. representations of "feminist" ideas in popular culture;
- 2. the popularity of such representations;
- 3. the popular understanding of "feminism" that is generated through this exchange.

Paradigms come and go – from power-dressing to "Girl Power" to empowerment – but, broadly speaking, popular feminism has become

closely identified with the figure of the "independent woman" during the postfeminist era. As Kristyn Gorton argues, "popular representations of feminism in the media sell: whether in music, film or television, images of independent women appeal to a wide audience.... Throughout these representations it is implied that women have achieved the goals of second wave feminism - financial autonomy, a successful career, sexual freedom" (154). The second wave was about more than this, but popular culture's reductive understanding tends to involve little more than sex, money, and freedom of choice. While these particular ideas have certainly become part of mainstream representation of women, this probably has as much, if not more, to do with the demands of neoliberalism and consumer capitalism than the achievements of the second wave.2 Moreover, simply because a fictional character has achieved these goals does not mean the women watching her have: the figure of the independent woman sells because she provides a pleasurable fantasy of power and success, not because she is a "feminist". Indeed, in recent years, postfeminist film and television narratives (certainly in the US and the UK) have tended to resolve their conflicts by depicting women as "outgrowing" independence and becoming happily co-dependent through heterosexual romance.3

In this context, Private Benjamin, Baby Boom, and What Women Want offer a fascinating condensation of the historical trajectory of Hollywood's representation of independent women and "popular feminist" ideas.4 With the possible exception of Private Benjamin, I do not think any of Meyers's films can be called "feminist". They do, however, bear the traces of feminism,⁵ invoking popular feminist ideas in very direct ways, including pointed dialogue about the choices open to women in Private Benjamin, "having it all" in Baby Boom, and empowerment and "being yourself" in What Women Want. Thus, while all three feature a successful, independent woman, they articulate the trope in different ways. Private Benjamin's poster, for example, shows a bedraggled Judy Benjamin (Goldie Hawn) wearing army fatigues, with smudged mascara and a band-aid on her face. It is difficult to imagine a contemporary chick flick using such an unglamorous image as a selling point. While much of the film's comedy comes from the idea of a petite. hapless woman doing "men's work" by joining the army, the narrative is also about the submissive, hyper-feminine Judy's transformation into an independent woman, breaking free from patriarchal authority (her husband, her father, her colonel, her fiancé) and heterosexist institutions (family, the army, marriage). In Baby Boom, J.C. Wiatt (Diane Keaton) initially epitomizes the eighties' yuppie (a young, upwardly-mobile

professional), but her career promotion is jeopardized when she inherits guardianship of her cousin's baby, Elizabeth (Kristina and Michelle Kennedy). The narrative's conflicts are again encapsulated in the poster image. J.C./Keaton is attractively presented, but her stance indicates the struggle of trying to "have it all": clutching a briefcase in one hand and the baby in the other, she appears off-balance and overburdened. By the time of What Women Want, the idea of the independent career woman has become so familiar that Darcy Maguire (Helen Hunt) is no longer the protagonist; her story is displaced by the reformation of pseudo-rat packer, Nick Marshall (Mel Gibson), into postfeminist hero, in a film that relies on heterosexual romance as the "solution" to gender inequality. The film's various posters all emphasize the couple, usually showing Nick/Gibson dominating the frame and meeting our gaze, while the conventionally feminine Darcy/Hunt is positioned side-on, gazing at him, not us.6

Without wanting to impose an overly simplistic linear trajectory on these phenomena, these shifts in representation do seem quite typical of contemporary Hollywood – and of popular understandings of the history of feminism. We might say that popular culture has spun a familiar tale: Act 1, a woman breaks free of patriarchal oppression, proving her self-worth by becoming independent; Act 2, she discovers the difficulty of having it all; Act 3, lonely and frustrated, she decides the cost of independence is too high, settling down with a nice "new man" for a happily-ever-after ending. To unpick the implications of such representations for feminist politics, I want to analyse the role of heterosexual romance within these three films.

Private Benjamin begins and ends with a wedding, symbolizing the extent to which Judy has changed. Judy's second husband, Yale Goodman (Albert Brooks), dies of a heart attack on their wedding night, while - briefly - consummating their marriage on the bathroom floor. In many ways, this is represented as a lucky escape for Judy: the stereotypical Jewish "princess", her marriage looked set to revolve around home furnishings and unsatisfying sex-on-demand. Judy is distraught because, as she puts it, "I've never not belonged to somebody – never". Tricked into enlisting, she ends up belonging to Uncle Sam. Judy is transformed by basic training and becomes the first female Thornbirds paratrooper, but she is sexually harassed by her Colonel (Robert Webber) and negotiates a transfer to Belgium as a purchasing specialist – "The one job I've trained for all my life". She falls in love with a Parisian gynaecologist, Henri Tremont (Armand Assante), whose stereotypical expertise finally enables her to achieve sexual fulfilment. Forced to choose between the army and marriage to Henri, she picks him, immediately reverting to stereotype: we next see her wearing a garish pink and blue outfit that Henri had earlier admired in a boutique, but in which Judy had shown no interest. Standing at the altar, Judy has an epiphany. Three quick shots are intercut as flashes of her memory: marrying Yale; her father admonishing her for running away; and Henri asking her to sign a prenuptial agreement. Each shot represents her submissive relationship to a man. In this way, the film articulates her subsequent refusal to marry as a refusal of patriarchy, not just a refusal of Henri's womanizing. When Henri tells her, "For once in your life, don't be stupid" – echoing her father's words, "You were never a smart girl" – she punches him, declaring, "Don't call me stupid". The film ends with Judy throwing her veil to the wind, striding away from Henri's house in her wedding gown, head held high.

This moment of "feminist" triumph remains relatively unusual for a mainstream Hollywood film. *Private Benjamin*'s final rejection of heterosexual romance seems to speak quite directly to the second wave's critique of the ways in which compulsory heterosexuality, romance, and marriage subjugate women within patriarchy. The image of the bride striding away plays out very differently here to the recuperative representation of weddings and marriage in more recent films, such as *Runaway Bride* (1999), *Forces of Nature* (1999), or even *Wedding Crashers* (2005), not to mention Meyers's own work on *Father of the Bride* (1991). However, it should be borne in mind that *Private Benjamin* is at the tail end of a cycle of comedies, such as *Shampoo* (1975), *Annie Hall* (1977), and *Semi-Tough* (1977), which ended unconventionally as part of the broader countercultural moment. *Private Benjamin*, like all Meyers's work, is very much of its time; indeed, her films seem particularly adept at tapping into the zeitgeist.

Baby Boom, for example, begins with a montage of (white) women striding along the New York streets on their way to work. The sequence is reminiscent of the opening credits of Cagney and Lacey (1982–1988), with Bill Conti's score bearing a striking resemblance to his well-known theme for that series. We also hear a voiceover, spoken by the NBC news reporter, Linda Ellerbee, lending the words factual authority as well as connoting the real-world success of women:

Fifty-three percent of the American work force is female. Three generations of women have turned a thousand years of tradition on its ear. As little girls, they were told to grow up and marry doctors and lawyers. Instead, they became doctors and lawyers... Take J.C. Wiatt,

for example.... She works five to nine. She makes six figures a year and they call her "The Tiger Lady". Married to her job, she lives with an investment banker married to his.... One would take it for granted that a woman like this has it all. One must never take anything for granted.

From the outset, then, the film expresses an ambivalent attitude to women's professional success. When J.C. fails to get the promotion she deserved, because she has been struggling with the newfound responsibilities of parenthood, she decides to move to Vermont. After various domestic and financial disasters, she launches her own gourmet baby food company, rapidly becoming even more successful as an entrepreneur, but this time on her own terms.

The film is a prescient example of the postfeminist "retreatist" narratives discussed by Diane Negra: in films and telvision shows like Hope Floats (1998), Judging Amy (1999–2005), The Gilmore Girls (2000–2007), and Sweet Home Alabama (2002), a career woman relocates back home, or to an idealized New England small town, "'downshifting' her career or ambitions in order to re-prioritize family commitments and roles" (18), enabling her to (re)discover love along the way; like Baby Boom, the television series particularly privilege the mother-daughter relationship. Negra argues that these retreatist narratives work "to manage a pervasive cultural contradiction in which claims of feminist victories need to be squared with abundant evidence of feminism's losses" (15) – the same kind of contradiction expressed in *Baby Boom*'s opening voiceover: equality has (supposedly) been achieved, but at what cost? All too often, postfeminist culture represents (white, middle-class) women's achievement of social and economic independence as being at the expense of femininity, relationships, and happiness.

Like other retreatist narratives, Baby Boom suggests there is more to a woman's life than loving a man, but heterosexual romance is nonetheless constructed as a vital ingredient for happiness. J.C.'s initial relationship of convenience with investment banker, Steven Buchner (Harold Ramis), contrasts strongly with her later romance with country vet, Jeff Cooper (Sam Shepherd). Steven is Jewish and – much like Yale in Private Benjamin – his ethnicity is stereotypically used to bring his virility into question: we first see him wearing a facemask in bed. His idea of foreplay involves asking "Do you want to make love?" and removing his glasses; four minutes later, he is putting them back on, declaring, "That was incredible". In contrast, when J.C. asks Jeff if he is tired the morning after they have sex, he remarks, "Well, I usually require more than 20 minutes sleep a night". While Steven is represented as safe but dull, Jeff is represented as sexually confident and dynamic.

The catalyst for change, however, is Elizabeth, who inspires J.C.'s retreat and her business success. Elizabeth humanizes, as well as feminizes, the Tiger Lady. J.C.'s career change involves replacing the masculinized office environment of sharp suits and cut-throat competition with a feminized domestic environment of natural soft foods, boosting the local economy as well as feeding the next generation. By rejecting the man-eating Tiger Lady in favour of the nurturing motherentrepreneur the film's resolution finally enables J.C. to have it all: a beautiful home, a successful business, a passionate man, a place in the community, and – above all else – a loving mother–daughter relationship.⁷ Motherhood is represented as central to female happiness and the film's final image emphasizes this cosy, reassuring sentiment: J.C. sits with the pink-clad Elizabeth in an old-fashioned rocking chair, surrounded by flowers and comfy country-style furnishings with diffuse sunlight streaming through the windows.

What Women Want places even more importance on heterosexual romance and is typically postfeminist in the way it uses this romance as an individualized solution to systemic problems. As Rosalind Gill has helpfully elucidated, "postfeminism should be conceived of as a sensibility" (148) involving a number of interrelated elements, including:

the notion that femininity is a bodily property; the shift from objectification to subjectification; the emphasis upon self-surveillance, monitoring and discipline; a focus upon individualism, choice and empowerment; the dominance of a makeover paradigm; a resurgence in ideas of natural sexual difference; a marked sexualization of culture; and an emphasis upon consumerism and the commodification of difference. (149)

While all of these elements are present in *What Women Want*, I want to focus on the issues around femininity, commodification, and "natural" sexual difference in relation to the film's fantastic articulation of heterosexual romance.

The commodification of femininity as a bodily property is signalled by the pink box of consumables distributed by Darcy, which Nick then drunkenly tests out: anti-wrinkle cream, make-up, bath beads, home waxing and pregnancy kits, a "more wonderful wonderbra", control-top panty-hose, pore-cleansing strips, painkillers, and (essentially) a credit card. The parodic makeover scene flirts with critique (Nick's bafflement

at how anyone manages to wax hair more than once, for example), but overall the film constructs a sense of sympathy with, even admiration for, women's commitment to external beauty (rather than suggesting women might choose to *stop* waxing). When Nick wakes up with the power to hear women's thoughts, what he hears further reinforces the idea of "natural" gender difference, conforming to gendered (and ethnic) stereotype. The first women he encounters are his Latina cleaner (Diana-Maria Riva) and African-American doorwoman (Loretta Devine): both are thinking about him. In the following scene at the park (where every female he encounters, including a French poodle, is white) he hears women thinking about domestic appliances, kissing a woman once, calories, oestrogen, a hyperactive kid, and a man who doesn't listen; not one woman is thinking about work, or politics, or anything apart from her personal, domestic life. The scene's overwhelming association of the female mind with bodily concerns is confirmed by the poodle: "Monsieur, I need to poop". Nick's ability to hear women's thoughts places him in an exceptionally privileged position. As his ex-counsellor (Bette Midler) spells out: "Freud died...still asking one question: 'What do women want?' ... If men are from Mars, and women are from Venus, and you speak Venusian...the world can be yours". For the most part, the exploitative aspects of this power are glossed over, diverting attention to Nick's re-education – but here, too, conservative gender discourse prevails: while female makeovers emphasize external transformation (products applied to the body), Nick's makeover is about internal transformation (knowledge that changes his mind).

Given this emphasis on gender difference, Nick's power becomes indispensible to the romance plot: his ability to "speak Venusian" enables him to understand Darcy in a way no other man can. At the same time, Nick's "mind-reading" ability is complemented by Darcy's tendency to "speak her mind" – a trait which she describes as a curse, but which he sees as an "enormous relief", specifically asking, "Do you know how rare that is?" Both are marked as exceptional among their sex, evoking the romantic notion that they are "made for each other". Thus, the romance plot provides a powerful, but contradictory, fantasy, imagining that men can change and women can (finally) be happy – but only if men learn to read women's minds and women (then) speak theirs.

Nick's "mind-reading" ability also enables him to hear the disjunction between Darcy's thoughts and actions, revealing her vulnerability and insecurity. For example, finding her working late, he is momentarily confused because her words and thoughts overlap; the camerawork reinforces this sense of distortion, craning in towards Darcy at the same time as canting the angle. Out loud, she comments about how late it is, but internally she thinks, "I'm glad you're here: I'm stuck and I feel so alone". He offers to help: she declines; he perseveres. As they talk, she reveals that she is ill and has "basically stopped sleeping" since taking the job. This, too, is a common pattern for postfeminist representation: post-Ally McBeal, the career woman is increasingly imagined as a *fragile* figure, anxiously struggling to maintain (the facade of) success. While Darcy's self-presentation at work is capable and confident, she remains physically "delicate": blond, extremely slender, impeccably turned out in pale shades. J.C. Wiatt was a "Tiger Lady", but it seems implausible that anyone would describe Darcy as the "man-eating bitch Darth Vader of the ad world". She's just too nice, and admits defeat all too easily.

Nominally, Darcy is Nick's "superior", but he has the power for most of the film. The narrative is constructed around him - we rarely see Darcy without him, for example – and the film's subplots reinforce his importance, as he rescues his daughter from the prom, intervenes in a co-worker's possible suicide, and saves Darcy's job. To redress the balance, the film inserts a last-minute reversal: Nick is struck with the realization that, while it looks like he is there "being all heroic, trying to rescue" Darcy, he is the one that "needs to be rescued". The fairytale rhetoric is intensified by the couple's final embrace. Meeting in a mid-shot on the spiral staircase, Darcy wonders, "What kind of knight in shining armour would I be if the man I love needs rescuing and I just let him walk out my door?" The scene cuts to a close-up as he moves around her, circling like a dance, before tipping her back slightly (so he appears taller). Sighing, he declares, "My hero", and kisses her. The dialogue's glib gender inversion is counteracted by framing and performance, both of which emphasize Nick's "natural" male dominance as he controls the embrace and kiss.

What is particularly disconcerting about this ending (from a feminist perspective, at least) is the idea that Darcy *needs* love – that, as Nick puts it, she does not feel "complete" or a "winner" without it (in marked contrast to Judy Benjamin's final triumph). This rehabilitation of heterosexual romance is also explicitly old-fashioned in conception. While the postfeminist narrative requires that Nick's sexual prowess is brought into question, the romantic fantasy would be undermined if Darcy were the one to re-educate him sexually; instead, this function is fulfilled by Lola (Marisa Tomei), an easily manipulated (and discarded) coffee shop waitress. In contrast, Nick and Darcy's relationship is associated with the old-fashioned innocence of kissing and dancing, displacing sex with

romance in a very knowing way: as they sway to a modern rendition of Cole Porter's "Night and Day", Nick points out, "So, if you had a bed, we'd be dancing on it".

I find one aspect of this romantic nostalgia particularly striking. The date scene at the Hidden Door bar reminded me of a similar scene in Woman of the Year (1942), where newspaper columnists Tess Harding (Katharine Hepburn) and Sam Craig (Spencer Tracy) sit in a back booth, learning about each other while having a drinking competition. The DVD extras confirmed my suspicion: the actors watched some of Woman of the Year before rehearsing the scene. I find the connection striking not simply because of the "old-fashioned" influence, however, but because Woman of the Year was part of a cycle of career woman comedies in which a successful woman falls in love, becomes more "appropriately" feminine and relinquishes some of her power in order to form a (relatively) more "equal" heterosexual couple.8 Another film from the cycle, Honeymoon in Bali (1939), includes dialogue which may seem strangely familiar:

I'm not a feminist...but the expression "it's a man's world" always irritates me. It's anybody's world, who can live it.... I don't believe in marriage... – not for me or for any woman who has the sense to live her own life.... I earn a salary that makes most men's look sick and I'm the boss. And [I have] the most precious thing of all: absolute personal freedom.

These words are spoken by Gale Allen (Madeleine Carroll): initially married to her job as Executive Vice-President of Morrissey's Department Store, by the end of the film she has adopted a small child and married the man she is speaking to, Bill Burnett (Fred MacMurray). A film like Baby Boom, then, not only foreshadowed a conventional postfeminist narrative – it also resurrected one. In a sense, these postfeminist retreatist narratives are telling us the same old story, using heterosexual romance as an old-fashioned solution to the "problem" of the independent woman. But there is a paradox here: while the onscreen narratives of career woman comedies typically involve the heroine's feminization, domestication and/or retreat from power, off screen these films enable a few women to have unusually successful careers. Woman of the Year, for example, was part of a very deliberate strategy on Hepburn's part to revitalize her film career,⁹ and *Honeymoon in Bali* was scripted by Virginia Van Upp, who later became an executive producer at Columbia Studios. Similarly, by centring her films on topical issues affecting the lives of (white, middle-class) independent women, Meyers has been able to develop increasing control over her own career within an industry that is still heavily dominated by men. Indeed, Martha L. Lauzen's annual report on women's employment on the top-grossing 250 films at the US box office suggests that things are getting worse, not better: in every category studied – directors, writers, executive producers, producers, editors, and cinematographers – the percentage of women employed was lower in 2009 than it had been in 1998, totalling just 16 per cent of the people working on these films. Bearing in mind that in at least one case – *It's Complicated* – the director, writer, and producer would have been *one* woman, not three, Nancy Meyers's exceptional status becomes still clearer.

Some aspects of reception and consumption also warrant attention. Reviewers usually suggest Meyers's films are uneven, unoriginal, and too long, yet they also acknowledge the pleasures of the performances and the romance, before (often begrudgingly) admitting the films' affective power. Anna Smith's review is typical:

While fitfully amusing, *The Holiday* is at its best when going all out for old-fashioned romance. True, it's overlong and peppered with corny dialogue, much like director Nancy Meyers' previous romantic comedies *Something's Gotta Give* and *What Women Want*. But with a likeable cast and credible romantic unions, it still has the power to move us as the credits roll over its shamelessly idealised closing scene. (58)

I suspect the length of these films is an important part of their commercial success. The leisurely pace of *What Women Want* (127 minutes), *Something's Gotta Give* (128 minutes), *The Holiday* (138 minutes), and *It's Complicated* (120 minutes) enables a certain self-indulgent expectation in the audience – a wallowing in postfeminist pleasures and old-fashioned romance. Self-indulgence is extremely prevalent in current discourses around chick flicks, from the popular cultural idea of the "Girls' Night In" to niche marketing and product tie-ins: Galaxy chocolate, for example, had tie-ins with *Down With Love* (2003) and the *Sex and the City* movie. In various ways, watching chick flicks has been constructed as the filmic equivalent of – and accompaniment to – comfort eating. It is not surprising, then, that recent reviewers have used food metaphors to describe Meyers's films: Justin Chang describes *The Holiday* as "a lavishly overstuffed gift basket of a movie"; the UK DVD cover quotes the *Mail on Sunday* describing *It's Complicated* as "a delicious

treat"; while Peter Travers suggests, "You don't have to feel guilty for lapping up this froth. Just don't expect nourishment".

Metaphors such as these are part of a much longer history of taste formation, in which hierarchies of quality are constructed along the lines of gender and class. Genres such as romance have been culturally denigrated partly through their association with "feminine" audiences and the idea that romance "readers" are passive and lacking emotional distance. These are loaded debates for feminist study of popular culture – extending well beyond the scope of this chapter - but I want to conclude by considering how the commodification of self-indulgence relates to postfeminist and neoliberal discourses of pleasure as a way of addressing the problems that "popular feminism" might pose for feminist politics.

It was once a political necessity for feminist scholars to validate "feminine" popular culture as a strategic interrogation of the ways in gender power was structured through hierarchies of taste. This work was vitally important, but I share Stevi Jackson's concerns:

Some recent accounts...give me the uneasy feeling that romance is being rehabilitated....new perspectives which take women's pleasure in romance seriously...have produced more sophisticated accounts of women's readings of romance. At the same time, this shift of emphasis risks blunting the edge of feminist critique. Recognizing the pleasure gained from reading romance should not prevent our being critical of it. (262)

Much postfeminist criticism tends to do just this, however, often invoking second wave feminist analysis in order to reject it as overly severe. As Charlotte Brunsdon notes, this has led to the emergence of an "Ur feminist article" (112), in which an academic takes a popular media text centred on women, addressed to a "feminine" audience. The Ur article

usually involves setting up...an "obvious" [second wave] feminist reading...in which the text itself – and the heroine – fail some sort of test. The heroine is not independent enough...she is always worrying about her looks, or she just wants to find a man and settle down. The author then mobilizes her own engagement with the text...to interrogate the harsh dismissal of this popular text on "feminist" grounds. The author thus reveals the complex and contradictory ways in which the text – and the heroine – negotiate the perilous path of living as a woman in a patriarchal world. (113)

I have no intention of redeeming Nancy Meyers's work in this way: her films *are* complex *and* contradictory, but they are also conservative, stereotypical, and increasingly reliant on heterosexual romance as the solution to the independent woman's problems. Looking at her films within a broader historical context reveals patterns of representation that further confirm the limitations of the texts. Nonetheless, *I enjoy watching these films*.

While Meyers's films undoubtedly bear the traces of second wave feminism in the way they foreground independent women, they are more directly influenced by neoliberal and postfeminist gender discourses. Neoliberalism and the postfeminist sensibility encourage self-indulgent pleasure to be mistaken for empowerment, as if the mere fact that a woman enjoys doing something means this pleasure is, in some sense, "feminist". To me, the pleasures these films provide are antagonistic to feminist politics. "Popular feminism" is feminism without protest, politics replaced with pleasurable self-indulgence in the personal problems of the privileged few. We need to acknowledge the limits of our fantasies and pleasures as distinct from the political struggle against sexism and inequality. Lest we forget the economic realities, the US Census Bureau estimates that, between 2006 and 2008, 14.5 per cent of women were living in poverty, compared to 11.7 per cent of men (S1701); the average median earnings for men over 25 was \$41,298. compared to \$29,104 for women (S2001); and the pay gap between male and female median earnings was over 33 per cent at every level of educational attainment (S2001), including professional careers. The success of an individual woman - onscreen or off - should never be mistaken for the achievement of feminism's goals.

Notes

- 1. Compare this to another writer-director, Nora Ephron, whose eight films earned \$515,045,627 at the US box-office; Meyers's five films earned \$549,809,187 (Box Office Mojo).
- 2. See Walkerdine and Gill.
- 3. See Negra 93.
- 4. Each film is also a key moment in Meyers's career. Her first film, *Private Benjamin*, was the first time she worked with Shyer; *Baby Boom* was the first film she produced single-handed (Shyer directed) and the first time she worked with Diane Keaton, who then co-starred in the *Father of the Bride* films (1991 and 1995) and *Something's Gotta Give*; and *What Women Want* was her first film without Shyer (and the only one she did not write).

- 5. This issue was explored in more depth by Yvonne Tasker in her keynote address at the FWSA's Feminism and Popular Culture conference (Newcastle University, 2007).
- 6. See IMP Awards for poster images.
- 7. Interestingly, J.C.'s change of career appears to have little bearing on her economic status. While many postfeminist fictions associate the professional woman's shift towards domesticity with various forms of financial sacrifice, Baby Boom presents a female protagonist who prioritizes her family but retains her affluent lifestyle and enhances her business profile.
- 8. See Glitre 110, 116-30.
- See Glitre 113–15.

Works cited

Baby Boom. Dir. Charles Shver. MGM. 1987.

Box Office Mojo. http://boxofficemojo.com/. [Accessed May 19, 2010].

Brunsdon, Charlotte. "Feminism, Postfeminism, Martha, Martha and Nigella". Cinema Journal 44.2 (2005): 110-16.

Chang, Justin. Rev. of The Holiday. Variety (November 30, 2006). http:// www.variety.com/awardcentral_review/VE1117932231.html?nav=reviews07& categoryid=2352&cs=1. [Accessed May 19, 2010].

Gill, Rosalind. "Postfeminist Media Culture: Elements of a Sensibility". European Journal of Cultural Studies 10.2 (2007): 147-66.

Glitre, Kathrina. Hollywood Romantic Comedy: States of the Union, 1934-65. Manchester: Manchester University Press, 2006.

Gorton, Kristyn. "(Un)fashionable Feminists: The Media and Ally McBeal". Third Wave Feminism: A Critical Exploration. Ed. Stacy Gillis, Gillian Howie, and Rebecca Munford. Basingstoke: Palgrave Macmillan, 2004. 212-23.

The Holiday. Dir. Nancy Meyers. Universal, 2006.

Honeymoon in Bali. Dir. Edward H. Griffiths. Front Row Entertainment, 1939.

IMP Awards. http://www.impawards.com/. [Accessed May 19, 2010].

It's Complicated. Dir. Nancy Meyers. Universal, 2009.

Jackson, Stevi. "Love and Romance as Objects of Feminist Knowledge". Women and Romance: A Reader. Ed. Susan Ostrov Weisser. New York: New York University Press, 2001. 254-64.

Lauzen, Martha L. "The Celluloid Ceiling: Behind-the-Scenes Employment of Women on the Top 250 Films of 2009". http://womenintvfilm.sdsu.edu/files/ 2009_Celluloid_Ceiling.pdf. [Accessed May 19, 2010].

Negra, Diane. What a Girl Wants?: Fantasizing the Reclamation of Self in Postfeminism. London: Routledge, 2009.

Private Benjamin. Dir. Howard Zieff. Warner Bros, 1980.

Smith, Anna. "The Holiday". Sight and Sound 17.2 (February 2007), 58.

Something's Gotta Give. Dir. Nancy Meyers. Warner Bros, 2003.

Tasker, Yvonne. "I'm not a feminist, but...". Feminism and Popular Culture. Feminist and Women's Studies Association Annual Conference. Newcastle University, June 29-July 1, 2007. Keynote address.

- Travers, Peter. "It's Complicated". Rolling Stone. 2009. http://www.rollingstone.com/movies/reviews/%3Bkw=%5B15595,104832%5D. [Accessed May 20, 2010].
- US Census Bureau. "\$2001: Earnings in the Past 12 Months". American Community Survey, 2006–2008. http://factfinder.census.gov/servlet/STTable?_bm=y &-geo_id=01000US&-qr_name=ACS_2008_3YR_G00_S2001&-ds_name=ACS_2008_3YR_G00_. [Accessed May 21, 2010].
- US Census Bureau. "\$1701: Poverty Status in the Past 12 Months". American Community Survey, 2006–2008. http://www.factfinder.census.gov/servlet/STTable?_bm=y&-geo_id=01000US&-qr_name=ACS_2008_3YR_G00_\$1701&-ds_name=ACS_2008_3YR_G00_. [Accessed May 21, 2010].
- Walkerdine, Valerie. "Neoliberalism, Femininity and Choice". New Femininities: Post-feminism and Sexual Citizenship Seminar Series: Seminar 1: Theorising the Changes. LSE. November 19, 2004.

What Women Want. Dir. Nancy Meyers. Icon, 2000.

Woman of the Year. Dir. George Stevens. MGM, 1942.

2

"I'm nothing like you!" Postfeminist Generationalism and Female Stardom in the Contemporary Chick Flick

Shelley Cobb

Since the term first accrued cultural currency in the early 1980s, "postfeminism" has been entangled with critical debates about feminist histories, the legacy of the second wave, and the tensions between different "generations" of writers, theorists, and activists. Several Hollywood "chick flicks", including Monster-in-Law (2005), The Devil Wears Prada (2006), Prime (2005), The Family Stone (2005), and Because I Said So (2007), stage this generational conflict by pairing baby-boomer female stars, associated with the 1970s, with younger female actors. In these films, the younger star tends to perform "the tropes of freedom and choice which are now inextricably connected with the category of young women, [while] feminism is decisively aged and made to seem redundant" (McRobbie 11). Typically, then, the postfeminist woman has been presented as the envoy of an apolitical version of feminism that "has been effectively assimilated into our cultural common sense" (Tasker and Negra 2). Postfeminism maintains this assimilation by promoting a traditional view of femininity, in which "good" women are defined by their personal relationships, while "bad" women are marked out by their resistance to familial and romantic intimacy. In the postfeminist generational plot, either the younger woman or the older woman can learn the lesson of prioritizing family and relationships over her career and herself, although it is the younger woman who is prevailingly situated as the exemplar of appropriate postfeminist behaviour. By contrast, the older actor's stardom is used as shorthand for a politicized and "outdated" mode of feminism that is based around the caricature of the career-obsessed and/or neurotic woman. This stereotype not only refuses to occupy her "proper" place within the patriarchal family unit, but is also, seemingly, incapable of maintaining "normal" or functional relationships. The figure of the aging woman is thus central to theories of postfeminist generationalism as the default symbol for a feminist lifestyle that is inconsistent with, or inappropriate to, the preoccupations and concerns of contemporary Western women. As Sadie Wearing reflects, this "scandalous presence of the inappropriate is... a feature of both popular representations of the aging body and postfeminist representations of feminist critical positions" (280). In the context of the postfeminist chick flick, then, the (in)appropriate practice of female choice and independence is mediated, in part, through the specific bodies of the film's female stars (280).

In her article "The Selfish Feminist", Imogen Tyler describes how the earliest (and most persistent) criticism directed at feminism in the 1970s was that it made women selfish - that liberation meant nothing more than a rejection of home and family in order to pursue the narcissistic goal of self-fulfilment. These accusations, Tyler argues, were founded on truths, insofar as they reflected - albeit in a very distorted manner – feminism's belief that "the institution of the family needed to be opened to scrutiny, dismantled and restructured in order for women to gain any measure of social and political equality" (179). For many conservatives, however, it was the feminist political agenda, and not the oppressive structure of the traditional nuclear family, that was encouraging women to leave their husbands and abandon their children. In this "anti-family" version of feminism, the selfish feminist is prevailingly situated as the worst perpetrator of the 1970s "narcissism of minorities that was ripping apart the social fabric of America from within" (184). In this chapter, I am interested in the extent to which Jane Fonda and Meryl Streep – two actors whose star personae were principally defined in the late 1970s and early 1980s - are each, to varying degrees, associated with the feminist narcissism that Tyler identifies with this historical moment. With special reference to Monster-in-Law and The Devil Wears Prada, I would like to show how the casting of Fonda and Streep, respectively, works to perpetuate "backlash" images of the "selfish feminist". while also taking account of the ways in which the aging female star can resist, and even subvert, the uses to which she is put in these films.

Punishing Hanoi Jane: Teaching the feminist monster a lesson

Monster-in-Law was the film which marked Jane Fonda's return to acting, 15 years after she declared her retirement in 1991. Fonda's Hollywood

career had initially taken off in the early 1960s, when she was regarded primarily as a "sex-kitten". 2 Richard Dyer and Tessa Perkins have both suggested that her sex appeal became implicated in the growing feminist movement as a result of her role as the prostitute Bree Daniels in *Klute*, the 1971 film for which she won an Oscar. In 1972 she visited Hanoi, in Vietnam, and was photographed on an anti-aircraft battery that had been used against US forces. That visit, along with her other leftist political activities during the 1960s and 1970s – including her participation in the occupation of Alcatraz, her association with the Black Panthers, and her marriage to Tom Hayden (one of the Chicago Seven) - earned her regular and ongoing censure from conservatives, who nicknamed her Hanoi Jane.³ Unsurprisingly, critics have tended to interpret Fonda's choice of films in the 1970s as a reflection of her intensifying political convictions. It was during the latter part of this decade that she took on two of her most overtly political roles, playing the left-wing writer Lillian Hellman in Julia in 1977, and Sally Hyde, a character who works with disabled Vietnam veterans, in Coming Home in 1978. In one of the defining moments of Coming Home, Fonda's earlier status as a titillating symbol of sexual liberation is compellingly fused with her new profile as a key representative of the progressive gender politics of the 1970s when Hyde experiences her first orgasm with a veteran with whom she falls in love while her husband is serving in Vietnam.

For Tracy Young, Fonda's box-office appeal during this decade was "a direct result of the women's movement, a movement in constant search of role models" (80). In a similar vein, Tessa Perkins situates Fonda as "the Hollywood star who, in the seventies at least, came closest to being a feminist heroine" (238). Throughout the 1980s, Fonda's star persona changed with the development of her aerobics video empire, her marriage to the media mogul Ted Turner, and her public conversion to Christianity after the breakdown of her 10-year marriage to Turner. This decade saw her berated by the Left for being a sell-out, while remaining, for a large portion of the United States, the hated Hanoi Jane. Within the context of the Hollywood star system, then, Fonda is unusually defined by the ambiguities and ambivalences by which she is encircled. As Perkins puts it, "'Jane Fonda' functions as a sign whose meanings are still the subject of contestation"; it is within the framework of this contestation that Fonda's return to Hollywood in 2005 is, in my opinion, most productively considered (248).

Despite the contradictory reception of her star persona, Fonda's talents as an actor have been publicly acknowledged through the various awards she has received over the years, and her return to Hollywood was hotly anticipated. This anticipation was amplified by her pairing with Jennifer Lopez, a multi-sector star (pop music, fashion, and film) with previous success in romantic comedies such as The Wedding Planner (2001) and Maid in Manhattan (2002). Readings of Lopez's action films (such as Anaconda [1997], and Out of Sight [1998]) have suggested that her ethnic profile functions ambivalently in her stardom – drawing on stereotypes of tough Latina femininity that add an air of authentic urban identity to her embodiment of Hollywood beauty.⁴ This tough-but-sexy image on screen coincides with the period of Lopez's life when she was in a highly public relationship with the rapper Sean "Puff Daddy" Combs. Lopez's stardom both on and off screen regularly overlaps in this way, a conflation that continues through her appearance in Monsterin-Law. Since the earliest days of her fame, Lopez's personal life, including two failed marriages and relationships with P. Diddy and Ben Affleck, has been a staple feature of tabloid gossip columns. While her engagement to Affleck undermined her image of authenticity - most notably when he appeared in her video for the hit song "Jenny from the Block" lounging about on a yacht and giving her diamonds - her credibility was restored, to some extent, following her marriage to her music collaborator Marc Anthony in a private ceremony in 2005. As Alan Dodd and Martin Fradley have noted, in Monster-in-Law Lopez brings a "more confident...tone" to her role, mirroring as it does contemporaneous press descriptions of Lopez as "a woman who has crawled through an abyss and got out the other end stronger" (204-05). The promotional materials for the film give Lopez top billing over Fonda, conceding the power of Lopez's popularity and the importance of her own return to the screen after the box-office failures of Gigli (2003) and Jersey Girl (2004). Her character's success in finding personal happiness works to reinforce the narrative of Lopez's renewed success in her personal life, creating the perfect star text for promoting the postfeminist lessons that this chapter attempts to enumerate.

In *Monster-in-Law* Lopez plays Charlie, a dog-walking temp and part-time artist who lives in Venice Beach, California. At the beginning of the film, Charlie meets and falls in love with a young, handsome doctor (Michael Vartan), who asks her to marry him during her first meeting with his mother, Viola. Viola, played by Fonda, has already been established within the film as a formidable and intimidating, if emotionally unstable, woman. Viola is initially introduced to the viewer as a woman who has carved out a long and successful career for herself as a Barbara Walters-type talk show host. This career, however, comes to an abrupt end when Viola is informed by the studio executives that she is being replaced by a younger woman. Angry and betrayed, Viola gives vent

to her frustration during a live interview with Tanya Murphy, a "teen singing sensation" in the mould of Britney Spears. As the latter attempts to promote her single, which features the line "if you want to know me look in my makeup bag", Viola admonishes her for "probably having no idea of the significance of Roe versus Wade". Lending credence to Viola's suspicion, Murphy replies, "Oh, I don't support boxing as a sport. I think it's too violent". This inane comment, from a pop star who has sold five million CDs (which Viola initially refers to as "albums" – one of several signifiers of her age and "outdatedness"), causes Viola to scream in anger, before launching herself at the young girl and toppling them both to the ground. The specific reference to Roe versus Wade – the 1973 US Supreme Court abortion rights case that remains the touchstone for American feminist politics and a lightening rod for the ongoing culture wars – is, in this instance, the ultimate sign of Viola's 1970s feminism. It is also the first moment when Fonda's historical stardom is directly invoked and contained as redundant and of the past.

As Dodd and Fradley argue, "Lopez's roles in rom-coms are typically imbued with the neo-utopian discourses of post-feminist 'choice'", meaning that Viola is positioned within the structure of the narrative as "the dysfunctional and fundamentally unhappy victim of secondwave feminism's supposedly anti-feminine imperatives" (204). The two women do perform postfeminist/feminist opposition, but rather than Fonda filling the role of feminist victim, the film seems to draw on Fonda's historical stardom to situate her as a perpetrator of feminist politics, one who has become emblematic of the long-running stereotype of liberal feminists as narcissistic and selfish. Certainly, the film works hard to equate Fonda to Viola, and the plot functions to punish Fonda/Viola from both sides by making jokes that contradictorily evoke and invert Fonda's political history: Viola, for example, mentions interviewing Henry Kissinger and receiving a gift from Chairman Mao, and her assistant jokes that Charlie has had fewer lovers than Viola did on "the last day of Woodstock". In this way, the particular politics of Fonda and/or Viola no longer matter; her only consistent crime is to be a successful woman of a certain age with three failed marriages and a Freudian obsession with her only son.

Viola receives her first narrative punishment for being "too old" when she is replaced by a younger woman. Viola's narcissism causes her to mistake her replacement for an intern, and she commands the young woman to get her a latte. In the following scene, the network executives tell Viola that she has had an "amazing career", but they are "trying to appeal to a younger demographic". From behind a closed dressing

room door, we, and everyone on the set of her show, hear her screaming and breaking things before she interviews (and attacks) Tanya Murphy. It is at this moment when Viola becomes the "abject feminist" of the popular imagination, whom Tyler describes as having "physical and psychical...connotations [that] include the figuration of the feminist as selfish, cold, frigid, irrationally angry, confused, and perhaps more than anything a singular, lonely and unhappy figure" (185). Monsterin-Law works hard to make the stereotype clear when, upon release from a clinic where she has "learned to change" after her breakdown, Viola says to her assistant Ruby (Wanda Sykes), "I've figured it out. Life, I mean. It's not about how many celebrities I interview or what my ratings are; it's about relationships and family. Me and my son". In the midst of this speech, Ruby responds with sarcastic comments like "This ought to be good". Sykes's character plays on the long tradition of the "sassy" black servant, while also filling the role of the loyal and straight-talking ethnic minority friend often found in contemporary cinema – a role which predictably marginalizes the black woman, at the same time as effecting a liberal-left critique of Viola's whiteness and privilege.⁵ Additionally, Ruby articulates the position of disbelief that the film expects of the audience in response to Viola's claims that she has learnt her lesson.

These doubts echo a wider cultural suspicion of Fonda - that she never really learnt her lesson - which is still registered, I would suggest, in the continual presence of Vietnam veteran protestors at major Fonda events.⁶ Viola's and Fonda's images become further entangled in the film when Kevin brings Charlie to meet his mother. On the way, he tells the stories of his mother's four marriages (evoking Fonda's own three marriages), and finishes with "I'm all she's got now". Upon entering the house, Charlie peruses a side table full of pictures of Viola with various famous figures, including the Dalai Lama, Barbara Walters, Nelson Mandela, Gloria Steinem, Jon Voigt, and Oprah Winfrey - many of which are actual photos from Fonda's life. Missing, of course, is the most (in)famous photo of Fonda on the anti-aircraft gun in Vietnam. In the context of the film, these photos - some of which point to Fonda's activism - are politically neutered, as they now represent Viola's successful career. These photographs are the central symbol of Viola's grandiose, narcissistic, and selfish life, which is further signified through the film's formulation of class and race.

Throughout the entire film, Lopez's Charlie acts the carefree, good-hearted postfeminist woman: she is independent; she keeps herself afloat with odd jobs; she has ambitions in her art, but they always remain domesticated and charming. Viola's own mother-in-law may call

her "an exotic Latina", but the characterization of Charlie's ethnicity in the film mostly functions to highlight her "quasi-proletarian ordinariness". This, in turn, implies "that the fight for racial equality is no longer relevant", and uses ethnic identity, instead, as a marker of class (McRobbie 69). By contrast, Viola exudes wealth. Her house is a suburban mansion: "four acres, with two swimming pools, one indoor, one out". On first seeing Charlie from the window of her upstairs bedroom, Viola references their class differences by saying to herself, "Playing dress-up are we?" Later, she even asks Charlie if she is "an illegal alien". Charlie's ethnic identity is again referenced, albeit less explicitly, at the "barbeque" Viola throws to celebrate Kevin and Charlie's engagement. Having assumed that the event will be casual, the couple are surprised and embarrassed to find Viola and all her famous friends decked out in full formal dress. Viola has laid out a vintage dress for Charlie to wear. but it is the wrong size. Lopez is famous for her posterior, which is regularly invoked as a signifier of her authentic ethnic identity. As such, Charlie's inability to get the dress over her hips performs a "refus[al] to fit into the restrictive bourgeois world symbolized by the dress" (Dodd and Fradley 205). The conflict between the two women, then, figures Viola's feminism as inextricably intertwined with a supercilious, racist, bourgeois whiteness that invokes the critiques of second wave feminism by ethnic minority activists and academics. At the same time, and very problematically, it recontextualizes that critique as being just as antiquated as Viola's feminism. It does this by representing Lopez/Charlie as the exemplar of a version of contemporary femininity that supposedly transcends racial politics, and by making her the recipient of the ultimate postfeminist fantasy: finding romantic and (hetero)sexual fulfilment with a successful and rich (white) man.

Throughout the rest of the film, the two women torture each other, each trying to gain the upper hand in their relationship triangle. Finally, at the wedding for Charlie and Kevin, Viola's own "monster-in-law" shows up for a deus ex machina ending. Gertrude (Elaine Stritch) mocks Viola and makes plain that she was never good enough for Kevin's father. This pattern of generational conflict convinces Charlie to call the wedding off. After an intervention by Ruby, Viola convinces Charlie not to walk out, and offers to stay out of Charlie's and her son's life. It seems that she has finally learned her lesson, but Charlie has one more lesson for her: she demands that they do have a relationship – one which is constructed wholly around the family unit and the projected grandchildren. Charlie says, "You must be present for every Christmas, Thanksgiving, birthday, school play, clarinet recital, and soccer game in our kids' lives. I want you to love them, and spoil them and teach them things that Kevin and I can't. I want you there, Viola. I do, up front and center". Only when the postfeminist woman articulates it does Viola accept the lesson the narrative has been trying to teach her all along. The feminist "monster" is tamed. Throughout the film the humour and satisfaction in Viola's punishment and taming depends on the stardom of Fonda and the spectacle of witnessing the domestication of Hanoi Jane on her return to Hollywood.

From Joanna Kramer to Miranda Priestly: The power of the feminist "Devil"

Since Susan Faludi's publication of Backlash in 1991, negative characterizations of feminism and feminists in popular culture have seemed to be symptomatic of the postfeminist era. However, Tyler argues that "by the mid-1970s the most defiant, dismissive and powerful images of feminism had been supplanted by pejorative images of the selfish feminist and her narcissistic twin, commercialised images of 'liberated women'" (185). To illustrate, she gives a detailed reading of the 1979 film Kramer vs. Kramer, starring Dustin Hoffman and Meryl Streep. Hoffman plays Ted Kramer, a family man who spends most of his time at his job. Streep plays his wife, a graduate of Smith College who stays at home, becoming depressed, isolated, and neurotic, before leaving him and their son. Her absence permeates the narrative of Ted's change into a loving and feminized father, which develops in contrast to his wife's selfishness, epitomized in a letter to her son explaining why she left: "Being your mommy was one thing, but there are other things and this is what I have to do". Tyler argues that the film enacts the perceived destructiveness of feminism, dramatizing the scorn of conservatives like Phyllis Schlafly: "As a homewrecker, women's liberation is far in the lead over 'the other man', 'the other woman', or 'incompatibility'" (182). After a protracted custody battle that she wins, Joanna decides to let Ted have full custody. What might appear to be Joanna's most selfless act actually condemns her for abandoning her "natural" feminine identity as a mother. In The Devil Wears Prada, the 2006 film directed by David Frankel, the character of the selfish feminist is not only resurrected but also updated and adapted for the twenty-first century.

Tyler notes that Streep was first identified with feminist politics as a young actor (181, n. 9).⁷ Streep's political affinities and activities have never been seen as strident, but over the years she has supported feminist causes and, along with Fonda, she recently signed an open letter to

George W. Bush appealing for equal rights for Afghan women.8 In her early film career, Streep co-starred in the Vietnam film The Deer Hunter (1978) and appeared as Woody Allen's lesbian ex-wife in Manhattan (1979), gaining a reputation, like Fonda, for portraying strong female characters. This reputation was further galvanized by her decision to play the title role in Silkwood (1983), which dramatized the life of Karen Silkwood, who was murdered for exposing safety violations at a nuclear plant. After her first Oscar nomination for The Deer Hunter, Streep was nominated for an Academy Award every 2 years. The 1980s was a period of highly regarded films, including Sophie's Choice (1982), Out of Africa (1985), and Ironweed (1987), and she received seven Oscar nominations during this decade. She went on to receive a further three nominations in the 1990s and five in the 2000s. Streep, with 16, has the most Academy Award nominations for any actor (and has won twice). From the very beginning, Streep's stardom was formed by, and continues to be understood in terms of, her quality as an actor. Accordingly, in The Devil Wears Prada, she was given top billing over Anne Hathaway and received an Academy Award nomination for Best Actress.

The Devil Wears Prada is based on the book of the same name by Lauren Weisberger, a thinly veiled exposé of her time as Anna Wintour's assistant at Vogue magazine. Streep plays Miranda Priestly, the tyrannical editor-in-chief at the fictional Runway magazine, while Hathaway is cast in the role of Andrea, Miranda's latest assistant's assistant. As Andrea, Hathaway exudes Midwestern naïveté and is initially distinguished by her lack of fashion savvy. She is, however, quickly seduced by the world of designer labels and celebrity parties and gradually begins to put her job - and Miranda - before her family, her friends, and her boyfriend. Eventually, Andrea is chosen over Emily, the other assistant, for a coveted opportunity to accompany Miranda to Paris Fashion Week. As Carina Chocano, a critic for *The Los Angeles Times*, has commented, while The Devil Wears Prada might "[cast] doubts as to who the actual heroine of the story is, it's very clear on who's the star of the show" (para. 1). Miranda becomes the star of the show, if not the heroine of the film, due in large part to Streep's screen presence; through her quality stardom and the sensitivity of her performance, she usefully complicates the film's representation of a character that, in the original novel, is a fairly straightforward caricature of female selfishness and narcissism.

On the whole, the film presents Miranda as a woman who puts the concerns and needs of others, and any feeling she might have for them, far behind her hard-won success and desire for control. In the climax

of the film, Miranda thwarts a plan by the owners of the magazine to give her job to the younger female editor of Paris Runway by giving the Paris editor a job that she had promised to her loyal fashion editor Nigel (Stanley Tucci). As Nigel's friend, Andrea is disappointed by Miranda's decision, and on the way to the next fashion event she sits quietly while Miranda explains how she used her power to keep her position. This, however, is followed by another, more startling, revelation: "I never thought I would say this Andrea, but I see a great deal of myself in you.... You can see beyond what others want or think they need, and you can choose for yourself". In response, Andrea disagrees with Miranda: "I don't think I'm like that. I couldn't do what you did to Nigel", to which Miranda replies, "But you already did...to Emily". Andrea protests that she had no choice since Emily was ill, but Miranda tells her that she made the choice to get ahead. The postfeminist lesson of this scene is clear: for some time Andrea has been seduced by the success of the "selfish feminist". When Andrea says, "But what if I don't want to live the way you live?", Miranda is quick to retort: "Oh don't be ridiculous Andrea. Everybody wants this. Everybody wants to be us". Delivered by Streep, wearing designer sunglasses and a mink stole in the back seat of a chauffeur-driven limousine, the expected reaction of Andrea and the audience, that none of "this" is worth it, is difficult to accept. As Chocano concludes in her article for the LA Times, "What is unexpected here is that the triumph of virtue...doesn't feel entirely triumphant. It smacks of giving up" (para. 17). Yet, when they arrive at their hotel, Andrea does not follow Miranda in; she walks away. Her phone rings, and the name displayed, predictably, is "Miranda". With a smile, Andrea triumphantly throws it into a fountain, before making amends with her boyfriend, her friends, and even Emily. The female generational plot demands a moral climax in which the young postfeminist woman who expects career success learns her lesson not to become just another selfish feminist with an unsuccessful personal life. As a rising star, Hathaway fulfils this role perfectly. Only 24 when the film was released, she was previously most well-known for the "tween" film series The Princess Diaries (2001/2004), in which she plays Mia, an awkward teenage girl from San Francisco who learns she is meant to inherit the throne of a small European country. These films offer a postfeminist view of independence and agency (Mia chooses to accept the crown on her own, and only then does her "prince" arrive) in the midst of a girlish princess fantasy.9 Hathaway's personal life also seemed princess-like. with her Italian millionaire boyfriend and her burgeoning professional profile.10

Inevitably, Streep brings to the role of Miranda Priestly the intertextual references of the selfish feminist Joanna Kramer - the role for which she won her first Oscar. It is possible to read Miranda Priestly as Joanna Kramer 25 years later: in Kramer v. Kramer, after all, Joanna gets a job in the fashion industry. Furthermore, an important scene links the two characters, indicating how Streep's actorly stardom complicates the contemporary caricature of the selfish feminist. When they are in Paris, Andrea finds Miranda in her hotel in a state of undress, sitting forlornly on her couch after her third husband has left her. Without make-up, hair undone, and wearing a grey robe and reading glasses, she looks much older. Abjection is written on her body, fulfilling the image of the selfish feminist as "a singular, lonely and unhappy figure" (Tyler 185; emphasis added). Streep's performance, however, works to complicate this interpretation. Miranda says that she is not concerned for herself but for her daughters, who will take the loss hard, and who will have to endure the gossip. Streep delivers the line without irony, and sadness infuses her face, implying that Miranda does care about more than just herself. The scene is in such contrast to what we expect of Miranda that it stands out as an "actorly" moment that is invested with Streep's "quality" stardom. At the moment when Miranda most conspicuously fills the stereotype of the selfish feminist, then, Streep intervenes and infuses her with pathos.¹¹

In both the book and the film Andrea's rejection of Miranda's version of success is rewarded with a job in journalism. In the book, she sends a short story about her experiences at Runway to Seventeen magazine. The editor of Seventeen hates Miranda Priestly too, and says, "Someone needed to tell that woman to go fuck herself, and if it was you, well, then, hats off! That woman made my life a living hell for the year I worked there, and I never even had to exchange a single word with her" (426). She says she will take anything Andrea writes for the magazine. They are two young women bonded in postfeminist sisterhood against the old, lonely, crone-ish feminist. The film's ending is subtly, but also radically, different. Andrea has an interview with the male editor of The New York Mirror. He tells her that he called Runway for a reference and "received a fax from Miranda Priestly herself, saying that of all her assistants, you were her biggest disappointment. And, if I don't hire you, I'm an idiot". In this instance, the "selfish" feminist has acquired enough power and influence to compel a man into giving another woman a job - a triumph of selfish feminism that, to the surprise of Andrea and the audience alike, works to the benefit of the postfeminist woman.

Given the casting of Streep as Miranda, this denouement is, perhaps, not that much of a surprise. Later, Andrea makes brief eye contact with Miranda as she gets into her car, and Andrea waves. Miranda snubs her, and Andrea shakes her head in recognition laced with relief. The penultimate shot, before we see Andrea's obligatory confident walk through the streets of New York, is a close-up of Miranda in her car. Watching Andrea walk away, she appears pensive, but then a slow, wry smile appears on her face, and she lets out a small knowing laugh. Played by Streep and imbued with her star persona as a "quality" actor, the older feminist is not the young woman's enemy; Miranda seems to find some pride in Andrea's choice to go her own way. As much as it is clear that the film needs Andrea to make a decision not to be like Miranda, and to learn to prioritize relationships over ambition, it cannot help but give Miranda a final moment of respect because of Streep's star persona as the older. wiser, and more successful female actor. As the LA Times review suggests, the ending casts doubt on Andrea's status as the hero, and the film most definitely knows that Streep is the star. Through her quality stardom Streep subverts the image of the feminist "devil", making a fissure in the film's structuring of generational conflict and suggesting that postfeminism's insistence that women can now do whatever they want would not be possible without the selfish feminist who did whatever she wanted.

Conclusion

I hope that these initial examinations of postfeminist generationalism and female stardom might invite more scrutiny into "the ways in which we appropriate icons as they age and outgrow their initial purpose, and how icons weather changing cultural climates" (Roberts 102). Many of the female icons of 1970s Hollywood are being re-appropriated by contemporary Hollywood for postfeminist narratives that emphasize the impossibility of generating bonds amongst women outside of familial relationships, and which thus participate in the general cultural climate that understands "successful" femininity only in terms of a woman's relationships. This is particularly true in Monster-in-Law, in which Fonda's star persona is used to subordinate her to the example of the young postfeminist woman. I have argued, though, that Streep's performance in The Devil Wears Prada shows that stardom can still offer agency and authority to women in contemporary Hollywood; this, in turn, suggests that we need to further consider the ways that age, stardom, and the discourses of (post)feminism interact to confine

and, on occasion, expand the roles that women play in Hollywood films.

Acknowledgements

Many thanks go to Neil Ewen and the editor of this book for their comments and suggestions.

Notes

- 1. See Gillis and Munford.
- 2. See Perkins 239-42.
- 3. For more on "Hanoi Jane", see Kinney.
- 4. See Beltrán.
- 5. See Hicks.
- 6. See Dobnik.
- 7. A 1979 article in The New York Times parenthetically remarks that as a university student Meryl Streep "wrote funny feminist dramas" (see Gussow).
- 8. This open letter was organized by Equality Now in 2005.
- 9. The "girlish princess fantasy" is a key feature of other postfeminist texts. For an analysis of the ways in which the princess fantasy is utilized in the reality makeover show, see Brenda Weber's "Imperialist Projections: Manners, Makeovers, and Models of Nationality" (in this book).
- 10. Hathaway's relationship with Raffaello Follieri ended in 2008 when he was arrested on charges of fraud. In court, he blamed her Hollywood lifestyle for influencing his actions (see "The Envelope").
- 11. Unlike Fonda, Streep has largely kept her private life private, distancing the characters she plays from herself and her personal investments in feminism.

Works cited

- Beltrán, Mary. "The Hollywood Latina Body as Site of Social Struggle: Media Constructions of Stardom and Jennifer Lopez's 'cross-over butt'". Quarterly Review of Film and Video 19.1 (January 2002): 71-86.
- Chocano, Carina. "A comic Meryl Streep Brings a Stylishly Better-thanthe-Book Allure to Prada". The Los Angeles Times. June 30, 2006. http:// www.calendarlive.com/movies/reviews/cl-et-devil30jun30,0,7739063.story. [Accessed September 5, 2009].
- The Devil Wears Prada. Dir. David Frankel. 20th Century Fox, 2006.
- Dobnik, Verena. "Jane Fonda's Broadway Play Picketed by Vietnam Vets". Huffington Post. February 22, 2009. http://www.huffingtonpost.com/2009/02/ 22/jane-fondas-broadway-play_n_168897.html. [Accessed 30 August 30, 2009].
- Dodd, Alan, and Martin Fradley. "Jennifer Lopez, Romantic Comedy, and Contemporary Stardom". Falling In Love Again: Romantic Comedy in Contemporary Cinema. Eds. Stacey Abbott and Deborah Jermyn. London: IB Tauris, 2009. 190-207.

Dyer, Richard. Stars. 2nd edn. London: BFI, 1998.

"The Envelope". *The Los Angeles Times*. http://latimesblogs.latimes.com/thedishrag/2008/10/raffaello-folli.html. [Accessed September 30, 2009].

Gillis, Stacy, and Rebecca Munford. "Genealogies and Generations: The Politics and Praxis of Third Wave Feminism". *Women's History Review* 13.2 (2004): 165–81.

Gussow, Mel. "The Rising Star of Meryl Streep". *The New York Times*. February 4, 1979.

Haskell, Molly. "Finding Herself: The Everlasting Prime of an Acting Powerhouse Who Gracefully Eludes Definition Yet is Every Inch a Star". Film Comment (March–April 2008): 33–41.

Hicks, Heather J. "Hoodoo Economics: White Men's Work and Black Men's Magic in Contemporary American Film". *Camera Obscura* 18.2 (2003): 27–55.

Kinney, Katherine. "Hanoi Jane and Other Treasons: Women and the Editing of the 1960s". *Women's Studies* 32 (2003): 371–92.

McRobbie, Angela. *The Aftermath of Feminism: Gender, Culture, and Social Change*. London: SAGE, 2009.

Monster-in-Law. Dir. Robert Luketic. New Line, 2005.

Perkins, Tessa. "The Politics of 'Jane Fonda'". Stardom: Industry of Desire. Ed. Christine Gledhill. London: Routledge, 1991. 239–52.

Roberts, Chadwick. "The Politics of Farrah's Body: The Female Icon as Cultural Embodiment". *The Journal of Popular Culture* 37.1 (2003): 83–104.

Tyler, Imogen. "The Selfish Feminist". *Australian Feminist Studies* 22.53 (July 2007): 173–90.

Tasker, Yvonne, and Diane Negra, eds. *Interrogating Postfeminism: Gender and the Politics of Popular Culture*. London: Duke University Press, 2007.

Wearing, Sadie. "Subject of Rejuvenation: Aging in Postfeminist Culture". *Interrogating Postfeminism: Gender and the Politics of Popular Culture*. Ed. Yvonne Tasker, and Diane Negra. London: Duke University Press, 2007. 277–310.

Weisberger, Lauren. The Devil Wears Prada. New York: Anchor Books, 2003.

3

Alias: Quality Television and the New Woman Professional

Rosie White

The character of Sydney Bristow in Alias (Warner Brothers, 2001-06) offers a compelling representation of the female spy that both reflects and illuminates contemporary debates about the role of women in the professions. The cinematic production values of this spectacular series, together with its complex narrative arcs and stellar guest list, epitomize what has come to be known as American quality television.² As with earlier quality television series centred on female protagonists – such as Ally McBeal (Fox, 1997–2002) and Buffy the Vampire Slayer (Warner Brothers/UPN, 1997–2003) – Alias focuses on the uneasy relationship between women's professional ambitions and personal responsibilities. Like these earlier shows, Alias explores the profound inextricability of the professional and the familial/romantic, positioning the workplace as a space in which and through which the personal is worked upon. Exploring the ways in which emotional labour is tethered to professional employment, quality series such as Alias function - at one level - as etiquette guides for the (post)modern urban woman. In this respect, Alias does invite consideration alongside HBO's Sex and the City (1998-2004), in which the drama is based around the sexual practices and quandaries of four women with apparently limitless time and funds. Certainly, Carrie Bradshaw and friends have hours to spend planning, engaging in, and discussing their emotional and sexual lives. Their work lives, on the other hand, are barely visible. While in Alias the drama is set entirely around Sydney Bristow's career as a secret agent, the series - like Sex and the City – is characterized by its slick, glossy surface. Although Sydney is not overtly obsessed by fashion, the "undercover" sequences where she dresses in glamorous outfits and struts to a pumping soundtrack do mimic the fashion aesthetic which is more demonstrably operative in Sex and the City.3 Both series also privilege the emotional lives of

their protagonists: despite Sydney's spectacular ability to defend herself from the physical threats she encounters at work, it is the emotional trials which are shown to be most painful. As Elizabeth Barnes notes, Sydney's visible suffering "is the raison d'être of the show: this is a woman who takes on the pain of the world" (57). With its sustained focus on emotional drama, its continuous-serial storylines, and its exposition of familial/romantic conflicts, the show draws heavily on the heritage and conventions of soap opera. In the case of Alias, however, the soap opera is set within the workplace (which for Sydney includes hi-spec office space and exotic global missions), so that the narrative reflects upon shifts in the twenty-first-century workplace and women's roles within it. Sydney's emotional vulnerability thus resonates beyond the scope of the domestic or romantic narratives that have traditionally featured female protagonists on television. Angela McRobbie argues that popular accounts of the post-feminist working girl [sic] constitute a reconfiguration of normative femininity which is part of a wider process of gender re-stabilization in the light of recent shifts in employment and global economies:

The post-feminist masquerade exacts then on the part of the working girl a kind of compromise, she takes up her place in the labour market and she enjoys her sense of status as a working girl without going too far. She must retain a visible fragility and the displaying of a kind of conventional feminine vulnerability will ensure she remains desirable to men. (79)

This is a particular feature of the "new woman" on television; like Ally and Buffy, Sydney must suffer visibly. In this regard these series again follow the visual and narrative traditions of soap opera; viewers are offered privileged insights into private moments where Sydney is alone and distressed. Such narrative strategies bear comparison with earlier depictions of working women in films like *Presumed Innocent* (Alan J Pakula, 1990) and *Disclosure* (Barry Levinson, 1994), where the new woman was seen as "bad news" and thus as "deserv[ing] punishment and/or annihilation by the patriarchal system she so overtly transgresses" (Jones 297). The visible distress of Ally, Buffy, and Sydney represents a different version of such "punishment", which functions both to confirm their heterofemininity and to indicate the personal cost that they – as working women – will inevitably incur. While the alternative is seldom presented in any explicit sense, the implication is that women who follow a more traditional career route to marriage, family, and housekeeping

are less "conflicted" and more fulfilled. The finale of *Alias*, for example, gave Sydney a "happy" ending where she is suddenly depicted in an idyllic nuclear family setting, far from the world of work. Invariably, the model of femininity on which these depictions draw is that of an idealized white Western middle class: "White middle-class women, historically viewed as the cultural bearers of compassion and the producers of human feeling and family, are thus not so much reimagined in these shows as recontextualised" (Barnes 58).

These strategies in popular cinematic and televisual narratives regarding working women may be understood as part of an ongoing response to second wave feminism and to perceived shifts in the number of women entering the workplace at a professional or managerial level.⁴ Several critics have deployed the term "New Woman" to refer to representations of the working woman in late twentieth- and early twenty-first-century popular culture – not least because these accounts of women in the professions bear comparison with debates that took place in Britain and America a century earlier. Sarah Grand is credited with originally coining the term "New Woman" in an article for the 1894 North American Review, which noted "a modern discontent with the traditional stay-at-home life of marriage and motherhood deemed appropriate for middle-class women" (Gamble 283). It was taken up by journalists and authors (both pro- and anti-feminist) as part of a debate about the public role and sexual identity of middle-class white women at the fin de siècle. Like her sister the femme fatale, the New Woman marked shifts in gender roles that were taking place as the nineteenth century drew to a close and the twentieth century began; both terms, then, represent a nexus of contradictory discourses regarding gender, sexuality, race, and class. In the 1990s a number of scholars working in film studies identified comparable shifts in screen portrayals of working women. Yvonne Tasker's Working Girls: Gender and Sexuality in Popular Cinema (1998) reflected on the sexualization of the working woman. Amelia Jones argued that in the "new woman's films" of the 1980s and 1990s career women are caricatured and punished; she proposed that films such as Working Girl (Mike Nichols, 1988) and Presumed Innocent may be understood as "structured by what Alice Jardine has called 'male paranoia'" even as they offer apparently positive accounts of women in the workplace (297). Hilary Radner examined Sarah Connor from Terminator 2: Judgement Day (James Cameron, 1991) and Marge Gunderson from Fargo (Joel Coen, 1996) as examples of how the female body has been transformed in its cinematic representations.⁵ Work such as this mapped evident changes in popular depictions of working

women in the late twentieth century, while noting how such changes may be seen as the latest in a series of modifications that rarely serve women well. Inevitably, representations of new woman professionals in film and high-end Hollywood action series such as *Alias* comment on late Western capitalism and the continuing evolution of white-collar working practices, such as the demands of the New Economy.

The term "New Economy" refers to the exponential expansion of a global economic system towards the end of the twentieth century an expansion made possible by electronic capitalism and the increasing dominance within Western economies of information, computer technologies, and telecommunications (ICT). For some, the putative work practices of the New Economy are regarded as potentially liberating, in that they enable employees to choose where and when they work, while providing a flexible and market-responsive pool of labour (Takacs 148). Certainly, the New Economy is often seen as a feminized workplace, privileging communication skills and white-collar forms of labour. In theory, ICT could allow women to work from home, to combine childcare and a professional career, to "have it all". In reality, however, it has not fulfilled its egalitarian potential: as Stanworth writes, "ICT-based work physically and contractually outside organisational boundaries is often isolated and exploitative, for women especially where skills are low, easily replaceable or undervalued" (21).6 Sydney Bristow and her sister professionals in mainstream Hollywood cinema and television do work in computerized environments, but they are not an underprivileged, out-sourced workforce. Rather, they represent a recent variation on Hollywood representations of the American white middle classes as over-achieving professionals. The phenomenon of the over-achieving professional appeared on American television just as it surfaced in the American corporate culture of the 1990s, depicting working lives of extreme dedication, long hours, and superhuman ability:

In the supermom fantasies of TV and the mommy track proposals of corporate America, what remains enshrined is our country's craven, hypercompetitive yuppie work ethic. Babies and parents are supposed to work around these increasingly preposterous norms of what constitutes adequate job performance.

(Douglas 282)

The "mommy track" was a media term which emerged in the 1990s, referring to American corporations' proposal that "mothers should be on a separate – and unequal – career track that gives them more flexible

hours in exchange for no promotions, no challenging assignments, less autonomy, and no raises" (Douglas 282). Takacs, Stanworth, Perrons, and Douglas indicate the contradictory and conflicted terrain of such white-collar work, particularly for women who choose to have children; television fictions which address the New Economy have the potential to expose that terrain in ways which fuel the narrative drama and inspire external debate.

ER (NBC, 1994–2009) has repeatedly exposed the difficulty of maintaining a career as a professional medic and raising a family, particularly through storylines involving Abby Lockhart (Maura Tierney). While ER may favour a more realist account of professional life – fuelling its drama with many accounts of its characters' chaotic personal lives outside the Chicago hospital – the action-adventure style of Alias lends a fantastic bent to the depiction of espionage as professional occupation. *Alias's* Sydney Bristow is consequently a fantasy of the professional superwoman, and, by Season Five, a "supermom". In this way, Sydney Bristow is an extreme version of such over-achieving fantasies; the series continually reveals that she has no life outside the agencies she works for, as her friends and family are either working for secret agencies or are inadvertently swept up in the spying game. In her essay "Why Sydney has no social life", Jody Lynn Nye enumerates the commitments and trainno social life", Jody Lynn Nye enumerates the commitments and training that actually being Sydney would involve, producing a convincing argument regarding the unfeasibility of her workload. Sydney Bristow is a mathematical and physical impossibility; her expertise in almost every field, her language skills, her physical prowess, and her infallible efficiency make her a parody of over-achievement. Sydney may thus be understood both as a fantasy of the superhuman professional and as an ironic account of the extreme demands of professional labour in the twenty-first century.

In this sense, *Alias* and series like it comment upon a failure of second wave feminism and mainstream responses to it, as they comment upon the *lack* of change in working practices across the professional sphere. What Sydney Bristow tells us is that women may have a position in the professional workplace but can sustain it only by being more driven, more unassailably efficient than their colleagues. She also tells us that the workplace remains unfailingly masculine in outlook and organization. Sydney and her sisters in quality television drama represent the privileged middle-class professional. They are separate from the masses, from the often unseen and undifferentiated "ordinary" women who exist around them (Radner 5). Slim, predominantly white, immaculately presented, and committed to their jobs, they embody professional

efficiency. Female characters in ensemble dramas such as *Without a Trace* (CBS, 2002–), *CSI Miami* (CBS, 2002–), *CSI New York* (CBS, 2004–), and *Grey's Anatomy* (ABC, 2005–) are subsumed by their work, matching their male colleagues' dedication, focus, and long hours. Like their male colleagues these working women are rarely allowed successful relationships or functional family lives. Where personal lives intrude on the work of the professional team – whether familial or romantic – they are most often shown to be problematic, a cause of disruption in the workplace and thus likely to produce further drama. The conflict between personal and professional lives is sometimes a storyline for male characters, but it more often becomes a women's issue, involving problems with childcare, ex-partners, or inadvisable liaisons.

Women in the professions have had a chequered history on screen; as characters who combine femininity and authority they are always-already ambiguous figures, contradicting the traditional formation of femininity as powerless and passive. Amelia Jones describes how these women are punished in mainstream Hollywood cinema, citing examples such as *Presumed Innocent*, *Working Girl*, and *Fatal Attraction* (Adrian Lyne, 1987):

The extraordinary lengths to which [these films] go to destroy or close down female sexuality and professional independence indicates precisely that there is a real threat perceived in the new woman – in her destabilization of patriarchal economies of labor and relations of sexual difference. (299)

Professional women on television tend to be compromised by problems in their personal life; in Sydney's case, the threat of her professional ability is also contained through hyperbole and fetishization. Sydney Bristow is one of the most exaggerated accounts of such femininity on the small screen; she is unfailingly efficient, impeccably glamorous, and largely impervious to human failings, such as envy, anger, or exhaustion. Sydney is clearly an aspirational figure, a hyperreal account of what women in the professions should be, could be, or would want to be. This idealized figure also inadvertently indicates the costs of Sydney's extraordinary life, and these costs are specifically those of a masculine economy, thus giving the lie to any notion of the New Economy as liberating or indeed feminized.

Sydney at home and at work is unfailingly caught within an economy of power, hierarchy, and exchange. As Irigaray noted in "Women on the Market", her 1977 account of the masculine economy, "The work

force is always assumed to be masculine, and 'products' are objects to be used, objects of transaction among men alone" (800). Alias shows us that little has changed in the last 30 years. Many of the intricate plotlines centre on Sydney herself as a desirable asset; not just in professional and sexual terms but literally, as a commodity within the secret world she inhabits. In "Full Disclosure" (3.11) Sydney's eggs are harvested by acolytes of Rambaldi who think she is the "chosen one",7 while in "There's Only One Sydney Bristow" (5.12), the enemy agency is seeking to acquire a sample of Sydney's DNA in order to replicate her appearance. Sydney's unique chemistry has become part of the trade in information which the secret agencies compete for – and despite the role of her mother, Irina Derevko (who in one storyline is symbolically referred to as "The Man") – this is an unequivocally masculine environment of trade between men, where Sydney is an asset but never a director. The Dereyko sisters intervene in this masculine trade – as does CIA director Hayden Chase (Angela Bassett) – but only as, respectively, demonized or marginal figures.8

As in her professional life, in her personal and familial relationships Sydney is framed by masculine economies. Despite a tortured relationship with her father, Jack Bristow, he is the central figure in her life, and Arvin Sloane's claims to be her (other) father only make Sydney's identification with a masculine economy more evident. Jack Bristow is Sydney's creator as well as her father; as the manager of "Project Christmas", a secret scheme to train and develop young children as super-agents, Jack is revealed to have brought his daughter into the field as a child, without her consent.9 A successful woman in a man's world, Sydney is an exceptional figure – her female co-stars are either less able than Sydney or are shown to be working for the wrong side - and Sydney's exceptionality is taken further than the Project Christmas revelation; the Milo Rambaldi storyline posits Sydney as part of a wider plan for the salvation or destruction of the world (Ruditus 79–94). Sydney is, quite literally, a superwoman: a chosen one, like Buffy the Vampire Slayer, who is predestined to have a significant role in events. Her abilities are, however, at the service of the CIA and are thus part of a masculine bureaucracy in which women are present but have little power. Sydney, as Project Christmas and the Rambaldi prophecies imply, is man-made.

While Sydney is framed by a masculine economy in her professional and private life, *Alias* occasionally reveals the costs that such an economy incurs. Sydney is rarely at rest. She lives to work, and the intensity of this work is repeatedly foregrounded in the depiction of her espionage

assignments, characterized by rapid editing and pumping soundtracks. This is epitomized by the Season Four credit sequence, which was cut to the rhythm of the theme tune. This sequence is organized around images of Sydney in disguise and in various fetishistic costumes - costumes which she is required to wear in the course of her work. In the DVD commentary for the opening episode of the season, Jennifer Garner comments that the credit sequence is a "bit much", while JJ Abrams states that he cannot think of a better opening than this quick-cut sequence of 70 images in 30 seconds. What the new credit sequence capitalizes on is the fantasy role-play of Sydney's professional roles: this is an accomplished actor playing a professional woman playing a range of feminine clichés. The multiple images underline Sydney's exchangeability; she is "everywoman" and all possible fantasies: "just as a commodity has no mirror it can use to reflect itself, so woman serves as reflection, as image of and for man, but lacks specific qualities of her own. Her value-invested form amounts to what man inscribes in and on its matter: that is, her body" (Irigaray, 2004, 808-09). Yes, there are a few less sexual images in the sequence (particularly, perhaps, the beekeeper's outfit?) but as a whole the sequence reveals the economy in which both Jennifer Garner and Sydney Bristow work one in which women are most valued as sexually visible figures. 10 None of the rapidly edited shots show Sydney in her mundane office suits or at home; the visual and aural onslaught of fetishized images and theme music compound the heightened reality of Sydney's assignments and present them as the "real" focus of the series. As if to confirm this impression, the first episode of Season Four opens with Sydney on assignment, revealingly dressed in a blonde wig and baby-doll lingerie to seduce a chemist in order to obtain an isotope. In this way, Sydney Bristow's professional labour is clearly aligned with sex work (Tasker, 1998).

Such images conform to elements of the "male gaze" as it is conceptualized by Laura Mulvey; Sydney is presented to-be-looked-at, in scopophilic terms, with fetishistic costumes and props. The aspect of Mulvey's argument Sydney confounds in these sequences is the fast editing and speed of movement; the Hollywood stars Mulvey described in her famous essay were largely static figures, composed and carefully presented for the camera. While Garner is carefully presented she is rarely static, and her fleshless, muscular physique suggests athletic movement rather than static femininity. *Alias*, like much action cinema and television, has a hyperactive aesthetic but here that aesthetic is symbolic of the organizations that employ Sydney and her peers. In its attempt to make white-collar labour sexy, *Alias* depicts office work on fast-forward.

This is most graphically embodied by Sydney's espionage assignments, during which Sydney is constantly on the move, physically and geographically. Fast-paced, high-octane action sequences are accompanied by fast-paced, high-octane music, which was played on the set during the filming to ensure that the frequent shots of Garner "strutting" towards some action were kept to a beat. Missions inevitably involve Sydney going undercover in glamorous locations, referencing the jetset tradition of Bondian espionage and offering a narrative reason for Garner to be dressed in body-skimming outfits. 11 This hyperactive aesthetic, however, might also be read as a parody of white-collar labour in the twenty-first century.

In the first season, Sydney's exceptional work ethic is the subject of comment within the series:

WILL TIPPIN: It doesn't make sense any more. Nobody works as hard as you. I mean, it's not like you're a brain surgeon getting called in the middle of the night to save a life. I mean, these are bankruptcies. And how much are they paying you to live like this?

SYDNEY: Not enough.

WILL: I'm going to actually call them and quit for you right now.

SYDNEY: I can't quit my job.

WILL: Why? Why - because you just have to be, like, the greatest banker?

SYDNEY: Because it's my job. I want to do it well.

WILL: Okay. Congratulations. Me too. But at what cost?

SYDNEY: Look, to you my job might seem pointless and stupid, but it's not. It's far from pointless and if you knew what I dealt with every day you might thank me for doing my job so well.

WILL: What the hell are you talking about?

SYDNEY: Nothing. I'm going to work.

(1.10)

This dialogue makes explicit the nonsense of Sydney's cover; her alias as a college student and banker are not feasible within the terms of the series itself: Will merely voices what is self-evident. This lack of fit between the roles Sydney plays at work and in her private life offers a critique of the demands made upon professional workers; it is an account of work-life imbalance in a postmodern workplace where the employee is constantly on call via email, mobile phone, or Blackberry. Will's reference to brain surgery makes the connection between Alias's fictive account of professional employment (espionage) and other professions. Sydney has entered a workplace where a personal life is a luxury

she cannot afford. Most tellingly, in the pilot episode Sydney's fiancé is assassinated by her employers, SD6, thus precipitating her discovery that SD6 is not a secret arm of the CIA but the very enemy she thought she was fighting against.

What such narrative details make evident is the cost of the new economy. By Season Four Sydney's personal life has been subsumed by her work. Sydney no longer lives in a shared graduate house in a leafy suburb, but a slick urban apartment. She invites her half-sister, Nadia, to live with her, and life outside APO is barely distinguishable from her life inside the agency, as she socializes only with colleagues. The plotlines of the series marry Sydney's family and sexual life with that of her profession: her mother, father, aunts, and sister all work in the field, and her romantic interest, Michael Vaughn, is her CIA handler when she is a double agent in SD6. Most of the major protagonists in the series have family within secret agencies and – in the case of Vaughn. Sydney, and Nadia – are fascinated by the mysteries around their parents. The internecine familial plots in Alias would appear to open it up to psychoanalytic interpretation, yet the extreme nature of the family relationships are, like the account of professional life, a hyperreal pastiche of emotional dysfunction. Sydney's mother Irina Derevko is first thought to be dead, then is found to be alive but working as an enemy agent who eventually takes out a contract on her daughter's life. 12 Sydney's father, Jack Bristow, has Irina killed in order to save Sydney but it later emerges that a genetic duplicate of Irina was killed in her place, so she is still alive but being kept prisoner and tortured by her sister, Elena Derevko. Towards the end of the fourth season Nadia and Sydney rescue and release their mother, Irina, with Jack Bristow's help. The family narratives of Alias grow ever more bizarre as the series progresses, so that by the fourth season Sydney's private and professional worlds have effectively combined.

Despite Sydney's professional abilities she is unable to function outside the workplace and this symbolic fault demonstrates the cost of the masculine economy. This is not merely a masculine economy of emotion where "male power in *Alias* is associated with lack of emotion ... the ability to keep one's vulnerabilities concealed" (Wright 203). It is also a privileging of masculine forms of power, (self) control, and cultural capital. Despite the allegiance of television series such as *Alias* to the style of soap opera – by including family drama in the scenario, together with a romantic narrative – a form which has traditionally been seen as privileging feminine concerns, these dramas inevitably return to the father as a source of epistemological authority. Ack Bristow is Sydney's prime source of truth and knowledge, a man who sacrifices his own life in

the final episode to save his daughter and the world. Mothers, however, are shown to be untrustworthy. Irina, Katya, and Elena Derevko in Alias occupy ambiguous moral ground during the series, but by the finale their motives are exposed as greedy and self-serving. Yet these older women are themselves subsumed within a masculine economy: they are women who have conformed to the demands of the professional sphere rather than shifting the terms on which it operates. In this sense the Derevko sisters do not represent a postfeminist aesthetic, but instead gesture towards the continuing politics of a pre-feminist work environment. While this is a depressingly predictable binary conclusion it also exposes the limits of any egalitarian politics that fails to examine the terms of that binary. Legislative interventions for "equality" in the workplace have failed to address the basis of work itself as a gendered field: historically, "work" is what men do and women's work has tended to be denoted as separate (Irigaray, 1993, 84-86). Women's work in the home and childcare is designated as amateur and thus undeserving of financial support or reward. 15 In these terms, Alias offers a fractured and fragmented reflection upon battles lost following the second wave. More specifically, Sydney's mother and her aunts represent that generation, and also a potential (and feared) future for the new woman professional. These are women who have taken the "equality" agenda to its logical conclusion by assuming the most derogated aspects of masculinity and femininity. Their betrayals and manipulations are presented as a contrast to the moral and ethical figures of Sydney and Jack Bristow. 16 Because such quality television privileges a masculine economy - and a New Economy that is as damaging for men as it is for women in the workplace - older female characters reveal the limited options open to professional women when they are no longer young. If Sydney could be proposed as representing an "empowered" new woman, then her older counterparts give the lie to any assumption that power relations have significantly shifted. Alias thus offers its viewers an account of the new woman professional as a monstrous figure, but also represents the battles yet to be won.

Notes

- 1. An earlier version of this essay appeared in White, 126–46.
- For a sustained analysis of "quality television", see Jancovich and Lyons' Quality Popular Television (2003).
- 3. One of the *Alias* fan websites features an editorial called "The Fashion Assassin", which wittily critiques Sydney Bristow's outfits episode by episode for the first two seasons of the show. See http://www.vartanho.com/fa/1x01. html>. [Accessed May 5, 2009].

- 4. As sources such as the Fawcett Society website note, this perceived influx of women is not statistically proven; for example, in Britain: "Women working full-time earn, on average, 17% less an hour than men working full-time. For women working part-time the gap is 36% an hour. Two-fifths of women in employment in Britain work part-time, compared with 11% of men. 11% of directors of the UK's top 100 companies are women". See http://www.fawcettsociety.org.uk/index.asp?PageID=459. [Accessed April 9, 2009].
- 5. See Radner.
- 6. See also Perrons 65-93.
- 7. See Angelini 30–31.
- 8. While the five main leads in *Alias* all male apart from Jennifer Garner performed in 105 episodes, Lena Olin as Irina Derevko (Sydney's mother) was in 27 episodes, Isabella Rossellini and Sonia Braga, as Yekaterina (Katya) and Elena Derevko (Sydney's aunts), were in five episodes each, and Angela Bassett as CIA director Hayden Chase was in four episodes.
- 9. See Angelini 31–34.
- 10. See also Finding and MacLachlan 75-77.
- 11. Part of the action-espionage genre, the Bond franchise is, perhaps, a useful point of reference when analysing Sydney's status as a female action hero and spy. For an examination of the roles accorded to women in Bond films, see Lisa Funnell's "Negotiating Shifts in Feminism: The 'Bad' Girls of James Bond" (in this book).
- 12. The murderous mother is an increasingly frequent feature of quality television, making appearances in *The Sopranos* (1999–2007) and *Prison Break* (2005–09) See Anna Gething's "'A Caligula-like despot': Matriarchal Tyranny in *The Sopranos*" (in this book).
- 13. See Irigaray "When the Goods Get Together" and "Women on the Market".
- 14. See Modleski 85-109 and Fiske 179-97.
- 15. See campaigns in the 1970s and in recent years for Wages for Housework, and also Ann Oakley's groundbreaking study *Women's Work: The Housewife, Past and Present* (1974).
- 16. For a resonant analysis of this intergenerational tension in the context of the postfeminist chick flick, see Shelley Cobb's chapter in this collection.

Works cited

Abbott, S., and Brown, S. (eds.) *Investigating Alias: Secrets and Spies*. London: I B Tauris, 2007.

Alias. Warner Bros, 2001-2006.

- 1.10. "Spirit". Dir. Jack Bender. December 16, 2001.
- 3.11. "Full Disclosure". Dir. Lawrence Trilling. January 11, 2004.
- 5.12. "There's Only One Sydney Bristow". Dir. Robert M. Williams Jr. April 26, 2006.

Angelini, S. "Endoscopic Spies: Mapping the Internal Landscape of Alias". Investigating Alias: Secrets and Spies. Ed. S. Abbott, and S. Brown. London: I B Tauris, 2007. 27–39.

- Barnes, E. "The New Hero: Women, Humanism and Violence in Alias and Buffy the Vampire Slaver". Investigating Alias: Secrets and Spies. Ed. S. Abbott, and S. Brown, London: I B Tauris, 2007, 57-72.
- Douglas, S. J. Where the Girls Are: Growing Up Female With the Mass Media, London: Penguin, 1994.
- Finding, D., and A. MacLachlan. "Aliases, Alienation and Agency: The Physical Integrity of Sydney Bristow". Investigating Alias: Secrets and Spics. Ed. S. Abbott, and S. Brown. London: I B Tauris. 2007. 73-86.
- Fiske, I. Television Culture, London: Routledge, 1987.
- Gamble, S., ed. The Routledge Companion to Feminism and Postfeminism. London: Routledge, 2001.
- Irigaray, L. "When the Goods Get Together". New French Feminisms: An Anthology. Ed. E. Marks, and I. de Courtivron. Hemel Hempstead: Harvester, 1981, 99–110.
- . Je, Tu, Nous: Toward a Culture of Difference. London: Routledge, 1993. ----. "Women on the Market". Literary Theory: An Anthology. 2nd edn. Ed. J. Rivkin, and M. Ryan. Oxford: WileyBlackwell, 2004, 799–811.
- Jancovich, M., and J. Lvons, eds. Quality Popular Television, London: BFI, 2003.
- Jones, A. "'She Was Bad News': Male Paranoia and the Contemporary New Woman". Camera Obscura 25-26 (January-May 1991): 297-320.
- Ledger, S. The New Woman: Fiction and Feminism at the Fin de Siècle, Manchester: Manchester University Press, 1997.
- McRobbie, A. The Aftermath of Feminism: Gender, Culture and Social Change. London: Sage, 2009.
- Modleski, T. Loving With A Vengeance: Mass-Produced Fantasies for Women. London: Methuen, 1984.
- Mulvey, L. Visual and Other Pleasures. London and Basingstoke: Macmillan, 1989. Nye, J. L. "Why Sydney Has No Social Life". Alias Assumed: Sex, Lies and SD-6. Ed. K. Weisman with G. Yeffeth. Dallas: Benbella Books, 2005. 89–100.
- Perrons, D. "The New Economy and the Work-Life Balance: Conceptual Explorations and a Case Study of New Media". Gender, Work and Organization 10.1 (January 2003): 65-93.
- Radner, H. Shopping Around: Feminine Culture and the Pursuit of Pleasure. London: Routledge, 1995.
- -----. "New Hollywood's New Women: Murder in Mind Sarah and Margie". Contemporary Hollywood Cinema. Ed. S. Neale, and M. Smith. London: Routledge, 1998. 247-61.
- Ruditis, P. Alias: Authorized Personnel Only. New York: Simon and Schuster. 2005. Stanworth, C. "Women and Work in the Information Age". Gender, Work and
- Organization 7.1 (January 2000): 20-32.
- Takacs, S. "Speculations on a New Economy: La Femme Nikita, The Series". Cultural Critique 61 (Fall 2005): 148-85.
- Tasker, Y. Working Girls: Gender and Sexuality in Popular Cinema. London: Routledge, 1998.
- White, R. Violent Femmes: Women as Spies in Popular Culture. London: Routledge, 2007.
- Wright, L. A. "Only Ourselves to Blame". Alias Assumed: Sex, Lies and SD-6. Ed. K. Weisman with G. Yeffeth. Dallas, Texas: Benbella Books, 2005, 199–212.

4

The Horrors of Home: Feminism and Femininity in the Suburban Gothic

Melanie Waters

In The Aftermath of Feminism (2009), Angela McRobbie draws on a constellation of imagery that has become peculiarly prevalent in recent feminist scholarship. In order to describe the variety of "postfeminist" phenomena she identifies, McRobbie takes repeated recourse to the notion of a phantasmatic feminism that haunts popular culture. While this "ghost of feminism" (22) presents itself as a "hideous spectre of what feminism once was", it bears little correspondence to any "real" feminism and instead adopts as the basis of its spectral visage the cartoonish features that are so frequently, if erroneously, ascribed to second wave feminists. In this way, explains McRobbie, feminism is fantastically and insistently (re)configured as a "monstrous ugliness" which sends "shudders of horror down the spines of young women today, as a kind of deterrent" (1). Evocative and striking, these macabre formulations of feminism's "ghostly" status have been an increasingly common point of reference in feminist discourses since the 1990s. From Avery Gordon's work on psychoanalysis to Terry Castle's critique of queer representation in *The Apparitional Lesbian* (1993), the spectral metaphor has been deployed as a means of symbolizing and interrogating women's historical (in)visibility and cultural inheritance. Given the centrality of these issues to contemporary debates about postfeminism, it is perhaps no surprise that the apparitional trope has been invoked with growing regularity in the twenty-first century. In Female Chauvinist Pigs (2006), for example, Ariel Levy rationalizes the perceived reluctance of young women to articulate "feminist" anxieties through reference to the phantom of 1970s radical feminism: "nobody", she proposes, "wants to be the frump at the back of the room anymore, the ghost of women past. It's just not cool" (92). Karen Boyle, likewise, points to the ways

in which postfeminism has endeavoured to "banish the spectre of the radical...feminist and her analysis of patriarchy" from its accounts of popular culture (185), while Natasha Walter – in a contrary vein – advises "this generation of feminists" to work on exorcizing the second wave "spectre of political correctness" from its rhetoric in order to enhance the credibility of feminism in the new millennium (4).

For a number of scholars, then, the concept of haunting is a convenient and apposite metaphor for the state of feminist politics in the twenty-first century. Crystallizing anxieties about the legacy of feminism and its current relevance to women, it functions not only as a sign of loss, but also as a site at which losses can be acknowledged, recuperated, or worked through. As Victoria Hesford reflects:

Haunting is intrinsic to every dominant social and political order because it is a sign of what has been forcibly expunged or evacuated from that order: the other that threatened to disrupt the emergent hegemony. (229)

As well as registering collective concerns about the relationship between power and oppression, the use of spectral metaphors in contemporary feminist discourses productively focalizes particular strategies in popular culture, and in feminist readings of it. Perhaps the most prevalent of these is the staging of tension or conflict between different generations of women. As Shelley Cobb explains elsewhere in this book, recent chick flicks like The Devil Wears Prada (2006) and Monster-in-Law (2005) often pit older career women against their younger counterparts. In such scenarios, the older woman is prevailingly situated as a figure who has made sacrifices – usually hard, personal sacrifices – in order to achieve professional success. "Learning" from this example, the younger woman, when faced with similar choices, refuses to prioritize her career ahead of her domestic obligations, seeking instead to find a compromise in which the personal and professional can exist comfortably alongside one another. This kind of postfeminist manoeuvring is equally evident in television shows like Damages (2007-) and Ugly Betty (2006-10), in which the female protagonists are frequently required to choose between their loyalty to family and friends, and the fulfilment of their career ambitions. In each of these scenarios, then, the older woman tends to "ghost" for second wave feminism - emblematizing through her professional achievements and domestic impoverishment the sacrifices by which the struggle for equality was necessarily striated.

Just as the notion of a phantasmatic feminism illuminates the ways in which postfeminist culture attempts to negotiate the complex legacy of the second wave, the concept of spectral femininity might perhaps shed new light on popular formulations of female identities and the relationship of these identities to the past. In this chapter, then, the spectral metaphor functions as a starting point for investigating the representation of feminine identities in contemporary female-centred television fictions. Focusing on texts that foreground the tensions between women, maternity, and domesticity, I analyse the extent to which mainstream representations of gender are haunted by anxieties about femininity, whether in terms of its perceived over-abundance or lack, its desirability or sustainability, its authenticity or fraudulence, or, of course, its relationship to the feminist subject. With specific reference to The Feminine Mystique (1963), I excavate the dark Gothicism that inflects Betty Friedan's account of the "happy housewife heroine" and show how it continues to inform contemporary representations of domestic femininity, from the nostalgic stylings of primetime shows like Desperate Housewives (2004-) and Mad Men (2007-) to the suburban supernaturalism of Medium (2005-) and Ghost Whisperer (2005-10). While I am intrigued by the persistence with which revived versions of the "happy housewife heroine" continue to haunt mainstream portrayals of feminine identity, I am more explicitly interested in how the idea of a "spectral femininity" – with all its eerie resonances – might speak to the prevailing uncanniness of domestic feminine identities, as they are rendered in contemporary American programming and twentieth-century feminist theory alike.

Uncanny femininities?

As it is identified by Freud in his 1919 essay, the uncanny, or *unheimlich*, is an order of experience that is expressly "related to what is frightening – to what arouses dread and horror". More explicitly, though, it is a special subcategory of the frightening in which "the frightening element can be shown to be something repressed which *recurs*.... something which is familiar and old-established in the mind and which has become alienated from it only through the process of repression". The uncanny, then, registers the defamiliarization of the familiar: it is the point at which what the individual has tried to evacuate from his or her conscious mind re-materializes, horribly, in a form that is experienced as strange and threatening. Although Freud struggles to define the uncanny in any precise or categorical sense, he does trace

its threatening elements to two particular sources: the fear of repetition and the fear of castration. Castration anxiety, of course, occupies a key position in the Freudian imaginary; when the infantile male becomes aware of the anatomical differences between the sexes, he assumes that the female has already been castrated, and that he himself will suffer the same fate at the hands of the father, as a punishment for desiring his mother. Freud's tethering of the uncanny to castration anxiety – which is, necessarily, a masculine concern – might thus imply that women are unlikely to experience its full force. As Tania Modleski asks in *Lov*ing with a Vengeance (2008), however, if women are less attuned to the sensation of the uncanny, then how can we account for its prevalence within the *female* Gothic, specifically? In response to this question, she offers an alternative formulation of the uncanny, in which it is recast "as part[s] of a deeper fear – fear of never developing a sense of autonomy and separateness from the mother". Given the female's anatomical similarity to her mother, and the consequent difficulty of establishing an identity that is distinct from hers, the fear of being forever "lost in the mother" is one to which women are acutely sensitive. This approach to the uncanny helps to make sense of its prevalence within the female Gothic, which – in Modleski's terms – performs the reassuring function of convincing "women that they are not their mothers" (22).

While it is left to Modleski to account for women's experience of the uncanny, Freud insists on their centrality to the generation of uncanny effects. The womb, as Freud points out, is the ultimate uncanny venue, having "originally nothing terrifying about it at all", but becoming unfamiliar through the processes of repression. Indeed, as Barbara Creed reflects in *The Monstrous Feminine* (1993), what Freud refers to as "the phantasy... of intra-uterine existence" provides the architectural blueprint for the dark, enclosed spaces that constitute the preferred venue of Gothic horror (367). As it is connected to the "feminine" space of the womb, so the uncanny is inextricably yoked to the equally feminized space of the home; indeed, amongst the many definitions that Freud cites in the etymology of *heimlich* and *unheimlich* with which he opens his essay, "homely" and "unhomely" are the most markedly recurrent. If Freudian theory sometimes blurs the boundaries between the female body and the home, then this symbolic convergence is also discernible in postfeminist discourses, where, for Negra, "new rhetorics of domestic practice symbolically extend the female body to include the home...[redressing] the crisis over the female body, subject as it is to intense, deeply anxious, and often conflicting discourses of management, regulation, and surveillance" (130). In this way, the homemaker,

with her special relationship to maternity and the home, emerges as a logical locus for the contestation of anxieties about the uncanny nature of femininity and the threats it might conceal.

From Plato to Luce Irigaray, theories of femininity have tended to intersect – though not necessarily intentionally – with elements of the uncanny. Within feminist thought in particular, scholars have often explored the artificial status of femininity in ways that imply its uncanniness. Identified by Friedan as a post-war media myth, the "happy housewife heroine" is the idealized incarnation of the suburbanite homemaker: "healthy, beautiful, educated, concerned only about her husband, her children, her home", she was imaginatively embedded as the "cherished and self-perpetuating core of ... American culture" from the late 1940s to the early 1960s, though her influence is still in clear evidence today (15-16). According to Friedan, the "happy housewife heroine" is the fictional embodiment of the post-war "feminine mystique", which "makes certain concrete, finite, domestic aspects of feminine existence – as it was lived by women whose lives were confined, by necessity, to cooking, cleaning, washing, bearing children - into a religion, a pattern by which all women must now live or deny their femininity" (39). Femininity, then, is understood as a mechanical state that estranges women from themselves. The woman who seeks to conform to the impossible model of the "happy housewife heroine" is thus regarded by Friedan as turning away "from individual identity" in order to become "an anonymous biological robot in a docile mass" (267). Associated with inanimate artefacts, and imitating the awkward contours of an "unreal, fixed [and] perfect" femininity, women begin to resemble the frightening automata to which Freud makes reference in "The Uncanny"; denied independence, women appear as "living dolls" who look as if they are "real" and autonomous, while they are really only agents through which a fiction of femininity is transmitted (547). With its unrelenting equation of "perfect" femininity to the fulfil-

With its unrelenting equation of "perfect" femininity to the fulfilment of domestic and familial accomplishments, the feminine mystique aggressively restricts women's sphere of influence to the home and its inhabitants. In this way, Friedan argues, it generates a situation in which the housewife is valorized as the expert guardian of the home, but is simultaneously recognized as a danger within that home. Narrowly focused on her role as domestic custodian, the housewife is endowed with the potential to damage or destabilize the family unit through her "excessive" attempts to supervise, dominate, protect, and maintain it (167–79). This apparent antithesis continues to inform representations of women and the domestic, and is key to understanding the

ways in which the relationship between femininity, agency, and threat is configured within the terms of popular culture.

The creative configuration of domestic feminine identities as uncanny has been a long-standing, if under-theorized, strategy within popular culture. Across different historical periods, different media, and different genres, the home has functioned consistently as a site at which anxieties about women – and about their capacity to nurture and harm, to charm and deceive – have been dynamically contested. Even in the 1950s, when the ideology of the "happy housewife heroine" was at its strongest, domestic femininity was routinely configured as uncanny in popular American drama. Marked by its speculative engagement with issues relating to technology, invasion, and conformity that reflect its Cold War context, The Twilight Zone (1959–64) is enduringly concerned with the home and its vulnerability to malevolent forces. Women are often placed at the heart of these dramas, as both guardians of domestic stability and threats to it.¹ This is exemplified with characteristic eeriness in "Long Distance Call" (1961), an episode which takes place entirely within the space of the home. In the opening scene, a boy named Billy receives the gift of a toy telephone from his doting, widowed, grandmother. After she dies (in the family home), he continues to "talk to her" on the phone - an activity that his parents initially dismiss as a childish fantasy. When the boy throws himself in front of a moving car, however, his mother – the paradigm of protective maternity – starts to become suspicious. Suspecting the dead grandmother's (supernatural) involvement in Billy's strange behaviour, she grows angry and tries to shake an explanation out of him. Later, when she hears him "talking" on the phone, she pulls it from him, only to drop it when she hears what she thinks is breathing on the end of the line. Billy, meanwhile, runs downstairs and tries to drown himself in the fish pond. It is only after Billy's father "speaks" to his dead mother through the toy telephone, pleading with her for the life of his son, that the doctors are able to revive him.

From the outset, the grandmother's aggressive dedication to Billy is placed in the register of threat; it is repeatedly shown to disrupt the "natural" bond between the boy and his mother and causes conflict between Billy's parents. However, because the threat is wrapped up in the cuddly guise of domestic femininity, it is repeatedly mistaken for "ordinary" – if particularly intense – grandmotherly devotion. As Billy's father reassures his wife: "No matter what she did, she did it out of love". This is, perhaps, true; "Long Distance Call", after all, explores the point at which the selfless, unconditional love that we associate with, and expect

from, maternal guardians reaches its logical limit, becoming selfish, suffocating, and ultimately destructive. While Billy's mother is situated as the "happy housewife heroine" of this particular fable, she is – as the mother of an only son – the natural successor to the dead grandmother. This disturbing configuration of motherhood is redolent of other Cold War approaches to maternal femininity. In particular, it recalls Philip Wylie's cult of "momism", which held bored, overprotective mothers accountable for ruining the nation's children through their excessive maternal attentions.² Although the concept of momism lost currency in the wake of women's entrance into the workplace, it continues to inflect contemporary representations of maternity in popular film and television. This is especially marked in shows like *Mad Men* and *Desperate Housewives*, where the figure of the "happy housewife heroine" is the agent through which the Gothic dimensions of suburban existence are most compellingly excavated.

"I Don't Know Who I Am!"

Mad Men, a critically acclaimed AMC series about the rise of advertising in the early 1960s, trades heavily on the restrictive model of the "happy housewife heroine" that Friedan describes in *The Feminine Mystique*. The character of Betty Draper, an ex-model and the wife of Don Draper – a creative director at an advertising agency in Manhattan – exemplifies the plight of the white, middle-class woman who is tethered to the private space of the suburban family home while her husband conducts his affairs – both business and romantic – in the city. As is the case with many other examples of contemporary US drama, *Mad Men* is embedded in the very cultural critiques that we might use to make sense of the show's approach to femininity; indeed, the character of Betty even shares a first name with Friedan, telegraphing the creator's knowing engagement with Friedan's epochal text.

Betty's domestic discontent, like that which Friedan ascribes to the post-war American housewife, is stressed from the outset; in the second episode of the first season she begins to see a psychiatrist after suffering from spells of numbness in her hands. This numbness initially becomes apparent when Betty is unable to open and apply her own lipstick, though it is most dramatically evidenced when she is driving her two children through the neighbourhood and loses control of the car. Speculatively diagnosed as a psychosomatic condition, Betty's episodic paralysis seems to have particular connections to the "feminine" uncanny. With historical links to hysteria, and thus to the womb, psychosomatic disorders are traditionally gendered as "feminine" maladies. In the first

place, it theatricalizes the return of the repressed, in that it marks the point at which psychic fears and desires that have previously been held at bay make an unanticipated reappearance in the guise of a neurological symptom. Secondly, of course, Betty's condition generates a situation in which she experiences her own body as something which is both unfamiliar to her and – as is made clear in the car accident – potentially threatening. Significantly, Betty's bouts of numbness are each entangled with anxieties about "feminine" appearance: her inability to apply lipstick seems to register Betty's growing, if mostly unconscious, resistance to the demands of the feminine mystique, while the incident with the car functions as a catalyst for Betty's nightmarish fantasies about her daughter's future. As she explains to Don:

I keep thinking - not that I could have killed the kids - but worse...that Sally could have survived and gone on living with this horrible scar on her face and [lived] some long, lonely, miserable life. Don... what's happening to me? Do I need to see someone?

(1.2)

Here, Betty's uncanny experience of her own body is replicated in her seeming estrangement from her own mind, as she asks Don what is "happening" to her - a concern that she repeats a number of times, in various contexts and to various interlocutors, throughout the series. Certainly, repression, as it is highlighted through Betty's psychoanalysis and Don's wartime flashbacks, is a key point of reference in Mad Men and remains central to the way in which the show forges the relationship between femininity and the uncanny. As Freud himself reflected, psychoanalysis is itself uncanny, in that it lays bare psychological mechanisms that are otherwise obscure to the subject. Unfortunately for Betty, her psychological mechanisms are not only revealed in the course of the analysis itself, but also retrospectively, when her doctor reports back to Don about his wife's state of mind.

In the context of the psychiatrist's office, Betty's symptoms are tentatively attributed - not least by Betty herself - to her mother's recent death. Experiencing the aftershock of bereavement, Betty scarcely knows who she is, and her identity becomes ever more problematically entangled with that of her dead mother.3 When her father has a stroke and she goes to visit him, Betty is repeatedly shown staring at, or set against, a portrait of her mother. At one point, Betty's father even mistakes her for his dead wife, groping her breast and inviting her to "go upstairs". The kind of psychical estrangement to which this statement speaks is not only implied through the show's dialogue, but is also inscribed at a visual level - both through Don's flashbacks and Betty's daydreaming. Like other recent shows, such as Six Feet Under (2001-05), Mad Men takes occasional recourse to daydream sequences in order to illuminate the unspoken (or unspeakable) desires of the housewife, while also literalizing - and simultaneously effacing - the split between fantasy and reality. In one memorable scene, shots of Betty pressing herself up against the washing machine are intercut with images of a "fantasy" seduction sequence, in which she imagines herself having sex with a male acquaintance in the family home. This is one of the ways in which the uncanny comes to inscribe itself as a formal, as well as a thematic, preoccupation. As is the case in this scenario, Betty's repressed frustrations tend to manifest themselves most forcefully in the domestic space within which they were conjured: on one occasion she is shown smashing a chair to pieces while her children watch television, and on another she slips outside to shoot the neighbour's pet birds after he threatens the family dog. In this way, Betty's femininity – her performance as the perfect wife and mother – is often represented as uncanny, functioning as a mask for her aggression and the dangers that she (potentially) poses to domestic stability.

Similar anxieties are explored through the protagonists of ABC's Desperate Housewives. While Mad Men is interested in a metaphorical spectre of femininity, and its estranging effects on women, Desperate Housewives is narrated by an actual spectre – the dead Mary Alice, whose suicide marks the point at which the show begins its run. This narrative device literalizes the idea of haunting. Despite its contemporary setting, the show's formulation of feminine identities is strangely nostalgic, trading heavily on the 1950s model of the "happy housewife heroine". Bree Van Der Kamp, played by Marcia Cross, conforms to the popular image of the happy housewife from her flipped-out bob to her twin set and pearls. Certainly, she is styled in ways that are not dissimilar to January Jones's Betty in Mad Men. In the pilot episode of the series, Bree is introduced through a montage of images that demonstrate her domestic prowess. As the accompanying voice-over states:

Bree was known for her cooking, and for making her own clothes, and for doing her own gardening, and for re-upholstering her own furniture. Yes, Bree's many talents were known throughout the neighbourhood. And everyone on Wisteria Lane thought of Bree as the perfect housewife and mother. Everyone, that is, except her own family.

Bree's adept mastery of traditional domestic skills forms the pretext for her suburban status as "the perfect housewife and mother" - a status which is subsequently formalized by her public success as a professional caterer and the acclaimed author of Mrs. Van Der Kamp's Old-Fashioned Cooking. Over the course of the next six seasons, however, Bree's cartoonish performance of feminine perfection disguises her "secret" involvement in murder, infidelity, divorce, alcohol addiction, sexual fetishism, and various other deceits, from the incidental to the monumental. Indeed, the show's contemporary twist is in many ways reliant on the repeated exposure of the discontinuity between the seductive, wholesome appearance of suburban femininity she projects and the dark, threatening behaviours that it conceals. What is particularly interesting in the case of Bree is that the dangers she presents are often linked to her desire to fulfil her duties as the "perfect housewife and mother". In an early episode she interrupts the funeral of her first husband in order to change his tie; elsewhere, she publicly intimidates one of her daughter's friends for scooping some icing from a perfectly frosted birthday cake, and she later shoots at a spurned lover from her bedroom window, having excused herself from the dinner party she is hosting downstairs.

Although very different, Desperate Housewives and Mad Men instrumentalize the uncanny in similar ways. In each series, visual analepses, prolepses, dream sequences, and (in the case of Desperate Housewives) otherworldly narration are used to generate uncanny fissures in the verisimilitude of the narrative – fissures in which the repressed desires of characters are dramatically articulated or envisioned. These devices are used with particular regularity in relation to the housewife, serving to highlight the uncanny split between her controlled exterior and the threats it supposedly hides - implying, once again, the unstable and irrational status of femininity. While these devices necessarily destabilize the boundaries of fantasy and reality, these shows are not engaged, in any explicit sense, with the supernatural; they are used, rather, to give image (or voice) to repressed desires that cannot be symbolized in any other way. Even shows which are outwardly unconcerned with the relationship between femininity and domesticity per se tend to construct and interrogate new female identities – and the ambivalences by which they are striated – through close reference to the space of the home. In recent drama, the home is rarely a safe haven to which female characters retreat to rest or recuperate; rather it is always and already a site which is eminently vulnerable to threats that are conjured from within – and without - its architectural borders.

Domestic femininity and suburban supernaturalism

Following the success of supernatural dramas like Buffy the Vampire Slayer (1997–2003) and Charmed (1998–2006), there has been a renaissance in female-centred Gothic television. Like their popular predecessors, the majority of these shows are concerned primarily with investigating "young" femininities: Joan of Arcadia (2003-05) follows the exploits of a girl who converses with God; Point Pleasant (2005) focuses on the strange events that ensue when Satan's teenage daughter washes up on the shore of a small town in New Jersey; Tru Calling (2003-05) features Eliza Dushku as a psychic mortuary assistant who is able to hear the voices of the dead and "relive" the past in order to save them; and True Blood (2008–) centres on the life of Sookie Stackhouse, a telepathic waitress who falls in love with a vampire. Some recent examples of Gothic television do, however, use the supernatural as a means of exploring the anxieties about maternity and femininity that are addressed in Desperate Housewives and Mad Men. CBS's Ghost Whisperer stars Jennifer Love Hewitt as Melinda Gordon, a young wife and mother with psychic abilities. As well as owning an antiques store, Melinda helps restless spirits to cross over into "The Light" by carrying out their unfinished business on earth. Medium features Patricia Arquette in the role of Allison DuBois, a medium who assists law enforcement agencies in the investigation of unsolved crimes. In both series, the paranormal insight that the protagonists appear to possess is part of a dreadful maternal legacy: Melinda can trace her "ghost whispering" back through five generations of women to her great-great-great-grandmother, while it transpires in the first few seasons of Medium that Allison shares her psychic abilities with her three daughters. In a broad sense, the seeming inextricability of maternity and the paranormal in these dramas works to revivify long-standing cultural anxieties about the "otherness" of femininity, as well as fears about female sexuality, motherly influence, and women's special connectedness to dreams, the unconscious, and irrational (or supernatural) forms of knowledge. Certainly, the female protagonists in Ghost Whisperer and Medium are held accountable, albeit indirectly, for contaminating the purity of the bloodline and for introducing (potentially) malevolent forces into the otherwise sacrosanct space of the home.

In Medium, when Allison's eldest child starts dreaming about a little girl who was abducted by a child molester, it is Allison who becomes the target of her husband's anger: "There's enough death and darkness waiting out there for her when she's an adult [T]wo days ago she didn't know that there were really monsters. And now she does. And I hate that" (1.9). Here, Allison's husband is principally concerned with the fact that his 10-year-old daughter's apparent psychic abilities have acquainted her with the horrors – in particular the sexual horrors – of the adult world. This intertwining of carnal knowledge and psychic insight is interesting, in that it subverts conventional formulations of the *femme-enfant* as a figure that is granted special access to the fantastical as a result of her purity.⁴ Rather, *Medium* suggests that the psychic insight of the child is to some extent concomitant with an awareness of adult sexuality and/or the onset of sexual maturity.

As Barbara Creed has commented, because of its reproductive and procreative functions, the post-pubescent female body is inherently "unstable": it grows during pregnancy to accommodate its progeny, it lactates, it menstruates, it can be "taken by force" (15). In short, the maternal body is both penetrable and porous, and in this way it works to query the borders – and thus the integrity – of individual female identity. In Ghost Whisperer and Medium, the permeability of the maternal body is replicated in the representation of the psychic mind, which confounds the notion of individual identity in similar ways. In the cases of Allison and Melinda, after all, the boundaries of the mind are perpetually breached by memories, thoughts, and experiences which are not their own. Already mothers, these women are forced to relive the experience of pregnancy at a symbolic level, being forever laden with an evolving cast of restless souls. As Allison describes it, "there's a kind of collective consciousness out there, a kind of giant filing cabinet filled with all the thoughts of everyone who has ever lived, just floating around, waiting to be received by someone" (1.11). Like children, these souls make sustained demands on the women's reserves of time and energy: the stock shot in both shows is that of the female protagonist waking up in the middle of the night, having intuited that someone needs her help. This visual trope quite clearly evokes the interrupted sleep patterns of early parenthood. *Medium*, in particular, seems to elaborate on this connection. In an episode from the first season, Allison appears to awake to her eldest daughter's insistent cries for "mommy". Moving through the home, Allison is unable to locate her daughter, though her cries remain persistent. What she finds, instead, is a strange, affectless man, who introduces himself as he steps out of the shadows: "You know me. I'm a golum. I'm the devil. I'm a monster. And your little girl? She's in the trunk of my car. And if you'll excuse me, I've come back to get the other ones". Within seconds, Allison awakes for a second time, to the same cries of "mommy". On this occasion,

however, she finds her daughter asleep in bed and sources the cries to a mechanical doll on the bedroom floor (1.6). Here, and in a number of other episodes, the vulnerability of Allison's subconscious to unsolicited psychic invasions is imagined through the visual motif of the domestic intruder. This motif is similarly deployed in Ghost Whisperer. In the opening episode of the first season, Melinda and her husband move into a house that is literally falling apart. During the first week in their new home, Melinda wakes up during a thunderstorm to find her husband gone. Seeing him outside in the rain, trying to reattach some tarpaulin that has come loose in the wind, Melinda opens a window to shout out to him, only for the frame to break off in her hands. When she makes her way back to bed, she is confronted by the cadaverous spectre of a soldier who claims to be lost and asks for her help. Melinda agrees, but only after she has admonished him for his encroachment upon her private, domestic space: "You're not supposed to be in my home. That's not how this works" (1.1). As the architectural borders of the home are crumbling around her, the perimeters of Melinda's psyche are likewise breached. The home, then, is again understood as an extension of the female body and/or mind; both are eminently penetrable in ways that undermine their apparent status as "place[s] of peace" from which evil is absent. Such complex evocations of domestic space are typical of the Gothic genre from which shows like these draw, where "the home can never be purified once and for all [because] it is inextricably connected to 'the world', whose violence and danger must be faced, and wrestled to the ground, again and again" (Ellis 220). As psychics, Allison and Melinda are magnets for the supernatural forces that endanger the home and also the guardians of that home - guardians who are not only charged with the role of keeping evil out, but who must also ensure that those around them are forewarned about, and protected against, the forces by which they are threatened. Set in this light, the custodial responsibilities of the psychic are broadly continuous with the nurturing duties of the "happy housewife heroine". Allison and Melinda are symbolically recast as über-mothers, becoming temporary custodians to those whose consciousnesses (apparently) converge with their own.

In this way, the psychic woman becomes a powerful metaphor for feminine identity and the tensions by which it is beset. Torn between fulfilling her own needs and carrying out her responsibilities to others – both living and dead – her condition speaks to the increasingly complex negotiations that women are required to undertake as they try to balance personal, familial, domestic, and professional obligations.

While uncanny configurations of feminine identity are by no means new to American television, they have been particularly prevalent in the early years of the twenty-first century. This phenomenon is explicable, in part, through reference to the growth in programming for female viewers which has taken place over the past decade, and the related foregrounding of "women's issues" within television fictions. It might also, however, invite consideration alongside more widespread concerns about privacy rights and surveillance culture. At a time when the US government is able to monitor the activities of the individual in unprecedented ways, and to an unprecedented degree, it seems apposite that anxieties about the sanctity of domestic space and personal autonomy should loom so large in the cultural imaginary. From The Twilight Zone to The Ghost Whisperer, feminine identity remains a key venue for the inscription of these kinds of anxieties. While feminism has interrogated patriarchal formulations of femininity as masculinity's mysterious, irrational "other", such formulations are a mainstay of recent television drama, pointing to the stubborn resilience of conventional conceptions of gender within the seemingly enlightened context of postfeminist culture.

Notes

- 1. This demonization of the feminine is especially characteristic of the male Gothic. See Creed.
- 2. Wylie explains the premise of "momism" in scathing detail in the chapter on "Common Women" from Generation of Vipers: "Nowadays, with nothing to do, and all the tens of thousands of men...to maintain her, every clattering prickamette in the republic survives for an incredible number of years, to stamp and jibber in the midst of man, a noisy neuter by natural default or a scientific gelding sustained by science, all tongue and teat and razzmatazz. The machine has deprived her of social usefulness; time has stripped away her biological possibilities and poured her hide full of liquid soap; and man has sealed his own soul beneath the clamorous cordillera by handing her the checkbook and going to work in the service of her caprices". See Wylie 184-96.
- 3. Mad Men is, of course, fundamentally concerned with anxieties about individual identity. In order to escape his impoverished past, "Don" (born Richard Whitman) stole the identity of an army colleague - Lieutenant Donald Draper – who was killed alongside him in the Korean War. Issues about female identity also loom large, not least in the offices of Sterling Cooper, where the identities of the women who work there are regarded as largely interchangeable. This is demonstrated in an episode from the first season when the new secretary Alison is referred to, incorrectly, as "Debbie"; when she attempts to correct the error, her objections are disregarded, as if such confusion is of little consequence: "Whatever".
- 4. See Creed 154-55.

Works cited

Boyle, Karen. "Feminism Without Men: Feminist Media Studies in a Post-Feminist Age". Feminist Television Criticism: A Reader. Ed. Charlotte Brunsdon and Lynne Spigel. Maidenhead: Open University Press, 2008. 174–90.

Castle, Terry. *The Apparitional Lesbian: Female Homosexuality and Modern Culture*. New York: Columbia University Press, 1995.

Creed, Barbara. *The Monstrous Feminine: Film, Feminism, Psychoanalysis*. London and New York: Routledge, 1993.

De Beauvoir, Simone. The Second Sex. London: Vintage, 1997.

Desperate Housewives. ABC, 2004-.

1.1. "Pilot". Dir. Charles McDougall. October 3, 2004.

Ellis, Kate Ferguson. *The Contested Castle: Gothic Novels and the Subversion of Domestic Ideology*. Champaign, IL: University of Illinois Press, 1989.

Freud, Sigmund. "The Uncanny" (1919). *The Pelican Freud Library: Art and Literature*, vol. 14. Ed. Albert Dickson. Harmondsworth: Penguin, 1985. 339–68. Friedan, Betty. *The Feminine Mystique*. London: Penguin, 1992. *Ghost Whisperer*. CBS/ABC, 2005–10.

1.1. "Pilot". Dir. John Gray. September 23, 2005.

Gordon, Avery. "Feminism, Writing and Its Ghosts". Social Problems 37.4 (1990): 485–500.

— Ghostly Matters: Haunting and the Sociological Imagination. 2nd rev. edn. Minneapolis, MN: University of Minnesota Press, 2008.

Hesford, Victoria. "Feminism and Its Ghosts: The Specter of the Feminist-as-Lesbian". Feminist Theory 10.1 (2009): 227–50.

Hollows, Joanne. "Can I Go Home Yet?". *Feminism in Popular Culture*. Ed. Joanne Hollows and Rachel Moseley. Oxford and New York: Berg, 2006. 97–118.

Levy, Ariel. Female Chauvinist Pigs: Women and the Rise of Raunch Culture. London: Pocket Books, 2006.

McRobbie, Angela. *The Aftermath of Feminism: Gender, Culture and Social Change*. London: Sage, 2009.

Mad Men. AMC, 2007-.

- 1.1. "Smoke Gets in Your Eyes". Dir. Alan Taylor. July 19, 2007.
- 1.2. "Ladies Room". Dir. Alan Taylor. July 26, 2007.

Medium. NBC/CBS, 2005-.

- 1.6. "Coming Soon". Dir. Vincent Misiano. February 7, 2005.
- 1.9. "Coded". Dir. Bill L. Norton. February 28, 2005.
- 1.11. "I Married a Mind Reader". Duane Clark. March 21, 2005.

Modleski, Tania. Loving with a Vengeance: Mass-produced Fantasies for Women. 2nd edn. London: Routledge, 2006.

Negra, Diane. What a Girl Wants?: Fantasizing the Reclamation of Self in Postfeminism. Oxon and New York: Routledge, 2009.

Oakely, Ann. Housewife. Harmondsworth: Penguin, 1974. The Twilight Zone. CBS, 1959-64.

2.22. "Long Distance Call". Dir. James Sheldon. March 31, 1961.

Walter, Natasha. The New Feminism. London: Virago, 1999. Wylie, Philip. Generation of Vipers. 1942. New York: Pocket Books, 1955.

Part II Sex and Sexuality

5

Bad Girls in Crisis: The New Teenage Femme Fatale

Katherine Farrimond

In May 1992, 17-year-old Amy Fisher confronted and shot Mary Jo Buttafuoco, the wife of Joey Buttafuoco, with whom Amy was having an affair. In the extensive tabloid coverage that followed - most of which emphasized the spicy details of the affair and the young woman's past involvement in the sex industry - Fisher was dubbed the "Long Island Lolita" and became the inspiration for three salacious madefor-television movies: Amy Fisher: My Story (1992; released in the United Kingdom as Lethal Lolita); Casualties of Love: The Long Island Lolita Story (1993); and The Amy Fisher Story (1993). As Elizabeth Wurtzel points out, "The Amy Fisher story is about an attempt to focus on one girl's special effects and pretend that no storyline preceded it. And there's a lot of that going around these days" (94). In this chapter, I argue that while this troubling dynamic has persisted in the teenage femme fatale films that have emerged in the wake of the Fisher story, recent examples of the genre have registered a shift towards a potentially more fruitful consideration of the background "storyline" that Wurtzel describes. While the focus on the fireworks caused by girls-behaving-badly remains a staple of the teen femme fatale narrative, some texts have moved away from the straightforward glorification and/or demonization of the bad girl's bad behaviour in order to examine the lived reality of her experiences.

Throughout the history of Hollywood cinema, teenage girls have been variously presented as tearaways, Lolitas, coquettes, high-school bitches, and jailbait. Until the 1990s, however, these bad girls were not approximate to the sexy-but-deadly femme fatales of classic American noir. Indeed, it is only in the last two decades that the femme fatale's cruel single-mindedness and erotic allure has been transferred to the figure of

the teenage girl.² In an acknowledgement of the advent of the teenage femme fatale, Timothy Shary notes the following:

"Evil women" whose power arises from their sexuality and intelligence have been popular since at least the 1940s emergence of femmes fatale in films noir, and seemed to find a resurgence in the last generation as a reaction to women gaining professional power.... The fact that teen films have recently been demonstrating the supposedly corruptive effects of female intelligence and sexuality suggests that this tradition is shifting its concerns (and fascinations) to a younger generation of women. (249–50)

As Shary suggests, the teenage femme fatale has emerged from the 1980s noir revival which took the form of femme fatale-centred erotic thrillers such as Body Heat (1981), Black Widow (1987), and Fatal Attraction (1987). This resurgence coincided with what Catherine Driscoll has termed "a hypersuccessful genre" (216) of teen films in the 1980s, exemplified by John Hughes' The Breakfast Club (1985) and Pretty in Pink (1986), and Amy Heckerling's Fast Times at Ridgemont High (1982). This cinematic climate is arguably the reason that the director Katt Shea was, in her words, "hired by New Line Cinema to come up with a teenage Fatal Attraction", resulting in Poison Ivy (1992), the first major teen femme fatale film (qtd. in Williams 392). While many teenage femme fatales do feature in films made for teenagers, still more appear in erotic thrillers, as in the case of Shea's Poison Ivy and Wild Things (1998), science fiction horror films such as The Faculty (1998) and Decoys (2004), and independent productions such as Brick (2005) and The Opposite of Sex (1998). Such films register the media's growing interest in girls and girlhood during the 1990s and 2000s, out of which context the teenage femme fatale emerges as a locus for debates about the ways in which teenage girls are understood by, and represented in, Western popular culture at the beginning of the twenty-first century.³

Postfeminist lolitas: The evolution of the teen femme fatale

As I have indicated, the beginnings of the teenage femme fatale can be traced to the erotic thrillers of early 1990s, such as *Poison Ivy* and *The Crush* (1993), which feature teenage girls as babysitters, daughters of landlords, and high-school students. These films present scenarios that are designed to place older men in proximity to devious and nubile teenage girls who first seduce them, then wreak havoc on their lives.

Although the Amy Fisher case, and the media frenzy surrounding it, did not initiate the cycle (Poison Ivy was released before the murder), the particular way it was reported speaks to the same concerns as the films that were released at this time: the combination of sexuality, criminality, and youthful femininity is interpreted in a way that emphasizes the teenage girl's seductive danger, while playing down any concern for her personal wellbeing. The femme fatale in these films thus functions primarily as the object of desire: her motivations go unquestioned and the threats she poses to the family (and to adult masculinity in particular) are neutralized through her death or incarceration. This trend continues throughout the 1990s, with films like Wicked (1998), Devil in the Flesh (1998), Teacher's Pet (2000), and Swimfan (2002) presenting the teenage femme fatale as an unexamined psychotic who will stop at nothing to get what she wants. Although this trend shows no sign of abating (the latest in the *Poison Ivy* series was released in 2008), the teenage femme fatale has evolved since the mid- to late-1990s into an increasingly complicated figure, whose own desires and motivations are not only acknowledged but also foregrounded. Rather than being punished at the end of her films, then, the new teenage femme fatale is celebrated for her ability to escape justice, as in Wild Things and Mini's First Time (2006). Such films seem indebted to postfeminist valorizations of female sexuality that began to emerge in the mid-1990s. Certainly, using sex as a means to an end is presented as an empowering strategy in these "getting-away-with-it" narratives; as the patriarchal desire for younger women is mocked, so the femme fatale's sexual conquests are advanced as evidence of her agency and independence. Such an interpretation is, however, undermined by the patriarchal iconography of the films; structured around titillating images of threesomes, pseudo-lesbian sex, and the femme fatale's teenage body, these narratives exemplify what Rebecca Munford refers to as "the dangerous slippage between feminist agency and patriarchal recuperation" (148–49). While she is prevailingly presented as an icon of female empowerment, then, the teenage femme fatale – with her outwardly conventional "sexiness" and apparent sexual availability – is best understood as a figure that occupies the liminal territory between sexual empowerment and patriarchal objectification.⁴ In this way, these films speak to a core myth of postfeminist ideology: "the sense that we inhabit a world which already offers us a range of ready choices and where we can play at sexy vamp with no ill-effect because we are 'in control' of the look we create" (Whelehan 178). What the teenage femme fatale narrative fails to note is that the "control" to which Whelehan refers is surrendered as soon as the "look" or image of the femme fatale becomes public. In other words, the dominating patriarchal gaze is likely to read the teenage "sexy vamp" as anything but powerful. And while the teen femme fatale does appear to control and create her "hot bad girl" persona in order to gain agency from it, this power is reliant on the unexamined assumption that the role of sexual performer is the only valid source of agency available to pretty teenage girls. Although this persona may permit her victory over patriarchal figures in the narrative's conclusion, this victory depends on a visual style which insists that – for the teen femme fatale who gets away with it – her *only* power is her highly problematic ability to look sexy.

Sympathy and punishment: The new teen femme fatale

Both Cruel Intentions (1999) and Pretty Persuasion (2005) present versions of the teenage femme fatale which, in making her a more central and sympathetic character than her Lolita-style predecessors, follow a similar pattern to the postfeminist films discussed above. However, in contrast to the unequivocal celebration of the femme fatale's victory, these films do not end happily for the teenage bad girl. Similarly, unlike the earlier "Lolita" femme fatale films, they do not culminate in the femme fatale's death or incarceration, but instead demonstrate the impact of her actions and the environment in which she lives on her emotional well-being. As Kerry Mallan and Sharyn Pearce have pointed out, contemporary Western culture promotes a "concept of the youthful body as a site of cultural inscription and objectification"; rather than offering a straightforward recapitulation of this formulation, these texts seek to interrogate it (xiv). In Cruel Intentions and Pretty Persuasion, the politics, pleasures, and problems of the teenage femme fatale bleed into one another, creating representations of agency and sexuality which are neither clear-cut condemnations nor unexamined celebrations; as such, they expand the depth and breadth of the femme fatale type. Rather than offering the unquestioning celebrations of the bad girl's deviancy found in the postfeminist femme fatale narrative, these films articulate the type of concern expressed by Whelehan in her analysis of postfeminism's rhetoric of sexual empowerment. While the teenage femme fatale may be punished at the end of films like The Crush and Poison Ivy, Cruel Intentions and Pretty Persuasion do not condemn and vilify these characters in the same way and are, instead, fraught with tensions about agency, sexuality, romance, and social acceptance that leave space for a sympathetic reading of the teenage femme fatale.

To begin with, the teen femme fatale's relationship to sex in these films is far more complex than in other examples of the genre. In Kimberly and Kathryn, their respective seductive schoolgirls, both Pretty Persuasion and Cruel Intentions present teen femme fatales who use sex predominantly as a means of achieving their various ambitions – hence the fact that it is inextricable from bribery, blackmail, and other forms of emotional manipulation. The sex scenes would thus appear to continue in the tradition of classic noir, in which the femme fatale's "lust was overwhelmingly for money rather than sexual pleasure.... Her sexuality per se was passive, limited to its allure. Although narratively she manoeuvred the male protagonist with her sexuality, the specifically sexual pleasure it served belonged to the male" (Straayer 152–53). This dynamic is also present in both the "Lolita" subgenre of the femme fatale film and the postfeminist bad girl films discussed above. However, Pretty Persuasion and Cruel Intentions reconfigure this conventional dynamic in their refusal to focus entirely on the pleasures of the male recipient on whom the femme fatale's sexual attentions are lavished; instead, they gesture towards the complex ways in which the femme fatale uses her sexuality as a means of achieving sexual and non-sexual objectives alike.⁵ Scenes of sexual manipulation and sexualized performance are countervailed by others in which the teenage femme fatale does claim her sexuality for herself, and for its own sake, complicating a reading of Kimberly and Kathryn's use of their sexuality as purely a means to success in other areas of life. In Cruel Intentions, an infuriated Kathryn makes an extensive speech bemoaning the sexual double standard which prevents her from exercising her sexuality publically:

Eat me Sebastian. It's alright for guys like you and Court to fuck everyone, but when I do it I get dumped for innocent little twits like Cecile. God forbid I exude confidence and enjoy sex. Do you think I relish the fact that I have to act like Mary Sunshine 24/7 so I can be considered a lady? I'm the Marcia fucking Brady of the Upper East Side, and sometimes I want to kill myself.

In this statement, Kathryn not only telegraphs the intensity of pressures on young women to conform to patriarchal models of virtue and disposition, but also makes claims on the very enjoyment of her sexuality that other scenes – such as one in which she stages a screamingly orgasmic sexual performance with a man in whom she has no interest just to demonstrate her power to her step-brother Sebastian – would seem to deny her. In light of Kathryn's actions throughout the rest of the film, and her apparently constant use of sex as a means to empowerment, the points she makes in this scene may be easily dismissed as an anomaly. Certainly, this is the position taken by Brigine E. Humbert:

If Sebastian enjoys his reputation as a seducer while Kathryn does her best to appear virtuous, it seems that this opposition lies less in a difference imposed by gender as in [the original novel] - although Kathryn alludes to this – than in the different natures of their ambitions: he is happy just being the "bad apple" whereas she worries about securing her position as student body president. (281–82)

Humbert's throwaway reference to Kathryn's dissatisfaction with the constraints of her femininity belies the pivotal role that this speech plays in illuminating the intricate ways in which anxieties about social expectations, personal (female) desires, and power are woven together in the film. While Kathryn does worry about preserving her position as president, this is arguably because that position allows her to live the decadent and highly sexual lifestyle she finds appealing - the lifestyle that Sebastian can enjoy unencumbered by public rejection and shame - behind a smokescreen of modest and appropriate feminine behaviour. Here, sex for the teenage femme fatale is not about the binary oppositions of male pleasure and female success; rather, sex is the means through which her own desires - whether erotic, emotional, or material - might be realized.

Similarly, in an early sex scene from Pretty Persuasion, Kimberly is the recipient of oral sex, which she is shown as actively enjoying. This scene complicates straightforward constructions of the femme fatale's sexuality as a means to a lucrative end, as Kimberly's relationship with her boyfriend is apparently one that she entertains solely for the purposes of attaining her own sexual pleasure. She does not appear to like the boy, who is presented as ignorant and boorish, and he complains that she always tricks him into pleasuring her first, after which she makes her excuses and leaves. Although Kimberly's relationship with sex is frequently framed as one in which she performs oral sex on other people in order to achieve her ambitions, this scene disrupts the notion that the femme fatale is the sole provider of erotic stimulation. At the same time, it complicates the idea that the teenage girl is someone who does not or should not pursue her own sexual desires. If the femme fatale narrative is characterized, in part, by its tendency to identify female sexuality with manipulation, then the teen subgenre is one in which the lines between the femme fatale's use and enjoyment of her sexuality are

decidedly blurred. In the final analysis, then, the teen femme fatale's sexual conquests are not only a way of getting what she really desires, but also expressions of desire itself.

Rather than following a naïve and inherently problematic "girl power" model, these two films demonstrate the complexities of trying to live as a teenage girl in a space which insists that girls' only power lies in their sexuality, and yet judges and vilifies them for utilizing it publicly. While these films are neither explicitly nor exclusively feminist, their strategy of exploring this situation is closely aligned to the "prowoman" argument asserted by Jennifer Baumgardner and Amy Richards in Manifesta. With reference to second wave rhetoric, they argue that

women weren't passively brainwashed by the patriarchy into marrying or looking as pretty as possible; they were actively making the best choice they could, given the circumstances of sexism. The reality was, and still is, that married women had some economic and societal protections that single women didn't have; and attractive women could get better jobs than their mousy sisters. [Ellen] Willis and the Redstockings argued that women would make different choices in a non-sexist world, but the point of a pro-woman line is to acknowledge the barriers around which women must manoeuvre rather than to blame the women themselves. (95–96)

This argument usefully acknowledges the strategies that women employ to negotiate the restrictions placed upon them, and shows how these strategies might be reframed as expressions of agency rather than passivity. Within this model, actions which may be read as implicitly antifeminist – traditional heterosexual coupling, wearing high heels and makeup, and using sex as a means to an end - can instead be viewed as aids to survival within systems that attempt to dictate how should women look, behave, and achieve power. Unlike the postfeminist and antifeminist teen femme fatale films outlined at the start of this chapter, the new teen femme fatale films uncover the usually invisible networks of constraints and requirements within which the twenty-first-century teenage girl must function, and in doing so they shed vital light on the techniques she employs in order to succeed within those systems.

In re-visioning the teenage femme fatale, these films articulate and interrogate postfeminist notions that using sex to get what one wants is a form of empowerment for young women. In both Cruel Intentions and Pretty Persuasion the teenage femme fatale is thus presented as existing in a double bind: the high premiums that Western societies place on teenage femininity allow her to use her youthful sexuality to get what she wants; however, these same societies also demonize girls who are too available, too sexual, too promiscuous, and this not only impacts on her ability to use sex to achieve her ambitions, but also on the extent to which she can explore her own personal sexual desires.

In Pretty Persuasion, the contradictions that swirl around the sexuality of the teenage girl are explicitly foregrounded in an incident involving Warren, a boy Kimberly was "sort of" dating who persuades her to engage in anal sex, before dumping her on the grounds that he "didn't want to go out with a girl that would let a guy do that to her". As becomes apparent, Troy, the former boyfriend over whom Kimberly pines and obsesses, broke up with her because he heard about the incident with Warren. Troy's retelling of this incident is of great significance to understanding Pretty Persuasion's treatment of the femme fatale's sexuality: "I heard something, that kind of freaked me out, and to be honest with you it was kind of making me look bad. I was over at Kimberly's house one night and she came out of the bathroom and started doing this nasty little dance". The film then cuts to a flashback in which Kimberly is shown doing a dance that echoes the dance that her teacher's wife performs for him, while dressed as a schoolgirl, earlier in the film. What her teacher, Mr Anderson, finds alluring and attractive in his naive wife's performance of the sexy schoolgirl, Troy finds repellent in the apparently genuine expression of desire from a girl with a bad reputation. In this way, the film suggests that standards of appropriate sexuality for women vary enormously based on the public perception of the woman's sexual experience and identity. To return to Whelehan's comments on the problematics of public sexual performance, the film implies that women are not "in control" of the look they create, and that power is removed from them as soon as they fall under the attentions of the male gaze. Troy then stops Kimberly with the line "Warren Prescott told me what he did to you". This line again highlights a sexual double standard: Warren is presented as the active party in the relationship, as Troy attributes the incident to his ability to "do" anal sex to Kimberly, while she is the one taken to task for it. Kimberly attempts to rescue the situation by saying "If you're good I'll let you go where Warren went", to which Troy replies "no, that is not cool Kimberly, I don't take some loser's sloppy seconds, alright? And I don't want to be with some dirty little whore". Again, this scene is instrumental in acknowledging the disjunctive ways in which female agency is exercised and interpreted. While Kimberly may be active in choosing her partners and consenting to sex with them, under the heteronormative patriarchal

gaze – embodied here by Troy – her attempts to attain the status she wants will never truly function as manifestations of agency, as sexual activity will always be something that is "done to her" by someone else. This dynamic is demonstrative of what Catherine Driscoll describes as a "patriarchal capitalist coding" in which feminine adolescence is positioned as both "desirable commodity and undesirable identity" (130). Kimberly knows that sexual availability is the best way to get what she wants, as evidenced by frequent scenes in which she exploits this very idea, and yet the sexual history she accumulates in doing so marks her as undesirable to partners she is interested in romantically. In this instance, the sexually available girl is as appalling as she is alluring, and so her attempts to gain agency via sex are both facilitated and vilified by the patriarchal society in which she aims to succeed. This situation is also explored in Cruel Intentions, in which Kathryn makes it clear that she hates the role she must maintain; if she could be as overtly promiscuous as Sebastian, she would, but she understands how the society she inhabits expects her to act and knows that she must at least appear to conform in order to behave in the way she wants.

While male promiscuity is persistently glorified in the film, female promiscuity is approached rather differently. When Kathryn suggests to Cecile that she ought to sleep with as many people as possible because "practice makes perfect", Cecile worries that this might make her "a slut", but Kathryn is quick to reassure her that "everybody does it; it's just that nobody talks about it". This contrast makes it clear that male promiscuity is rewarded with admiration and status, whereas women who wish to behave promiscuously must do so discreetly or be branded as sluts. What this implies, in turn, is that the teenage girl can define her image in accordance with one of two key paradigms: virgin or whore. Kathryn's desire for exciting and varied sexual experience must be hidden behind a veneer of virginal innocence, but in order to maintain this pretence and attain a social position that will allow her access to the type of men she wants to have sex with, she uses her sexuality as leverage for blackmail and bribery. As a result, the motives that underlie Kathryn's various sexual exploits are difficult to discern, and never readily locatable as either erotic or emotional or manipulative. Just as in Pretty Persuasion, this confusion of purpose is what ultimately causes her downfall. When Sebastian's secret diary is revealed to everyone at her school, it not only denounces Kathryn as an "alcoholic" and a "liar", but also – most tellingly – brands her as "promiscuous". Kathryn is judged and castigated for her sexual history – a history that reflects her ambition and her pursuit of pleasure within the context of a society that finds the sexually available girl both desirable and distasteful. In *Cruel Intentions* and *Pretty Persuasion* alike, the voyeuristic display of the slutty bad girl's sexual antics gives way to her punishment, thus re-enacting the very combination of sexual objectification and vilification that I have argued these films critique. However, rather than simply re-inscribing Driscoll's model of female adolescence, these narratives pose an important question about the ways in which sex and power are negotiated in relation to the figure of the teenage girl: If the only power available to teenage girls is their sexuality, and if that sexuality is temporarily sexy but ultimately unacceptable, what happens to ambitious young women?

Such a question invites consideration alongside the "girls in crisis" discourses that emerged in the 1990s. Exemplified by Mary Pipher's Reviving Ophelia (1994),6 recent studies of "mean girls",7 and a growing academic interest in Western cultural attitudes to sex and teenagers, the "girls in crisis" phenomenon predates films like Cruel Intentions and Pretty Persuasion and seems to inform their ambivalent portrayals of teen femininity. As femme fatales who are both desirable and disgusting, Kathryn and Kimberly are presented as "girls in crisis": away from the eyes of their neglectful and frequently absent parents, they each (ab)use drugs, such as cocaine and prescription medication, and exhibit signs of eating disorders. That these pathological behaviours are typically perceived as the domain of rich white Western youth seems to speak to the main point of the films: while these teenage femme fatales deceive, cheat, and seduce everyone around them, they cannot be interpreted straightforwardly as evil Lolitas, but nor are they postfeminist heroines to be lauded and celebrated. Instead, they are girls suffering in environments where their bodies and actions are under constant scrutiny. In this respect, the looming presence of eating disorders is particularly revealing, in that it connects the abstract concept of "girls in crisis" with the more specific desires that are ascribed to these girls: firstly, the desire for control over a body that is seemingly incapable of creating its own meaning away from the male gaze; and secondly, the desire to remove "the social and sexual vulnerability involved in having a female body" (Bordo 179). While the suggestions of domestic instability point to a generalized sense of "femme fatales in crisis", the spectre of the eating disorder draws explicit links between the teenage girl's sexualized body, the power it supposedly gives her, and the cultural meanings it is ascribed - meanings which she is incapable of anticipating and/or manipulating.

Both Cruel Intentions and Pretty Persuasion struggle with the implications and contradictions of the bad girl identity, with each film developing a narrative strand in which the femme fatale attempts to

turn her virginal love-rival into a slut so that she, too, will be rejected. In Cruel Intentions, Kathryn vows to make Cecile, the girl who inadvertently "stole" her boyfriend, "the premier tramp of the New York area". She then embarks on a plot to ensure that Cecile gains an enormous range of sexual experience under the expert tutelage of Sebastian so that Court, the ex-boyfriend, will no longer desire her. Similarly, at the end of Pretty Persuasion, Kimberly reveals her plot to make Brittany look cheap so that Troy would reject her. While this motif of good-girls-turnedslutty certainly provides further evidence for the precarious nature of the sexual girl's position in Western society, it also speaks to the "girls in crisis" sensibility that surrounds the representation of femme fatale in Cruel Intentions and Pretty Persuasion alike. In Kimberly's final scene, she explains her motivation and methods to the now-crushed Brittany: "you're not [Troy's] perfect little angel any more are you? Oh no. Now, you're a dirty little whore, just like me. I turned you into me!" In this announcement lies an inherent self-loathing which is likewise present in Cruel Intentions; in each film, the femme fatale's project to turn the virginal girl into herself, and to see her punished for it, is a clear indication that the teen femme fatale is not happy with her lot. The teenage girl may be able to extort status and success from her sexual availability, but these prizes are hard-won and do not, ultimately, grant her happiness.

If these films spell out the disasters that can occur when "active girlhood becom[es] too active" they also attempt to analyse the strategies that young women employ in order to succeed within the restrictive parameters of patriarchal society (Nayak and Kehily 61). That said, neither Cruel Intentions nor Pretty Persuasion is capable of expanding these parameters: while both films identify the various dilemmas by which the teenage girl is plagued, the representations of Kathryn and Kimberly do not suggest a clear means of escape from the restrictive boundaries of the desirable-but-despicable bad girl role.9

The femme fatale model can only, perhaps, go so far in untangling the complex intersections of gender, sex, and power that take place within and around the body of the teenage girl. Still, in reflecting on the causes and effects of the teen femme fatale's vexed behaviour, films like Cruel Intentions and Pretty Persuasion offer valuable correctives to recent cinematic representations of hot-but-dangerous girls; while they do not necessarily disrupt the teenage girl's cultural objectification, they usefully analyse her strange social currency in a world where the postfeminist rhetoric of sexual empowerment is in permanent competition with the sexual double standards that continue to prevail.

Notes

- 1. See, for example, *The Big Sleep*'s Carmen Sternwood (1946), Veda in *Mildred Pierce* (1945), Sue in *Pretty Poison* (1968), Delly in *Night Moves* (1975), Violet in *Pretty Baby* (1978), and the eponymous characters in *Heathers* (1988).
- For a useful list of qualities connected with the femme fatale figure, see Tasker 120.
- 3. For more on girls and girlhood, see Gonick 1.
- 4. In *Rethinking the Femme Fatale in Film Noir*, Julie Grossman argues that critics have tended to fixate on the category of the femme fatale in ways that can undermine the complex and varied ways in which women in film noir are characterized. According to Grossman, an examination of "narrative, social psychology and the mise-en-scene in film noir ... reveal[s] that a large majority of so-called bad women in noir are not demonized in the films in which they appear and are very often shown to be victims: first, of the social rules that dictate gender roles and, second, of reading practices that overidentify with and overinvest in the idea of the 'femme fatale'" (2).
- 5. This is not to say that the femme fatale with sexual desires of her own exists only within teenage incarnation. The deadly women of *Basic Instinct* (1992), *The Last Seduction* (1994), and other frequently discussed neo-noirs of the 1980s and 1990s would attest to the strong presence of personal feminine desire existing alongside the femme fatale character in recent years. However, where female sexual desire is presented in such films as aggressive, dangerous, and unnatural, I argue that the teen femme fatales operate within entirely different frameworks that instead allow for a more complex interpretation of feminine sexuality and ambition.
- For further examples of "girls in crisis" literature, see Orenstein and Sadker and Sadker.
- 7. This cluster of literature on "mean girls" is exemplified by Wiseman's Queen Bees and Wannabes: Helping Your Daughter Survive Cliques, Boyfriends, Gossip, and Other Realities of Adolescence (2003) and Gabarino's See Jane Hit: Why Girls are Growing More Violent and What We Can Do About It (2006).
- 8. See Levy, Valenti, and from the anti-feminist right Platt Liebau.
- 9. See Grossman 1-21.

Works cited

- Baumgardner, Jennifer, and Amy Richards. *Manifesta: Young Women, Feminism, and the Future.* New York: Farrar, Straus and Giroux, 2000.
- Bordo, Susan. *Unbearable Weight: Feminism, Western Culture, and the Body.* 10th Anniversary edn. Berkeley: University of California Press, 2003.
- Driscoll, Catherine. *Girls: Feminine Adolescence in Popular Culture and Cultural Theory*. New York: Colombia University Press, 2002.
- Gabarino, James. See Jane Hit: Why Girls are Growing More Violent and What We Can Do About It. New York: Penguin, 2006.
- Gonick, Marnina. "Between 'Girl Power' and 'Reviving Ophelia': Constituting the Neoliberal Girl Subject". NWSA Journal 18.2 (2006): 1–23.

- Grossman, Julie. Rethinking the Femme Fatale in Film Noir: Ready for Her Close-Up. Basingstoke: Palgrave, 2009.
- Humbert, Brigine E. "Cruel Intentions: Adaptations, Teenage Movie or Remake". Literature/Film Quarterly 30.4 (2002): 279-86.
- Levy, Ariel. Female Chauvinist Pigs: Women and the Rise of Raunch Culture. London: Pocket Books, 2006.
- Mallan, Kerry, and Sharyn Pearce. "Introduction: Tales of Youth in Postmodern Culture". Youth Cultures: Texts, Images, Identities. Ed. Kerry Mallan, and Sharyn Pearce. Connecticut and London: Praeger, 2003. i-xix.
- Munford, Rebecca. " 'Wake Up and Smell the Lipgloss': Gender, Generation and the (A)politics of Girl Power". Third Wave Feminism: A Critical Exploration. Ed. Stacy Gillis, Gillian Howie, and Rebecca Munford. Basingstoke: Palgrave Macmillan, 2004. 142-53.
- Nayak, Anoop, and Mary Jane Kehily. Gender, Youth and Culture: Young Masculinities and Femininities. Basingstoke: Palgrave Macmillan, 2008.
- Orenstein, Peggy. Schoolgirls: Young Women, Self Esteem, and the Confidence Gap. New York: Doubleday, 1994.
- Pipher, Mary. Reviving Ophelia: Saving the Selves of Adolescent Girls. New York: Ballantine Books, 1994.
- Platt, Liebau, Carol. Prude: How the Sex-obsessed Culture Damages Girls (and America Too!). Nashville: Center Street, 2007.
- Sadker, Myra, and David Miller Sadker. Failing at Fairness: How America's Schools Cheat Girls. New York: Charles Scribner, 1994.
- Shary, Timothy. "The Nerdly Girl and Her Beautiful Sister". Sugar and Spice and Everything Nice: Cinemas of Girlhood. Ed. Frances Gateward, and Murray Pomerance. Detroit: Wayne State University Press, 2002. 235-52.
- Straayer, Chris. "Femme Fatale or Lesbian Femme: Bound in Sexual Différance". Women in Film Noir. Ed. E. Ann Kaplan. rev. edn. London: British Film Institute, 1998, 151-63.
- Tasker, Yvonne. Working Girls: Gender and Sexuality in Popular Cinema. London: Routledge, 1998.
- Valenti, Jessica. The Purity Myth: How America's Obsession With Virginity is Hurting Young Women. Berkeley: Seal Press, 2009.
- Whelehan, Imelda. Overloaded: Popular Culture and the Future of Feminism. London: The Women's Press, 2000.
- Williams, Linda Ruth. The Erotic Thriller in Contemporary Cinema. Edinburgh: Edinburgh University Press, 2005.
- Wiseman, Rosalind. Queen Bees and Wannabes: Helping Your Daughter Survive Cliques, Boyfriends, Gossip, and Other Realities of Adolescence. New York: Three Rivers Press, 2003.
- Wurtzel, Elizabeth. Bitch: In Praise of Difficult Women. London: Quartet Books, 1999.

6

Butch Lesbians: Televising Female Masculinity

Helen Fenwick

Critical accounts of lesbian representation have been enduringly vexed by the contentious and polysemic status of the term "lesbian". As Judith Butler explains in "Imitation and Gender Insubordination", it is "permanently unclear what that sign [lesbian] signifies". While Butler embraces the freedom that this ambiguity represents, pointing to the fact that "identity categories tend to be instruments of regulatory regimes" (13-14), Elaine Marks has observed that "a sense of identity", however fictitious, remains essential to understanding the ways in which different identities are formed and interrogated within any given society (110; emphasis added). In exploring the nuances of lesbian representation, then, we need to establish "a sense of [lesbian] identity" in order to address key questions about on-screen images of lesbianism: How is lesbianism represented within visual culture? How, if at all, do representations of lesbians shape impressions of, and approaches to, lesbianism in wider society? Why does it matter if lesbians are represented in ways that are positive, negative, or even authentic?

The development of digital technologies has an important role to play in debates surrounding representations of lesbians on screen. The advent of systems that allow live programmes the same functionality as recorded ones and the growing popularity of online downloading and streaming has changed the way we consume television profoundly. Such developments have created a "new, demographically fragmented universe in which networks must compete" to attract audiences that are "composed of multiple minoritarian segments". According to Sasha Torres, this competitive environment can account, to some extent, for "the recent explosion of gay-themed programming" (399). As well as impacting on the content of the schedules in the way that Torres describes, the ease of access to global programming has also worked to

diminish anxieties that US television is eroding and endangering British broadcasting. Paul Rixon argues that in the present technological times, "the question should not be one of an alien culture invading our screens, but [one of] how American programmes work as part of our television culture" (50). It is clear that US programmes are no longer used to fill in the gaps between the "proper" programmes; rather, "American programmes are now attractions in their own right" (55) and contribute vitally to the shaping of European identity (Morley and Robins 57).

The rise of American quality television has been led by Home Box Office (HBO), a subscription channel which provides original programming to paying customers. As Marc Leverette acknowledges in his introduction to *It's Not TV*, "other networks have begun to imitate the HBO formula in terms of style and content", producing programmes that have the "HBO effect" (1). Showtime's *The L Word* (2004–09) is one such example of the HBO formula at work. The L Word was even marketed by Showtime under the slogan "Same Sex Different City", alluding to HBO's hugely successful show, Sex and the City (1998–2004). The HBO effect or formula stands on the economic foundations of the channel; being subscription-based, the channel can afford to take risks and provide viewers with programmes that they are "not ... willing to watch, but [which] they want to watch" (15). The viewers of HBO expect provocative and challenging content, and the channel has certainly delivered on its promise to be "Different and First" – its slogan from 1972 until 1978 (McCabe and Akass 88). While the popularity of HBO may have waned in recent years – most likely as result of new digital technologies – its commitment to producing provocative, original programming, such as Sex and the City and The Wire (2002–08), has percolated down to the other networks, leaving viewers with an increasing number of shows that they want to watch.

Before embarking on my analysis of the representation of the "butch" lesbian¹ in *The Wire*, I want to first consider the Showtime programme The L Word - a show that was screened in the United Kingdom in advance of The Wire and which actively follows the "HBO formula". In both The L Word and The Wire the portrayal of the butch lesbian is bound up with ideas about race.² While Samiya Bashir has referred to the black lesbian as the "big pink elephant in the middle of the room", on account of her prevailing underrepresentation in mainstream popular culture (20), the black *butch* lesbian is, perhaps, a less elusive figure. Light and dark have traditionally been used to symbolize the butch-femme dynamic: black lesbians are partnered, in the main, with lighter-skinned or white femmes. Indeed, as Anna Marie Smith observes, "it is often assumed that the black woman is, by nature, the butch" (214). On occasions when the white butch does appear within the field of visual representation, her identity is intimately linked to female-to-male transgenderism, without the tension of the "border wars... between these two modes of identification" (Halberstam 172). In light of this, it would appear to be easier for white heteronormative supremacy to accept transgenderism, which upholds traditional gender binaries, than to endorse the idea of white, butch lesbianism.

Following the notorious demise of the show Ellen (1994-98), the commercial success of an American mainstream show about lesbians seemed an unlikely prospect. In Ellen, both the character and the actor/comedian Ellen DeGeneres came out as lesbian and this, in turn, led to the show being cancelled. As the ABC President Roger Iger explained, Ellen was cancelled because it "became a programme about a character who was gay every single week, and ... that was too much for people" (qtd. in McCarthy 596). So what has changed since Iger made this remark in 1998 to allow *The L Word* to show characters being "gay every single week" without it being "too much"? The answer can be found in the two groundbreaking shows: Sex and the City and Queer as Folk (1999). Through their innovative depictions of female agency and male homosexuality respectively, these shows created a space on mainstream television where lesbian identities could emerge. The L Word is, to some extent, a hybrid of Sex and the City and Queer as Folk. According to Showtime's executive, Gary Levine, however, The L Word's "potential appeal" initially "rested on the understanding that lesbian sex...is a whole cottage industry for heterosexual men" (qtd. in Sedgwick xix). Although there are some attempts to run with a butch character, the show never escapes the demands of this heterosexual market, meaning that the bastion of white male masculinity remains secure.

In *The L Word* the butchness of the central character, Bette, is closely linked to her racial heritage. However, Bette can pass as a straight woman and as white, embodying the "social expectations of womanhood while simultaneously embodying butch ideology" (Farr and Degroult 428). *The L Word* thus implies a connection between butchness and blackness – a connection that is consolidated by the fact that Bette's partner, Tina, is a blonde femme. This strategy is reminiscent of the early lesbian film *Desert Hearts* (1985), where " 'hyperfemininity' and its 'butch' counterpart are constituted through a set of 'colour codings' which connote wider discourses of racial difference" (Stacey 105). The characters of Ivan and Moira/Max have the potential to introduce a

representation of the white butch into The L Word. However, the possibility of a white butch and its threat to white male masculinity vanishes into the issue of transgender, whereby an "Ivan who is fluid in gender identity disappears leaving a male-identified Ivan full of shame about his female body" (Moore and Schilt 167). This change in Ivan has the wider impact of averting a crisis in white masculinity and restoring the bluary distinction between male and female. This narrative is almost duplicated in a later season of the show through the character of Moira/Max, who initially presents as a white butch, but whose identity - like that of Ivan – is more clearly defined as transgender. Although Max does not disappear during the transitioning process in the way that Ivan does, what does disappear – in both cases – is the representation of white butch lesbians performing white female masculinity.

By Season Four, it is clear that the images of butch lesbians that predominate in The L Word are those which pose the least threat to white masculinity. The only stable image of the butch in *The L Word* is that of Tasha Williams, a young, African-American GI in the US military. Throughout the series, Tasha's butchness remains consistent and uncompromised, and this seems progressive within the context of the show.³ On closer consideration, however, this particular construction of butch identity remains conservative: the fact that Tasha is black not only means that she poses little threat to the supremacy of white male masculinity, but also connects her to prevailing stereotypes of the "unfeminine" black woman.4

As with any series, The L Word is bound by economic limitations and the need to keep the heterosexual audience engaged. Although the notion of white female masculinity is raised, then, it is simultaneously collapsed into the category of transgender – where the binary split between male and female is actively reasserted – before it can pose any tangible threat to the authority of white male masculinity. While it may be pleasurable to watch a butch lesbian being portrayed in an "authentic" way, the pleasure in watching the character of Tasha Williams is disturbed by the racist implications of show's decision to present her as black – especially given that the show is set, predominantly, in white America.

The Wire

The Wire is a Baltimore-based police drama that explores issues of institutional corruption within the intersecting spheres of politics, education, law, and the media. While the show investigates the interconnectedness of these institutions, it is equally committed to an analysis of the ways in which they impact on the day-to-day lives of the Baltimoreans, in particular those who live in poverty and deprivation.

Here, I would like to examine how the lesbian bodies of Detective Kima Greggs (Sonja Sohn) and Snoop (Felicia Pearson) are visualized in the series, and the wider impact this has in relation to lesbian representation. In her role as a detective, Kima is initially attached to the Narcotics Department, but is subsequently moved into the Homicide Unit. Snoop, on the other hand, is part of a criminal duo that engages in murder and intimidation on behalf of the drug lord Marlo. Sixteen minutes into the first episode of *The Wire*, "The Target", we are introduced to Kima's partner, Cheryl. By the end of this episode, then, Kima has been established as a black, butch police detective, with a live-in, middle-class, femme partner, who encourages Kima to study law.

If. as Ann Ciasullo attests, the "body or image that is [constantly] made invisible is the 'butch'", then the character of Kima necessarily contravenes dominant tendencies within the mainstream media through her sustained portrayal of female masculinity (578). If "we regularly punish those who fail to do their gender right", it might be supposed that Kima's subversion of gender conventions will be "corrected" through her eventual disappearance or demise (Butler 140). Kima, however, is not killed off; she not only survives for the show's five seasons, but survives as a black butch dyke who works on the side of law and order and lives with a black femme. Kima, in fact, is only ever coupled with a black femme - be it Cheryl or her nameless one-night stand. Given that Ciasullo has argued that "the femme body is...a white body", and the black lesbian "cannot be a femme" (597), The Wire marks itself out as progressive through its attempt to subvert and re-script of the traditional on-screen partnership of the black butch and the white femme.5

In "Mission Accomplished" (3.12) there are two scenes which epitomize *The Wire*'s approach to sex. The first of these takes place in the opening half of the episode and features Kima having a one-night stand with another black woman. Kima is shown sucking noisily on the breasts of her lover, who straddles her, while Kima's mobile phone rings – with a call from Cheryl – in the background. The second sex scene of the episode takes place between Cedric Daniels, a black police lieutenant attached to the Major Case Unit, and Rhonda Pearlman (or Ronnie), a white female attorney. This scene is intercut with scenes of another character, Dennis "Cutty" Wise, venting his own frustrations on a punch-bag in a gym across town. Although Kima is committing infidelity, while

Daniels and Ronnie are in a relationship, it is this second scene which is presented as illicit and erotic. Obviously speaking to the issue of miscegenation, this scene also comments on the lesbian sex scene that precedes it; in particular, it refuses to resort to the commonplace strategy – evidenced in *The L Word* – of presenting lesbian sex as titillating and instead reserves this effect for the heterosexual sex scene.

While Kima's sexuality is not the focus of the drama, she does not escape the oppression of homophobia. That said, the drama tends to use Kima's sexuality as a means of illuminating the ignorance and/or sensitivity of other characters. In an episode from the first season, Carver attempts to press Kima on the issue of her sexuality: "Kima if you don't mind me asking, when was it that you first figured that you liked women better than men?" Kima's retort – "I mind you asking" – immediately terminates the conversation, leaving the viewer in little doubt that her sexuality is not going to be the principal focus of *The Wire* (1.2). There are a few homophobic slurs in the early part of Season One, many of which are made by Kima's work colleagues behind her back, though these dissipate as her professional relationships evolve. However, when Marquis "Bird" Hilton is arrested for murder, he tells Kima to "suck my dick, dyke cunt", and refers to her as a "freak cunt eater" and an "ugly ass cunt eater". In this tirade of verbal abuse, Kima's sexuality is not only rendered visible, but is also – along with her gender – the subject of policing by Bird (1.7).

Towards the end of the first season, the institutionalized homophobia and racism of the Baltimore Police Department are signposted with increasing regularity. When Kima is shot during a covert operation. the Police Commissioner arrives on the scene and immediately assumes that the white Crime Scene Investigator is, in fact, Daniels. His apology reeks with the embarrassing insincerity that inflects his expressions of sympathy for Kima's injuries. This is evidenced further when Carver and Daniels are discussing "Kima's girl", whom Erve, Lieutenant Daniels' superior, assumes to be Kima's daughter, rather than her partner. Daniels, protecting Kima's privacy, explains to Erve that Cheryl is Kima's "room-mate". At this point, Erve approaches the Police Commissioner to request that he speak with Cheryl on behalf of the Baltimore Police. Although the viewer is not privy to this dialogue, it is clear that dealing with black lesbian lovers is not something with which the white, racist Police Commissioner is entirely comfortable and Erve comments to Daniels that he'll do it himself. In this scene, the homophobia for which Kima is a target is complexly entangled with the racism to which Daniels is subject. The ignorant attitudes of the Police Commissioner thus come to symbolize the bigotry that pervades the upper echelons of civic life, while also functioning to query the public legitimacy of the successful white male. At this point it is unclear whether Kima will live, or whether she will be "punished" for her performance of female masculinity, and the drama plays with the traditional expectation that "all dykes die".

Over the course of its five seasons, The Wire charts Kima's development into "true police". Kima negotiates this journey, in part, through her resistance to Cheryl's designs on her passing the bar and becoming a lawyer; not to mention through her narrow avoidance of McNultv's pathological drinking, womanizing, and professional rashness. In a scene from "The Cost" (1.10), Kima's identity as "true police" is humorously emphasized over and above her identity as a lesbian. Set in a bar, where Kima and Cheryl are socializing with their lesbian friends, this scene is plotted as a "coming out" scenario; here, however, it is Kima's status as "true police", rather than her already-established identity as a lesbian, that is subject to revelation. The only white lesbian present asks Kima how she knew she wanted to be a cop: "I mean how did you choose that? When you were little did you think about it at all?" This question echoes Carver's earlier attempts to probe Kima on the subject of her sexuality, though Kima here responds in full confessional mode. In revealing and rationalizing her identity as "true police", Kima satirizes the process of coming out as a lesbian and indirectly highlights the series' strategic eschewal of any conventional coming-out sequence.

The feminization of Kima is one of the methods by which the series simultaneously comments on and reinforces mainstream portrayals of lesbianism. In "The Cost" (1.10) Kima goes undercover as the feminine girlfriend of Orlando and comments that she is "looking the part too". Interestingly, it is when Kima performs this version of female femininity - and when her Southeast Asian looks are the subject of "traditional" eroticization - that she gets shot. In other words, it is as a feminine woman that Kima comes closest to being killed off. The only things that are killed off, however, are old stereotypes and expectations, as The Wire reverses the stale, if persistent, formula that "all dykes die". When Kima is funnelled into an office job after the shooting, she is routinely emasculated. She is ridiculed by Herc for being a "house cat" and "pussy whipped" (2.1), and her clothes reflect this domestication. Although this subversion of stereotypes may push boundaries, we are reminded that Kima is feminine enough to attract the heterosexual male. In one particular scene from Season Three, Kima walks away from Jay Landsman and Bunk, and they are both shown staring at her buttocks. "Man", Jay remarks, "I would murder that if she wasn't . . . ". As Jay's reflection trails off, Bunk weighs in, finishing his colleague's sentence with the word "particular" (3.4). There is no denying the humour here, but such scenes do appear to problematize the straightforward representation of Kima as butch. The reason for this feminization becomes clearer when the murderous Snoop enters the series in "Homecoming" (3.6). Snoop, after all, operates on the border between butch lesbian and transgender, necessitating the careful repositioning of Kima as the face of heterosexually acceptable lesbianism.

The character of Snoop ticks all the predictable boxes in relation to lesbian representation: she is black, butch, and a criminal.⁶ Described by Stephen King as "the most terrifying female villain to ever appear in a television series", Snoop's performance of female masculinity is monstrous yet comedic as she develops exaggeratedly "masculine" behaviours in order to compensate for her female body (para. 3). Like Kima, Snoop is not the tokenistic face of lesbianism in *The Wire*. Her character's story is not focused on sexuality; it is concerned with revealing how she has been shaped by her experiences within the institutions in Baltimore.

At first glance, Snoop's violent criminality seems to be at odds with her physical presentation as a petite, beautiful, doe-eyed young woman. Because she uses a gun to kill, her diminutive stature rarely interferes with her role as Marlo's henchwoman and over time she develops a reputation for extreme brutality. Indeed, by the end of Season Three, Snoop's notoriety is such that when she claims to be responsible for the murder of Stringer Bell - the second-in-command of the renowned Barksdale gang - she is believed readily and without question (3.12). Even the hardened criminal Hungry Man defecates in fear at the prospect of being tortured and killed at the hands of Snoop (5.4). Snoop's monstrosity takes on a distinctly gothic dimension in Season Four, when she and her partner, Chris, are rarely seen during daylight hours and are depicted, with increasing regularity, as silhouettes – easily recognizable on account of Snoop's exaggerated swagger. Indeed, in the opening credits of Season Four Snoop is shown in silhouette, sitting outside the empty houses where she entombs the victims that Chris, for the most part, murders. To Snoop, these killings are just a part of business, and are undertaken without emotion. Chris, in fact, takes a perverse care in making sure the kills are quick and clean for his victims. This theme of murder-as-a-job is highlighted through Snoop's dialogue. After liming and entombing one particular victim, she turns to Chris as they walk away from their "work", and enquires casually if he wants to "get some Chinese?" (4.8). By contrast, in "Misgivings" (4.10), Chris kills Michael's stepfather, who sexually abused Michael. This murder is extremely graphic, as Chris kicks and punches the man until he is dead, eschewing the execution-style method of killing that he and Snoop have made their signature. As she watches Chris's bare-knuckle attack, Snoop is forced to acknowledge the fact of her own "feminine" limitations. This silent acknowledgement is granted open articulation in her final scene: Snoop's last question to Michael, as she prepares for him to shoot her, is "how's my hair?" (5.9).

Snoop's status as a monster is often convergent – perhaps predictably – with her status as a woman, and in "Soft Eyes" (4.2) she is situated explicitly in relation to the institution of motherhood. In one particular sequence, Snoop is shown training young boys how to shoot a gun. While this is grossly irresponsible on a number of levels, the fact that Snoop's "lesson" takes place within the benign greenery of a local park implies its status as an act of nurture: like a mother, Snoop is equipping her charges with the skills they need to survive in the dangerous world of Baltimore's "corners" (4.8). On other occasions, Snoop's palpable monstrosity is offset by humour, much of which ensues from the discontinuity between her status as a woman and her "masculine" presentation. In order to operate effectively in the criminal world of Baltimore, after all, Snoop needs to override traditional gender stereotypes: she needs to be tougher than the men, talk more "gangsta" than the men, and have a swagger to match. When Snoop is shown buying a nail gun at a large hardware outlet in the opening episode of Season Four, for example, her comic dialogue with the salesman, as they talk at cross-purposes about the effectiveness of different products, serves to distract the viewer from the grim use to which the nail gun will doubtlessly be put (4.1). Similarly, when Chris kills Michael's stepfather with his bare hands, Snoop relieves the horror of the scene with a characteristically affectless statement: "Damn, you didn't even wait to get the mother-fucker in the house".

Throughout its five series, *The Wire* avoids representing its lesbian characters solely in terms of their sexuality. Kima's journey is not presented as a journey of sexual self-discovery, but as a journey in which she establishes her status as "true police". Snoop, on the other hand, is never even shown with a sexual partner, and only once in the series does she mention "pussy", giving a subtle nod to her sexual preference. Although, in some respects, Snoop does adhere to the conventional model of the black butch lesbian, her monstrosity is not ascribable to

these aspects of her identity, but to the fact she is a product of the failing and corrupt institutions by which Baltimore is governed. While The Wire's treatment of same-sex desire does begin to trouble viewers' traditional expectations of what lesbian characters can be and do, it would be misleading to situate the show as a representational utopia in which these expectations are wholly subverted or reversed. On this point. It is noteworthy that the only queer to make it through the series unscathed by injury is Rawls, who we see in a flitting moment in a gay bar in "Reformation" (3.10). Ultimately, then, it is the figure of the white (closeted) male who remains at the helm of Baltimorean institutional life, leaving the standard balance of patriarchal power fundamentally unchallenged.

Conclusion

Since the late 1990s, fictional representations of lesbianism on British and American television have increased exponentially, and lesbian characters are now staple features of soap operas, sitcoms, and costume dramas. The portrayal of female masculinity – and white female masculinity in particular – is probably the last taboo of lesbian representation. As I have already suggested, this is largely a result of the implicit threat that the butch poses to the structures of masculine (and patriarchal) authority – a threat which is rendered particularly proximate in the figure of the white butch – who, as a white woman, already enjoys greater access to these structures than her non-white counterparts. While The Wire does not shy away from the representation of female masculinity, it represents black female masculinity, consolidating existing links between blackness and butchness. Still, given that the series is set in Baltimore, where the majority of the population is black, such representations do not emerge as being particularly stereotypical – especially in light of the fact that lesbianism is only ever represented as one facet of the characters' identities. Yet for all the progressiveness of The Wire, the continued supremacy of Rawls – a powerful white man – functions as a strategic reminder of the resilience of white patriarchy, and throws any powers accorded to Kima or Snoop into stark relief. In redefining the parameters of lesbian representation, then, *The Wire* also telegraphs the persistence of discrimination, stressing the need for an ongoing interrogation of existing power structures and underlining the continued role that feminism has to play in accounting for the complex renderings of female identity in contemporary culture.

Notes

- 1. Butch-femme identities have often been understood as imitating the perceived dynamics of heterosexual relationships. Attempts to define butch-femme identity positions against this dominant construction emerged in the late 1980s and early 1990s. Judith Butler acknowledges a level of heterosexual imitation within butch-femme roles, but this derivativeness is used to displace heterosexual norms through subversion and illuminate the mechanics of gender constructions. See "Imitation and Gender Insubordination" (1991).
- 2. In *Female Masculinity* Judith Halberstam is consistently attentive to the complex ways in which racial stereotypes inform cultural representations of the butch lesbian. For Halberstam, images of the black butch are "particularly complicated locations" that "may all too easily resonate with racial stereotyping in which white forms of femininity represent a cultural norm and nonwhite femininities are measured as excessive or inadequate in relation to that norm". In line with my own argument, however, Halberstam also contends that the "butch of color" might also possess "the power to defamiliarize white masculinity and make visible a potent fusion of alternative masculinity and alternative sexuality" (180–81).
- 3. For a fuller discussion of Hollywood and femininity, see Dyer.
- 4. In Debra Wilson's 2003 documentary on black butch women, *Butch Mystique*, several of the women interviewed report feeling as though they are regularly perceived not as black women, but as black men.
- 5. This is evident in the 1991 film *Salmonberries* where the Native American butch is partnered with a blonde white femme. For a discussion of race, gender, and sexuality in *Salmonberries*, see Allen.
- 6. For a fuller analysis of blackness, butchness, and criminality, see Halberstam 114–16. See also Halberstam's discussion of Queen Latifah's "gangsta butch" in Gary Gray's Set it Off (1996) in Female Masculinity 227–29.
- 7. See Wiltz and HBO's biography of Snoop http://www.hbo.com/thewire/cast/actors/felicia_person.shtml. [Accessed May 10, 2009].

Works cited

Allen, Louise. "Salmonberries: Consuming k.d. lang". Immortal Invisible: Lesbians and the Moving Image. Ed. Tamsin Wilson. London: Routledge, 1995. 70–84.
 Bashir, Samiya. "Fear of a Black Lesbian Planet". Curve. February 1, 2001. 20–22.

Butler, Judith. *Gender Trouble: Feminism and the Subversion of Identity*. New York: Routledge, 1990.

"Imitation and Gender Insubordination". *Inside/Out: Lesbian Theories, Gay Theories*. Ed. Diana Fuss. London: Routledge, 1991. 13–31.

Ciasullo, Ann M. "Making Her (In)Visible: Cultural Representations of Lesbianism and the Lesbian Body in the 1990s". *Feminist Studies* 27.3 (2001): 577–608.

Desert Hearts. Dir. Donna Deitch. 1985.

Dyer, Richard. White. London and New York: Routledge, 1997.

Fuss, Diana. Essentially Speaking: Feminism, Nature and Difference. New York: Routledge, 1989.

Halberstam, Judith. Female Masculinity. Durham, N.C.; London: Duke UP, 1998. King, Stephen. "Setting Off a 'Wire' Alarm". Entertainment Weekly 894 (2006). http://www.ew.com/ew/article/0,,1333799,00.html. [Accessed May 10, 2009].

Leverette, Marc, Brian L. Ott, and Cara Louise Buckley, eds. It's Not TV: Watching HBO in the Post-Television Era. New York: Routledge, 2008.

Marks, Elaine. "Feminism's Wake". Boundary 2 12.2 (Winter 1984): 99-110.

McCabe, Janet, and Kim Akass. "It's Not TV, It's HBO's Original Programming: Producing Quality TV". It's Not TV: Watching HBO in the Post-Television Era. Ed. Marc Leverette, Brian L. Ott, and Cara Louise Buckley. New York: Routledge, 2008, 83-93,

McCarthy, Anna. "Ellen: Making Queer Television History". GLQ 7.4 (2001): 593-620.

Moore, Candace, and Kristen Schilt. "Is She Man Enough?: Female Masculinities on The L Word". Reading The L Word: Outing Contemporary Television. Ed. Kim Akass, and Janet McCabe. London; New York: IB Tauris, 2006. 159-71.

Morley, David, and Kevin Robins. Spaces of Identity: Global Media, Electronic Landscapes and Cultural Boundaries, London: Routledge, 1995.

Rich, B. Ruby, "When Difference is (more than) Skin Deep". Queer Looks: Perspectives on Lesbian and Gay Film and Video. Ed. Martha Gever, John Greyson, and Pratibha Parmar. London: Routledge, 1993. 318-39.

Rixon, Paul. "The Changing Face of American Television Programmes on British Screens". Quality Popular Television. Ed. Mark Jancovich, and James Lyons. London: British Film Institute, 2003. 48-59.

Sedgwick, Eve Kosofsky. "Foreword". Reading The L Word: Outing Contemporary Television. Ed. Kim Akass, and Janet McCabe. London; New York: IB Tauris, 2006. xix-xxiv.

Sinfield, Alan. Cultural Politics - Queer Reading. 2nd edn. New York: Routledge,

Smith, Anna Marie. "'By Women, For Women and About Women' Rules OK? The Impossibility of Visual Soliloquy". A Queer Romance: Lesbian, Gay Men and Popular Culture. Ed. Paul Burston, and Colin Richardson. London: Routledge, 1995.

Stacey, Jackie. "Desert Hearts and the Lesbian Romance Film". Immortal Invisible: Lesbians and the Moving Image. Ed. Tamsin Wilton. London: Routledge, 1995. The L Word. Showtime (2004-09).

The Wire. HBO (2002-08).

- 1.2. "The Detail". Dir. Clark Johnson. June 9, 2002.
- 1.7. "One Arrest". Dir. Joe Chappelle. July 21, 2002.
- 1.10. "The Cost". Dir. Brad Anderson. August 11, 2002.
- 2.1. "Ebb Tide". Dir. Ed Bianchi. June 1, 2003.
- 3.4. "Hamsterdam". Dir. Ernest Dickerson. October 10, 2004.
- 3.6. "Homecoming". Dir. Leslie Libman. October 31, 2004.
- 3.10. "Reformation". Dir. Christine Moore. November 28, 2004.
- 3.12. "Mission Accomplished". Dir. Ernest Dickerson. December 19, 2004.
- 4.1. "Boys of Summer". Dir. Joe Chappelle. September 10, 2006.
- 4.2. "Soft Eyes". Dir. Christine Moore. September 17, 2006.
- 4.8. "Corner Boys". Dir. Agnieszka Holland. November 5, 2006.
- 4.10. "Misgivings". Dir. Ernest Dickerson. November 19, 2006.

102 Sex and Sexuality

- 5.4. "Transitions". Dir. Daniel Attias. January 27, 2008.
- 5.9. "Late Editions". Dir. Joe Chappelle. March 2, 2008.
- Torres, Sasha. "Television and Race". *A Companion to Television*. Ed. Janet Wasko. Malden, MA: Blackwell, 2005. 399–408.
- Wiltz, Teresa. "The Role of Her Life". Washington Post. March 16, 2007. http://www.washingtonpost.com/wp-dyn/content/article/2007/03/15/AR2007031501664.html. [Accessed May 10, 2009].

7

"Challenging and Alternative": Screening Queer Girls on Channel 4

Martin Zeller-Jacques

While in the early history of television, lesbians, when present at all, "were only seen as an 'issue' – a 'subject' up for analysis", the growth of digital media culture has greatly increased the quantity of televised representations of lesbians, often as recurring characters, or even as series protagonists (Collis 120-21). This mainstreaming of lesbian representations has significant implications for the discourse around lesbian visibility, which has been a major staple of feminist and queer critiques of television over the last several decades. In particular, such mainstreaming offers us the opportunity to explore some of the complex entanglements that surround lesbian visibility, many of which are neglected in critical analyses that imply the polarization of visibility and invisibility, and transgression and containment. Rather than investigating the effects of lesbian visibility "in the media" or "on television", it is imperative to examine particular trends in representation and to situate these within the wider mediated culture. For example, visibility on a subscription, quality television programme like Showtime's The L Word (2004-09) surely comes with different costs, and different representational freedoms, than visibility on a network sitcom like Ellen (1994–98). While some of these pressures will be registered in the text, others demand to be theorized on their own terms. Thus, current studies of lesbian visibility need to provide contextualized examinations of texts, which ask what costs, and what freedoms, might be incurred through representation on different media platforms.

In this chapter, I analyse recent representations of lesbians on the Channel 4 and E4 teen dramas *Sugar Rush* (2005–06) and *Skins* (2007–) through the lens of the Channel 4 Corporation's public service remit. Subject to the competing pressures of a public service obligation and an

overcrowded commercial sector, Channel 4 and its subsidiaries represent a unique television ecosystem that promotes a degree of lesbian and gay visibility at the same time as it imposes particular limitations on that visibility. These Channel 4 programmes, I argue, understand lesbian visibility - especially teen lesbian visibility - as challenging content. More specifically, though, they use this content to attract a young, lucrative demographic, while also fulfilling the terms of a public service remit that implicitly regards the provision of gay and lesbian visibility as a public service, regardless of the qualities of that visibility. As a result, these programmes construct a "post-lesbian" environment for their characters, in which a certain type of normative lesbian is accepted and almost all sexual choices are presented as entirely valid, so long as they do nothing to disrupt the fundamental unity of the normative structures of family. friendship, and the monogamous sexual relationship. 1 In creating this safe space for the representation of lesbians, Channel 4 contributes to the "double-entanglement" of postfeminist media culture, in which

neo-conservative values in relation to gender, sexuality and family life [are combined] with processes of liberalisation in regard to choice and diversity in domestic, sexual and kinship relations. It also encompasses the co-existence of feminism as at some level transformed into a form of Gramscian common sense.

(McRobbie 255-56)

As we will see, *Sugar Rush* and *Skins* are caught firmly in this double entanglement, as they reaffirm their lesbian characters' commitment to family and friendship groups, while valorizing their personal expressions of sexuality. This emphasis on personal choice leads to "the almost total evacuation of notions of politics or cultural influence... [as] every aspect of life is refracted through the idea of personal choice and self-determination" (Gill 260). In fact, the figure of the queer teen girl in *Sugar Rush* and *Skins* is profoundly apolitical. Rather than challenging and alternative, this figure is thoroughly contained within Channel 4's public service context, the normative structures of couples and families, and a contemporary media culture that is now comfortable with this well-defined, "common sense" vision of lesbian sexuality.

Channel 4: Public service and queer broadcasting

Channel 4 has a special place in the history of British broadcast television. Its creation, as an alternative to the broad, mainstream address

provided by the BBC and ITV, helped to usher in a time of increased variety in television provision, and thus increased viewer choice. Channel 4's original remit required it to cater to tastes not catered for by other terrestrial channels, and "to encourage innovation and experiment in the form and content of programmes" ("Broadcasting Act, 1981" 11.1). Subsequent legislation has further refined this remit, requiring the corporation to address "the tastes and interests of a culturally diverse society", and to contribute "programmes of an educational nature and other programmes of educative value" ("Communications Act, 2003" 265.3). Taken together, these responsibilities have given Channel 4 what Maggie Brown refers to as "a license to be different". Dorothy Hobson, too, suggests that the "main theoretical analysis which explains both the difficulties and triumphs of Channel 4 is the concept of difference" (192). Even today, Channel 4's marketing discourse emphasizes its "challenging and alternative" programming - and its consequent appeal to younger viewers – as its chief distinguishing characteristic ("Why Advertise on Channel 4?" para. 3 of 4). In the current media climate, Channel 4's brand is also strengthened by its associated digital television channels: More4, Film4 and E4. As part of the umbrella structure of the Channel 4 Corporation, each of these contributes to Channel 4's public service remit, although the manner in which they do so is left largely to the discretion of the corporation. Originally subscription services, all three channels were changed into commercial, free-to-air digital stations as part of Chairman Andy Duncan's project to keep Channel 4's public service remit at the forefront of its activities, even in the multi-channel environment. This strategy necessarily implies that simply spreading access is seen as helping to serve the public (Brown 293–97).

However it fulfils its public service role in the contemporary digital environment, Channel 4's "license to be different" has enabled it to engage with racial, social, and sexual minorities in a way that earlier terrestrial television channels had not. If, in its early days, this commitment to diversity grew out of the channel's public service remit, it now has a sound basis in the commercial logic of contemporary television. As television bandwidth has increased over the past several decades, the intense competition for audiences has led broadcasters to pursue programming strategies which target small, but lucrative, demographics and promote easily identifiable brands.² Thus, Channel 4's task of distinguishing itself, already inscribed in its charter, is also encouraged by the commercial conditions in which the channel now must operate. Consequently, Channel 4 works to strengthen its established brand as a provider of "difference". Its yearly review documents highlight this

aspect of its programming by publishing polls that show Channel 4 beating all of Britain's other terrestrial television channels in categories like "Covers ground other channels wouldn't" and "Caters for audiences other channels don't cater for" (Lygo, "Channel 4 Annual Review. 2007" 6). Meanwhile, its reputation for difference is maintained by the channel's willingness to showcase the lifestyles of racial, sexual, and social minorities, a programming tactic which helps Channel 4 to reach beyond these minorities and target some of their most lucrative markets. Ron Becker has charted the way that American networks have used gay and lesbian visibility in order to target a socially liberal demographic. arguing that appealing to discourses of multiculturalism and celebrating diversity became a way of reaching the "selectively affluent" consumers desired by advertisers (81–96). Channel 4's strategy of branding itself as "challenging and alternative" television is based on a similar logic: its showcasing of gav-themed programming is used to promote its reputation for difference and attract its young target audience. Brown offers an example of this dynamic at work, writing that Queer as Folk. Channel 4's most famously successful gay drama, was not so much marketed as "gay programming" as "anti-establishment programming": "Middleaged women were shown the tapes, their shocked reactions recorded and used in radio commercials.... When Becks lager withdrew its sponsorship, the marketing department was jubilant: still more press coverage" (233). Both Sugar Rush and Skins rely on a similar strategy, exploiting a music-video aesthetic and foregrounding the explicit sex, drug use, and frank treatment of homosexuality in the programmes. In this way, these shows mark themselves out as "anti-establishment" and thus begin to court their young target audience.

The politics of this approach, however, need to be problematized, in terms of both public service and commercial contexts. First of all, if the representation of lesbian characters is prescribed by the channel's public service commitment to diversity and difference, then the quality of that visibility becomes, implicitly, a secondary concern. As Amy Villarejo writes, "[t]o promote portraits of lesbian lives is to promote representational presence in public cultures and therefore to heighten public authority" (14). Thus, Channel 4's requirement to represent diversity reinforces the power of the public service television channel, and the state which empowers it, to set the terms of representation, both for lesbians and for other minorities. Historically, mainstream representations of lesbians have been, in Ann Ciasullo's terms, both "heterosexualized... via the femme body... [and] because the representation of desire between two women is usually suppressed... de-homosexualized" (578).

Channel 4's "license to be different" allows it to move past this older formulation and to produce texts which not only engage with lesbian desire, but centralize it. However, because these texts tend to be underlain by the assumption that the explicit is inherently challenging, they often trade on forms of representation that are predicated upon explicit sexuality rather than challenging politics. Channel 4's programming may be unafraid to showcase lesbian desire, but the desire it showcases is limited to sexual desire. It stops short of representing the desire for equal treatment, for social status, for alternative ways of living, and implicitly equates lesbian identity to lesbian sex. Secondly, if the representation of homosexuality is deemed commercially valuable because it is considered inherently "challenging and alternative", then the programmes which take part in that representation help to reinscribe an othering of homosexuals. In other words, while Channel 4 identifies homosexuality as transgressive, it also, simultaneously, contains its transgressive potential by presenting it within the "challenging and alternative" (yet publicly sanctioned) space of Channel 4 itself.

However, as representations of queer girl sexuality, Sugar Rush and Skins are marked by more than their presentation on a public service broadcaster. Both texts feature predominantly teenaged casts and focus on the social and sexual development of their teenage characters; they must also, therefore, be understood as teen texts. Davis and Dickinson point out that, whatever the investment of their audiences, "teen shows"

are created by adults, arguably with a particular adult agenda. In the broadest sense this might be: to educate and inform while entertaining...to set certain agendas at this delicate time just prior to the onset of a more prominent citizenship; and/or to raise crucial issues (of adult choosing) in a "responsible manner" that is entirely hegemonically negotiated. (3; emphasis in original)

One of the "crucial issues" so frequently raised in teen television is the thorny question of sexuality. As Ben Gove reminds us, "adult framings of pre-adult sexuality always involve an uneasy use of discursive power, for the adult show of interest immediately implicates the framer in what she/he frames" (177). The adult role in the creation of these teen texts cannot help but leave its ideological mark: the representation of queer teens is always and already caught in the crossfire of hegemonic discourses which frame ideas of "the teenager" and ideas of "the queer". Davis himself points this out, noting that Karen Lury's characterization

of teenagers as "being opposed to a dominant or mainstream culture" (12) "could be seen as analogous to that of queers: that is as outside the mainstream, not wishing to be compromised by the representational regime of the popular medium" (Davis 130–31). However, Channel 4's representations of lesbian teens seem less concerned with the lesbian part of that identity than with the teen. In fact, Channel 4's programmes represent the lesbian teen as a profoundly *un*-remarkable sexual subject. Rather than being marked by difference due to her sexuality, she is just like everyone else around her as she negotiates a matrix of personal and sexual behaviours, constantly exploring and reconstructing her own subjectivity. In fact, in both Sugar Rush and Skins, she makes these negotiations somewhat more successfully than her heteronormative peers, and is thus positioned as a fulfilled and fully realized subject by the end of the narrative. Susan Driver has commented on a tendency in contemporary culture for girls in general, and queer girls in particular, to be regarded as exemplary neo-liberal subjects:

A convergence of popular, commercial, and theoretical discourses valorizing the nonfixity of girls intersects with public representations of queer girls as not only fathomable but symbolically special and convenient in displaying the unique uncertainties of adolescent desires. (7)

In this way, the non-fixity of the lesbian teen, who is unfailingly represented as socially and sexually flexible, comes to stand for the more general non-fixity that is characteristic of contemporary subjectivity. However, in emphasizing the importance of the lesbian teen as subject, these programmes also depoliticize her. Even if the representations in question are sometimes genuinely novel, the effect of this discourse of subjectivity is all too familiar. In a broad summary of typical trends in the representation of gays and lesbians in the media, Bonnie Dow comments that they "all contribute to the conclusion that homosexuality is relevant almost exclusively for its impact on personal relationships. and moreover, that the most important personal relationships a gay or lesbian character has are those s/he has with heterosexuals" (100–01). Since Channel 4's lesbian teens exist in a more generally heterosexual milieu, their sexuality is typically represented as important only insofar as it disrupts their relationships with family and friends. Dow suggests that this kind of emphasis on the personal allows such programmes to elide the political, ignoring the real-world problems of discrimination and prejudice.

As I have mentioned above, Channel 4's lesbian teens exist in what we might call a "post-lesbian" space. Their identity as lesbians, and the questions it might raise, is sidelined in favour of the more generic valorization of personal, sexual choice. Wolfe and Roripaugh have noted popular and scholarly trends towards post-lesbian representation, observing that such perspectives "centre primarily around a perceived need to uncouple lesbian and feminist identities, as well as a desire to dismantle, usurp, and transgress against prior generations' identitarian formations of lesbian identity" (213). This tendency, amply evidenced in both Sugar Rush and Skins, has the benefit of breaking down stereotypical representations of lesbians, but still elides questions around identity politics. Ultimately, it often manifests in the form of lesbian characters who are indistinguishable from their heterosexual peers, except when they are in the act of desiring, or having sex with, other women. As a result, all that is left which might be transgressive in these texts is the presence of lesbian sex itself; as I have argued above, however, this content is also rendered safe through its confinement to the publicly sanctioned, commercially lucrative, and "challenging and alternative" Channel 4.

Lesbian teens on Channel 4: Sugar Rush and Skins

I have argued that Channel 4's public service remit and commercial imperatives will direct its representations of lesbian lives in particular, apolitical directions. In the following analyses of Sugar Rush and Skins, I hope to demonstrate some of the parameters of those representations, which typically validate a singular, relatively conservative form of lesbian subjectivity – one which is entirely compatible with other forms of orthodox, neo-liberal subjectivity. Both of these programmes value personal choice above personal identity, and thus portray the problems of their characters' sexuality as personal or family problems. Significantly, this is no different to the treatment of any other character in the narrative. Being a lesbian, these texts imply, is morally and practically equivalent to being black, or poor, or having divorced parents, or living with a mental illness. In their attempts to avoid all of the potential restrictions of these categories of identity, both Sugar Rush and Skins risk a dangerous levelling in their representations - rendering all difference as the same kind of obstacle to the free, subjective choice which is represented as ideal.

Sugar Rush follows the late teenage years of Kim, a self-identified "15-year-old queer virgin", as she explores her burgeoning "sexual obsession" with Maria "Sugar" Sweet. Set in Brighton, where Kim and her family have just moved, the programme chronicles the way the family is tested and redefined as a result of its proximity to Brighton's culture of relatively free (queer) sexual morality. Throughout the show's run, the family struggles to cohere, briefly breaks apart, and is ultimately reconstituted in order to make room for the wide variety of non-normative sexual practices of its various members. During this time Kim eventually comes out, develops a brief sexual relationship with Sugar, and ultimately enters into a committed relationship with Saint, the owner of a local sex-shop. Kim's experiences are aligned to the equally tortuous sexual journeys of her parents, Nathan and Stella, her brother Matt, and the eponymous Sugar. These journeys involve infidelity, bondage, swinging, abstinence, cross-dressing, date-rape, anal sex, and more, prompting Kim to ask herself, "Why is everyone so fucked up about sex?" (1.1). It is this question that the rest of the series sets itself to answering.

In its representation of lesbian teens, Sugar Rush employs two strategies, both of which valorize the independence and subjectivity of the lesbian teen, while simultaneously setting boundaries around her choices. The first and most consistent strategy is best described as "normalization-through-juxtaposition". Amidst the vast variety of sexual practices engaged in by the characters in Sugar Rush, lesbian sexuality is presented as something ordinary and unsurprising. Next to Stella's infidelity, or Sugar's penchant for allowing herself to be taken advantage of, Kim's lesbianism is consistently shown to be both relatively "normal" and entirely consistent with the healthy functioning of the nuclear family. The second strategy is perhaps more familiar, involving another juxtaposition – this time of "good" lesbians against "bad" ones. Here. Kim and Saint's model of lesbian subjectivity, which is white, middleclass, femme, and monogamous, is opposed to alternative models of lesbian subjectivity, sometimes characterized as frumpy, sometimes as predatory, but always as ultimately unhealthy or undesirable. Through this combination of representational strategies, Sugar Rush constructs a post-lesbian space in which Kim is free to explore and express her sexuality, but where the hegemony of the nuclear family and the monogamous couple is never really in doubt.

The strategy of normalization through juxtaposition is best exemplified by an episode late in the second season (2.8). By this time Kim has come out to her parents and is involved in a committed relationship with the sex-shop owner, Saint. Although her parents are (relatively) comfortable with her sexuality, they are also pushing their children to exhibit more traditional family values, and for this reason Kim remains

reluctant to tell them that Saint owns a sex shop. Unbeknownst to Kim, however, Nathan's recent penchant for "family" activities stems from the fact that, while he and Stella claim to be attending marriage counselling, they are actually visiting swingers' parties. He thus overcompensates, first by inviting Kim and Saint to a wholesome family dinner, and then, paradoxically, by chastising his teenage son, Matt, for cross-dressing. All of this sets in motion a farcical chain of events; of course, Nathan and Stella's parties are supplied by Saint's sex shop, and through a series of coincidences, both Kim and Saint arrive at one of the parties just in time to see Nathan and Stella collapse in a heap beneath a shoddily assembled sex-swing. During the later family lunch, the power dynamic shifts so that it is not Kim and Saint who feel interrogated, but Nathan and Stella. All of a sudden, sex has invaded the family home. It is present during lunch when Nathan asks Saint if she would like "breast or thigh", and in the fact that Matt now openly wears a pair of metallic gold pumps at the dinner table. As a result of the revelation that Kim's parents are attending a swingers' party, then, the discovery that Saint is running the party, and works in a sex shop, becomes normalized. In fact, Saint, as the party organizer, becomes analogous to the fictional marriage counsellor that Nathan and Stella claimed to be seeing, a figure of wisdom and a source of support for the nuclear family.

Perhaps the most marked example of Sugar Rush's strategy of normalization-through-juxtaposition is evidenced by an event which does not appear in the programme at all. Despite being one of the few television programmes to focus explicitly and unremittingly on the development of a single lesbian character, Sugar Rush features no scene of Kim's "coming out" to her family. The first season ends without Kim telling any major character, other than Sugar, about her sexuality, and the second begins with Kim openly gay and with her parents largely, if awkwardly, supportive.

If the coming-out scene has been a staple of lesbian film narratives from Personal Best (1982) and Desert Hearts (1985) to Kissing Jessica Stein (2001), then its role in television is, perhaps, less clearly established. Within film, the coming-out scene is often used as a narrative crux; it is a way of organizing narratives about lesbian identity and a means of signalling a character's final realization of that identity. Still, as a number of critics have noted, the heavy stress that filmmakers have placed on coming out - and its presentation as a "positive and healthy action" can work to "[reduce] the importance, and even the imperative, of the action of coming out" (Bronski 23). In contrast to film, with its obvious time constraints, the serial nature of television shows like Sugar Rush,

Skins, and *The L Word* would seem to present programme makers with an opportunity to look beyond "the action of coming out" in order to examine the lives of lesbian characters in more complex, sustained, and groundbreaking ways.

The elision of Kim's coming out seems to occur because it happened at the same time as a number of other events that were more integral to the progression of the narrative. In the final episode of the first season of Sugar Rush (1.10), Sugar and Kim flee from Brighton in order to hide Sugar from the police and to get Kim away from her parents' deteriorating marriage. During their escape to London, Sugar and Kim become partners in crime, stealing credit cards and staying together at an expensive hotel, where they drink champagne in the penthouse suite and make love for the first and only time. Thus, Kim's first consummated sexual experience has its transgressive force normalized by the many other, much more transgressive activities in which she is involved when it occurs. When her parents come to pick her up, Kim's involvement in a stabbing, several thefts, and running away are foremost in their minds: her sexuality is secondary. The only reason we know that it must have been discussed is that, when we first see her in Season Two, Kim is out and proud. More than any actual event in the narrative, the absence of a coming-out scene works to portray Kim's lesbian sexuality as important only in regard to its potential to disrupt the nuclear family; since the rest of the narrative attempts to demonstrate the polymorphous perversity of that same nuclear family, Kim's lesbianism is drained of its transgressive potential.

In addition to comparing Kim to her family, Sugar Rush juxtaposes Kim's performance of lesbian sexuality with those of other lesbians, creating a neat binary of "good" and "bad" lesbians. This comparison is not accomplished, as might be expected, through the well-worn categories of butch and femme; without exception. Sugar Rush's lesbians are femme.4 In fact, Sugar Rush judges its lesbians based upon their performance of normative femininity and monogamous sexuality, representing Kim and Saint as superior to other lesbians by virtue of their conventional appearance and committed relationship. This is accomplished chiefly through the pair's interactions with several other lesbian characters during the second season of Sugar Rush. The most significant of these are Anna, a predatory older woman who picks up teenage girls, and Melissa, a bookish, young lesbian who is politically aware, but sexually inexperienced. Whereas Kim and Saint are presented as ideal, normative lesbians, capable of moving easily within heterosexual society, Anna and Melissa are stigmatized through their failure to

satisfactorily perform, respectively, monogamy and femininity. Thus, while Sugar Rush celebrates the sanctioned, monogamous sexual desire of Kim and Saint, the desires of Anna and Melissa are mocked, or pathologized, and serve as obstacles to the central characters.

Anna, the first woman with whom Kim has sex as an adult, is the most openly vilified character in Sugar Rush. An attractive, middle-aged femme, her encounter with Kim comes after a dizzying night at a local lesbian club. The sex scene is treated briefly, with a pumping pop song insisting "I've fallen in love again", as Kim looks out upon the lights of Brighton. Anna then treats Kim to a bout of cocaine-fuelled cunnilingus, and the next morning dresses Kim in her school uniform in order to enact a predictable S&M fantasy. Although this is initially played for laughs, especially when Kim's parents catch them in the act, the audience's potential discomfort with the scene is given voice by Sugar. Siding with Kim's angry father, on hearing the story she denounces Anna as "some filthy old perv". It is not the association with casual drug use or paedophilia, however, which condemns Anna in the show's diegesis; in fact, she is only confirmed as a villain when she makes it clear to Kim that she was only interested in a one-night stand. Kim is devastated, and Anna, now referred to as the "psycho-bitch", becomes Kim's touchstone for everything undesirable in a sexual partner. In pointed contrast to Anna's villainy, the most obviously comic of the lesbian characters in Sugar Rush is Melissa, Kim's college classmate. Referred to in the voiceover as an "uber-geek", she shares some superficial physical similarities with Kim, but is socially awkward and makes no effort to appear conventionally attractive. Melissa is the only character in Sugar Rush to even gesture towards a wider discourse around lesbian identity, and even this is couched as a joke, as she invites Kim around to see "her Jeanette Wintersons" (2.2). Due to her frumpy appearance, Melissa is portrayed as chronically undesirable, and her advances towards Kim are framed as ridiculous. Finally, she is dismissed as more prey for Anna, as Sugar Rush unites both of its models of the undesirable lesbian, the more easily to dismiss them.

Meanwhile, Sugar Rush offers an exemplar of its approved performance of lesbianism in the form of Saint. Slightly tomboyish, but still unmistakably femme, Saint is portrayed, from the moment of her introduction, as a confident woman in full control of her own sexuality. When she first bumps into Kim on the Brighton promenade, the crate she is carrying spills its contents: an assortment of multi-coloured dildos and other sex-toys. In a programme which often seems to equate sexuality solely with sexual activity, Saint's puissance with sex paraphernalia

is the ultimate sign of her secure sexual identity. At the same time, though, Saint's life experience is portrayed as being even more important than her sexual experience. Early in their relationship (2.3), Kim and Saint take a lunch date at Saint's apartment just above the Munch Box. Assuming that the date's purpose is sexual, Kim worries: "What if she had accessories I'd never seen? What if I couldn't strap them on right? What if I put the wrong end in the wrong place?" We are offered just a glimpse of the imaginary scene, with Saint dressed in bondage gear and a black veil, brandishing a riding crop and ordering Kim to use a variety of arcane sex-toys, which is then contrasted with the actuality of Saint, casually dressed, making sandwiches and tea. When the pair do make love, Saint sets Kim at ease by explicitly opposing their soft, consensual lovemaking to Kim's previous experience with Anna. Reassuring Kim that "We don't have to do anything". Saint exhibits a less aggressive mode of lesbian sexuality, allowing Kim gently to take the lead. In contrast to the earlier scene of Kim's night with Anna, this scene is suffused with soft music and the camera remains relatively still, focusing on the faces of both girls as Kim runs her fingers along Saint's thigh, then strokes her hand and face. Instead of the cuts and dissolves that characterized the scene with Anna, we have simple hand-cam shots which pan or zoom to capture small moments: Saint running her finger along the edge of Kim's bra, or staring in wonder at her bare stomach. As Saint kisses Kim's torso, the shot dissolves and reverses the girls' positions, with Saint lying on her back and Kim kissing her way up Saint's body and into shot, creating the sense of mutual sexual experience. The scene is altogether quieter and gentler, and finishes with Kim's relieved exhalation: "That wasn't half as scary as I thought it was gonna be". Given the context in which Sugar Rush was broadcast. it is difficult not to read Kim's remark as indicative of the attitude of Channel 4 itself: satisfied that it has provided a public service in the form of lesbian visibility, yet relieved that nothing too transgressive has taken place.

Taken together, these two strategies help to construct the post-lesbian space of *Sugar Rush*. Coupled with the permissive atmosphere of the programme's Brighton setting and the outright stigmatization of alternative modes of lesbian identity, the juxtaposition of Kim and Saint's monogamous, apolitical sexuality with the hedonistic (and equally apolitical) sexuality of Kim's family promotes an atmosphere in which sex and sexuality are one and the same. For Kim and Saint, being a lesbian means nothing more than sexually desiring women – but rather than moving them towards a transgressive, queer disavowal of homo-normativity,

this leads them towards the adoption of the entirely conventional model of normative monogamy.

In contrast to Sugar Rush, Skins, as an ensemble drama, presents lesbian teens as a small part of a wider narrative, but still partakes of a similar dynamic, which on the one hand normalizes them through comparison with other teens, and on the other valorizes their sexuality as a product of personal choice rather than identitarian discourses. Focusing on the lives of a group of British sixth-formers, Skins unapologetically celebrates teenage sex, drug-use, and alcohol abuse as aspects of a universal teen culture that cuts across the boundaries of race, gender, and sexuality. Thus, unlike Sugar Rush, it does not merely ignore identity politics; rather, it actively sets itself against them, asserting "teen" as an identity category capable of superseding Queer, Asian, Muslim, or any other. In its third season, Skins returned to its setting but followed a new group of sixth-form students. Among the new cohort of characters introduced by the show are the quiet Emily (identical twin of the more popular, and seemingly much less intelligent, Katie) and the indie-outcast, Naomi. Throughout the course of the third season of Skins, Emily and Naomi develop a tentative romance. Although Naomi enters sixth form stigmatized as a lesbian, having supposedly made a pass at Emily years before, it quickly becomes clear that Emily not only initiated that contact, but is the more certain of the two about her own sexual feelings for girls. Naomi, on the other hand, is harder to read, and certainly more cautious. Although clearly attracted to Emily, it takes several episodes and a plate of drugged brownies before Naomi and Emily kiss again. This sparks a series of tense exchanges, first between the two would-be lovers, and later involving Emily's family, who are concerned that Naomi's influence will shatter the (supposedly) close relationship between Emily and her twin sister, Katie.

The first significant example of normalization through juxtaposition occurs in relation to Emily and Naomi when they finally do consummate their romance (3.6). Despite a central narrative conceit in which each episode of *Skins* is focalized through a different character, the sex scenes in the third season are almost exclusive in their representation of hard, fast, unsentimental, heterosexual sex. In contrast, Emily and Naomi's coupling focuses on slow, small details, such as holding hands, or removing an article of clothing. The first quasi-sexual contact is made through "blow-backs", the sharing of the smoke from a joint. This offers the viewer a coy image of the girls kissing behind their hands, which are held up to keep in the smoke and to mask this private moment. As their passions escalate the camera focuses solely on Naomi as she reaches

her climax. This emphasis on the softness, slowness, and pleasure of sex is in marked contrast to the rough and ready sexual encounters of other episodes, which are often constructed as moments of desolation, especially for the girls involved. As in *Sugar Rush*, then, a tender, monogamous mode of lesbian sexuality is valorized. Here, however, it is not set in contrast to other modes of lesbian sexuality, but to the coarse, loveless heterosexual sexuality of *Skins'* other teens.

Throughout the series, Emily's sexuality is not only defined in relation to the sexual practices of other characters, but in relation to more broadly defined personal practices as well. In the episode following her sexual encounter with Naomi, Emily visits a local psychiatrist (3.7). There she runs into JJ, a character with an unspecified mental illness which causes him to become "locked on" when upset. Both Emily and JJ have been prescribed the same pills (Sitro-Tesic-Ulbaceous-Neoprenes [STUN]) for their "conditions", and both express their contempt for the treatment. Yet even while disavowing the adult world's treatment of Emily, Skins reaffirms it, allowing her insight into the way JJ thinks and feels, and explicitly linking her abnormal sexuality to his abnormal personality. Emily seems immediately to understand JJ, and is able to stop his emotional outbursts, something previously managed only by his best friend, Freddy. Ultimately, this connection allows Emily the opportunity to demonstrate to JJ the power of subjectivity over identity when she offers to make love to him. When he is suspicious of the offer, because he knows she is gay, she retorts, "I'm lots of things, JJ, and I really like you". This highlights the performativity of both Emily's sexuality and JJ's disability, implying that, if Emily can choose whether or not to act gay, JJ can choose whether or not to act "autistic". This comes perilously close to the advice of JJ's uncaring doctor, who tells him, when he begins to worry or feel upset, "Just don't". In its valorization of personal choice and interpersonal equality, then, Skins is happy to explode identity categories indiscriminately, regarding them as uniformly constrictive and hierarchical.

Skins unites the strategy of normalization through juxtaposition with the rejection of narrow identitarian categories in the exchanges between Katie and Emily. Throughout the series they are contrasted to one another, with Katie dressing in revealing, "trashy" clothes and aggressively pursuing social success, while Emily is quiet and academically successful. The opposition between the twins is brought to a head in the penultimate episode of the third season when Emily, frustrated with Naomi's refusal to acknowledge their relationship, outs herself to her family (3.9). Appearing at the dinner table, bedraggled and upset, Emily

responds to her family's insistent questioning with the truth: "I've been making love to a girl. Okay? Everybody satisfied?...Her name's Naomi. She's rather beautiful. So I was nailing her". So shocked are Emily's family by her declaration, and her appropriation of the coarse, masculine word, "nailing", that they react as if she's joking. Even Katie, who has previously seen Emily and Naomi kissing (3.4), later accuses Emily of having concocted a relationship with Naomi because she is jealous of the attention Katie gets from boys. Emily, however, attacks the consequences of Katie's supposedly normal behaviour, reminding her sister of the beating she recently received at the hands of her boyfriend's ex-girlfriend: "I'm stupid because I don't let anyone fuck me when they're in love with somebody else.... That's a normal relationship, isn't it? She fucked you up good, didn't she? Nobody hits me over the head with a rock" (3.9). By questioning the foundation of Katie's self-image, her skilful performance of normative femininity, Emily explicitly restates the critique already posed by her sexuality. If Katie's femininity no longer provides her with success and happiness, and Emily's lesbianism no longer stigmatizes her, or leads to unhappiness, the foundation of the twins' mutual identity is called into question. Moreover, since the twins effectively form a kind of controlled pairing, in which the single factor which truly separates them is their sexuality, Emily's superiority to her sister implicitly queries the value of normative femininity itself.

Ultimately, however, *Skins* shies away from such a broad interpretation, instead remaining on the safe ground of personal choice. The final episode of Season Three sees Katie carrying the incestuous suggestion of her rivalry with Naomi to its logical conclusion as she coerces Emily into accompanying her to the end-of-year "Love Ball". Wearing matching dresses with coordinated hair and makeup, the twins' attire loudly proclaims a unity which is quickly shattered by Naomi's arrival. This opposition – between an identity so innate that it marks Emily from birth and a sexual preference so particular that it may extend little farther than Naomi – is fully articulated in the final scene of the episode. Here, Emily and Katie literally wrestle out their differences in the middle of the ballroom, with Emily defeating her sister, but still helping her to her feet. Emily then tears off the matching dress and explains to her sister that: "I love you, and I'll never really leave you. And I can't fix us. I like girls. No, I like a girl. No, I love her...ok? I love (pointing at Naomi) her. Okay?" Emily thus avoids any explicit avowal of sexuality, transferring her desire from girls in general to Naomi in particular. She constructs her love for Naomi as a personal choice, and one

that should not come into conflict with her identity as Katie's twin. This micro-personal treatment of Emily's sexuality is emblematic of *Skins'* general approach to subjectivity, and, more specifically, its wholesale rejection of identity categories in favour of the related ideals of self-determination and individuality.

As the visibility of lesbians in the mainstream media becomes ever more regularized, it remains important for us to continue interrogating the costs of that visibility, while acknowledging the powers and the pressures at work in different media outlets. In both Sugar Rush and Skins, then, the lesbian teen is presented first and foremost as a teen like any other, though in her negotiation of the difficult terrain of personal subjectivity, she leads the way for others who seem less certain of what they want. Her sexual choices are celebrated, but she is careful not to transgress against the hegemonic structures of family and friendship. within which she remains bound. Moreover, this type of representation is encouraged, if not mandated, by the complex network of competing discourses at work in Channel 4 as a broadcaster, as it seeks to attract an audience, fulfil a public service remit, and educate its teenage audience. Thus, even while Channel 4 encourages the expansion of lesbian visibility, its nature as a channel limits the quality of that representation, circumscribing any discussion of lesbian identity within a carefully constructed post-lesbian environment and confining its potentially transgressive images of lesbian sexuality to a publicly sanctioned forum for "challenging and alternative" content.

Notes

- 1. See Wolfe and Roripaugh.
- 2. See Rogers et al.
- 3. For full episode details, see "Works Cited".
- 4. Helen Fenwick discusses the conventions of butch/femme representation on television in "Butch Lesbians: Televising Female Masculinity" (in this book).

Works cited

Becker, R. *Gay TV and Straight America*. New Brunswick, NJ and London: Rutgers University Press, 2006.

"Broadcasting Act, 1981". Office of Public Sector Information. http://www.england-legislation.hmso.gov.uk/RevisedStatutes/Acts/ukpga/1981/cukpga_19810068_en_1. [Accessed June 15, 2009].

Bronski, M. "Positive Images and the Coming Out Film: The Art and Politics of Lesbian and Gay Cinema". *Cineaste* 26.1 (2000): 20–26.

Brown, M. A Licence to be Different: The Story of Channel 4. London: BFI Publishing, 2007.

Brunsdon, C., and L. Spigel, eds. Feminist Television Criticism: A Reader. 2nd edn. Maidenhead, UK: Open University Press, 2008.

Ciasullo, Ann M. "Making Her (In) Visible: Cultural Representations of Lesbianism and the Lesbian Body in the 1990s". Feminist Studies 27.3 (2001): 577-608.

Collis, Rose. "Screened Out: Lesbians and Television". Daring to Dissent; Lesbian Culture From Margin to Mainstream. Ed. Liz Gibbs. London: Cassell, 1994.

"Communications Act, 2003". Office of Public Sector Information. http://www. opsi.gov.uk/acts/acts2003/ukpga_20030021_en_1. [Accessed June 15, 2009].

Davis, G. "Saying it Out Loud: Revealing Television's Queer Teens". Teen TV: Genre, Consumption and Identity. Ed. G. Davis, and K. Dickinson. London: BFI Publishing, 2004.

Davis, G., and K. Dickinson, eds. Teen TV: Genre, Consumption and Identity. London: BFI Publishing, 2004. 127-40.

Dow, B. "Ellen, Television and the Politics of Gay and Lesbian Visibility". Feminist Television Criticism: A Reader. 2nd edn. Ed. C. Brunsdon, and L. Spigel. Maidenhead, UK: Open University Press, 2008. 93-110.

Driver, S. Queer Girls and Popular Culture: Reading, Resisting, and Creating Media. New York: Peter Lang, 2007.

Ellen (1994-98), ABC.

Gill, R. Gender and the Media. Cambridge, Polity, 2007.

Gove, B. "Framing Gay Youth". Screen 37.2 (1996): 174-92.

Hobson, D. Channel 4: The Early Years and the Jeremy Isaacs Legacy. IB Tauris: London and New York, 2008.

The L Word (2004–09). Showtime.

Lury, K. British Youth Television: Cynicism and Enchantment. Oxford: Clarendon Press, 2001.

Lygo, K. "Channel 4 Annual Review, 2007". http://www.channel4.com/about4/ programmepolicy.html. [Accessed June 15, 2009].

—. "Channel 4 Statement of Promises, 2008". http://www.channel4.com/ about4/programmepolicy.html. [Accessed June 15, 2009].

McRobbie, A. "Post-feminism and Popular Culture". Feminist Media Studies 4.3 (2004): 255-64.

Rogers, M., et al. "The Sopranos as HBO Brand Equity: The Art of Commerce in the Age of Digital Reproduction". Ed. D. Lavery. This Thing of Ours: Investigating the Sopranos. Columbia University Press: New York, 2002. 42-57.

Skins. E4 and Channel 4 (2007-).

- 3.4. "Pandora". Dir. Simon Massey. February 12, 2009.
- 3.6. "Naomi". Dir. Simon Massey. February 28, 2009.
- 3.7. "JJ". Dir. Charles Martin. March 5, 2009.
- 3.9. "Katie and Emily". Dir. Charles Martin. March 19, 2009.

Sugar Rush. Channel 4 (2005–06).

- 1.1. Dir. Sean Grundy. June 7, 2005.
- 1.10. Dir. Harry Bradbeer. August 2, 2005.
- 2.2. Dir. Harry Bradbeer. June 15, 2006.

- 2.3. Dir. Harry Bradbeer. June 22, 2006.
- 2.8. Dir. Philip John. July 20, 2006.
- Villarejo, A. *Lesbian Rule: Cultural Criticism and the Value of Desire.* Durham: Duke University Press, 2003.
- "Why Advertise on Channel 4?" Channel 4 Sales. http://www.channel4sales.com/platforms/Channel + 4. [Accessed June 15, 2009].
- Wolfe, S., and L. Roripaugh "The (In)visible Lesbian: Anxieties of Representation in *The L Word*". Ed. C. Brunsdon, and L. Spigel. *Feminist Television Criticism: A Reader*. 2nd edn. Maidenhead, UK: Open University Press, 2008. 211–18.

Part III Makeovers

8

Under the Knife: Feminism and Cosmetic Surgery in Contemporary Culture

Stéphanie Genz

"There are no ugly women, just lazy ones", Helena Rubinstein once said, highlighting that beauty is essentially women's work and responsibility. Indeed, the seemingly intrinsic links between womanhood and the desire for beauty have long been upheld by patriarchal discourses that seek to characterize women in relation to their looks, thereby consigning them to the status of objects, to be looked at, displayed, and bought. At the same time as beauty has been championed by patriarchy as a route to female, or rather feminine, success, it has also been criticized by waves of feminist writers who unmask its manipulative, constraining, and mutilating aspects. From Mary Wollstonecraft's feminist classic The Vindication of the Rights of Woman (1792) to Naomi Wolf's bestselling The Beauty Myth (1991), feminists have called out for female enlightenment and liberation from the "gilt cage" of beauty, denouncing whatever pleasure and power women believe that beauty accords them (Wollstonecraft 113). In effect, one of the most iconic events that brought (second wave) feminism to public attention - the demonstration that the New York Radical Women's group staged at the Miss America beauty pageant in Atlantic City in 1968 - was conceived as a direct attack on the beauty industry and an attempt at collective consciousness-raising, designed to engender a feminist-inspired realization of oppressive standards for (feminine) appearance.¹ In this sense, feminist activism and consciousness-raising were meant to bring forth a more enlightened, emancipated and "authentic" femaleness that defines itself in opposition to male-identified femininity and beauty.²

What makes beauty – and women's involvement therein – so treacherous and precarious in feminists' eyes is precisely that it does not come without its benefits and seductions; historically, beauty has functioned

as a "patriarchal invitation to power" that confers onto (mostly white, heterosexual, middle-class) women a number of social privileges and economic gains (Lorde 118). Liberal feminist critics like Betty Friedan refer to this as "the pretty lie of the feminine mystique" or femininity's "protective shade" (180, 208), while radical feminists like Mary Daly maintain that patriarchy has colonized women's (even feminists') heads to such an extent that it "prepossesses" them and inspires them with "false selves" (322). To combat this stealthy colonization ("the pig in the head"), Daly urges her readers to free "the Hag within" and become "wild women" - a process she describes in terms of a radical defeminization and exorcism, an undoing of femininity and an "unravelling of the hood of patriarchal woman-hood" (343, 15, 409). For these feminist writers, women are oppressed not only from the outside by institutional, political, societal, and cultural directives and norms, but also, more insidiously, they are victims of their personal beliefs and self-understanding, caught in "the prison of their own minds" (Friedan 265). In these accounts, a woman's feminist awakening is intimately connected to an acceptance of victimization, a growing awareness of alienation, and a willingness to wage war against those parts of society and her self that have undermined her attempts at freedom. Consciousness-raising is thus predicated on a differentiation between "real" femaleness and "false" femininity whereby women are encouraged to relinquish those harmful and "inauthentic" elements and practices that bind them to feminine beauty and adopt a state of selfdivision and suspicion, of "being radically alienated from her world and often divided against herself" (Bartky 21).

This feminist mode of argument is unequivocal in its outlook and message: beauty is depicted as a culturally and socially constructed lure, whose perpetrator is patriarchy and whose victims are women. It is a sexualized form of dehumanization that is institutionalized and systematic, a "form of obedience to patriarchy" that reduces women to mere bodily beings who are cut off from a fully human existence, from autonomy, agency, and independent thought (80). Everything that helps to perpetuate or facilitate this objectification of women – that reinstates and regulates norms of female embodiment and comportment – is similarly condemned, from the so-called "instruments of female torture" (bras, curlers, false eyelashes, wigs) that were thrown into the "freedom trash can" at the Miss America protest in 1968 to more modern and progressively high-tech beauty practices. The feminist focus on the risks and oppression inherent in beauty routines has given rise to a now widely held belief that feminists are "enemies of the stiletto heel" who,

in a gesture of political activism, discard the mask of femininity in an attempt to refuse patriarchy's gaze (41).

In this chapter, I suggest that this line of reasoning has become increasingly problematic and difficult to sustain, particularly since the advent of postfeminism and its celebration of femininity as a source of empowerment. Postfeminism stands feminism's critique of beauty on its head by claiming femininity as a route to female power and - in contrast to earlier liberal and radical feminist analyses – authenticity. In postfeminist rhetoric, the feminine body is no longer envisioned as a site of manipulation and feminist "disidentification", whereby women who adopt beauty regimes are necessarily understood as victims or – even worse – as co-conspirators of patriarchy (McRobbie 255). The postfeminist feminine body questions the causal link between beauty, oppression, and inauthenticity by highlighting a paradoxical form of female/feminine embodiment that is experienced as "authentic" while being (self) created. In effect, authenticity emerges as a new discursive ideal in postfeminist media culture that stresses the possibility of self-realization in the absence of essentialist conceptualizations of the self. This is especially apparent in contemporary forms of "lifestyle television" and surgical makeover shows that are premised around the notions of transformation and renewal.³ In this case, authenticity comes to acquire a range of different meanings, being at once an indicator of individual agency and choice while also becoming linked to consumerist ideologies and a postmodern visuality that privileges surface over interiority. As I will go on to argue, the construction of a "real" self in cosmetic surgery makeover shows is now fully incorporated in a postmodern, consumer-orientated world in which self-image is inextricably bound to physical appearance, and where authenticity is converted into a saleable commodity. Moreover, I will investigate how the paradox of the makeover genre allows us to shed light on what Young has identified as a crucial contradiction inherent in feminine embodiment and its surgical reconstructions: the tension between the female subject as embodied agent and the female body as object. The surgical makeover show thus provides us with a new medium and lens through which the long-standing question "Is beauty good or bad for women?" can be re-evaluated, while also offering an opportunity to complicate existing feminist approaches to cosmetic surgery.

To begin, I would like to revisit some of the ideas that have structured the debates on cosmetic surgery and feminist responses to it. Cosmetic surgery has witnessed an unprecedented boom in recent years with a growing number of people opting to change their bodies surgically; in

Britain alone, £1 billion was spent on cosmetic surgery and treatments in 2008 (Williams 7). The term "cosmetic surgery" (instead of "aesthetic" or "plastic surgery") already firmly establishes this field of medicine as a predominantly feminine or feminized site. Indeed, women in particular are drawn to the modern culture of chirurgia decoratoria that instructs the individual to remake herself in the pursuit of social success, desirability. and, above all, "happiness". According to the rates of inflation published by the British Association of Aesthetic Plastic Surgeons (BAAPS), the majority of cosmetic surgery is carried out on women (91%), with breast augmentation remaining the most popular "job" among the 34,000 procedures in 2008.4 One clinic was even reported to offer one-hour breast implant operations that can be performed in the patient's lunch hour. The procedure (which costs £4500 and is done under local anaesthetic) was hailed by the owner of the clinic (Medispa in Cheshire) as a revolutionary development in breast enlargement surgery: "You walk into hospital and within hours you are walking out. Professional women haven't got time to spend lying in hospital.... In years to come the lunch time boob job will be happening across the industry" (qtd. in Kumi). Cosmetic surgery is normalized and "domesticated" in this way as a "perfectly natural, affordable, routine procedure", which women especially are encouraged to embrace as an expression of individual pleasure and consumer sovereignty (Tait 119; Douglas 266). As Sue Tait notes, this is part of a "post-feminist surgical imaginary" that values individual consumption as a means to empower the gendered body (124, 120).

Cosmetic surgery's popularity and normalization are not only the result of increased availability and surgical developments but also of sustained media coverage. From newspaper articles to televisual makeover shows (including Nip/Tuck [2003–10], The Swan [2004], Extreme Makeover [2002–07], and Ten Years Younger [2004–], to name but a few), cosmetic surgery has been popularized as a new "lifestyle" option available to seemingly everyone in a postfeminist, neo-liberal society.⁵ Nowadays, it seems that achieving a Brand New You (2005) (the title of another makeover show broadcast on British television) has become a feasible possibility and choice, achievable through the magic of modern-day fairy godmothers who appear to participants in the form of cosmetic surgeons, dentists, nutritionists, fitness gurus, beauticians, and fashion stylists. In recent years, these televised makeovers have become increasingly more radical, invasive, and time-consuming - from Trinny and Susannah's infamous breast-grabbing and fashion advice on What Not to Wear (BBC 2001-07) to more extensive life and body transformations

that can take months, and even years, to accomplish. The makeover paradigm thus emerges as a crucial feature of postfeminist media culture whereby the "idiom of reinvention" can be applied to every aspect of our social world, from homes and gardens to clothing, cleanliness, and raising children (Gill 262; Lewis 441). As Tania Lewis summarizes, the classic personal makeover format often starts with a surprise visit to the home or workplace of the participant; the "makeoveree's" deficiencies – whether in the areas of taste, health, appearance, or broader life management issues – are then diagnosed by the show's experts before s/he undergoes a series of procedures and a lifestyle regime (442). The climax of each episode consists of the "reveal" - a narrative moment employed by almost all televisual makeover shows that is reminiscent of a fairytale trope⁶ – when the transformed candidate is shown his/her new self and restored to family and friends.

In the cosmetic surgery variant of the makeover paradigm, the focus on (mostly female) bodies underlines the gendered nature of this medical field, as the majority of these shows circle around the construction of a particular norm of feminine beauty which is, as Brenda Weber observes, white, heterosexual, and middle class. In Sarah Banet-Weiser's and Laura Portwood-Stacer's eyes, the end result of such cosmetic surgery programmes is a flawless, idealized kind of femininity that is inherently racist, sexist, and classist: "makeover shows continue to reinforce a certain dominant beauty ideal when they literally cut away physical features that deviate from this ideal" (264). They insist that the outcome of these shows constitutes a kind of "mainstreaming", as the new, improved self conforms "even more readily to dominant norms". This leads Banet-Weiser and Portwood-Stacer to the conclusion that the "'celebration' of the body, the pleasure of transformation and individual empowerment function as a justification for a renewed objectification" and a "more intense policing" of female bodies (267, 257, 263). While I do not deny that most candidates emerge from their makeover process more feminine or feminized, for me the vital ingredient and key to the makeover shows' continuing appeal and success is the articulation not just of a normatively beautiful body but of a more authentic feminine self that understands empowerment as an effect of consumption and firmly binds (self-) identity to representation. The makeover genre constructs a version of femininity that while still dependent on the body as a site of female power – severs its former associations with inauthenticity/falseness and reframes appearance as a location of individual choice and agency. In this sense, the (female) body is no longer conceived merely as a two-dimensional image

that simply reflects back patriarchal meanings and norms; contrastingly, the corporeal surface acquires a centrality in makeover shows whereby authenticity – itself a crucial theme and component of reality television⁸ – is expressed through (feminine) embodiment and – in the course of becoming feminized and televised – is turned into a marketable commodity. The emphasis on feminine authenticity, rather than physical beauty, also helps to account for recent scheduling changes on British television that see shows based around fashion advice, such as *What Not to Wear*, being cancelled in favour of more psychologically orientated programmes like *How to Look Good Naked* (Channel 4 2006–) in which presenter Gok Wan tells the makeoverees that fashion can be "life-changing", that being better dressed can make you into "a happier, more fulfilled, better person".⁹

Similarly, in the documentary-style Brand New You, participants do not just experience a superficial makeover and fashion fix; rather, they are carving into their own flesh to overcome past traumas, kick-start a new, more rewarding, life, and discover a more authentic identity that has been hiding inside their bodies and can only be brought to light by the surgeon's scalpel. In one episode (broadcast on 12 June 2007), the viewer is introduced to 48-year-old Penny Wilkinson from Winchester who, we are told, looks 20 years older: "Smoking, childbirth and bad genes have ravaged her face and body". The solution is extreme but effective: Penny is whisked off to Los Angeles for a \$200,000 makeover that includes facial and dental surgery, a marathon 10-hour operation, oxygen therapy, a diet and exercise regime, a tummy tuck, and a couture dress. Penny continues to remind the viewing public how grateful she is for her 4-month transformation: "I feel guilty that I am getting everything I asked for", she declares at the beginning of her journey. Throughout her painful surgical interventions, she keeps reiterating how "absolutely ecstatic" she is "about being able to do this". Her surgeons also confirm that she has made the right decision: "When you go home, people won't even know who you are", her dentist tells her after he has reshaped and whitened her teeth. At her "reveal" party, we are presented with a "brand new" Penny: dressed in a couture gown, with a new face and body, she is greeted by her surgeons' and instructors' exclamations of how "amazing" and "beautiful" she is. Penny herself cannot believe her luck and concludes by saying how "deliriously happy" she is.

What are we to make of the surgical makeover that produces a seemingly more confident, content, and self-assured individual? Does cosmetic surgery have the potential to bring about such a state of delirious happiness, as we are led to believe by the programme, or is this

a case of self-induced delirium? The show itself leaves no room for doubt, depicting the participant's transformation as the creation of a better self, a more proactive, determined, and courageous identity. The opening sequence conveys this message of increased freedom, using the almost-biblical image of two hands releasing a white dove, supposedly representative of the new self that is set free by the hands of the sur geons. As Cressida Heyes has argued, "in this context, cosmetic surgery is less about becoming beautiful, and more about becoming oneself" (21; emphasis in original). The makeover show sidesteps the notion of beauty, then, by focusing on the patient's "inner truth" - an "inner truth" that is not, at the outset, aligned with her bodily appearance. While feminine beauty is still visibly achieved in these programmes, it is not acknowledged as the driving force that motivates these transformations. Instead, cosmetic surgery is seen as a strategy to bring a deviant and unrepresentative body into line with the inner beauty and strength that hide behind its unshapely contours. Accordingly, as Sadie Wearing suggests, the logic of cosmetic surgery makeover shows is predicated on "the assumption of a psychic split between the 'inner self' and the body, which can be rectified by expert...intervention" (289). The goal of these programmes, then, becomes not so much the creation of a beautiful body but "the externalisation of a supposedly more authentic inner self": as Gareth Palmer puts it, "you are what 'you appear to be'" (qtd. in Roberts 242). Rather than just being vain, the women seeking cosmetic surgery are portrayed as "enterprising" selves who are engaged in a project of self-realization and actively use their determination to change their bodies and improve their lives. 10

Not surprisingly, feminist writers have been wary of readings of cosmetic surgery that present appearance as the basis of identity and have thus identified a number of motives for women going "under the knife". Equally, the question of authenticity has produced a range of different interpretations and raised a series of questions, most specifically with regard to its undeniable connections to commodification: feminists who are critical of femininity/beauty have attacked the idea that the post-operative body can be the site of an "authentic" female self. The surgically refashioned face and body have been read as patriarchal inscriptions that signal an oppressed subjectivity that also bears the hallmark of individualist, consumerist capitalism. As Anne Balsamo notes, this presupposes "romantic conceptions of the 'natural' body", a pre-inscriptive body that is uncontaminated by cultural, patriarchal, and economic scripts (79). Holliday and Sanchez Taylor agree, noting that "feminists have come to celebrate the 'natural' body: beauty is associated with decoration and adornment, and the natural body strips these accoutrements away", leading to a "rejection by feminism of the enhanced body" (185). The discourse of surgically constructed, feminine authenticity is similarly discarded as the profitable creation of a capitalist market economy that sells the idea of an authentic female self in its effort to interpellate women in their capacity as consumers.¹¹

Other critics working within postmodern and performative frameworks have highlighted the liberating and democratic possibilities of viewing the body as text. In her study of the body in Western culture, Susan Bordo notes that "the postmodern body is no body at all" and she invokes "plasticity" as a postmodern paradigm, celebrating a newly imagined condition of human freedom from bodily determination (229). Following postmodernism's deconstruction of the humanist self, the status of the body as a fixed, unitary, and natural given has been transformed into a malleable construct, an object of work to be fixed and improved. The "natural" body (if we can still use this term) is presented as nothing more than the starting point of a person's "identity project", which potentially leads to an intriguing distinction between the naturally defective body and its authentic, textually mediated counterpart. Some critics, such as John Fiske, have extended the idea of bodily construction to a radical suggestion that thoroughly "textualizes" the body and thereby eradicates its historicity and materiality. The notion of the body as pure text has been criticized for the way in which it masks the body's historical, social, and cultural links. Teresa Ebert, for example, argues that "to engage in the textual play of postmodernism, taking the body (as an inscriptive surface) as the text to play with is 'romantic'" (34) – a view which is in direct contrast with Balsamo's previous identification of a feminist nostalgia for a "natural", pre-inscriptive body. Ebert goes on to locate textual play within a masculinist tradition, implicating it in the power structures which reinforce patriarchy and capitalism. Instead of plastic multiplicity, the body operates in a highly restricted realm of cultural plasticity that reconstructs the bodily frame according to eminently ideological standards of physical appearance.

As might be evident from these diverse theoretical positions on the body, cosmetic surgery has been the subject of an equally complex and varied critical history. While Banet-Weiser and Portwood-Stacer insist that "it is difficult for feminists *not* to theorize the cultural practice of cosmetic surgery – and especially its televisual expression – as anything short of objectifying and alienating" (262), others have highlighted that this is a modern democratic (albeit capitalist) solution to a most undemocratic problem. In *Flesh Wounds* (2003), Virginia Blum makes

the point that once beauty turns out to be surgical, "something any of us can have for the purchase, then we are no longer in thrall" (259). In this context, we can vaguely distinguish between two main critical strands that can be grouped, rather presumptively, into the "yes, but" and "no, but" camps. On the one hand, we have critics like Kathy Davis and Sander Gilman who focus on the potentially liberating aspects of cosmctic surgery, exploring how patients use it as a resource to protest against the constraints of the "given" in their embodied existence. As Davis suggests, "cosmetic surgery may be, first and foremost about...taking one's life into one's hands, and determining how much suffering is fair" (23). These commentators do not deny the existence of cultural and social restrictions but they advocate a pragmatic, consumeroriented approach to the constraints that their bodies impose on their lives.

By contrast, critics who adopt a "no, but" approach are generally more sceptical about the benefits of cosmetic surgery, while still seeking to attribute some degree of agency to this medical practice. This is mainly the position of writers who adopt a Foucauldian framework to analyse cosmetic surgery as a form of normalization, characterized by a paradoxical effect whereby it acts in both constraining and enabling ways. In *Discipline and Punish* (1977), Foucault describes the "power of the norm" in terms of its two functions: "In a sense", he writes, "the power of normalization imposes homogeneity; but it [also] individualizes" (184). The concept of normalization can be usefully employed to explain the disciplinary powers inherent in cosmetic surgery and the televisual makeover. Brand New You provides an example of the homogenizing aspects of normalization, as the participants' bodies are measured for their deviation from the norms of heterosexual desirability. In the episode previously mentioned, the makeoveree is told that "she is not a perfect 10", and the purpose of her extensive transformation is to narrow the gap between the perceived inadequacy of her old self and the more feminine sphere into which she aspires to move. At the same time, normalization also provides an opportunity for individualization as it promises the eradication of self-loathing and the release of a more authentic identity. As the Brand New You contestant asserts at the end of the programme, she is "finding it much easier to look in the mirror" and her makeover "will allow [her] to lead a more normal life". Ultimately, however, writers in this camp remain highly critical of the amount of agency and choice enabled by cosmetic surgery. Kathryn Morgan voices these concerns, noting that "while the technology of cosmetic surgery could clearly be used to create and celebrate idiosyncrasy, eccentricity,

and uniqueness, it is obvious that this is not how it is presently being used" (35). In effect, "choice" could be nothing more than "necessity", whereby "elective cosmetic surgery ... is becoming the norm" and those "women who contemplate not using cosmetic surgery will increasingly be stigmatized and seen as deviant" (28; emphasis in original). This is one of the challenges posed by the rhetoric of choice: what looks like individual empowerment, agency, and self-determination can also signal conformity and docility. Rosemary Gillespie refers to this as "the paradox of choice": "The decision whether or not to undergo cosmetic surgery clearly involves individual choice, yet the concept of choice is itself enmeshed in social and cultural norms" (79).

Similarly, I propose that critics seeking to come to terms with this contradictory medical practice - and its expression on reality television – face equally paradoxical choices: Do we keep our intellectual and feminist authority intact, but thereby risk victimizing cosmetic surgery patients by subjecting them to what has come to be known as "the cultural dope approach"? Or, do we accept their agency and maybe endanger our feminist beliefs and any attendant critique of beauty norms? Moreover, how do we account for the commodified version of femininity that is produced through the makeover genre - with its explicit blurring of surface and depth, appearance and identity - once and for all? Rather than interpreting this development despairingly as a postfeminist elision of critique and a displacement of feminism (Tait 123), I maintain that the surgical makeover show provides an opportunity to confront the contradictions and possibilities inherent in commodity culture and its construction of femininity and authenticity. The cosmetic surgery makeover presents us with a rich site for examining the shifting dynamics of selfhood and the conjunction of "citizen" and "consumer" in late modern societies (Roberts 228). What this amounts to is a call for a more nuanced and comprehensive understanding of postfeminist agency that addresses citizens' choices of/and identities within the context of neo-liberal consumer cultures that value individualist conceptions of empowerment and depict authenticity as an effect of representation and consumption.¹² Perhaps, then, the challenge of our "paradox of choice" as feminist critics is to interrogate the usefulness of our own theoretical and ideological paradigms, the preconceptions that ultimately determine how we interpret cosmetic surgery and makeover shows. In this sense, "choice" stands for an ongoing debate which acknowledges that simple divisions between feminism and femininity, embodiment and authenticity, consumption and critique are just as likely to limit our enquiries as to enhance them.

Notes

- 1. For a detailed analysis of the Miss America protest, see Genz, Postfemininities in Popular Culture, chapter 2.
- 2. Mary Daly expresses this idea clearly in Gyn/Ecology (1978), stating that "femininity is a man-made construct, having essentially nothing to do with femaleness" (68).
- 3. See Bell and Hollows.
- 4. In the largest-ever survey of breast augmentation, BAAPS announced that there has been a 275 per cent increase in the number of operations since 2002, with almost 8500 procedures carried out in 2008 (www.baaps.org.uk). These already remarkable figures for the United Kingdom seem modest when compared to American statistics: Of the 1.7 million cosmetic surgical procedures carried out in 2008, breast augmentation was also a favourite among American women (with over 307,000 operations). This was closely followed by liposuction, nose reshaping, evelid surgery, and tummy tucks. Overall, far more women than men underwent cosmetic surgery, with 1.4 million female patients compared to 220,000 male patients (www.plasticsurgery.org).
- 5. In Ordinary Lifestyles (2005), David Bell and Joanne Hollows highlight the importance of the concept of lifestyle for our contemporary existence and self-understanding. The idea of lifestyle is underpinned by a description of the self that foregrounds personal choice and flexibility. This line of thought is common in sociological examinations of self-identity and is particularly associated with the work of Anthony Giddens who formulates a flexible notion of "post-traditional" selves that are able to (re)invent their own biographies. See Modernity and Self-Identity.
- 6. For a more sustained consideration of fairytale tropes in the makeover show. see Brenda Weber's analysis of the American Princess and Australian Princess franchises in "Imperialist Projections: Manners, Makeovers, and Models of Nationality" (in this collection).
- 7. See Weber.
- 8. See Holmes and Redmond.
- 9. When it was announced in 2008 that Trinny Woodall and Susannah Constantine were not having their ITV contracts renewed after their *Undress* the Nation programme lost viewers, British newspapers blamed "the Gok factor" (Freeman, "Why Britain fell out of love with Trinny and Susannah"). In contrast to "a gorgon-headed beast of matronly, imperious bossiness", Gok Wan - who as news reports never fail to recount used to be a "21-stone, mixed-race, gay teenager" who was bullied at school - is "much nicer than T & S" and teaches the female participants to love their "gorgeous curves" and "bangers" (breasts in Gok Speak) (Freeman, "We are all beautiful!"). As Wan notes in an interview, "clothes aren't just this superficial thread you put on your body. There's a massive psychology behind dressing and I think that [the programmes] have enabled people to see that" (qtd. in Freeman "We are all beautiful!").
- 10. See Rose.
- 11. A similar charge has been raised in many critiques of postfeminism in relation to the rhetoric of "choice". As Sadie Wearing points out, feminist television criticism has to be vigilant to the notion of choice as it has "a

sinister edge of compulsion, where the celebration of 'choice' and the upbeat reliance on a rhetoric of possibility to become your own 'best self' exist alongside a concomitant edge of responsibility" (292). This amounts to a paradoxical kind of "compulsory freedom" where subjects are encouraged to freely choose an image of themselves within prescribed guidelines (Roberts 241). As John Storey aptly summarizes, "there are choices, but not choices over choices – the power to set the cultural agenda" (229).

12. See Genz and Brabon 166-72.

Works cited

Balsamo, Anne. *Technologies of the Gendered Body: Reading Cyborg Women*. Durham and London: Duke University Press, 1996.

Banet-Weiser, Sarah, and Laura Portwood-Stacer. "'I Just Want to be Me Again!': Beauty Pageants, Reality Television and Post-feminism". Feminist Theory 7.2 (2006): 255–72.

Bartky, Sandra Lee. Femininity and Domination: Studies in the Phenomenology of Oppression. London and New York: Routledge, 1990.

Bell, David, and Joanne Hollows, eds. *Ordinary Lifestyles: Popular Media, Consumption and Taste*. Maidenhead: Open University Press, 2005.

Blum, Virginia L. *Flesh Wounds: The Culture of Cosmetic Surgery*. Berkeley, CA: University of California Press, 2003.

Bordo, Susan. *Unbearable Weight: Feminism, Western Culture and the Body*. Berkeley: University of California Press, 1993.

Daly, Mary. *Gyn/Ecology: The Metaethics of Radical Feminism.* 1978. London: The Women's Press, 1995.

Davis, Kathy. "Remaking the She-Devil: A Critical Look at Feminist Approaches to Beauty". *Hypatia* 6.2 (1991): 21–43.

Douglas, Susan. Where the Girls Are: Growing Up Female with the Mass Media. New York: Times Books, 1995.

Ebert, Teresa. "Ludic Feminism, the Body, Performance, and Labor: Bringing Materialism Back into Feminist Cultural Studies". *Cultural Critique* 23 (1992–93): 5–50.

Fiske, John. *Understanding Popular Culture*. London and New York: Routledge, 1989.

Freeman, Hadley. "Why Britain Fell Out of Love with Trinny and Susannah". *The Guardian*. August 20, 2008. http://www.guardian.co.uk/lifeandstyle/2008/aug/20/fashion.beauty/print. [Accessed May 13, 2009].

Freeman, Hadley. "We are All beautiful!". *The Guardian*. October 21, 2008. http://www.guardian.co.uk/lifeandstyle/2008/oct/21/women-television/print. [Accessed May 13, 2009].

Friedan, Betty. The Feminine Mystique. 1963. London: Penguin, 1992.

Foucault, Michel. *Discipline and Punish: The Birth of the Prison*. London: Penguin, 1977.

Genz, Stéphanie. *Postfemininities in Popular Culture*. Houndmills, Basingstoke: Palgrave Macmillan, 2009.

Genz, Stéphanie, and Benjamin A. Brabon. *Postfeminism: Cultural Texts and Theories*. Edinburgh: Edinburgh University Press, 2009.

- Giddens, Anthony. Modernity and Self-Identity: Self and Society in the Late Modern Age. 1991. Cambridge: Polity, 2008.
- Gill, Rosalind. Gender and the Media. Cambridge: Polity, 2007.
- Gillespie, Rosemary. "Women, the Body and Brand Extension in Medicine: Cosmetic Surgery and the Paradox of Choice". Women and Health 24.4 (1996):
- Gilman, Sander L. Making the Body Beautiful: A Cultural History of Aesthetic Surgery, Princeton, New Jersey: Princeton University Press, 1999.
- Heyes, Cressida, J. "Cosmetic Surgery and the Televisual Makeover". Feminist Media Studies 7.1 (2007): 17-32.
- Holliday, Ruth, and Jacqueline Sanchez Taylor. "Aesthetic Surgery as False Beauty". Feminist Theory 7.2 (2006): 179-95.
- Holmes, Su, and Sean Redmond, eds. Framing Celebrity: New Directions in Celebrity Culture. London and New York: Routledge, 2006.
- Kumi, Alex. "One-Hour Breast Implant Operations Raise Concerns". The Guardian February 11, 2006. http://www.guardian.co.uk/print/0,,5397361-110418,00.html. [Accessed May 2, 2006].
- Lewis, Tania. "Introduction: Revealing the Makeover Show". Continuum: Journal of Media & Cultural Studies 22.4 (2008): 441-46.
- Lorde, Audre. Sister Outsider: Essays and Speeches by Audre Lorde. Freedom, CA: The Crossing Press, 1984.
- McRobbie, Angela. "Post-Feminism and Popular Culture". Feminist Media Studies 4.3 (2004): 255-64.
- Morgan, Kathryn Pauly. "Women and the Knife: Cosmetic Surgery and the Colonization of Women's Bodies". Hypatia 6.3 (1991): 25-53.
- Roberts, Martin. "The Fashion Police: Governing the Self in What Not To Wear". Interrogating Postfeminism: Gender and the Politics of Popular Culture. Ed. Yvonne Tasker, and Diane Negra. Durham and London: Duke University Press, 2007. 227-48.
- Rose, Nikolas. "Governing the Enterprising Self". The Values of the Enterprise Culture. Ed. Paul Heelas and Paul Morris. London: Routledge, 1992, 141-64.
- Storey, John. Cultural Theory and Popular Culture: An Introduction. Harlow, England: Pearson Longman, 2009.
- Tait, Sue. "Television and the Domestication of Cosmetic Surgery". Feminist Media Studies 7.2 (2007): 119-35.
- Wearing, Sadie. "Subjects of Rejuvenation: Aging in Postfeminist Culture". Interrogating Postfeminism: Gender and the Politics of Popular Culture. Ed. Yvonne Tasker, and Diane Negra. Durham and London: Duke University Press, 2007. 277-310.
- Weber, Brenda. Makeover TV: Selfhood, Citizenship, and Celebrity. Durham, NC: Duke University Press, 2010.
- Williams, Rachel. "Cosmetic Surgery and Treatments Set to Hit £1bn a Year". The Guardian December 19, 2007: 7.
- Wollstonecraft, Mary. A Vindication of the Rights of Woman. 1792. Vol. 5 of The Works of Mary Wollstonecraft. Ed. J. Todd, and M. Butler. London: Pickering and Chatto, 1958.
- Young, Iris Marion. Justice and the Politics of Difference. Princeton, NJ: Princeton University Press, 1990.

9

Imperialist Projections: Manners, Makeovers, and Models of Nationality

Brenda R. Weber

In 2000 the media scholar Rachel Moseley identified a "makeover takeover" in lifestyle programming; as of this writing in 2009, that takeover has flourished to such a degree that we might more vividly describe the television lifestyle mediascape as colonialized, the takeover having given way to complete occupation. Colonialism, with its particular connotations of the overbearing and imperious British Empire, is a rather apt metaphor, for in the context of a diversified set of television texts that teach viewers how to pimp a ride, spice up a wardrobe, prune back household clutter, and discipline a diet comes a modified form of the makeover that attends to manners and etiquette in its attempts to enact image-based and class- and race-specific transformation goals. 1 Each of these shows corrals a group of "hopeless", "unruly", "incorrigible", and largely working-class participants (what could well be taken as the "ignorant" natives) and subjects them to the ministrations and demands of English expertise (to close the metaphor, such experts here handily stand in as foreign agents of domination and control). Even so, these makeover texts are not so straightforward or so one-dimensional that we can read them only as uncomplicated popular culture tracts that simply re-enact colonialist oppression. Makeovers, after all, contain a complex ideology that covers a theoretical spectrum ranging from neoliberalism to postfeminism, and from identarian empowerment to authoritative religiosity. In saying, then, that makeovers work through a logic of imperialism, I do not mean to indicate that they do not also contain and contribute to other discourses, but in this article I want to focus my examination on the way in which transformation-themed shows are simultaneously nostalgic for an idealized past conveyed through the

specific mythos of the British Empire and critical of the very qualities they so idealize.

These themes of endorsement and critique are all the more nuanced when filtered through other national media outlets. In the United States, many shows - both those imported from Great Britain and those produced by American companies - deploy the trope of the English expert/scold, who can save the day, open paths to enlightenment, eliminate dirt and clutter, soothe long-standing familial tensions, and essentially save the ignorant masses. Indeed, Englishness is pointed, for although reality television shows with Scottish or Welsh hosts do exist and are broadcast in the United States, they are rare. More common are the English experts, who stand in for a class-based form of knowledge, superiority, and instruction, even when the hosts themselves speak in accents or behave in ways that do not suggest Oxbridge educations, toney addresses, or cultivated behaviours (as, for instance, when the notorious Trinny Woodall and Susannah Constantine of What Not to Wear, Trinny and Susannah Undress, The Great British Body, or Making Over America with Trinny and Susannah pull down their own trousers so as to show a seemingly universal trait of womanhood: cellulite). Such shows where English experts dominate American subjects include Supernanny, Nanny 911, Clean House, Hell's Kitchen, Wedding SOS, and, of course, Making Over America with Trinny and Susannah.² Thanks to BBC America, Americans are also given access to the toxic brew of Gillian McKeith's You Are What You Eat, although thus far she has exclusively targeted corpulent Brits, not daring to venture into the unchartered adipose of America. One must still travel to the United Kingdom or trawl the Internet to see examples of McKeith's other television fare, which includes Three Fat Brides One Thin Dress, Supersize vs. Superskinny, or Gillian Moves *In,* each show seemingly fascinated with the mandatory "poo samples" that McKeith so regularly demands.

On the manners makeover shows that I will analyse in this article, new hairstyles and refined fashion codes are insufficient to these programmes that put both female and male participants through a series of tests and challenges designed to build the social infrastructure necessary to support the refinement accorded to the terms "lady" and "gentleman". In each case, the class-specific designation of "lady" or "gentleman" – or in particular of "princess" – is *a priori* understood as a recognizable, desirable, and achievable identity location. An underlying logic suggests that it is the participants' internalized desire to change – rather than the mandates imposed by the style gurus and etiquette coaches – that brings this rag-a-muffin crew to the transformation domain of Makeover TV.

In this way, these shows underscore a tacit mandate of colonialism that justifies incursions into others' lands, politics, governments, and society through an argument that natives wish to be "saved" by the knowledge the imperializing force wields. Those shows airing on US expanded cable that make use of the English style expert or the surrounding trappings of butlers, charm schools, and British cultural capital include Australian Princess, Ladette to Lady, Mind Your Manners, Girls of Hedford Hall, American Princess, Style by Jury, Mo'Nique's Flavor of Love Girls: Charm School, Rock of Love Charm School, Ricki Lake's Charm School, Groomed, Tool Academy, and From G's to Gents.

These behaviour and image modification shows air across the globe and are produced either in Great Britain or in Anglophone countries, including the United States, Canada, and Australia. Together, they speak to and help to create the myth of a performance and appearancebased model of identity that simultaneously reifies and critiques the classed codes of British Empire. These tensions are expressed through an agonistics between elitism vs. egalitarianism, aristocracy vs. meritocracy, blood-entitlements vs. social privilege, and royalty vs. commoners. Although made by different production companies, aired on competing networks, and targeted to a diverse viewership, each of these shows gives narrative space to the complicated raced and classed tensions and power dynamics that reproduce notions of class hierarchies, style etiquette, and social status. In short, these programmes reproduce the colonialist norms that sustain the conceptual significance of the British Empire. Yet, their construction of the "princess" or the aristocratic "lady" or "gentleman" is often enigmatic, as participants are typically coached in such lessons as, on one episode of Groomed, how to do the dishes or iron a shirt properly, or, on an episode of Charm School, how to assemble an outdoor play set for children - both labour-intensive activities far outside the ken of the upper-class denizen.

Colonialist makeover ideologies are less enigmatic and more depressingly regressive in relation to gender. As I have already noted, men are frequently referenced in this genre of programming, but the attention focused on women's behaviours, bodies, and appearance is fierce. Rigid gender imperatives prevail on shows such as the US-based *Mind Your Manners*, where a "scary feminist" must learn to be less intimidating, or on *Ladette to Lady*, where "Britain's worst women" are quarantined in a finishing school and taught to enact more normative iterations of femininity. As so depicted, television programming that is consumed with the *Pygmalion*-inspired idea of "making the lady" offers an interesting gendered commentary on the shifting meanings of class. Such

hermeneutic slipperiness is particularly evident on the two shows I analyse in this article, American Princess (2005-07) and Australian Princess (2005–07), since residents of both America and Australia pride themselves on national identities grounded in independence and autonomy, even as citizens of each country are fascinated by the exploits of the English royals. Indeed, in both countries a sentiment prevails that the English crown may have begun things, but a larger ethos of democratic meritocracy far outweighs any obligations to the British motherland. In this case, American Princess and Australian Princess equally and audaciously suggest that it is possible to achieve princess status – technically a position claimable only by birth and sometimes by marriage – through hard work, training, and competition.

Revealed in these fantasies where "ordinary girls" compete to become "actual royalty" is the very pointed idea that when women are allowed to participate in a competitive democratic meritocracy where they can achieve whatever they desire, they will desire precisely what meritocracy is unable to offer: the privileges of aristocracy. In both of the programmes I will examine, the dominant rhetoric encourages subjects to adopt a neoliberal regard for the self, whereby women learn to regulate their bodies and behaviours, ostensibly for the new confidence and self-esteem such discipline will afford. Yet, in the midst of such arguments about individual identity in the neoliberal global marketplace, questions emerge about the possibility of shaping the docile body into a willing colonial subject. If makeover television shows more broadly communicate a logic of Americanness in their reliance on notions of egalitarianism, meritocracy, and volition,³ then this article seeks to determine if manners-based lifestyle television offers a counter-model to the American Dream that simultaneously undermines and endorses colonialist projects.

Empire of the imaginary

Although the British Empire was a real and historically verifiable phenomenon, my interest here lies in the *idea* of the Empire rather than in its actual ascent or decline. Political theorists Michael Hardt and Antonio Negri have argued in this regard that an "informal empire", constituted by cultural practices and codes, is just as powerful as the "formal empire", on which geopolitical formations are based. Thus, multinational corporations, systems of monetary hegemony such as the International Monetary Fund and the World Bank, and cultural ideology exercise a comparable degree of influence to the soldiers and agents of the British state that enforced the pax Britannica. Hardt and Negri consequently argue that "Empire dictates its laws and maintains the peace...through mobile, fluid, and localized procedures" (354). This is particularly so, explains Ketu H. Katrak, in the geographies of the affective – in the homes, schools, and other interior places where ideology takes hold: "Colonial power was consolidated with the chalk and blackboard, more crucial ideological tools than military might" (92). In our current historical moment, where the might of the British Empire is more historical memory than political reality, it is the public iteration (and constant reiteration) of former glory that keeps the Empire of the imaginary alive.

It is presently not so much in the schoolroom where the significance of Empire finds its pedagogical meaning and perpetuation, but in the mediated spaces of television. Accordingly, Empire as a culturally resonant category is alive and well and airing each day through reality TV, offering those of us who consume reality fare sound-bite lessons in the shape and stature of the British Empire. A bit of a personal confession in this regard is perhaps telling. Although I lived in the United Kingdom for a year and have visited there frequently, it was not until I began studying American Princess and Australian Princess that I actually discovered that there was a Loyal Toast offered at formal social occasions in obeisance to the Queen of England, much less heard the words (admittedly, I lived in a particularly independent-minded part of Scotland, but I attended plenty of formal dinners throughout the UK). I have also, perhaps not surprisingly, never heard a toast made in honour of the Queen of England on my trips to Australia or Canada. Yet, due to the Princess programmes, I now have not only heard the toast upwards of 25 times, I seem to have memorized part of it. Thanks to Ally, the winner of the first Australian Princess competition, here is the toast in full: "To her most Excellent Majesty, Elizabeth the Second, by the Grace of God, the United Kingdom of Great Britain and Northern Ireland, and all of her other Realms and Territories Queen, Head of the Commonwealth. Defender of the Faith, the Queen". Even when said in jest as a lugubrious tongue-twister test for the "princesses in training", if these words and their constant repetition do not remind the viewer of the ubiquitous reach of Empire, then television surely cannot be blamed for a lack of trying.

In choosing American Princess and Australian Princess as my case studies in this chapter, I necessarily privilege a trope of British imperialist colonialization that stresses the opposition between a white foreign body and an indigenous land inhabited by darkened peoples. While

the phenomenon I am examining here is not necessarily anomalous, in that many shows work through this model, it is also not the most common trope through which the power dynamics of makeover shows exert themselves. Most television makeovers, after all, feature Americans attending to sloppy Americans or Brits making over other hopeless Brits. Still, the logic of colonialism is equally pervasive in these shows, as style gurus, designers, and "experts" invade the homes of their fellow country people, those who are deemed dowdy and down-on-their luck. The principle that allows for "intervention" and "salvation" – words the makeover throws around with abandon – is clearly one predicated on class and race, where the working classes are labelled as "a race apart", what nineteenth-century British Prime Minister Benjamin Disraeli called "The Two Nations".4 In the mediated spaces of postmodernity, where image functions as an index to identity, one need not actually be working class or coded as non-white to cause concern. Indeed, one need only appear working class or non-white to be thought of as the "worst" of the two nations, and thus to draw the eyes of the reality TV makeover squads roaming across America and Britain in the name of enforcing positive self-esteem and empowerment through the image. American Princess and Australian Princess take the imperative for style beyond the usual mandates established by Makeover TV, however, since they seek to create the edifice not just of style, nor even of the class-coded "lady", but of royalty.

Producing the princesses

Both American Princess and Australian Princess are made by Granada Entertainment, a media company based in London that not only sells primarily to Britain's ITV1 and ITV2 channels but also produces and distributes widely in Germany, Australia, and the United States. In fact, Granada's website boasts that it is one of the "largest international producers for the US market and a major force in acquiring, developing and producing reality and scripted programming for US networks". Granada is global in its reality TV imagination, covering a wide range of programming that includes cooking shows such as *Hell's* Kitchen, The Chopping Block, and Ramsay's Kitchen Nightmares, more conventional makeovers such as Celebrity Fit Club, Nanny 911, and Room Raiders, and docu-tainment programming such as Animal Extractors: Polar Bears in Peril and Cracker: An American Dream, Both American Princess and Australian Princess premiered in their respective countries in 2005. American Princess aired for two seasons in the United States, the first in 2005, the second in 2007. *Australian Princess* aired for two seasons in Australia, also in 2005 and 2007. Since then, both shows have been broadcast in England, Canada, Australia, and across Europe and the Middle East. They are in continual rotation and air regularly in the United States on the WE (Women's Entertainment) network.

Australian Princess and American Princess adhere equally to a reality competition format, where advisors admonish and inspire "average" young women, who are then judged as they compete to win what the show offers, in this case a "\$100,000 prize package" including a "real diamond tiara", a "real British title", \$50,000 in cash, and other princessly baubles. The winner of each respective competition also becomes the guest of honour at a lavish grand coronation ceremony, where she is escorted by "a real prince". As is evident even in this small description, the prize package itself sets up a contrast between categories of the real and artificial that works to service an aspirational fantasy for young women. As the title princess might indicate, it is significant that participants be youthful (ages range between 19 and 29) and unmarried, although several of the subjects are mothers of young children. Most women are white, although there are some Indian and African American participants. The women are coded as uneducated – although not necessarily working class – and their naiveté is situated as a factor of age as well as upbringing.

Central to the Princess competition format are the key advisors and *de* facto television presenters, Paul Burrell, former butler to Princess Diana and self-proclaimed "authority on all things regal", and Jean Broke-Smith, an English etiquette teacher and former principal of the Lucie Clayton House, a ladies school specializing in grooming, modelling, and deportment.⁵ Burrell and Broke-Smith anchor each programme and are typically joined by a third judge: for the Australian competition this role was filled by Lady Jane Ferguson, sister to the (former) Duchess of York, Sarah Ferguson (aka Fergie); for the American competition the third judge was often Catherine Oxenberg, an American actress who has notably played such roles as Princess Diana in the made-for-television drama, The Royal Romance of Charles and Diana (1982). As the eldest daughter of Princess Elizabeth of Yugoslavia, Oxenberg has royal blood coursing through her veins. In the contradictory logic of Makeover TV. where revealing the "authentic" self requires that one overwrite the natural body, Oxenberg's bonafides as a princess make her the perfect person to participate in a show about commoners who aspire to royalty. The shows are hosted by good-looking television personalities, whose celebrity and attractiveness are meant to indicate some standing in the

world of glamour, if not royalty. On Australian Princess, the radio host, television presenter, and Barbie look-a-like Jackie O assumed this role her name ironically referencing Jacqueline Kennedy Onassis, arguably the exemplar of American-style royalty. On American Princess, hosting duties fell to Mark Durden-Smith, whose website claims he is "one of Britain's most versatile presenters", having worked on such reality television shows as I'm a Celebrity Get Me Out of Here Now and Millionaire Manor.

In all of this illustrious assortment of celebrities and expertise, it is the butler and the charm school doyenne who govern the shows. Burrell and Broke-Smith have made a post-career career of their days in service through the various manners modification outlets offered by reality TV and other media sites. Burrell is a veritable media phenomenon, having turned his service to the royal family into several tell-all memoirs (and having survived a scandal in which he was accused of stealing Princess Diana's personal possessions. As rumour has it, he managed to broker a deal directly with Queen Elizabeth in which charges against him were dropped in exchange for a promise that he would not reveal damaging information about the royal family). Broke-Smith has appeared across a broad swathe of television programming far beyond the Princess franchises, including Ladette to Lady, 6 Britain's Next Top Model, and Snobs. By her own reckoning, it is no longer Britain's high-society girls, but those from more working-class backgrounds, that keep her so busy, particularly since this clientele accesses her wisdom through the pedagogical reach of television. As she told The Guardian, "There aren't any finishing schools now, sadly. I suppose people thought it was a bit naff. But I'm working more than ever, and with people from all kinds of backgrounds, from girls who work in TV to girls from council estates who want to better themselves."

Although self-improvement is a key trope of Americanness, to better oneself has never been designated as important, or even relevant, to the upper classes – and far less to royalty (finishing schools notwithstanding). Indeed, self-improvement stands as an oxymoron to an aristocratic and royal elite which believes itself to be naturally superior and thus in no need of making over: the aristocracy simply is. As Pierre Bourdieu has argued in Distinction (1984), a critical element of aristocracy is the belief in its own naturalness. In short, the aristocrat belies his or her own construction, which, in turn, ratifies the perceived naturalness of class distinction as a matter of perpetual status quo regeneration. Gareth Palmer and other media scholars have argued that Bourdieu's work is crucial to understanding the class dynamics of lifestyle television,

particularly the notion that "'Good taste' and discrimination may seem (and must seem) 'effortless' and 'natural', but they are in fact not easily acquired" (177). As Palmer argues, "The mystique around the tasteful is...crucial in keeping them in positions of cultural superiority" (177). That said, to crib a line from South Pacific, class must be carefully taught. The aristocrat learns from what Bourdieu terms the "habitus", or the tacit system of rules and expectations that structure classed conventions. As just one example, Prince Charles may have needed training when he was a boy in how to actually ride a polo pony, but he never needed to be told that an interest in polo is itself critical to his distinction. At one level, it makes sense that if all actors within a classed field must learn codes of distinction, it might be possible to ascend the class hierarchy through specific forms of deliberately acquired knowledge. Indeed, such is the promise of the Princess narratives (and many American literary classics like *The Great Gatsby*), since these shows traffic in the allure of elite skills and concepts and suggest that a woman must learn in order to achieve. To their credit, in their message of meritorious advancement, American Princess and Australian Princess are a far cry from the more ubiquitous Princess myths we have inherited from fairytales and folklore, where a Cinderella or Sleeping Beauty ascends to princess heights because her beauty and/or natural docility attracts the eye of a Prince Charming. While the shadowy figure of Prince Charming is referenced throughout both of these series, it is worthy of note that he does not get screen time until the final episode of each season. Despite the obvious insistence that the skills in deportment and etiquette that the women learn are ostensibly the necessary credentials that will suit her for the marriage market, the shows also suggest that these qualities of poise and self-presentation are valuable qualities in their own right. The majority of the narrative time and interest is devoted to the lessons in labour and learning afforded to the young women, and this instruction is nuanced by a competing set of logics about work, authenticity, and the image.

"It's a hard job"

Although American Princess and Australian Princess are structured by their adherence to fairytale outcomes that are punctuated by glittery tiaras, designer clothes, fancy parties, and handsome princes, the narratives they offer are more Cinderella-as-the-scullery-maid than Cinderella-at-the-ball. In some ways, this fascination with the labour behind the image puts the *Princess* shows in good company, since they join with

other reality television texts, such as America's Next Top Model or Project Runway, that focus on the professional work required to produce beauty. These "making of the princess" narratives also bear a strong resemblance to feature films that have filled the Cineplex of late, including *The* Princess Diaries (2001), The Princess Diaries 2: Royal Engagement (2004), The Prince & Me (2004), The Prince & Me 2: The Royal Wedding (2006), and The Prince & Me 3: The Royal Honeymoon (2008), all of which play on the trope of an "all-American girl" who is plucked from obscurity, refashioned, and coached so that she might awkwardly fulfil the princess role.⁷

Bearing in mind their generic coding as elimination-style reality shows, *American Princess* and *Australian Princess* build several "princess challenges" into each episode, and it is on the basis of such challenges that the participants' future ascendency is determined. Labour is critical to these outcomes: it is a mark of discredit if a "princess in training" acts like a guest rather than a hostess at a social event, and she can be faulted for "not doing a lick of work". Burrell incessantly scolds the participants, reinforcing the rigour of being a princess in terms that are suited to the business world: "Do you really want to be a princess? It's a hard job. To give up your life, for a life of duty and protocols. Timetables, strict routines". In light of this, some of the princess challenges are probably quite predictable, such as having to mingle at an elite social event or learning to walk in high heels and a ball gown. Other challenges (or punishments for those who do not do well in competition) are, however, downright bizarre. Consider, for instance, the archery challenge that features in Australian Princess. The girl who hits the bull's eye is allowed to have an elite dinner in a Sydney hotel with one of the other participants, and with their authoritative expert, Paul Burrell, standing in waiting as the champagne-serving butler. Back at the princess compound, those who did not win the challenge are sent to the barn where they are put to the task of cleaning shoes, which requires that they scrub and polish a pile of mud-covered brown boots that have been thrown into an indiscriminate pile (an activity that I doubt was ever required of either Cinderella or Princess Diana). The advisors justify such labour by saying "the girls must learn to look after themselves before others look after [them]". Jean Broke-Smith recognizes that "of course a princess doesn't clean her own tack", but such activities, she argues, are meant to enforce discipline. What such discipline will produce is difficult to determine, since outcomes are often conflated. Zena, one of the Australian Princess participants, says, for instance, that she hopes to "find the discipline of becoming a female", here collapsing idealized codes of sex and gender into equally idealized conceptions of class and rank.

The mandatory tea-making lessons serve a comparable sex/gender and class/rank function. These lessons, held interchangeably on both programmes by Broke-Smith and Burrell, are meant to enforce the austerity of rank and tradition. "Every single tea cup has its handle at 5:00", instructs Burrell to the Australian Princess contestants. "Every single day of the year, the Queen of England sits down at 5:00 and has a cup of tea". Burrell admonishes the princess acolytes for their shoddy skills at making a cup of tea. He rebukes one subject, Karusha (of southeastern Indian descent), who has put milk in her cup before pouring the hot water: "You did the thing that is never done. You committed the cardinal sin of tea time etiquette. The milk never, never, never goes in the tea cup first. That's what the common people do". Demonstrating the proper form for serving tea, Burrell intones, "It's a fine routine; it's a strict discipline. If it's good enough for the Queen, it's good enough for you". The diegesis delights in showing resistance to Burrell's fastidiousness. Wendy, who is labelled a "tomboy from the Outback", says in a moment of reflection intercut into the tea-making lesson, "I know I want to be a princess, but bloody hell, getting a lesson on how to make a cuppah? I'd like to get him out there and show him how to make billy tea. [Wendy gestures as if she is swinging a pot around her head]. You swing it around, mate, to settle the leaves". Another participant, "surfer girl" Ally, mocks Burrell's instructions, offering a decisive critique of the class-based behaviours he endorses: "How important can tea be? It's tea, y'know? Do I have to be serious about tea?"

Such moments of resistance, however, are powerfully shut down when other subjects continue to fail at mandatory lessons of teamaking, elocution, and painting, their tears and dismay attesting to the value of the challenges and the hard work of becoming a princess. Whether princess aspirants verbally mock or model the behaviours taught by their etiquette experts, these shows make a different kind of colonialist imperative more obliquely known: in support of the ideology or in opposition, one's sex-based identity requires coherence with gender's prevalent operating codes. Accordingly, while one woman might bemoan her lack of tea-making skills, dismissively telling the camera "That's what makes the English the English", she later acknowledges gratefully, "I became a female today". We see demonstrated here that she cannot think of herself as a woman unless she also upholds the mandates of being a lady. The teleology is one way, as Mark Durden-Smith makes clear to both viewers and princess wannabes: "Before you can become an American princess, you first have to become a lady". Critical

to becoming either lady or princess is satisfying the colonializing English experts.

The video-cinematic logic that governs the editing of the *Princess* shows relentlessly poses Burrell and Broke-Smith in positions of dominance to their "princess apprentices", as if to situate the experts as not only royalty themselves, but as persons of greater prestige and authority. They often speak to the contestants from brightly-lit elevated platforms that require both the women and the at-home viewer to squint up at them. Quite often, when small vignettes feature private interviews with the reality TV participants, these moments are interrupted by intercut critical remarks from the experts, as if to suggest that even in privacy the dominating rule-maker is present, which is to say there is no represented privacy in these mediated spaces, all zones – whether public and private – fall into the domain of the colonizer's power. These sorts of depictions cohere with what Anne McClintock has identified in Imperial Leather (1995), her important analysis of colonialism and cultural imagery, regarding the way in which mediated messages fulfil and reify larger colonialist narratives about race, gender, and oppression. Although only a few of the women competing for the title of princess are coded as non-Caucasian, the division of labour represented here effectively darkens the women, requiring that they look up to more enlightened (literally) expertise.

Even so, the shows' female participants are depicted as not only colonized subjects to the experts' royal rule and subalterns in thrall to their superiors, but as clerks or apprentices, since becoming a princess factors as a matter of learned skills and behavioural regulation. Given that the objective at hand is to take a group of "useless [Yankee and Ozzie] girls" and transform one of them into an English princess, there is a bit of a troubling contradiction at play, since an aristocrat is meant to possess wealth but not to labour for that wealth; such imperatives, of course, are even more implacable for royalty. Accordingly, one of the first rules the aristocrat would know is that those of the servant classes are not in a position to confer upper-class status on others, particularly when the subtle domain of the habitus becomes the overt instruction of the reality TV classroom. Thus, any princess made by Burrell and Broke-Smith's combined efforts in the mediated public spaces of television is, by definition, no princess at all. For Burrell and Broke-Smith their purported titles as experts is all the more problematic since it is their learned knowledge in combination with their celebrity – rather than their birth or station – that confers authority and arguably equips them to "make" princesses. Indeed, Burrell's notorious scandal-ridden past with the British royal family and Broke-Smith's on-call media expertise function more as appeals of ethos within an economic framework where celebrity and learned skills are Americanized currencies that evidence hard work, luck, and popularity.

The coded logic of the text offers a hodge-podge of ideologically contradictory possibilities, since tropes of meritocratic advancement are liberally interspersed with mandates for neoliberal marketplace competition, accentuated by a colonialist reverence for old-world power, privilege, and rank. We begin to see, then, that the elite values which are seemingly underscored in the making of the princesses are undone by the show's mandates of instruction and competition. The way the shows manage these contradictions is perhaps best revealed in the repeated references made to the categories of the natural and the artificial.

"All eyes are on her"

Given the way in which the Princess shows enforce neoliberal goals of market appeal and situate the creation of a gendered self as woman's most valuable commodity, it is plain to see that these programmes are as much about career development as they are fantasies of romance and royal ascendency. Or perhaps we might argue that the shows up the ante on what it means for an "average girl" to find Prince Charming: it is not apparently sufficient that she be in the right place at the right time; she must also be coiffed, dressed, refined, anointed, and crowned so that her "inner princess" will emerge and draw the eye of Mr. Right. Significantly, the male love object gets very little camera time, so in this respect the *Princess* shows perform a rather remarkable bait and switch, replacing the hoped-for male suitor with the ever-present male gaze, as it is located in and magnified by the camera. Not surprisingly, the shift from an actual viewer to an abstract sense that one is always being watched heightens the power of perceived image, and the Princess shows relentlessly impress upon the women that the first visual impression they give is imperative to their potential success as princesses.

Of course, whenever first impressions are at stake, mandatory style, make-up, and hair makeovers ensue. As with other iterations of Makeover TV, the "princesses in training" undergo what I have elsewhere described as affective domination, or a process of indoctrination that begins with shaming and humiliation and results in hugs and gratitude. When style and beauty experts are brought in, then, the *Princess* participants must be told that their hair looks like spaghetti, their tattoos

and piercings are "tarty", or that the "chubby girls" should really "go for a run every once in a while". Burrell reinforces this tough love as a mandatory element in being a princess during a mini-lecture directed at the women: "Princesses have to look the part. The first ten seconds are the most important time when you meet someone". To the camera, Burrell reinforces his claim: "They have to understand the way people see them. The way they present themselves impacts on a great deal of people". In so saying, Burrell reiterates a claim that runs across Makeover TV, where first impressions are seemingly the only impression available to a person (male or female, although men get a few more shots at making their mark). On reality TV, women apparently have only a ten-second envelope before they fade into obscurity, spinsterhood, and unemployment. "I'm not being sexist", pleads Burrell matter of factly. "Princesses have to look good wherever they go". Given that the stakes are so high, the participants appear not just willing but grateful for their public appraisals and consequent makeovers. As is the case across the Makeover TV genre, the makeover process is not only about appearance but engages with a deeply held sense of each participant's gendered and sexed identity. As one woman on *Australian Princess* says in response to her makeover: "I turned into a female today, as you can see".

Appearance, then, is only one element in the overall image that marks the transformation of the commoner into royalty. Princesses in training must learn not to wolf-whistle in public, not to jump up and down with raucous enthusiasm at the Royal Ascot, not to wear a hat at a polo match, not to eat a banana like a monkey, not to wear a g-string or thong when sailing, and a seemingly endless list of not-centred injunctions prohibiting behaviour. Of course, while these lessons are being offered, the camera captures the princess candidates violating the precise terms of the experts' advice, so that the overall logic of the text glorifies ruptures to the rules rather than obedience to their staid terms. A further rupture comes in the manner in which the experts themselves violate codes of propriety; while we are told that it is unseemly for a woman to show her undergarments, it cannot be appropriate for Princess Diana's former butler to yell across Sydney Harbour: "Melissa, pull your pants up!!!". Nor can Broke-Smith's pedigree as a fashionista be credible when every scene of her wearing trousers reveals the cursed VPL (visible panty line), a capital offence that would authorize Broke-Smith's immediate makeover were she ever spotted by Trinny and Susannah. These faux pas underscore all the more that there is something a bit askew about Burrell and Broke-Smith, and the narrative often delights in mocking their outmoded sense of propriety as much as it enjoys revealing the

difficulties the "apprentice princesses" experience in making the grade. There are many moments that illustrate this point, but one of the best featured on *Australian Princess*, when Burrell was enumerating his criteria for success: "I want someone with spirit and guts. That's what an Australian Princess should be", he declares. He immediately defies his own terms, however, when considering Laura K, an exotic dancer: "Even though she has a personality as big as a house, she failed to set the table properly", he says smugly, as if her shoddy table-setting skills completely undermine her personality.

Although Burrell's words might be laughable, the larger argument comes through loud and clear. As Broke-Smith explains: "An American [or Australian] Princess should be someone who has presence. When she arrives in a room or at a function, everyone notices her". This mandate that a "true" princess will not only command the gaze but also bask in its intensity puts the *Princess* programmes squarely in the discourses of both Makeover TV and American celebrity culture – discourses which dictate that a woman finds consummate meaning as the object of the gaze. It also, however, requires that *American Princess* and *Australian Princess* neutralize the stigma attached to desiring celebrity. It does so by suggesting that, when it really comes down to it, a princess cannot be trained for royalty; rather, it is her innate qualities that fit her for such a station.

"I am not sure how genuine she is"

By way of conclusion, I want to address the pervading contradiction between authenticity and artifice that is embedded in both American Princess and Australian Princess; even in the context of training girls to take on the elite codes of English royalty, both shows demonize those subjects who "want it too much", need too much instruction, or "play to the cameras", and instead place a premium on what it labels as "natural" qualities. "She'd murder someone to win", scoffs Jean Broke-Smith about one contestant. Sealing that participant's doom, Broke-Smith dismisses her, "She's a megalomaniac for power". In the omniscient words of one of the shows' many experts, "To be a princess you can't pretend all the time, you have to feel it from [the heart]", thus refuting the very validity of the contest by suggesting that the game is rigged from the beginning. Multiple seasons of each show notwithstanding, only one woman can be the princess, and that woman's fate, just like Cinderella's foot fitting perfectly into the glass slipper, is foreordained: "I think what's going to determine who Australian Princess is who they are inside", says one of the experts. The hermeneutic function of the

shows, then, is not to train the princess at all but to give her the forum – the ball, the carriage, and the fairy godmother - that will let her intrinsic qualities find outward expression, while all of the straggling ugly step-sisters fall by the wayside. As in Cinderella, the makeover's way out of the contradiction it poses between immanent worth and constructed value is to suggest that only the "right" girl can wear the glass slipper (or the cubic zirconia tiara), and it is Prince Charming (in the form of the camera's discerning gaze) who can sort the wheat from the chaff, the lady from the ladette, the princess from the commoner. Still. American Princess and Australian Princess are not solely derivatives of the fairytale lore that positions princess status as the desired but never achievable epitome of female fantasy; rather, they here function as aspirational texts that situate the outcome of becoming a princess - the English colonizer's place of utmost privilege – as not only attainable, but as the colonized subject's necessary credential for a stable identity and marketplace success.

Notes

- 1. Of course, the real United States of America is as complicit in imperialist policies as the United Kingdom, but in the logic of Makeover TV, "America" adheres to class-less, democratic fair play. In these depictions where English hosts endeavour to indoctrinate unkempt natives, we see a re-enactment that supports old-world ideologies.
- The bumper sticker on the Airstream Camper that Trinny and Susannah drive in Making Over America with Trinny and Susannah stresses the colonializing dimensions of their enterprise, reading "We Came, We Saw, We Madeover!"
- 3. See Weber.
- 4. See Disraeli's 1845 novel *Sybil, or The Two Nations*. Suggesting the transatlantic appeal of the "two nations" concept, the phrase was appropriated in 2004 by the US Presidential candidate John Edwards.
- 5. In 2007 *The Telegraph* reported that the Lucie Clayton had been sold and turned into bachelor flats. See Tyzack.
- 6. For a sustained analysis of *Ladette to Lady*, see Angela Smith's "Femininity Repackaged: Postfeminism and *Ladette to Lady*" (in this book).
- 7. These films are distinctly different than the princess craze among young girls at the moment, who idolize the Disney Princesses line and demand princess-themed birthday parties. For more on this phenomenon, see Orenstein.

Works cited

- American Princess. Granada, 2005–07. 14 episodes.
- Australian Princess. Granada, 2005-07. 16 episodes.
- Bourdieu, Pierre. Distinction: A Social Critique of Judgement of Taste. New York: Routledge, 1984.

- Disraeli, Benjamin. *Sybil, or The Two Nations* (1845). Oxford World's Classics. Ed. Sheila Smith. Oxford: Oxford University Press, 1998.
- Hardt, Michael, and Antonio Negri. *Empire*. Cambridge, Mass: Harvard University Press, 2000.
- Katrak, Ketu H. *Politics of the Female Body: Postcolonial Women Writers of the Third World.* Piscataway, NJ: Rutgers University Press, 2006.
- McClintock, Anne. *Imperial Leather: Race, Gender, and Sexuality in the Colonial Contest.* New York: Routledge, 1995.
- "Mark Durden-Smith". *KBJ Management*. http://www.kbjmgt.co.uk/clients/mark_durdensmith/. [Accessed August 24, 2009].
- Moseley, Rachel. "Makeover Takeover on British Television". Screen 44 (2000): 299–314.
- Orenstein, Peggy. "What's Wrong with Cinderella?" *The New York Times Magazine*. December 24, 2006. http://www.nytimes.com/2006/12/24/magazine/24princess.t.html. [Accessed August 24, 2009].
- Palmer, Gareth. "'The New You': Class and Transformation in Lifestyle Television". *Understanding Reality Television*. Ed. Su Holmes, and Deborah Jermyn. New York: Routledge. 2004. 173–90.
- Tyzack, Anna. "Lucie Clayton House: A Model Lesson in Home-Making". *The Telegraph* November 24, 2007. http://www.telegraph.co.uk/property/3359952/Lucie-Clayton-House-A-model-lesson-in-home-making.html. [Accessed August 4, 2009].
- Weber, Brenda R. *Makeover TV: Selfhood, Citizenship, and Celebrity*. Durham: Duke University Press, 2009.

10

Femininity Repackaged: Postfeminism and *Ladette to Lady*

Angela Smith

This chapter looks at the recent backlash against postfeminist discourses of empowerment through special reference to the commercial phenomenon of "Girl Power". Since the late 1990s, this backlash has manifested itself in the British press, which has generated and fuelled a "moral panic" about binge drinking, alcohol-induced violence, and increasing levels of sexually transmitted diseases in the young. This generally gives cause for concern about adolescent behaviour, which is persistently formulated as "out of control" – a formulation that was validated, to some extent, by the introduction of anti-social behaviour orders (ASBOs1) under the 1998 Crime and Disorder Act, Much of this attention has been aimed at young women, who are commonly referred to as "ladettes" because of their perceived adoption of behaviours more usually associated with young British men. As Katy Day et al. have shown, many British national newspapers in the period 1998-2000 reported on studies of teenage drinking which claimed that young women were "bigger binge drinkers" than their male counterparts. Such articles trade on wider moral panics about the behaviour of young women and are used to represent women as a threat to themselves (on account of the fact that their drinking leaves them more exposed to the risks of assault and ill-health) and to patriarchy (through the challenges they pose to established norms of female passivity). Although this chapter will focus primarily on representations of young women in British media texts, the anxieties with which these texts engage are not limited to the United Kingdom and are, as Ariel Levy observes in Female Chauvinist Pigs (2006), equally widespread in contemporary American culture.

While such negative coverage of women's behaviour is not new, what is different about this particular media attention is the extent

to which it extends into television entertainment programming.3 Certainly, the rapid rise of reality programming since the 1990s and the contemporaneous arrival of multichannel television – with its typical bias towards "female" genres – have led to an explosion in programming based around the home and domesticity (Holmes and Jermyn 24). Such programming makes conspicuous use of "documentary" strategies, altering the parameters of "factual" television in ways that are consistent with John Corner's description of "post-documentary culture" (156). As Anna Hunt observes in her study of Big Brother, Wife Swap, and How Clean is Your House?, many of these programmes feature "domestic dystopias", in which viewers are enticed by overtly negative images of domesticity. Like the inhabitants of the domestic dystopias to which Hunt refers, the figure of the ladette has - through the media been made available for public censure. This censure is, however, specific, in that it is inextricably linked to the role the ladette occupies in postfeminist discourse as the personification of an extreme performance of Girl Power.

The equality argued for - and, in some respects, won - by second wave feminism has been diffused by an increasingly consumerist culture. While this culture trades on the gains of the second wave, it has also produced the sense that there is still something missing in women's lives. This is writ large in the theme of "change the way you look; change your life" that guides the "narrative" of makeover programmes aimed at female participants.⁴ Focusing on the reality television series Ladette to Lady (RDF 2005–), I argue that the gender and class dynamics of such makeover shows contrast sharply with those of quality television drama – a genre that is increasingly preoccupied with "the oppression of upper-middle class suburban life" and its associated containment (Richardson 158). With special reference to the second series of Ladette to Lady, first screened in the United Kingdom on ITV1 in autumn 2006, I explore the complex ways in which the discourses of postfeminism operate within a makeover series that aims to turn "ladettes" into "ladies", with all the assumptions about lifestyle and class that these labels imply. As will become clear in the analysis that follows, the participants' postfeminist performances as ladettes are consistently opened up to criticism - criticism that turns on the fraught issues of taste and self-control.⁵ Still, as a show that combines elements of social documentary, soap opera, and disruptive comedy, Ladette to Lady occupies a hybrid generic space from which it invites the viewer to take up a range of positions – both critical and sympathetic – in relation to both the ladettes and their lady mentors.

Postfeminism

As Charlotte Brunsdon, Elspeth Probyn, Sarah Projansky, and Imelda Whelehan have argued, since its emergence in the 1980s postfeminism has often been viewed negatively as hailing the end of feminism. As its prefix implies, after all, the term suggests that the aims and objectives of the (white, middle-class) second wave agenda have already been addressed, achieved, and surpassed. More positively, though, the discourse of "choices" offered by postfeminism - with respect to work, family and dating - is frequently offered as a resolutely heterosexual alternative to "anti-sex" constructions of second wave feminism (Projanksy 67). As a playful, positive strand of postfeminism, however, Girl Power has a persistent tendency – signified through the term "girl" – to infantilize the women to whom it refers. Feminist scholars often point out that the freedoms won by the second wavers have allowed Western women to live the lives that they choose - lives which often have a vexed and/or unstable connection to feminist politics and to traditional gender roles. As Probyn has observed, this climate of instability is implicated in an increasingly prevalent strand of postfeminism, in which pre-feminist ideals and traditional, patriarchal models of femininity are seductively repackaged as postfeminist freedoms. This offshoot of Girl Power is, perhaps, most readily classifiable as "Lady Power", and it is, to some extent, symptomatic of Susan Faludi's "backlash" manifesto, in which the "having-it-all" single, career woman of the 1980s is returned to the patriarchal fold within the postfeminist discourse of "neo-traditional feminism".6

Girl Power and ladettes

In celebrating the equality and choice afforded by second wave feminism, the ladette is the personification of an extreme performance of Girl Power that started to draw media attention in the 1990s. As Whelehan states, the ladette playfully, if problematically, celebrates the male gaze (9). This is usefully demonstrated through the representation of Frances in *Ladette to Lady*, who – having received breast enhancement surgery as a gift for her eighteenth birthday – develops a tendency to flash her breasts in public. Frances's "playful" behaviour is necessarily equated to her exhibitionism; as a result, it is persistently framed as problematic within the context of the show. Through her implied courting of male attention, the ladette is rendered distinct from the longer-standing image of the "tomboy": the tomboy, after all, wants

to be one of the boys; the ladette wants to be attractive to the boys. As a result, the ladette – while appropriating aspects of "laddish" male behaviour, in terms of binge drinking and sexual promiscuity – remains resolutely heterosexual, embodying an "excessive" form of heterosexuality that could be perceived as a threat to the moral order of Western civilization. As Skeggs argues, in the British context, the sexualized appearance of working-class women is routinely defined against the well-dressed, cultivated women of the middle classes (100). In Ladette to Lady, middle-class tastes are insistently imposed upon the appearances and behaviours of the working-class ladettes, with a view to reinstating "safer" – or more traditional – codes of sexual conduct.

A more positively received aspect of Girl Power, according to Hollows, was its attempt to envision new, assertive feminine identities, while recapitulating – and popularizing – (second wave) principles of female solidarity (181). As Whelehan observes, Girl Power also seems to "recognise the age-old strengths of women's friendships and community and is particularly positive towards mother-daughter relationships" (46). This is writ large in *Ladette to Lady*, where the "school" venue, with its shared dormitories, is used as a tacit means of encouraging the female participants to develop strong friendships with their peers. In addition, the "teachers" at the school act as both mentors and mother figures, guiding the young women as they progress through various stages of "self-improvement". While this might be the case, however, the official curriculum works to undermine the politics of Girl Power through its nostalgic evocation of femininity – a femininity that is most readily signified in the term "lady".

Traditionalizing femininity: The spread of "Lady Power"

Diane Negra argues that one of the key premises of neo-traditional femininity is the need to abandon the overly ambitious 1980s programme of "having it all" (12). In its most assertive form, McRobbie suggests, this is part of a "patriarchal attempt to undo the achievements of the women's movement" (47). In this sense, the traditionalizing discourse of female empowerment sees ladettes as misguided, and thus "appeals to a nostalgia for a pre-feminist past as an ideal that feminism has supposedly destroyed" (Projanksy 67). That the ladette is misguided in her appropriation of Girl Power is clear in the urge to reveal the "real", "ladylike" self who will conform to neo-feminist ideals.

The decline of positive images of Girl Power in the twenty-first century marks a shift towards a "safer" femininity. In makeover television,

there has been a concentration on "reforming" ladettes to be more "respectable" in conduct and appearance, reverting to traditional feminine stereotypes.⁷ There is a foregrounding of the performative nature of femininity, where the sense of identity that is evident elsewhere in postfeminism becomes naturalized and internalized by the young women featured. This is seen in shows such as My Fair Kerry (Granada 2005) and Asbo Teen to Beauty Queen (North One Television 2006), as well as in Ladette to Ladv. Such shows follow on from cinematic representations in which women who pay too much attention to their physical appearance are coded as lacking in moral value, socially disruptive, and working class.8

Whelehan has observed that lifestyle politics leaves in its wake those who do not conform to its preferred images and those who cannot afford to engage in the "liberating" consumerism that would enable them to exercise "control" over their lives (178). Consumerism is therefore linked to notions of good taste and cultural capital, where "better taste" is usually aligned to upper-middle-class ideas. Glossy magazines consolidate this connection in their regular depictions of celebrities' homes, which – in Britain at least – are often designed to emulate those of the landed gentry. Likewise, when it comes to personal appearance, the "style" which is most actively esteemed is rooted in consumption patterns which seek to traditionalize femininity around a performance that is (predominantly) middle class and conservative, as we shall see shortly.

Ladette to Lady: A case study

Ladette to Lady, first aired on ITV1 in September 2005, is a reality makeover show which follows eight self-identified ladettes as they undertake a 5-week intensive course in learning how to be ladies. Predominantly white and working class, the young women are described on the show's website as being "loud, foul-mouthed, uncultured and unpleasant women, who like to drink to excess and are sexually promiscuous". Each week, one ladette is "asked to leave" the show, having failed – in the opinion of the school's teachers – to engage sufficiently with the traditionalizing process around which the show is based. Over the course of the series, the young women are assessed on their performance in various trials and at particular formal events, while also being judged on their unchaperoned behaviour. At the end of the series, the remaining participants are presented, Eliza Doolittle-like, at a "society ball", where the winner is announced as being the woman whose journey from ladette to lady has been the most remarkable.

Staged in Egglestone Hall, a former finishing school in North Yorkshire, the institutional format is stressed by providing the ladettes with a uniform (comprising a classic tweed suit, court shoes, and a pearl necklace). There is an implicit valorization of upper-middle-class, white Britishness, with an emphasis on domesticity based around heritage and glamour that is also found in a more playful way in celebrity magazines. Like Roberts, Skeggs has observed that the middle classes are usually associated with "restraint, repression, reasonableness, modesty and denial", contrasting sharply with the excesses of working-class behaviour that are embodied by the participants in *Ladette to Lady* (99). This traditional notion of middle-classness is carried through in the kinds of lessons which are taught, such as deportment, elocution, etiquette, flower-arranging, cookery, and dressmaking. These lessons are conducted in a less playful way, in that the participants are situated as schoolchildren who must respect and obey the teachers' authority. This forms an extreme version of the sort of governance that is found on other makeover shows, as discussed by Roberts. The teachers are addressed formally, and the participants are expected to abide by rules that are more usually imposed on much younger, school-aged pupils, particularly those at traditional boarding schools. Should any of the participants fail to abide by the rules, they risk incurring penalties; they may, for example, be confined to the school premises while their peers are "rewarded" with a trip to the local pub. In one episode, a participant who drank to excess at a weekend house party is subsequently made to wait a table at a formal party and forbidden from speaking to any of the guests. Thus, the containment of the young women is not only physical but also, as we shall see, behavioural, in line with traditional notions of femininity.

In face-to-face encounters with individual participants, the teachers are shown to be more maternal, offering advice and encouragement to any young woman who appears to be struggling. The apparent non-competitiveness of the show is emphasized through the fact that it is the teachers who decide which participant leaves at the end of each week, not some viewer phone-in vote or skills test. Instead, the teachers claim to look for aptitude and attitude, gathering this information through classroom and social observation in the way a mother would judge her daughter.

Sexual etiquette

Ladette to Lady implicitly upholds traditional, gendered notions of sexual etiquette through its aggressive endorsement of female chastity, modesty, and reserve. The "progress" of the participants in this area is tested at regular intervals when they are required to meet a group of young men who are (euphemistically) called "eligible bachelors". These bachelors are largely upper-middle-class and aristocratic men, and are promoted, in Lucy Briers' plummy-toned voiceover, as the "cream of the private school system". Interestingly, although the sexual behaviour of these men is broadly comparable to the promiscuity of ladettes, the former tend to be cast in far less judgemental terms as "cads". 10 In this way, the men's promiscuity is licensed by virtue of their gender and social class, and it is up to the young women to avoid their sexual advances. Should any of the women succumb to the allures of these "cads", she risks being expelled, though there is no such surveillance or sanction for the male protagonists.

Throughout the series, there are montages of the participants during their ladette days; most of these sequences are shot in pubs or clubs, where the participants are shown to be drinking excessively and dancing provocatively. This content is certainly typical of the montage which documents the antics of Rebecca, who is insistently situated as problematic on account of her sexual promiscuity. According to Ladette to Lady, Rebecca's promiscuity is facilitated by her job as a barmaid, which affords her frequent opportunities to meet men. In the following extract, this promiscuity is contrasted with Rebecca's own testimony about the benefits of celibacy, which she outlines to Liz Brewer, the sexual etiquette coach, and Jill Harboard, the (notional) principal of the school. However, this testimony has a very specific structural rationale, and this is hinted at in the opening voiceover, which anticipates Rebecca's subsequent "misbehaviour".

VOICEOVER: Now Principal Jill Harboard is rewarding the girls with a trip to the pub but Rebecca is out for more than a few pints tonight [shots of Rebecca as barmaid making eyes at customers] Twenty-one-year-old barmaid Rebecca Squire has a remarkable track record.

REBECCA: [pre-Egglestone to camera] I've probably slept with a hundred people if not a few more. I lost count quite a while ago.

VOICEOVER: [shots of class] In the first week of term a class in sexual etiquette struck a raw nerve.

LIZ: Make it difficult. It's a question of putting a value on yourself and being special.

REBECCA: [to camera after the class] It's all common sense and everything she said don't do I do. I just feel like dead really cheap and bit of a [sic]... just feel like a bit of slapper.

VOICEOVER: But after three weeks of celibacy Rebecca is becoming restless [montage of Rebecca in pub drinking pints, shots and smoking].

REBECCA: [to local lads in pub]. I'm not going home yet; not a fucking chance am I going home yet [shot of Rebecca applying lipstick].

VOICEOVER: Rebecca soon makes an acquaintance and arranges to meet at the local club [shot of ladettes walking to a club]. It's now ten-thirty and ladettes should be tucked up in bed [dancing, kissing]. It's one-thirty in the morning when they finally make it back to Eggleston Hall. [Next day. Rebecca is expelled. School head to camera].

JILL (SCHOOL PRINCIPAL): There is no way you could have turned that into a lady.

REBECCA: [Vox pop of Rebecca packing] I like sex and there's nothing wrong with that. It's healthy and keeps you fit. I've not had any in here and look at how much weight I've put on. When I was at home I was getting regular exercise and I weren't a chunky monkey [laughs].

(2.3)

The "reward" of a trip to the local pub is clearly a means of evaluating the participants' behaviour once they are out of the school and back in more familiar venues, where the stern eye of the teachers is geographically and temporally distant (though their activities are still accessible to viewers via the cameras that follow the participants). Potential problems are flagged up in the focus on Rebecca's past. She condemns herself through her own testimony, with a further montage of flashbacks of her sitting attentively through a sexual etiquette lesson before a brief to-camera shot of her after the lesson, in which she indicates that she has hegemonically accepted as "common sense" the positive messages about chastity and traditional femininity that the school promotes. However, this is immediately undermined by the voiceover, in which the delicate, euphemistic references to Rebecca's "remarkable track record" give way to a description of her sexual frustration as "restlessness". When a visibly drunken Rebecca is shown applying make-up in a pub toilet, her rebelliousness is highlighted through her use of taboo language and her refusal to abide by the infantilizing rule of lights-out by half-past ten. The cameras follow Rebecca and the other participants as they proceed to another venue, where Rebecca's raucous partying is ironically reformulated in Briers' voiceover as her "meeting an acquaintance in a local club" – a narrative register that is humorously evocative of upper-middle-class refinement and restraint. Rebecca's fall from grace is completed the following day when her behaviour leads to her expulsion. Here, the headteacher derogatorily refers to Rebecca as "that".

rather than "her", while Rebecca remains unrepentant, playfully recasting her promiscuous behaviour as a legitimate form of physical exercise that prevents her becoming a "chunky monkey". Rebecca is thus removed from the programme for her failure to adapt her behaviour in a sincere way, and is not regarded as worthy of further attention by the teachers.

Interestingly, Rebecca also touches on one of the less apparent aspects of traditional feminine performance: its sedate and sedentary dimensions. As the series progresses, it is clear that many of the participants are struggling to fasten their tailored jackets. Such weight gain is, perhaps, a predictable consequence of a curriculum that enforces the importance of ladylike deportment: visible evidence of an increase in weight brought about by their enforced inactivity. Perhaps this is also one of the expected consequences of a ladylike deportment: the women, after all, are severely restricted in their movements; they are required to negotiate staircases slowly and elegantly, and are forbidden from bounding around the premises as they might at home, where they are not subject to such stringent levels of self-governance.

Lessons in housewifery

The ladettes must also develop an array of domestic skills that are inextricable from traditional accounts of feminine behaviour, such as flower-arranging, dressmaking, and cookery. While such skills are, potentially, practical, they are taught in ways that render them irrelevant to the everyday lives of the young women. During the dressmaking, for example, the participants are taught how to make eveningwear, with a particular focus on the ball gowns that the finalists will wear in the concluding episode. The impracticality of such garments is only too apparent as the finalists proceed downstairs, stumbling over trailing hems and tugging awkwardly at low-cut necklines. The cooking lessons are similarly impractical, in that they focus on catering for formal dinner parties, where game is the most common main course (reflecting the culling by the shooting party seen earlier in the series).

Within this domestic fairytale, the general lack of regard for the young women's lives prior to their arrival at Egglestone Hall lives is remarkable. These lives are, in fact, dismissed as irrelevant as the teachers impose their code of behaviour on the participants. Only occasionally are the participants allowed to divulge evidence of their cultural backgrounds, and this is usually accompanied by tears of humiliation or self-pity. One such instance involves Frances, the serial exhibitionist to whom

I referred earlier. Throughout the series, Frances is seen as something of a comedy figure, and shots of her breasts are edited into every episode by the predominantly male production team, inviting us to read her playfulness as foolishness. However, after a drunken night out towards the end of the series, when she is called to account by the cookery teacher, Rosemary Shrager, Frances shows remorse. We see in this particular episode (2.4) evidence of the confessional culture that Furedi has discussed as central to a wider move towards emotionality in the popular media in recent years.

ROSEMARY: We don't really know anything about you, not really.

FRAN: No, you don't [shaking head and looking tearful].

ROSEMARY: Exactly, so why don't you tell me?

FRAN: I was really picked on for having no boobs and now I've got 'em just [.] I just flash 'em about a bit too much and it causes problems with me.

ROSEMARY: Did you expose yourself last night?

FRAN: [shameful and quiet] Yeh [sniffs].

ROSEMARY: You did?

FRAN: Yeh.

ROSEMARY: But you obviously don't have self esteem.

FRAN: I just [.] I've never had a proper boyfriend, never had a Valentine's Day card [brightening up as RS looks shocked and sympathetic].

ROSEMARY: What! Really?

FRAN: Nope.

ROSEMARY: Does that upset you?

FRAN: Yeh.

ROSEMARY: I can see that [Fran crying]. You know this weekend you've actually got a real opportunity to try and find out who you could be and what you could be like. [Fran nodding] I think you should take it up and really try.

FRAN: I promise you I'm really going to try hard now.

ROSEMARY: Promise. FRAN: I promise, yeh. ROSEMARY: Alright.

Rosemary here compels Frances to reveal the underlying problem: her low self-esteem. By electing to have breast enhancement surgery, Frances has taken a consumerist solution to this problem, by paying to change what she perceives to be the source of her low self-esteem. This has, however, led to other problems, given that she now exposes her breasts in

ways that are sexually provocative. Frances volunteers the flaw in this, illustrating Whelehan's argument that in the neo-traditional femininity strand of postfeminism, ladettes are misguided: Frances tearfully claims never to have had a "proper boyfriend", which she clearly expects her teacher to find shocking. Frances's admission also underlines the prevailing view that ladettes are not marriageable: they may have fun and flit with men, but the likelihood of their involvement in longer-term commitment is slim. Thus, the "genuine" Frances is revealed to be a person who accepts traditional femininity, inwardly aspiring to long-term relationships that fall within its boundaries. Rosemary then attempts to expedite the liberation of this "genuine" self by suggesting that Frances's hosting of the weekend party will be a "real opportunity to try and find out who [she] could be".

Ultimately, the programme demands that participants be grateful for their makeovers, and not bitter; enthusiastic, not cynical. This is achieved structurally through the editing and voiceover. Where a ladette is shown to be conforming, this will be intercut with a shot of her cavorting drunkenly in the past, demonstrating just how far she has been "improved" by the strict regimen. The voiceover will also draw attention to the "negative" ladette behaviour, and this is routinely reinforced by the testimony of the ladette herself. Only those whose behaviour is considered worthy are allowed to reach the series finale. Any woman who fails to embrace "Lady Power" is represented as flawed, most often through the instructors' comments, which draw on reductive discourses about gender that are presented without any critical interrogation. These essentializing tendencies are crystallized in the words of the etiquette coach, Liz, as she reflects on the meanings and implications of the term "slag":

When you understand what a slag is, and a slag is a woman of loose morals but it's also the scum that you take off, you know a coal pit, it's that scum and what we start off with are girls who are little more than that. (End of Term Report)

Ultimately, the programme's most successful transformations are shown to be those which involve the young women whose "real selves" conform most closely to traditional ideals of femininity, while those who fail to reform are discarded as irredeemable owing to their innate ill-breeding.¹¹ In this way, traditional femininity is elevated and glorified, at the same time as unconventional behaviour is denigrated and dismissed.

Conclusion

According to Moseley, postfeminist identity is a site of tension between feminism and femininity, and as such it is understands "conventional modes of femininity as not necessarily in conflict with female power" (419; emphasis in original). However, what I hope to have shown is that the recent backlash against Girl Power seeks to make traditional femininity more dominant within postfeminism in popular culture, although not quite as destructively as McRobbie suggests. In Ladette to Lady, the adoption of "Lady Power" leads to a willing acceptance of traditional feminine roles as a form of empowerment. Social attitudes towards traditional gender roles are revealed through the rules of sexual etiquette that are imparted to the young women - rules that seek to contain female desire while refusing to condemn male promiscuity. The playfulness of the performance of the ladette is curtailed and eventually rejected as misguided by the successful participants themselves. Visually, this bias is registered in the montage of images that features in every episode. This montage charts the ladettes' arrival at Egglestone Hall, where the sartorial symbols of working-class identity (namely leisurewear and conspicuous jewellery) are immediately removed and replaced by tailored suits and pearl necklaces that are constricting, traditional, and resolutely associated with the middle class. The lessons at the school are also highly marked by social class, acting as training for the management of a marital home (whether their own or someone else's). Confined to the domestic sphere, the participants are expected to host dinner parties, where the assumption is that everyone has a dining room in which to accommodate large numbers of guests. Such an earnest, grown-up lifestyle is very different from the "irresponsible" pub-crawling of the ladettes prior to their arrival at Egglestone Hall, but the show insistently valorizes this model of neo-traditional femininity as one that is worthy of adoption. Where dissident voices do come through, as with Rebecca's reaction to her expulsion, these are framed as being the voices of participants who were never going to be "ladies" anyway, and for whom there can be no salvation or redemption.

Overall, as Whelehan comments, discourses advocating pre-feminist ideals are meant to be read ironically (147); however, from this analysis of *Ladette to Lady* we can see that the participants themselves are not only shown to be internalizing these discourses of constraint, but are also rewarded for so doing. The adoption of traditional femininity by the successful participants is emphasized by the *End of Term Report* episode, in which former participants return to the school for tea with the

teachers. Of those who are finalists, we learn that they have all gained confidence and self-esteem, their experience at Egglestone Hall having "changed their lives" for the better. The positive, empowering effects of "Lady Power" over Girl Power are thus recapitulated, while the more problematic aspects of the show and its invocation of neo-traditional aspects of postfeminism escape any obvious interrogation.

Notes

- 1. The acronym "ASBO" stands for "anti-social behaviour order", aimed at curtailing troublesome neighbours and street behaviour. Largely perceived in the media as being served on young, working-class people, it has rapidly become synonymous with the "new lad" and, of course, the more problematic ladette.
- 2. Widely used in British culture, the term "ladette" was first coined in the men's magazine FHM in 1994 to describe young women who adopt "laddish" behaviour in terms of boisterous assertiveness, heavy drinking, and sexual promiscuity. In Britain, it is frequently associated with young working-class
- 3. See Jackson and Tinkler.
- 4. See McRobbie.
- 5. See McRobbie and Roberts.
- 6. See Probyn and Projansky.
- 7. See Roberts.
- 8. See Brunsdon.
- 9. As Brenda Weber argues, the monarchy and the aristocracy are key points of reference in the reality makeover genre, functioning as models for the contestants' behaviour and appearance. See Weber (in this book).
- 10. While "cad" is defined in the Oxford English Dictionary as "a man who behaves dishonourably", one of the many female equivalents that is used elsewhere in the series is "slag", which is defined as "a prostitute or promiscuous woman". Thus, the label applied to women carries a more explicitly moral judgement that, in turn, reflects society's double standards with respect to "appropriate" sexual behaviour.
- 11. The potentially awkward relationship between the reality makeover show's rhetoric of authenticity (manifested in repeated references to the contestants' "inner selves") and its emphasis on the work of self-improvement is also raised by Weber (in this book).

Works cited

Brundson, C. Screen Tastes. London: Routledge, 1997.

Corner, J. "Documentary in a Post-Documentary Culture? A Note on Forms and their Functions" (2001). http://www.lboro.ac.uk/research/changing.media/ John%Corner@20paper.htm. [Accessed August 1, 2009].

Day, K., B. Gough, and M. McFadden. "'Warning! Alcohol can Seriously Damage Your Feminine Health': A Discourse Analysis of Recent British Newspaper

- Coverage of Women and Drinking". Feminist Media Studies 4.2 (2004): 165–83.
- Furedi, F. Therapy Culture: Cultivating Vulnerability in an Uncertain Age. London: Routledge, 2004.
- Hollows, J. Feminism, Femininity and Popular Culture. Manchester: Manchester University Press, 2000.
- Holmes, S., and D. Jermyn, eds. *Understanding Reality Television*. Abingdon: Routledge, 2004.
- Hunt, A. "Domestic Dystopias: *Big Brother, Wife Swap and How Clean is Your House?" Feminism, Domesticity and Popular Culture.* Ed. S. Gillis, and J. Hollows. Abingdon: Routledge, 2009. 123–34.
- Jackson, C., and P. Tinkler. "'Ladettes' and 'Modern Girls': 'Troublesome' Young Femininities". The Sociological Review 55.2 (May 2007): 251–72.
- Ladette to Lady. ITV. Series 1. June 2, 2005-June 30, 2005. 5 episodes.
- ——— ITV. Series 2. September 28, 2006–October 26, 2006. 5 episodes.
- ——— End of Term Report. ITV. December 14, 2006.
- Levy, A. Female Chauvinist Pigs: Women and the Rise of Raunch Culture. New York: Free Press, 2006.
- McRobbie, A. The Aftermath of Feminism: Gender, Culture and Social Change. London: Sage, 2009.
- Moseley, R. "Glamorous Witchcraft: Gender and Magic in Teen Film and Television". Screen 43.4 (2002): 403–22.
- Moseley, R., and J. Read. "'Having it *Ally*': Popular Television (Post-)Feminism". *Feminist Media Studies* 2.2 (2002): 231–49.
- Negra, D. "'Quality Postfeminism?' Sex and the Single Girl in HBO". Genders OnLine Journal 39 (2004): 1–23.
- Probyn, E. "New Traditionalism and Postfeminism: TV Does the Home". *Feminist Television Criticism: A Reader*. Ed. C. Brunsdon et al. Oxford: Blackwell, 1997.
- Projansky, S. Watching Rape: Film and Television in Postfeminist Culture. New York: New York University Press, 2001.
- Richardson, N. "As Kamp as Bree: The Politics of Camp Reconsidered by *Desperate Housewives*". Feminist Media Studies 6.3 (2006): 157–74.
- Roberts, M. "The Fashion Police: Governing the Self in *What Not To Wear*". *Inter-rogating Postfeminism*. Ed. D. Negra, and Y. Tasker. Durham: Duke University Press, 2007.
- Skeggs, B. Class, Self, Culture. London: Routledge, 2004.
- Tasker, Y. Working Girls: Gender and Sexuality in Popular Culture. London: Routledge, 1998.
- Tasker, Y., and D. Negra "In Focus: Postfeminism and Contemporary Media Studies". *Cinema Journal* 44.2 (2005): 107–10.
- Whelehan, I. Overloaded: Popular Culture and the Future of Feminism. London: The Woman's Press, 2000.

11

Performing Postfeminist Identities: Gender, Costume, and Transformation in Teen Cinema

Sarah Gilligan

From Hollywood classics such as *Now Voyager* (1942), *My Fair Lady* (1964), and *Pretty Woman* (1990) to TV lifestyle programming such as *What Not to Wear* (2001–07), *10 Years Younger* (2004–08), and *Gok's Fashion Fix* (2008–09), the makeover narrative is an endlessly repeated and eagerly consumed staple of popular culture. Prevailingly structured around three key components – namely the make-under, the makeover, and the final revelation/affirmation¹ – the makeover narrative implies that through the processes of consumption and feminization, the female protagonist will achieve social mobility, popularity, and the "prize" of (a new or rekindled) heterosexual romance. Through their formulaic structure, such texts work to establish the parameters of acceptable feminine appearance, while also offering viewers the vicarious visual pleasure of witnessing the protagonist's transformation from frump to bombshell.

By perpetuating class-based ideals of taste and appearance that are aggressively enforced through strategies of humiliation and intimidation, recent makeover franchises like *What Not to Wear* (2001–07) and 10 Years Younger (2004–) have been interpreted as a form of "symbolic violence" against women (McRobbie 128). However, given these shows' reliance on a performative approach to gender – in which clothing, appearance, gestures, and utterances are rendered central to the construction and transformation of gendered identity – it is also possible to view the makeover narrative in more subversive terms.² As Judith Butler explains in *Gender Trouble*, after all, gender is not tethered in any straightforward sense to the biological configuration of a sexed body, but is, rather, only as real as its performance. Butler's approach, as Stella Bruzzi observes, emphasizes "the fluidity of identity and the construction of that identity simply at the moment of performance" (167).

In postfeminist transformation narratives such as *Pretty Woman*, the female protagonist is neither trapped in, nor rejecting of, her femininity. Instead, she uses it in order to gain control over her own life (Brunsdon 86). Thus, as a "series of enactments upon characters' bodies", garments and accessories can work to enhance female agency and facilitate fluidity between different versions of feminine identity (Bruzzi 167).

Unlike films such as *Pretty Woman, Clueless* (1995), and *Sex and the City: The Movie* (2008), or TV texts like *Gok's Fashion Fix* and *What Not to Wear*, teen films such as *Pretty in Pink* (1986), *Ghost World* (2001), *Save the Last Dance* (2001), and *She's All That* (1999) offer a space within which female protagonists can fashion feminine identities in ways that eschew the processes of conspicuous consumption. Rather than montages of shopping sequences and characters revelling in the pleasures of extortionately expensive designer items, teen films tend to fetishize vintage clothing, hand-me-downs, dressmaking, and stylistic experimentation as the means by which postfeminist subjectivities can be productively re-envisioned and performed. To use Bruzzi's terminology, these texts look "at", rather than "through", clothes, in order to refashion the makeover narrative for a postfeminist teen market (36).

This chapter analyses and interrogates the roles accorded to costume in the Hollywood teen film *She's All That*. Combining "traditional" theoretical approaches with more recent methodologies, I will show how the film uses costume to develop a visual discourse that not only functions as an important "storytelling" element of the mise-en-scene,³ but also as an independent source of meaning and pleasure.⁴ The film is essentially the story of a "plain Jane" named Laney Boggs, played by Rachel Leigh Cook, who believes she needs a makeover to become beautiful, popular, and to win the "prize" of a heterosexual relationship.⁵ As Zack, the high-school prom king, accepts a bet that he can transform Laney from "scary and inaccessible" to prom queen material in 6 weeks, *She's All That* presents itself as an "amalgam of makeover giants" like *Now Voyager*, *Cinderella* (1950), and *My Fair Lady*, interweaving and reconfiguring features of the paradigmatic Pygmalion and Cinderella narratives for a contemporary audience (Ford and Mitchell 72).

Over the course of this chapter, I will argue that Laney is transformed from an outdated, anti-fashion, feminist stereotype into an image of the retro, pre-feminist⁶ woman that recalls the iconic style of Audrey Hepburn. However, while *She's All That* seems to follow the arc of the Pygmalion narrative⁷ – charting Laney's transformation into a fairly conventional sexual stereotype and the object of Zack's desires – her image is never fully stabilized. Instead, Laney is granted agency over

her own image and has the ability to move between different "styles" of femininity. The final prom scene is not preceded by any straightforward "makeover" sequence, nor is her look determined by Zack's instructions or desires. Like the heroines of other postfeminist makeover narratives, then, Laney is never confined to a single, monolithic version of femininity; rather, exemplifying the playful approach to style that marks the postfeminist phenomenon of "Girl Power"⁸ (with which the film's release was contemporaneous), Laney has access to a multiplicity of interchangeable feminine identities that are characterized by play. experimentation, transformation, and performance

The make-under

In the context of the makeover narrative, the "make-under" plays an essential role in establishing the signifiers of dowdy and aberrant femininity. Since *Now Voyager*, these signifiers – namely poorly-fitting, unstylish, "unfeminine" clothing, unkempt hair, heavy brows, glasses, and a prevailing disinterest in cosmetics – have all functioned as clichéd indicators of a woman who needs a physical makeover in order to become attractive and achieve social acceptance. There are, in fact, two types of make-under: in the first, the subject starts out as "natural" or "made-under" and is subsequently "improved" through the processes of the makeover; in the second, conversely, the subject begins as "made-up", before being "made-under" to appear more "natural" (and thus desirable). The first use of the "make-under" is the most conventional and can be seen in films such as Now Voyager, Sabrina (1954), Funny Face (1957), She's All That, Maid in Manhattan (2002), and A Cinderella Story (2004), as well as in television programmes like What Not to Wear. How to Look Good Naked (2006–08), and Gok's Fashion Fix. In these texts. the woman undergoes a transformation from scruffy and dowdy (or carefree and childlike) to "made-up" through the acquisition of the accoutrements of "grown-up" femininity. The second type of make-under is far less common, but is exemplified to some extent by *Pretty* Woman and Mean Girls (2004), as well as by television programmes like BBC3's Shag, Marry or Avoid (2008–09), in which the participants' layers of cosmetics and revealing attire are traded in for clothes and make-up that speak to more "natural", understated versions of feminine style. Although these two kinds of make-under seem to operate in contrary directions, they are actually both about the same thing: attributing ultimate value to the beauty of the "real" woman. In both cases, however, the seemingly authentic beauty of the "real" woman reveals itself as a

performative construction that is contingent upon specialist knowledge, strategic consumption, and sustained effort. Regardless of the work that lies behind it, this beauty – in order to be accepted as "real" – must be performed seamlessly, as an authentic, effortless, and thoroughly uncontrived expression of the subject's self. In the context of the make-under, then, "real" beauty is simply that which best disguises its artifice.

While acting as a prelude to the climactic moment of the reveal, the make-under also functions to build spectator identification by conjuring the illusion of ordinariness. If, in films such as *Now Voyager, Sabrina, Pretty Woman*, and *Maid in Manhattan*, glamour provides the key to social mobility, then one can argue that the functionality of clothing and the illusion of ordinariness is also class-specific. In *She's All That*, Laney is signalled as a Cinderella figure whose time outside school is dominated by housework, caring for her father and brother, or working part-time in a fast-food restaurant. This is best illustrated in the film's early scenes, when Laney's wardrobe of t-shirts, paint-splattered dungarees, Dr Marten boots, and thick-framed glasses is used to foreground the practical demands of her day-to-day life and signify her prioritization of functionality over fashion.

Questions about clothing, embodiment, and personal adornment have long been central to feminist debates about the relationship between patriarchy and women's oppression. In the early scenes of *She's* All That, Laney's utilitarian costuming seems to feed into such debates through its indebtedness to dominant media stereotypes of the "masculinized" feminist woman. If Laney's additional penchant for 70s-style tie-dyed fabrics and batik detailing does imply her status as an artist, it is used more conspicuously to signify her lack of interest in contemporary trends. In the context of the postfeminist makeover narrative, then, Laney's clothes position her as a teen in need of a transformation. Laney's modest, retro-feminist costuming, her outsider status, her lack of interest in feminine dress, and her seeming reluctance to explore her (hetero)sexuality are enigmatic and threatening, signalling her difference from the other female characters, particularly the most popular girl in school (and Zack's ex-girlfriend), Taylor Vaughn.¹⁰ Taylor sashays along the school corridors as though on a catwalk, dressed in an array of short, clingy, brightly coloured outfits. While Taylor conforms to a fairly traditional image of objectified femininity, Laney's baggy dungarees and Dr Martens testify to her rejection of this image, and although she is never explicitly identified as a "feminist", her appearance works to imply her status as such.11

Although the cinematic cliché of the transformation from "unflatteringly ridiculous to respected" is problematic in the sense that it diminishes the girl's "intellectual authority", the actual processes of transformation and the surrounding discourses of femininity remain worthy of investigation (Shary 243). After all, the narrative tensions between intellect and image are not only integral to the discourses of transformation and conformity, but also occupy a central role in ongoing debates about feminism, femininity, and postfeminist identity.

Makeover potential

In the makeover film, the female protagonist's makeover "potential" is most usually identified by a male character. In the case of She's All That, it is Zack who recognizes Laney's potential when she removes her glasses at the end of their first date. This implies that feminine beauty, though hidden, can be detected and subsequently revealed by the discerning male. As Mary Ann Doane discusses in her analysis of Now Voyager, glasses simultaneously signify "intellectuality and undesirability". It is only when her glasses are removed that a woman can become a "spectacle, the very picture of desire", in what Doane argues is "one of the most intense visual clichés of the cinema" (139). Functioning as a key, transformative moment, the "glasses scene" is knowingly represented and subverted in She's All That as an eagerly anticipated, yet humorous, cliché. As Laney and Zack stand at the traffic lights, Zack pauses, looks at Laney, and asks: "Do you always wear those glasses?" While Laney initially averts her gaze, she internalizes the makeover "moment", turns to face Zack and briefly removes her glasses. The moment is fleeting and it is only when Laney puts her glasses back on that she makes direct and lingering eye contact with Zack, who raises his hands to her face and declares, "Because your eyes are really...beautiful". Rather than playing to audience expectations and removing Laney's glasses to reveal her beauty once again, Zack pushes them further up her nose. The contradiction between Zack's words and his actions work to subvert the spectator's expectations of the revelatory "glasses moment" in Hollywood cinema. With her glasses still firmly in place, Laney is able to see and analyse the moment; she is not, then, reduced to the position of erotic spectacle. The camera cuts back to reveal a mid-shot of Laney, her face aghast as she realizes Zack's intentions:

LANEY: Oh please. ZACK: What?

LANEY: Your eyes are really beautiful. You really broke out the guns with that one didn't you?

ZACK: Laney I was...

LANEY: No. I had an instinct, I went against it. This is my fault.

As Doane explains, glasses in film tend to signify an "active looking" rather than a deficiency in sight. Through the woman's possession of the look and "in usurping the gaze she poses a threat to the entire system of representation" (140). Laney's active status is also made manifest in her physical gestures; during her confrontation with Zack she first strides away from him, then turns back to admonish him further:

You want to know about art? When the class president starts touching my face on darkened street corners and talks about my eyes, there's a word for it. There's entire movement devoted to it in the 20s: it's called surreal [sic].

By undermining narrative expectations, this scene destabilizes the power of the male protagonist; Zack is left standing motionless, alone and silenced, while Laney is established as the locus of identification in the scene.¹²

The makeover

The parallels between She's All That and the Cinderella/Pygmalion narrative are writ large throughout the film. While Zack differs from Henry Higgins, his Pygamalion counterpart, in the sense that he neither tutors nor supervises Laney's makeover (Ford and Mitchell 75), he does instigate her transformation by providing the dress, the "mice" (in the form of the soccer team), and the fairy godmother (his sister Mac). As Linda Mizejewski has discussed elsewhere, makeover narratives promise a "miraculous transformation" through the combination of "expert instruction" and the "use of specific cosmetics" (168). Glamour is signified by the red, silk, spaghetti-strapped dress that Zack gives to Laney. In Pretty Woman, when Vivien is "allowed" to shop and indulge in conspicuous consumption, her natural beauty enables her to pass as Edward's girlfriend (Wartenberg 319). Conversely, in She's All That, Laney expresses her concern at not possessing enough natural beauty to conform to Zack's ideal version of feminine glamour, and when she sees her red dress she exclaims, "Oh my God! I'm such a mess".

The scene that follows closely patterns Vivien's shopping sequence in *Pretty Woman*. Rather than a montage of pleasurable "dressing up" and conspicuous consumption, however, the transformation sequence in

She's All That implies that changing one's appearance is hard work: eyebrows are plucked, cosmetics are applied, and hair is restyled as Laney endeavours to cultivate a contemporary feminine appearance. Laney's new haircut is, perhaps, the key element of her transformation. The cutting of Laney's long, dark hair not only serves to update her "retro" look, but also signals a moment of transition within the narrative, charting her movement from adolescence to a performance of adult femininity. The cutting or restyling of hair is a recurring motif in makeover films, and is a pivotal feature of Roman Holiday (1953), Funny Face, and Sliding Doors (1998). Laney's new hairstyle – a centre-parted bob – is not as short as Audrey Hepburn's hair in Roman Holiday and Funny Face, or Gwyneth Paltrow's cut in Sliding Doors, but it still marks a clear shift to a less fussy and freer style, which, in turn, indicates her conformity to contemporary ideals of pretty (but not overtly sexual) femininity.

Laney's transformation is also self-consciously remarked upon, as Mac announces her entrance: "Gentlemen, may I present the new, not improved, but different Laney Boggs". Here, the spectator, along-side Zack, waits at the foot of the staircase for the new Laney to be revealed; in a knowing allusion to earlier films like Now Voyager or Rebecca (1940), Laney's careful descent signals her passage into womanhood. As Deborah Cartmell et al. reflect, the staircase here functions as a "symbolic bridge" between the private space of girlhood and the world of "social womanhood", as stairs lead to the foyer and to the front door, which is the threshold between the familial home and "the world" (36-37). Zack looks through the spindles of the staircase (much as Claude Raines does in Now Voyager) to reveal a close up of Laney's feet and legs. Laney's Dr Marten boots, with all their connotations of masculinity, androgyny, and butch-dyke lesbianism, have been substituted by a pair of red high-heeled sandals; as modern day "ruby slippers", they promise to transport Laney into another world – that of popularity and heterosexual romance. The shoes mark a radical change in style, from functionalism to eroticism. The block heel, open toe, thick sole, and ankle strap establish Laney's fashionable status, while simultaneously situating her as an object of erotic spectacle. The block heel, in particular, gives Laney power and authority, and though it is not as overtly fetishistic as an elongated, stiletto heel, it does draw attention to the shape and flesh of her newly exposed legs. The open-toe design of the strappy sandals makes the foot the focus of erotic attention by drawing attention to Laney's painted toenails. Similarly, the visible enslavement of the foot in the ankle straps hints at bondage; while the elevated platform soles might be interpreted as erotic, however, they can also "signify high status", as Valerie Steele has discussed in her work on fashion and fetishism (98). As the camera pans up Laney's body to reveal her tight, red dress – which, again, accentuates her previously hidden curves and cleavage – she comes to occupy, and self-consciously perform, the familiar role of the eroticized, objectified woman. As Ford and Mitchell argue, Laney now "looks like everybody else", because in order "to be seen as beautiful, you must comply with current trends" (76). This observation, in turn, recalls Moseley's argument that recent teen films, including *She's All That*, are narratives that centre on "correcting the aberrant femininity" ("Glamorous Witchcraft" 405).

As Laney pauses for effect on the staircase, it is not only Zack's approval that she gains, but also that of her brother and Mac, who convey delight through their surprised and smiling expressions. Still, just as the film appears to play out this narrative cliché, Laney – freshly invested with the power of her own glamour – takes her final steps and falls down the stairs; the music, meanwhile, screeches to a halt. The high shoes draw attention to her attempts at passing as an adult, sexual woman. Laney's fall acts as moment of slippage, her gawky, adolescent self revealed in a lapsed moment of concentration. As she stumbles and falls into Zack's arms, the illusion of both glamour and height is broken, as it becomes clear just how small and childlike she is. Yet, rather than allowing herself to be "rescued", Laney pulls away, looking embarrassed, quickly attempting to retain her composure, and with it recuperate her performance of grown-up femininity.

Performing power feminism

While I agree with Robin Wood that "Laney is so obviously attractive" that all she ever will need is a better hairdo and some makeup (10), Laney's makeover signals her transformation into an image of the postfeminist woman. As Laney descends the stairs at Preston's party, she initially enjoys her newfound relationship with fashion and glamour, adhering to the postfeminist image of the "power feminist", who uses clothing as an expression of her individuality. Natasha Walter in *The New Feminism* calls for postfeminism to "free itself from the spectre of political correctness" and bury for good the "old myth about feminists, that they all wear dungarees and are lesbians and socialists" (4–5). Arguing that "we do not all have to dress the same" (5), Walter highlights that women actually have a "wickedly enjoyable relationship" with "their clothes and their bodies". This relationship, she contends, is intrinsically sensual and is marked by fantasy, role play, transformation,

and escapism (86). Following Walter's argument, the made-over Laney luxuriates in the admiring male gazes she attracts, and also wins female approval. Having been ridiculed previously by Taylor's friends, Alex and Katie, they suddenly want to talk to her and be seen with her. As Walter goes on to explain, while clothing can be read as the means by which women become the passive objects of the masculine gaze, it can also be seen as enabling a productive discourse of appreciation, pleasure, respect, admiration, and shared knowledge between women (89–90).

A seemingly problematic outcome for the postfeminist woman with

an interest in fashion is the potential for competition with other women. A battle ensues in which the "waspy, wealthy, young and beautiful" exist at the top of the pyramid (Douglas 224). Instead of a collective "sisterhood" binding women together "across ethnic, class, generational and regional lines", individualism and competition have the negative effect of dividing women (Douglas qtd. in Heywood and Drake 43). As a consequence of Laney's acceptance by some of the "in-crowd", Taylor's position as the most popular girl in school is placed under direct threat. When Laney bumps into Taylor, she is met with disdain and scorn as the girls mirror each other's costuming with their red dresses. Towering over Laney, Taylor attacks her by pouring a drink down Laney's dress. As a clone of Taylor Vaughn, Laney has seemingly lost her individuality and is reduced to a snivelling wreck as she stumbles outside the house. On one hand, then, the dress functions to propose conformity, rather than individuality, as the path to acceptance and popularity. Yet, although the scene can be read as negative, there is the possibility of casting it in more positive terms: by approaching clothes as props, Laney is able to cast off items and styles which do not work, choosing instead to develop and adapt her own, original look. Laney's "old" confidence and "new" interest in her appearance are jointly reflected in her coupling of familiar, trademark garments, such as dungarees, with her refashioned hair and makeup, as she (like Taylor) sashays down the corridors of the school and revels in her newfound popularity.

Performing the retro pre-Feminist

For Laney, the climatic prom scene provides a space in which the difficult balancing act between adolescent transformation and selfacceptance is achieved. The prom is not simply a moment of "becoming", but a space in which – through clothing – teens make sense of what it means to be young and "solidify their social identities" (Best 2). One would expect, therefore, as a culturally determined, pivotal moment in the transition between adolescence and adulthood, that narrative time in *She's All That* would be dedicated to representing Laney's anticipation and preparations for the prom. In *Pretty in Pink*, Andie's inability to buy a new dress for the prom becomes a marker of her class status and provides a narrative space for the expression of individuality, as she is forced to create her own dress through a combination of old dresses. In *She's All That*, there are no scenes of Laney's preparations, dressmaking, consumption, or the work of femininity. For the girls in Amy Best's ethnographic study, the preparations for the prom were "as important as the end product", whereas Laney seemingly goes from scruffy clothes to prom dress without any effort (40).

Rather than making a grand entrance at the prom (like Sam in *A Cinderella Story*), Laney is revealed already on the dance floor. Despite dancing with the other students, Laney's difference is marked through her costuming. She adopts the epitome of understated, chic, sophisticated attire: a black ankle-length, spaghetti-strapped shift dress, with her hair swept up into a French chignon. Even when Laney dances, she is not shown to be overly sexual (like Taylor in her showy, clingy, gold dress); instead, attention is drawn to what she is wearing and to her face. Laney's prom outfit can therefore be read as the outcome of a second makeover, where instead of shifting from "natural" or "made-under" to made-up (as she does in her first makeover, with the red dress), Laney moves from the made-up version of femininity represented by the red dress to a more "natural" look. Laney's understated elegance conveys a similar image to that of Audrey Hepburn – an image of "natural" femininity which is regarded as both authentic and appealing.

Sensible, yet sensual, a black dress neither talks too much nor "enters the room before its wearer" (Holman Eldeman 142). As Hepburn demonstrated in *Breakfast at Tiffany's*, with a classic little black dress and a string of pearls you can go anywhere, making the dress the ultimate transformative garment for women, the perfect masquerade. Laney's look, while alluding to Hepburn (especially through the casting of Rachel Leigh Cook), does not explicitly copy the iconic Hepburn image. It is even more pared down, without sunglasses, pearls, or props. The only ornamentation is the black sequinned beading on the dress, which gently catches the light as Laney moves, without being overtly flashy. The cut of the dress makes it appear fluid; the sequins reflect the light, making it appear hard like armour. Through the absence of scenes of consumption, one could speculate that the dress originally belonged to Laney's mother. Like the ring that Laney wears around her neck, the

dress connects her to her mother by creating a protective (maternal) shield; through the literal and symbolic safety of the black dress,¹³ then, Laney is able to remain a child while still performing adult femininity. Laney's unspectacular clothes actually draw our gaze in, leading her to appear far more beautiful than the extravagant, showy Taylor. In drawing attention to her face, Laney's look both further alludes to Hepburn's understated style and embodies Chanel's notion that a dress is well designed if people say, "what a beautiful woman". 14

The allusion to Hepburn's style in the costuming of Laney is interesting in terms of what the adoption of such a pre-second wave image signifies for the postfeminist woman. According to Elizabeth Wilson, the 1950s of our collective imagination has been transformed "into a world of lost innocence" that "anticipated a different and freer kind of 60s innocence" (1993, 36). For the postfeminist woman, then, Hepburn embodies an idealized "have it all" state in which she is both intelligent and beautiful, independent yet still desired by a man. The free, bohemian image of Hepburn in capri pants, ballet pumps, and black sweaters (represented in films like *Funny Face*) signifies a playful, youthful image of femininity, which is coupled with the performance of "grown-up" femininity where Hepburn wears a collection of elegant designer dresses.15

The central pleasures of Hepburn's look (and its re-appropriation within *She's All That*) lie in the duality of the image, together with Hepburn's existence in a transitional space in which (as in the iconic, endlessly reproduced shot from *Breakfast at Tiffany's*) grown-up clothes tend to signify a playful attempt at "dressing up". Glamorous femininity thus becomes one of many possible images that can be played at. It is not that Laney "becomes" the pre-second wave image that Hepburn embodies, but rather that she uses the space of the prom to dress as a grown-up woman before entering adulthood. The prom "provides an occasion to shed one's school identity and become someone else, even if only for one night" (Best 18). It operates, therefore, as an illusionary space between the imagination and reality, which enables the performance of gendered identity in the pursuit of heterosexual romance. Despite her attempts to perform an idealized, pre-second wave image of normative femininity, Laney is not willing to "do gender" enough to pass and win the title of Prom Queen. She performs the look without substance or meaning. As she kisses her handsome prince under the fairy lights by the pool, Laney declares: "I feel like Julia Roberts in *Pretty Woman* – except without the whole hooker thing". Through the prize of heterosexual romance, Lanev is saved from her outsider status and might even

be regarded as upholding a pre-feminist model of femininity through her seeming desire for a fairytale ending. Still, through its position as a teen transformation film, Laney's position is more fluid than Vivien's in Pretty Woman, and in this way she marks another shift in postfeminist representations of women. As a postfeminist teenager, Laney adheres in part to Brunsdon's category of the "post-feminist girlie" who "has ideas about her life and being in control which clearly come from feminism" (86). Yet unlike Cher and Dionne in Clueless, Laney is interested in more than surface appearances; equally, however, she does not end up becoming another "tough" postfeminist character such as Buffy, Laney therefore forms part of a shift in teen representations that includes characters such as Sara and Chenille (Save the Last Dance [2001]), Enid and Rebecca (Ghost World [2001]), Sam in A Cinderella Story and Cady in Mean Girls (2004) who each, in their differing ways, possess independence, intelligence, resilience, and often a desire to progress academically. It is not that the girls reject normative femininity, but that by the end of the narrative they each want social and geographic mobility, good looks. and a perfect heterosexual romance. Cady in Mean Girls, for instance. rejects the vacuous "plastics", repents, regains her friendships, wins the maths contest, and still gets the guy. 16

Yet the acquisition of the heterosexual romance does not mark the happy ever after, as it occurs at a moment of change: the girls are, after all, on the cusp of adulthood, nearing the end of their time at High School. With their adult futures ahead of them, these girls get to escape and move on, without being represented and punished as career-orientated, power-hungry Superwomen, like those in 1980s postfeminist backlash films such as *Fatal Attraction* (1987) and *Working Girl* (1988). For Laney, being Zack's girlfriend is just another identity that she tries on before going to away to college. The spectator in such teen films is thus given the pleasure of a feel-good, escapist happy ending, without being required to witness the confinement of the young women to any fixed (and thus potentially problematic) identity. As fictional postfeminist figures they get to have it all: the narrative ends before the complications of the future commence.

Notes

 For further discussion of cinematic makeovers, see Ford and Mitchell. See also Moseley, "Glamorous Witchcraft". For a more thorough analysis of television makeovers, see Heller and McRobbie. Also see the chapters by Weber, Smith, and Genz in this book.

- 2. For a discussion of performative approaches to gender, see Butler. For analysis of the ways in which costume functions in contemporary cinema to support the construction of identity, see Bruzzi.
- 3. See Gaines.
- 4. See Bruzzi and Church Gibson.
- 5. The allusions to Pygmalion and Cinderella were a recurring feature of the film's reviews in the press. See Macnab, Ellas, Collins, Fisher, Preston, and Cliff.
- 6. I use the term "pre-feminist" to refer to models of feminine identity that predate the advent of second wave feminism, in particular. Elsewhere in the chapter, I use the term "pre-second wave".
- 7. Originating from the Greek myth of Ovid's Metamorphosis, the figure of Pygmalion is a sculptor who carves a statue of his ideal woman (Galatea). Falling in love with his representation, the goddess Aphrodite takes pity on him and brings the statue to life.
- 8. "Girl Power" is a media phenomenon that emerged in the 1990s and which is largely associated with the success of the Spice Girls. As Stéphanie Genz observes, the term is typically used as "a media-friendly way of articulating a playful, sexualised subjectivity and agency that resist more passive, compliant versions of femininity" (87).
- 9. For examples and discussion of second wave feminist activism and debates surrounding clothes, appearance, and women, see Brownmiller, Thornham, Church Gibson ("Dressing the Balance"), and Wilson (Adorned in Dreams).
- 10. The representation of Taylor self-consciously parodies the teen film stereotype of the vapid, vacuous popular girl. Spoilt and self-obsessed, she lacks the warmth of Cher in Clueless and instead is more like the cliquey popular girls in films such as Heathers (1988) and Mean Girls.
- 11. Through her portrayal as the artistic feminist, Laney exists as a permissible, creative force, using media images to explore the victims of riots and the position of silenced women in sweatshops.
- 12. A second such moment occurs when Zack and his friends see Laney strip off her dungarees to reveal a classic black swimsuit. Dean declares "Check out the bobos on superfreak".
- 13. This need for protection is made explicit when Dean attempts to date rape
- 14. See Bruzzi and Holdman Edelman for a discussion of Chanel and style.
- 15. See Funny Face (1957), Sabrina (1954), Breakfast at Tiffany's (1961). Also see Moseley, Growing Up with Audrey Hepburn.
- 16. See Church Gibson, "Where Feminists Fear to Tread".

Works cited

Baum, Rob. "After the Ball is Over: Bringing Cinderella Home". Cultural Analysis: An Interdisciplinary Forum on Folklore and Popular Culture 1 (2000). The University of California. http://socrates.berkeley.edu/~caforum/volume1/pdf/baum. pdf. [Accessed January 18, 2009].

Best, Amy. Prom Night: Youth, Schools and Popular Culture. London and New York: Routledge, 2000.

Brownmiller Susan. Femininity. London: H. Hamilton, 1984.

Brunsdon, Charlotte. Screen Tastes. London and New York: Routledge, 1997.

Bruzzi, Stella. *Undressing Cinema: Clothing and Identity in the Movies*. London and New York: Routledge, 1997.

Butler, Judith. *Gender Trouble: Feminism and the Subversion of Identity*. 10th Anniversary edn. London and New York: Routledge, 1999.

Cartmell, Deborah, Imelda Whelehan, and Heidi Kaye, eds. Sisterhoods: Feminists in Film and Fiction. London: Pluto Press, 1998.

Church Gibson, Pamela. "Where Feminists Might Fear to Tread: Radical Shifts within Contemporary Popular Culture". Keynote address at the *Feminism and Popular Culture Conference*. Newcastle University (July 2007).

"Dressing the Balance: Patriarchy, Post Modernism and Feminism". Fashion Cultures. Ed. Stella Bruzzi, and Pamela Church Gibson. London and New

York: Routledge, 2000. 349-62.

—— "Film Costume". *The Oxford Guide to Film Studies*. Ed. Pamela Church Gibson, and John Hill. Oxford and New York: Oxford University Press, 1998. Cliff, Nigel. "She's All That". Film Rev. The Times. May 20, 1999.

Collins, Andrew. "The Best Days of Your Life? No Way". *The Observer* May 2, 1999. Doane, Mary Ann. "Film and the Masquerade: Theorising the Female Spectator" (1982). Reprinted in *Feminist Film Theory: A Reader*. Ed. Sue Thornham. Edinburgh: Edinburgh University Press, 1999. 131–45.

Douglas, Susan. Where the Girls Are. London: Penguin Books, 1995.

Ellas, Justine. "She's All That". Film Rev. The Village Voice. 9 February 1999.

Fisher, Nick. "She's All That". Film Rev. The Sun. May 25, 1999.

Ford, Elizabeth, and Deborah Mitchell. *The Makeover in the Movies*. Jefferson and London: McFarland, 2004.

Gaines, Jane. "Costume and Narrative: How Dress Tells the Woman's Story". Fabrications: Costume and the Female Body. Ed. Jane Gaines, and Charlotte Herzog. New York and London: AFI and Routledge, 1990. 192–96.

Genz, Stéphanie. *Postfemininities in Popular Culture*. Basingstoke: Palgrave, 2009. Heller, Dana Alice, ed. *Makeover Television: Realities Remodelled*. London: I B Tauris, 2007.

Heywood, Leslie, and Jennifer Drake. *Third Wave Agenda*. Manchester: University of Manchester Press, 1997.

Holman Edelman, Amy. The Little Black Dress. London: Aurum Press, 1997.

Macnab, Geoffrey. "She's All That". Film Rev. Sight and Sound. July 1999.

McRobbie, Angela. The Aftermath of Feminism. London: Sage, 2009.

Mizejewski, Linda. *Hardboiled & High Heeled*. London and New York: Routledge, 2004.

Moseley, Rachel. *Growing Up with Audrey Hepburn*. Manchester: Manchester University Press, 2002.

—— "Glamorous Witchcraft: Gender and Magic in Teen Film and Television". *Screen* 43.4 (2002): 403–22.

Preston, Peter. "She's All That". Film Rev. The Observer. May 23, 1999.

Roberts, Martin. "The Fashion Police: Governing the Self in *What Not to Wear*". *Interrogating Postfeminism: Gender and the Politics of Popular Culture*. Ed. Yvonne Tasker, and Diane Negra. Durham and London: Duke University Press, 2007. 227–77.

- Shary, Timothy. "The Nerdly Girl and Her Beautiful Sister". Sugar and Spice and All Things Nice. Ed. Frances K. Gateward, and Murray Pomerance. Detroit: Wayne State University Press, 2002. 235–53.
- She's All That. Dir. Robert Izcove. Miramax, 1999.
- Steele, Valerie. Fetish: Fashion, Sex and Power. Oxford: Oxford University Press, 1996.
- Thornham, Sue. Passionate Detachments. Edinburgh: Arnold, 1997.
- Walter, Natasha. The New Feminism. London: Virago, 1999.
- Wartenberg, Thomas E. "Shopping Esprit: *Pretty Woman*'s Deflection of Social Criticism". *Hollywood Goes Shopping*. Ed. David Desser, and Garth S. Jowett. Minneapolis: University of Minnesota Press, 2000. 309–30.
- Wilson, Elizabeth. Adorned in Dreams (1985). London: IB Tauris, 2005.
- —— "Audrey Hepburn: Fashion, Film and the 50s". Women and Film. Ed. Pam Cook, and Philip Dodds. London: Scarlet Press, 1993. 36–40.
- Wood, Robin. "Party Time, or Can't Hardly Wait for That *American Pie:* Hollywood High School Movies of the 90s". *Cineaction* 58 (June 2002): 2–10.

Part IV Violence

12

Return of the "Angry Woman": Authenticating Female Physical Action in Contemporary Cinema

Lisa Purse

A woman lies on her back in lush grass, eyes half-closed, panting gently – hair slightly mussed, but make-up perfect. This assemblage of signifiers speaks more of conventional cinematic representations of female sexual abandon than other kinds of physical activity. And yet this is a shot from the end of a busy action sequence in Aeon Flux (2005), in which the woman in question – after a running shoot-out in which she incapacitates scores of enemy guards - has just blown up a zeppelin, then been swept hundreds of metres through the air suspended from the exploding structure, finally throwing herself at the ground as the zeppelin ditches into a wall in front of her. The woman is Aeon (Charlize Theron), the heroine of the title, and this is the final action sequence of the film. Despite this, Aeon does not display any biological traces of her recent dramatic and extended physical exertion, such as a flushed face, perspiration, heavily laboured breathing, or the facial scrapes and dirt she might be expected to have picked up in the circumstances. The physical work of action has been elided, and leaves no traces on the body of the actor.

Here, and throughout the film, Aeon's face remains undamaged, undirtied, and carefully made-up; where injuries do happen they are minor and occur on other parts of the body, such as a shoulder or arm. An earlier action sequence plays on this facial untouchability; she and colleague Sithandra (Sophie Okonedo) are trying to cross a hostile garden territory in which grass metamorphoses into real blades. Sithandra lands on her hands, incurring multiple angry puncture wounds, and as Aeon tumbles headfirst towards another cluster of blades, the risk of her features being similarly punctured looms large. She prevents impact by using her legs to steady herself, but for a moment the

blades wave malevolently in close-up just millimetres from her face. The film is invested in "protecting" Aeon's face and make-up from harm because, in this way, a key conventional marker of her femininity can be maintained. Another conventional marker of this femininity is her costuming, tightly fitted to emphasize her curves and the graceful lines of balletic movement she achieves in the action sequences (it is still the case that attributes such as grace and fluidity are often associated with femininity in dominant discourses about gender). Such strategies in the presentation of female physical action are also observable in a range of other films since the millennium, such as *The Mummy* (1999, 2001, 2008), *X-Men* (2000, 2003, 2006), *Lara Croft: Tomb Raider* (2001, 2003), the *Charlie's Angels* films (2000, 2003), *Underworld* (2003, 2006, 2009), *Blade: Trinity* (2004), *Elektra* (2005), *Sin City* (2005), *Fantastic Four* (2005, 2007), *Ultraviolet* (2006), the *Pirates of the Caribbean* franchise (2003, 2006, 2007), and *Watchmen* (2009).

The prevalence and homogeneity of such representations bears further scrutiny, but so too does a dichotomous development that has emerged in the same period that these popular representations have predominated in mainstream US cinema. The active women in films like Monster (2003), Hard Candy (2005), and The Brave One (2007) are angry transgressors, their behaviours and actions locating them outside of dominant social norms, as well as outside mainstream codes of cinematic female representation. What is clear is that this is a contemporary moment in which conflicting representational impulses are at work. Set in opposition to dominant, "sanctioned" depictions of active femininity – of which Aeon Flux is a useful example – are alternative images of the active woman that are developed, primarily, within films that hover on the margins of the mainstream. This chapter investigates the co-presence and polarization of these different modes in the same cultural period, as well as asking what is at stake in these versions of the active female body: under what terms is contemporary mainstream cinema prepared to show active female physicality?

One of the explanations for Aeon Flux's superior physical agility and strength is the future world in which she exists, where technological advances make "upgrading" the body's capacities commonplace. Notably, these are *invisible* upgrades, meaning that her conventional femininity does not have to be disrupted by naturalistic evidence of exertion or strength. This is quite a different presentational strategy to the one at work in the female action hero films of the 1980s and early 1990s, such as *Aliens* (1986) and *Terminator 2: Judgment Day* (1991), in which visibly pronounced musculature authenticated – that is, made

more credible - the heroines' feats of physical action. Yvonne Tasker suggests that this muscular and physically assertive heroine posed "a challenge to gendered binaries through her very existence" (1998, 69). While her biological sex "fixed" her as female – setting up expectations of behaviour, dress, and appearance that are based on dominant constructions of femininity – "her qualities of strength and determination and, most particularly, her labour and the body that enacted it, marked her out as 'unfeminine'". ² Tasker argues that such films sought to resolve this challenge by attempting to offer a narrative explanation for the woman's actions, "to define her as exceptional" (69). In both Terminator 2 and Aliens, for example, the heroine is defined by a maternal drive that is so strong it presses her into extreme action. The science fiction context is another qualifying frame: placing the women into alternative and future realities respectively, the films distance the protagonists from the spectator's own real-world reality, in which their actions might seem unduly threatening to dominant social hierarchies and behavioural norms. Thelma and Louise (1991) provides an instructive counter-example: its two female protagonists, driven to manslaughter and armed robbery by an attempted rape, are depicted in a naturalistic, contemporary, everyday setting; in the resulting media furore, journalists worried that thousands of women across the United States would copy the onscreen pair's actions.³

Mainstream cinema's project is typically to explain away, qualify, and often to actively "undermine... female potency as it becomes threatening", usually containing the threat by reinstating "archetypal femininity" (Bruzzi 180). While the muscular heroines of the 1980s and early 1990s problematized this containment strategy in the realm of the visual, by the later 1990s and the 2000s the reinstatement of archetypal femininity was much more carefully and systematically enforced. The popularity of small-screen action heroines in series like *Xena: Warrior Princess* (1995–2001), *Buffy the Vampire Slayer* (1997–2003), and *Alias* (2001–06) had inspired a fresh influx of active women in cinema, but these women's displays of strength were qualified by particular narrative, aesthetic, and representational strategies. I want to briefly consider these strategies in the context of contemporary notions of postfeminism.⁴

In films like *Charlie's Angels, Lara Croft: Tomb Raider, Blade: Trinity, Mr & Mrs Smith, Wanted* (2008), and the *Resident Evil* films (2002, 2004, 2007), female heroes combine their readily apparent strength and skill with a more traditionally feminine, and often emphatically sexualized, physique. Tasker has called these action heroines "post-feminist", and

they seem to encapsulate the "have-it-all" claims of certain strands of postfeminist discourse (2004, 9). Strong, intelligent, and resourceful, they are also highly feminine in their appearance and costume. Marc O'Day has suggested that such movies break apart the binary logic that underlies traditional conceptions of gendered behaviour because they "assume that women are powerful" without resorting to the conventional negative narrative explanations for female aggression – maternal instinct, rape-revenge, terrorization by a serial killer (216; emphasis in original). Nevertheless, O'Day's catchall term for these films is "action babe cinema", a phrase that revealingly resonates with connotations of objectification, visual assessment, and gender stereotyping. The contemporary action heroine enacts a sexualized femininity to which display is central; while these women are physically active, independent agents. then, there is no doubt that their bodies are also being eroticized within the terms of a conventionally objectified femininity. Sporting a range of conventionally gendered, close-fitting, and revealing outfits, they appear uncannily similar to the semi-naked gun-toting girls of 1970s exploitation flicks like Caged Heat (1974) and Big Bad Mama (1974). Pam Cook noted at the time that these earlier movies presented "serious problems" for second wave feminists, popularizing (with exploitation audiences) "an overtly coded, fetishized image of woman as sexual object" that counteracted her status as an active subject (123). Taking this into account, then, is the contemporary action heroine's status as active subject and sexualized object any less problematic?

In a postfeminist cultural context, sexualized display is often characterized as an active choice made by women who have already benefited from second wave feminism's campaigns for gender equality. Robert Goldman, Deborah Heath, and Sharon L. Smith note how "[m]eanings of choice and individual freedom become wed to images of sexuality in which women apparently choose to be seen as sexual objects because it suits their liberated interests" (338). As Sarah Projansky has pointed out, however, this position – predicated on the assumption that feminism is somehow no longer necessary – reveals its own white, middle-class bias: only women in particular economic and social positions can afford the luxury of choice (70). In this context, it is significant that the majority of current mainstream action heroines resemble white middle-class women. From luxury apartments and the uncanny ease of instantaneous international travel to top-of-the-range cars and bespoke outfits, the women of films like Charlie's Angels, Underworld, and Wanted signal their independence in terms of high-paying jobs and the resulting signifiers of wealth. Such movies offer not only fantasies of physical empowerment, but also fantasies of *economic* empowerment.⁵ Still, if these heroines' revealing outfits and often sexually assertive behaviour are markers of their "liberation" in the fictional world of the film, their resulting status as sexual objects within the film text seems to commodify that independence and agency, draining such representations of any radical thrust. Action heroism thus becomes another brand of "commodity feminism" (Goldman et al. 347). At the same time, it is notable that white women's empowerment is often achieved at the expense of women of other ethnicities: in *Resident Evil* the gutsy female Puerto Rican marine Rain (Michelle Rodriguez) becomes a sidekick for the white heroine Alice (Milla Jovovich), and dies before the film's end; in *Aeon Flux* Sithandra, played by an actress of part-Nigerian descent, also dies protecting the Caucasian Aeon. Such representations perpetuate and naturalize hierarchies of power and influence that are active in the wider society, complicating attempts to read them as progressive.

Sexual objectification and the perpetuation of dominant class and ethnic hierarchies are just some of the representational tropes that are regularly present when depictions of female physical empowerment are "permitted". Other common containment strategies are operational at the levels of narrative and/or cinematography. Each film locates the action within a generic context that is distanced from contemporary reality: many are ostensibly "present-day" settings, but in genres where the fantastic or supernatural are possible (*Elektra*, *Resident Evil*). Comedy is also a popular compensatory tactic, removing the need to "take these women seriously" (as exemplified by *Charlie's Angels*, the rather obvious *My Super Ex-Girlfriend* [2006], and *Hancock* [2008]). Likewise, both narrative context and narrative closure often function to re-inscribe traditional feminine roles. Active women thus tend to be constructed as daughters – groomed for action by influential father figures,⁶ as in Elektra, the Charlie's Angels films, Lara Croft: Tomb Raider, and the Resident Evil franchise - or as wives, in Mr & Mrs Smith and the Fantastic Four films. They are also, quite often, transformed into wives and/or mother figures at the narrative's close, as is the case in Kill Bill: Vol 2 (2003), Elektra, Aeon Flux, and Hancock. Where the active woman co-exists alongside and coaches a central male protagonist into becoming powerful, she is most likely to have to "make way" for him, often through death: in the *Matrix* franchise Trinity (Carrie-Ann Moss) is relegated to the position of sidekick and love interest to Neo (Keanu Reeves), and in Matrix Revolutions is removed from the cinematic frame entirely when she killed in a crash. In Wanted the highly skilled assassin Fox (Angelina Jolie), who has helped recruit and train newcomer Wesley (James McAvoy), commits suicide to save Wesley's life and to free him from the grip of a rogue assassins' organization. Also significant is the inclusion in such narratives of villains who signal the danger of "too much" female agency, power, or independence: *Charlie's Angels: Full Throttle* (2003) pits the heroines against an ex-Angel who is characterized as a revenge-obsessed loner. Skilled and independent, she has forsaken the group and Charlie's paternalistic leadership; notably, she is pathologized through her "masculine" love of guns, rather than the more "ladylike" martial arts combat style of the Angels. In *X-Men: The Last Stand* (2006), the timid Jean Grey is driven mad by telepathic and telekinetic powers that she is unable to control, becoming a divided – if primarily monstrous and murderous – figure who must be killed off.

As the examples above demonstrate, the physically active female protagonist is, for the most part, a figure whose "unladvlike" bouts of violence are framed in ways that locate her at a distance from real life. In light of this, the re-inscription of traditional femininity has a further "off-setting" function, reasserting conservative behavioural "norms" that disconnect the feminine from the perpetration of physical aggression. The female heroine's physical potency is most damagingly qualified by the way in which her actions are not authenticated by reference to real-world laws of physics and physiology. In action sequences. the consequences of bodily momentum, weight, and collision that would be present in a more realistic rendering of the action are not conveyed. Moreover, physical markers of exertion and injury are virtually absent; recent films featuring female action heroes have tended to significantly downplay the physical pain and impact involved in action and combat sequences. Blood and other physical evidence of bodily impact are minimal: minor cuts are much more likely than more major, appearance-warping injuries such as swellings or broken bones. Moments of physical activity do not, then, intersect with realistic notions of the bodily consequences of violence, as this would unbalance the marketable hybrid formula of active hero and erotic object that the so-called "action babe" represents. Implicitly rejecting the sweatdrenched muscular exertions of earlier figures like Ripley, Sarah Connor, and Navy SEAL Jordan O'Neill in GI Jane (1997) as "inappropriate". these newer representations re-imagine the traditional heroic qualities of toughness and determination in ways that uphold conventional notions of gender, emphasizing the female action hero's "feminine" grace, dignity, and (well-maintained) appearance.

In a contemporary Western culture frequently characterized as postfeminist, then, these women seem to represent the "acceptable

face" – and body – of female empowerment: predominantly white, heterosexual, frequently scantily clad, and enjoying the trappings of a middle-class lifestyle. But in this homogenous and rather "safe" set of mainstream depictions, particular kinds of spectacles are suppressed in relation to the active female body: images of physical stress and extension; the biological consequences of exertion and violence; and the dangerous motivations that drive aggressive acts. However, the untidy female exertions refused in popular "action babe" representations are now erupting into view in a number of other contemporaneous movies. These movies might be understood as constituting a cinematic "return of the repressed", as through their visceral and realistic portrayals of female physicality they represent, precisely, what has been subdued within (or entirely cast out of) mainstream accounts of female action. In the second half of this chapter I want to turn my attention to the small number of films which – despite occupying different generic and production contexts – offer depictions of a female physicality that has been rendered invisible in most quarters of contemporary mainstream US cinema.

Patty Jenkins' *Monster* (2003) is a film based on the life of Aileen Wuornos, a Michigan prostitute who was put to death in Florida in 2002 for the murder of several men. The film's opening montage sequence proposes the factors contributing to her present state as an unhappy, alienated, aggressive alcoholic and destitute prostitute, which include (but are probably not limited to) child abuse, domestic violence, and sexualization at an early age. From the outset, then, Aileen is firmly established as an outsider. Despite Aileen's verbalized wish to "be beautiful and rich like the women on TV", the film – through a complex performance (from Charlize Theron) and make-up effects – emphasizes the range of ways in which her body does not "fit". Lank hair, pockmarked, puffy features, a large frame, and an awkward gait distance her from conventional conceptions of femininity. In addition, her failed or half-hearted attempts to perform a commodified femininity – for example when she attempts to talk dirty to johns, or says the wrong thing at a job interview – jarringly foreground both the rules of gendered behaviour and her non-compliance. Still, it is the depiction of Aileen's first murder that both narrativizes her aggression and offers a spectacle of authentic physical action, mobilizing elements emphatically denied in mainstream representations.

Aileen needs money for a date with her new girlfriend Selby (Christina Ricci), and, soliciting at night on a busy road, she gets picked up by Vincent Corey (Lee Tergesen), who brings the car to a halt in secluded

woodland. After some awkward small talk Aileen expresses reluctance to perform fellatio on Corey, and in response he beats her unconscious. Waking up bloodied and groggy, Aileen finds herself face down on plastic sheeting inside the car, her wrists tied; as she struggles to free herself, Corey asks her if she wants to die, brutally rapes her with a tyre iron, kicks her and douses her with bleach. In the brief moment it takes Corey to stow the bleach bottle back in the car boot Aileen struggles and screams so violently that she manages to free her wrists from their bindings. She quickly pulls a gun from her handbag and starts firing at Corey, not stopping until her ammunition is spent and he lies dying on the ground.

The rape scene is presented in medium close-up, a shallow depth of field bringing Aileen's dazed and blood-smeared face into sharp focus closest to the camera in an image that contrasts sharply with representations of the perfectly made-up, untouchable female face in Aeon Flux. Shallow staging foreshortens the space of the car, intensifying the claustrophobic effect of the shot, so that Corey's vicious attacks feel "too close", like an invasion of one's personal space. The staging prevents a clear view of what is being done to Aileen's body: we access the violence not through its spectacle (which risks sensationalizing or eroticizing the event) but through glimpses of Corey's instruments of torture and, much more importantly, Aileen's facial reactions; her struggle for comprehension; her silent cry as she experiences the physical and mental agony of the rape; and her shocked, agitated screams as the bleach burns into her skin. Her will to resist this horrific attack is expressed in the moment when she finds her "voice", the silent scream becoming an audible shriek of rage. Significantly, Aileen's howls mark her passage from victim to perpetrator; they begin towards the end of Corey's attack, continue during the series of gunshots she fires while propelling herself out of the car, and recur sporadically until long after Corey is dead. The vocal delivery, pitch, and persistence of these howls not only convey Aileen's rage but also her frustration at having been first compelled to endure the attack and then forced to lethally retaliate. As the gun is fired, two shots from the rapist's point of view frame the bloodied, brutalized female body as it projects itself into forceful retaliation. Out of the dark car interior Aileen moves towards the camera, wild-eyed, still screaming, still firing; her face is only fleetingly in focus in these shots, as if her angry reaction cannot be contained by the cinematic frame. The claustrophobic, static framing during the rape gives way here to the open space outside the car, Aileen freeing herself and the spectator from the confined space of physical trauma.

In its naturalistic but carefully designed presentation, this scene forces the spectator into uncomfortably close proximity with the female body as a site of violence and rage, emphasizing the visceral consequences of Corey's attack, the physical efforts of Aileen's straining, resisting body as it frees itself, and its corporeal force as she fights back. Such a representation of female agency, so markedly different from the sanitized and contained depictions described earlier in this chapter, is underpinned by an explicit return to the kind of rape-revenge narrative structure that generated early depictions of female physical agency in the exploitation movies of the 1970s and early 1980s. Films like *I Spit On Your Grave* (1978) and *Ms 45* (1981) show raped women so traumatized and angered by their experiences that they are driven to kill their rapist (and/or other men), establishing what Pam Cook called "the stereotype of the aggressive positive heroine obsessed with revenge" (124). Female anger born of a very personal, gendered suffering became an explanation for female violence and aggression – the implication being that women would not do "this kind of thing" except in response to a devastating and physically invasive assault, a hypothesis that does nothing to dismantle dominant binary conceptions of gendered behaviour. These films seemed to exemplify the problem Cook identified in the exploitation movie: depictions of female agency came at a price, frequently including titillating nudity, sexualized rape victims, and pre-vengeance "seduction" scenes. However, in a 1970s cinematic landscape in which women were not conventionally shown as physically active or aggressive beings, the rape-revenge narrative troubled representational norms by carving out a space in which female physical action *could* – at least and at last – be depicted. and at last – be depicted.

In a similar way, *Monster's* invocation of the rape-revenge narrative results in a representation of female violence that "interrupts" a contemporary landscape of sanitized images of active women. However, this time it is not the fact of female violence that is interruptive, but the realtime it is not the fact of female violence that is interruptive, but the realism, the credibility, of its depiction. Here the rape-revenge narrative does not precipitate titillating, sexualizing spectacles, and nor does it insist on the re-inscription of traditional femininity; rather, it produces the circumstances in which a naturalistic portrayal of female physical exertion can be advanced. Class does operate as a distancing factor – Aileen's poverty and profession locate her, initially, at a potentially reassuring distance from the majority of the audience for the film, which was distributed on the art cinema circuit – but the film encourages the audience to interrogate that distance. The film's title is crucial in this regard; it appears as we see Aileen huddled under a flyover, sheltering from the

rain. Even though the situation itself is likely to elicit some sympathy for the character's predicament, the image invites the audience to associate the title with the character in the frame. As the film progresses, however, the title's connection to Aileen is undermined. Theron's performance communicates not simply her belligerent attitude but the low self-esteem and anxiety that drives it, while the designation of "monster" becomes more applicable to those who surround Aileen, from the seething, misogynist rapist Vincent Corey to the pathologically manipulative girlfriend Shelby, who pressures Aileen to continue to prostitute herself, despite knowing that this is driving Aileen to kill again. Straightforward qualifications and sanitized depictions of female violence are replaced by aesthetic strategies that challenge the spectator to rethink notions of appropriate behaviour and justified action. More broadly, they urge a reconsideration of the ways in which disenfranchised persons are framed – by the media, in films, and in society – in relation to gender and class.8

The process of highlighting the corporeal signs of exertion and anger is at work at the moment of initial attack (as in Monster's rape scene), but also helps to authenticate the process of retribution - namely, the violence that is subsequently enacted by the female protagonist. In Hard Candy, Hayley (Ellen Page), a 14-year-old girl who may or may not have been a victim of sexual assault herself, is highly organized in her entrapment and punishment of suspected paedophile Jeff (Patrick Wilson), who she thinks has abused and killed a school friend. Much of her assault on Jeff is verbal, but the articulate teenager physicalizes her retribution in ways that are both premeditated (a mock castration, an electrocution) and unplanned. Despite being restrained to an office chair by electrical tape, Jeff momentarily disrupts Hayley's carefully orchestrated kidnapping and torture campaign, knocking her unconscious with a kick as she kneels in front of him, before managing to arm himself with his own gun (the "punishment" is taking place in his own house). Hayley is forced to use all her physical force to disarm him, desperately wrapping cling film around his head to cut off his airways while he uses the office chair to slam her violently into the wall behind them. An unstable handheld camera communicates this physically precarious struggle for power. Close-ups highlight sweat and Hayley's pained expression, and guttural grunts register each impact of her body against the wall. Despite this, she manages to keep Jeff restrained until he loses consciousness. Hayley extracts herself and, bent double, emits anguished groans and retches through tears as she forces herself to overcome the stomach injuries he has inflicted. Anger,

a motivator for all her actions in the film, peaks here as she scolds herself for letting down her guard: there are no words, just screams, as she slams her own body back against the wall in self-punishment. Staging and presentation, sound and image, not only work to emphasize Hayley's physical resilience and the corporeal force she is able to sustain, but also the determined emotional basis of her actions.⁹

In Monster and Hard Candy proximity is a crucial tool in allowing the film to pick out naturalistic detail in the image: sweat, blood, involuntary body convulsions, appearance-warping injuries that are farremoved from mainstream conventions of presentation. Sound design is also very important: ambient sounds are reduced to a minimum, pared away in order to focus attention on the instinctive, non-verbal noises emanating from these traumatized but struggling bodies. Wails, shrieks, guttural groans, and screams do not conform to the stylized phrasing of female screams that have a long tradition in the horror genre, but are untidy, uncontrolled, unpredictable, and communicative of the physical exertions being undertaken and/or endured. Even where verbal communication is possible, the vocalization of rage warps the pitch, timbre, and volume of expression. In *The Brave One*, for example, when a sympathetic police detective (Terrence Howard) tries to stop Erica Bain (Jodie Foster) from executing the remaining member of a gang that killed her fiancé and left her for dead, he appeals to her with the phrase "You do not have the right". She responds with a cry of "YES I DO!" in a shout that modulates into a frustrated wail, which conveys both her deep anguish and her conviction that this physical violence is the correct form of retribution. These naturalistic elements of presentation, particularly the strategic use of proximate camera positions and sound, construct the female body as a site of violence, but not in a titillating or sexualized way. 10 They thus assist in creating the circumstances in which the female body can harness traumatic experiences in order to become credibly violent. The central catalyst in this transformation from victim to perpetrator is not victimhood but anger. Carol Clover's "angry woman" of 1970s horror – a woman "so angry that she can be imagined as a credible perpetrator...of the kind of violence on which, in the low-mythic universe, the status of full protagonist rests" – returns in these films, still in the service of authenticating female physicality and aggression (17).

Of course, the assimilation of this angry woman trope into the mainstream is already being attempted. From *Kill Bill* and the *Resident Evil* franchise to *Mr & Mrs Smith* and *Hancock*, popular cinema is struggling to incorporate this figure of the angry woman into its narratives. Even so, as I signalled earlier in relation to some of these very films, the process of assimilation means the reinstatement of well-practised containment strategies. The anomaly in this group is *Kill Bill*, which is almost schizophrenic in its oscillation between a sanitized, highly stylized mode of non-authenticated female action, and a mode which offers visceral, raw, and naturalistic depictions of violent female exertions – using, as it does, sound design, static framing, and camera proximity in similar ways to *Monster* and *Hard Candy*. The extreme tension between these two representational modes in a single movie project (the oscillation continues across both volumes of *Kill Bill*) is a testament to the extent that representations of female action and physical exertion have become polarized – between the poles of "acceptable" and "unacceptable" – in contemporary media culture.

However, the portrayals of female action in films like Monster and Hard Candy still retain an aesthetic and affective distinctness that the mainstream cannot yet quite incorporate. What these films offer is an active body that can be experienced by the spectator, its bodily stresses and pain presented in close-up. This heroine is often untidily angry, bloody, and sweaty, and we are compelled to witness her determination and physical effort "up close", rather than at a comfortable distance. Such instances do not just contravene dominant conservative conceptions of what kinds of female physicality can be shown. Rather, the persistent use of close-ups at moments of extreme exertion creates a spectatorial proximity to the female body in action, subverting socially defined notions of appropriate spatial proximity to another person's exertions and suffering. Returning this particular "angry woman" to the cinematic frame offers a valuable corrective to the relatively well-behaved and unconvincingly physical heroines of mainstream film. Films like Monster and Hard Candy communicate convincingly, credibly, and in impactful ways that the female body can be active, physically effective, aggressive, and masterful through its projection of its own force. In this way, they challenge mainstream cinema's ideological project to repeat and confirm conventional conceptions of appropriate gendered behaviours. For all their problematic aspects, then, it is these representations of female physicality and agency that retain a radical intensity in the current context of mainstream, sanitized representations of active gendered bodies.

Notes

 In addition to her strength Aeon has a secret magnifying lens built into one eye; her colleague Sithandra has a more visible upgrade, replacing her feet with hands.

- 2. Such dominant cultural constructions of gender have their basis in "psychoanalytic accounts which theorize sexual difference within the framework of linked binary oppositions (active male/passive female)" that "necessarily position normative female subjectivity as passive or in terms of lack" a perspective that positioned these muscular women as phallic, "unnatural" or "figuratively male" (Hills 39).
- 3. See Cook and Sturken.
- 4. Lindsay Steenberg illustrates some of the ways in which postfeminism and containment strategies interrelate in her analysis of the figure of the female investigator (in this book).
- 5. These fantasies of physical and economic empowerment are likewise central to recent female-focused television fictions. For a compelling analysis of the ways in which these modes of empowerment operate in relation to small-screen portrayals of the "new woman professional", see Rosie White's chapter in this collection.
- 6. The influential father figure is similarly central to understanding representations of female action in television series like *Buffy the Vampire Slayer* (1997–2003), *Alias* (2001–06), *Veronica Mars* (2004–07), and *Heroes* (2006–10). For more on the role accorded to father figures in *Alias*, see White (in this book).
- 7. While Freud coin this term, Robin Wood uses it explicitly in relation to the ideological operations of 1970s horror films in "The American Nightmare: Horror in the 1970s".
- 8. As the rape sequence analysis illustrates, through editing and camera position the film forces the spectator to access and share Aileen's perspective at key moments. The job interview sequence is extremely effective in confronting the spectator with class prejudice, writ large in the patronizing, condescending behaviours of the interviewers; this scene also speaks to the institutional failings that caused Aileen to become disenfranchised in the first place.
- 9. It is probably worth saying that we are not used to seeing teenagers as young as Hayley using physical force in mainstream cinema, certainly not in an abuse-revenge or rape-revenge narrative framework. In this way, both *Monster* and *Hard Candy* challenge normative expectations of gendered behaviour and physicality, one in women, the other in mid-teen girls.
- 10. This invites consideration alongside the visual strategies of "torture porn".

Works cited

Aeon Flux. Dir. Karyn Kusama. MTV Films/Lakeshore Entertainment, 2005.

The Brave One. Dir. Neil Jordan. Village Roadshow Pictures/Silver Pictures, 2007.

Bruzzi, Stella. Undressing Cinema: Clothing and Identity in the Movies. London & New York: Routledge. 1997.

Clover, Carol. Men, Women and Chainsaws. London: BFI Publishing, 1992.

Cook, Pam. "'Exploitation' Films and Feminism". Screen 17.2 (1976): 122–27.

Goldman, Robert, Deborah Heath, and Sharon L. Smith. "Commodity Feminism". Critical Studies in Mass Communication 8 (1991): 333–51.

Hard Candy. Dir. David Slade. Vulcan Productions, 2005.

Hills, Elizabeth. "From 'Figurative Males' to Action Heroines: Further Thoughts on Active Women in the Cinema". *Screen* 40.1 (1999): 38–50.

- Monster. Dir. Patty Jenkins. Newmarket Gilms/Media 8. 2003.
- O'Day, Marc. "Beauty in Motion: Gender, Spectacle and Action Babe Cinema". *Action and Adventure Cinema*. Ed. Yvonne Tasker. London & New York: Routledge, 2004. 201–18.
- Projansky, Sarah. Watching Rape: Film and Television in Postfeminist Culture. New York: New York University Press, 2001.
- Sturken, Marita. *Thelma and Louise* (BFI Modern Classics Series). London: BFI, 2000.
- Tasker, Yvonne. Working Girls: Gender and Sexuality in Popular Cinema. New York & London: Routledge, 1998.
- ——— "Introduction: Action and Adventure Cinema". Action and Adventure Cinema. Ed. Yvonne Tasker. London & New York: Routledge, 2004. 1–13.
- Wood, Robin. "The American Nightmare: Horror in the 1970s". Hollywood from Vietnam to Reagan. Ed. Robin Wood. New York: Columbia University Press, 1986. 70–94.

13

Negotiating Shifts in Feminism: The "Bad" Girls of James Bond

Lisa Funnell

As the longest running film series in history, the James Bond franchise currently includes 22 films released across 48 years. Armed with a licence to kill, title character James Bond is routinely placed in situations which necessitate his use of deadly force. In order to obtain audience approval for these violent exploits, Bond functions within a clearly defined political space. Historically, then, the franchise has relied on gendered, racial, and sexual stereotypes in order to differentiate Bond's "normative" heroic identity from the deviant attitudes and behaviours of his male adversaries (Black 96–97). Operating within a British heroic tradition that links masculinity with (heterosexual) romantic conquest, Bond's serial seduction of women offers a "visual guarantee of the maleness of the Secret Service" and functions as a "tipping point" in the plot (107–09). By indiscriminately bedding "good" and "bad" women, Bond attempts to ensure the success of his missions by aligning his sexual conquests with his moral plight.

Since the start of the franchise, Bond's phallic masculinity has been challenged by an array of villainous women. Each generation of female antagonists takes stock of contemporaneous attitudes towards feminism. More specifically, through the characterization and narrative treatment of "bad" women, the Bond series endeavours to register the political impact of the women's movement and reflect popular attitudes to the evolving feminist agenda. In the 1960s, then, the Bond franchise uses the figure of the sexually liberated female villain to illuminate the new freedoms that feminism has accorded to women; while it does this, however, it also positions this woman as a locus for social anxieties about these freedoms – anxieties which are invariably borne out in her violent punishment and death. If the films of the 1970s and 1980s continue to operate in this "backlash" mode – marked, in particular,

by the gradual elimination of female villains from the series – then the 1990s augurs in a new generation of adversarial women who invite consideration alongside the fraught discourses of postfeminism. In this chapter, I conduct a close, critical examination of shifting representations of female villainy in the Bond films. Through detailed reference to the ways in which violence is enacted by, and upon, the female body, I show how the Bond franchise has both registered and interrogated the feminist gains that have taken place since the initial release of *Dr. No* in 1962.

Establishing the female villain

Established during the "swinging sixties", the Bond franchise initially engaged with the politics of the sexual revolution through its representation of "modernized" sexual identities, and a related querying of persistent gender stereotypes. According to Tony Bennett and Janet Woollacott, James Bond and his Bond Girl functioned as "key sites for the elaboration of a (relatively) new set of gender identities". Bond embodied a male identity freed from the sexual restrictions of chivalry that had limited the traditional aristocratic hero, while the Bond Girl was depicted as "the subject of a free and independent sexuality liberated from the constraints of family, marriage and domesticity". Still, although she appears to embody the liberal sexuality of the emerging women's movement, the 1960s Bond Girl is, perhaps, more accurately described as a "model of adjustment", a dependent and derivative character that is tailored to fulfil the sexual needs of Bond (24).

Certainly, the Bond film consistently links sexual pleasure with powerful notions of duty and punishment. Examining female characterization in the James Bond novels, Christine Bold writes that women's bodies are "designed to pleasure others: notably, James Bond". In this way, they function within a wider trope which draws connections between "lines of national affiliation and [those of] sexual attachment" (172). Bold's argument can be applied to the depiction of "good" and "bad" women in the Bond film. Throughout the 1960s, the franchise both engaged with and recapitulated historical approaches to gender that situated female sexuality as suspect and dangerous when articulated outside the confines of heterosexual marriage. When women act as independent agents expressing sexual desire, they are typically considered threatening, deviant, and "bad". According to Deborah Tolman and Tracy Higgins, "Women who wish to avoid the consequences of being labelled 'bad' are expected to define the boundaries of sexual behaviour, outlined

by men's desire, and to ignore or deny their own sexual desire as a guide to their choices" (205). Thus, in order to be presented as a "good" character, the Bond Girl is expected to submit to the will and libido of James Bond, forfeiting her own liberated sexual identity for a domesticated one. By comparison, women who embrace their liberal sexualities and refuse to adhere to the "Bondian" standard of normative femininity are presented as "bad" and are violently punished.

Interestingly, the first decade of the franchise (1962–69) featured the highest concentration of female villains in leading and supportive roles, and the films produced during these years relied on particular iconography to designate villainous and heroic embodiments of female identity. The image of the Bond Girl strongly adhered to the character template outlined by Ian Fleming in the James Bond novels. In the novels, for instance, Bond Girls are described as having either blonde or dark brown/black hair with no intermediate shades, and this trait is carried through into the cinematic imaging of the 1960s Bond Girl (Amis 55).² On the other hand, the most dangerous female villains of the decade – including Rosa Klebb (Lotte Lenya) in From Russia with Love (1963), Fiona Volpe (Luciana Paluzzi) in Thunderball (1965), Helga Brandt (Karin Dor) in You Only Live Twice (1967), and Irma Bunt (Ilse Steppat) in On Her Majesty's Secret Service (1969) - are depicted with red hair and placed in stark visual contrast to the Bond Girl. In his novels, Fleming reserved the use of red hair for Bond's most dangerous male adversaries: he employed the colour literally and metaphorically in order to express the sinister nature of the villain. As Kingsley Amis suggests, "The one sure way of spotting him is to watch his eyes. If you see a red blaze or even a glint of red in them, you know your man" (65). This convention was adapted into the imaging of villainous women (and not men) within the first decade of the cinematic franchise. Drawing on stereotypes relating to red-haired women, Bond's early female adversaries were figured variously as hot-tempered, weird, clownish, wild, and/or oversexed (Heckert and Best 365). While these women were always positioned as social and/or sexual deviants, the franchise did distinguish between them through reference to the key factors of age and sexual availability. This, as I will go on to discuss, gave rise to two distinct categories of female villain: the oversexed siren (represented by Volpe and Brandt) and the middle-aged sexual deviant (exemplified by Klebb and Bunt).

All the Bond villains of the 1960s are affiliated with SPECTRE,³ an

All the Bond villains of the 1960s are affiliated with SPECTRE,³ an international terrorist organization that is presided over by the megalomaniacal Starvo Blofeld. Consisting of 11 committee members and a variety of henchmen/henchwomen and spies, SPECTRE is a fairly

contained operation, and one in which women are accorded a certain measure of authority. Fiona Volpe is the trusted advisor and primary henchwoman of Emilio Largo (Adolfo Celi), second-in-command at SPECTRE, while Helga Brant is an official member of SPECTRE, ranked eleventh in the hierarchy. Although both red-haired women are intelligent, competent with weaponry, and willing to use violence to achieve their objectives, they are not presented as physical threats to Bond; instead, it is their liberal sexual identities which work to endanger Bond's phallic masculinity. Volpe, for instance, is a "black widow" assassin who uses her body to seduce and murder her prey. When she has sex with Bond in Thunderball, Volpe not only dominates him in bed, but also ridicules his phallic masculinity: "But of course, I forgot your ego, Mr. Bond. James Bond, who only has to make love to a woman and she starts to hear heavenly choirs singing. She repents and then immediately returns to the side of right and virtue. But not this one!" All at once, Volpe rejects domestication, challenges the notion of ideological repositioning, and unrepentantly proclaims her status as a "bad girl" in the film.

At the end of each film, Bond's adversaries are expected to die. Bond typically engages in hand-to-hand combat with his male opponents and eliminates them in the film's climax. Bond, however, does not use lethal force against villainous women in the first three decades (16 films) of the franchise. Bond's restricted use of his "licence to kill" highlights the social and generic codes that govern the "proper" (and gendered) use of deadly retaliation in the series. In spite of the feminist struggle for equal opportunities, the Bond film creates a double standard that allows women to enact violence on the male body and then removes them from the arena of violent combat. Inevitably, this works to undermine the efficacy of women's aggressive actions, which, in turn, results in the prevailing depiction of women as inferior adversaries.

The manner in which the deviant female body is disciplined in these Bond films draws attention to the franchise's precarious attempts to balance patriarchal and commercial interests. Early in the series, Bond producers were concerned that audiences would experience an aversion towards Bond if he used his "licence to kill" against his female enemies. According to Ellen Willis, violence enacted on the female body is typically linked with notions of female victimization and only becomes palatable when it "can be blamed on deviant individuals rather than systematic male power. Most people, even antifeminists... condemn the perpetrators in principle" (47). In order to maintain a positive rapport with audiences, Bond producers shifted the responsibility of violence

against women onto SPECTRE: Volpe is shot in the back by one of her henchmen and Blofeld drops Brandt into a pool of hungry piranhas. Both women are killed without warning and without the opportunity to defend themselves. The burden of their dishonourable deaths is placed on the shoulders of SPECTRE and works to further vilify Bond's longtime rival Blofeld. Volpe and Brandt are thus depicted as disposable subjects whose violent deaths strengthen the heroism of Bond, while enhancing the villainy of Blofeld.

As well as the "oversexed siren" paradigm, the Bond franchise offered another model of female villainy in the 1960s. Rosa Klebb and Irma Bunt are highly influential members of SPECTRE: Klebb is designated third-in-command of the organization, while Bunt is the trusted advisor of Blofeld. Both of these women share a remarkably consistent image: they are short, stocky, middle-aged white women who are conservatively dressed and appear androgynous in their films. However, their strongest physical link is their red hair, cut short to emphasize age over aesthetics. Too old and too unattractive to pique or satisfy Bond's libido, Klebb and Bunt retain a sexual currency in From Russia With Love and You Only Live Twice respectively through their erotic interest in the Bond Girl. Characterized as masculine lesbians, Klebb and Bunt pose an overt challenge to Bond's (hetero)sexual potency and are thus condemned as symbols of an "aberrant" (homo)sexuality that threatens to destabilize the status quo.4

Presented as sexually unavailable as a result of age and orientation, these middle-aged "deviants" deny Bond his plot "tipping points" and offer unbridled challenges to his phallic masculinity. Subject to the ideology of the franchise, which sanctions the disciplining of women who reject (hetero)normative gender roles, Klebb is killed in the final scenes of From Russia With Love. Pinned against the wall by Bond, an incapacitated Klebb is shot and killed by Bond Girl Romanova, who chooses her lover, James Bond, over her lesbian suitor. At once, Klebb is punished for her deviant sexuality while "normative" female heterosexuality prevails. As Christine Bold notes, "the equation never fails: beauty, heterosexuality, and patriotism go together", and are, in turn, pitted against "ugliness, sexual 'deviance', and criminality" (174). Bunt's fate, however, is markedly different from that of Klebb. The final scenes of On Her Majesty's Secret Service feature the marriage between Bond and his Bond Girl Tracy DiVincenzo (Diana Rigg). Moments later, DiVincenzo is murdered in a drive-by shooting. Interestingly, it is Blofeld who drives the car while Bunt does the killing. Although both villains flee the scene and survive the film, Bond eventually exacts revenge on the elusive Blofeld

in *For Your Eyes Only* (1981). Bunt, on the other hand, is never killed, captured, or punished. She is the only villain in the history of the film series to escape the violent retribution of James Bond. One of the reasons for this is that Ilse Steppat, the actor who played Bunt, died shortly after the film's release. Considered irreplaceable, producers elected to honour Steppat's memory rather than recast the role.⁵ At another level, though, Bunt's evasion of "Bondian" justice might also be understood in terms of the franchise's shift of narrative focus in the 1970s – a shift which corresponds to broader changes in the portrayal and treatment of female characters. Focusing more intently on the relationship between Bond and his Bond Girl(s), films of the 1970s relegate female antagonists to secondary and supportive roles in the franchise. In spite of these explanations, Bunt still remains the only female villain to survive the film, unpunished for the crimes she perpetrated against Bond and the social/sexual taboos she breaks.

Mayday! disappearing women

While the first decade of Bond films centred on the conflict between the protagonist and his adversaries, the films of the 1970s focused more closely on the relationship between Bond and his Bond Girl. This narrative adjustment coincides with what Susan Faludi refers to as a mediadriven "backlash" against the feminist advances of the 1970s (50-54).6 According to Bennett and Woollacott, the Bond films of the 1970s pivoted on the "putting-back-into-place" of women who were perceived as having taken their independence and liberation too far: "This shift in narrative organization clearly constituted a response - in truth, somewhat nervous and uncertain – to the Women's Liberation movement, fictitiously rolling-back the advances of feminism to restore an imaginarily more secure phallocentric conception of gender relations" (28). As a result, female villains of the 1970s played relatively minor roles in the franchise and spent limited time on screen. Instead of portraving SPECTRE agents and henchwomen, these female antagonists were typically cast as incompetent spies (see Gloria Hendry's portrayal of Rosie Carver in Live and Let Die [1973]), tragic mistresses (like Andrea Anders [Maud Adams] in The Man with the Golden Gun [1974]), and sexy secretaries (Caroline Munro's "Naomi" in The Spy Who Loved Me [1977]). By the 1980s, the number of villainous women in the Bond franchise had contracted radically, and such roles were excised entirely from Moonraker (1979), For Your Eyes Only, and The Living Daylights (1987). Over a two-decade period, then, the Bond films gradually phased out any images of "bad" women that might detract attention away from the franchise's new focus on female domestication.

May Day (Grace Jones) is the only female villain of the 1980s and is prominently featured in A View to a Kill (1985) as the girlfriend of villain Max Zorin (Christopher Walken). Not only does May Day outshine the rest of cast, but she is also privileged in the film's promotion, standing back-to-back with Bond in movie posters that asked, "Has James Bond finally met his match?" (Black 226). In spite of Jones's charismatic performance, May Day is considered an enigma by film critics, who struggle to read her character through the ideology of the film series. According to Black, May Day presents a challenge to Bond's masculinity that is never resolved. Like Volpe, she poses a tangible threat to Bond's physical safety and challenges his libido by dominating him in bed. While the film anticipates a showdown between Bond and May Day, this confrontation never occurs. Given that Bond does not use fatal force against women, the showdown between the charismatic enemies is perhaps eschewed on account of the likelihood that May Day would defeat Bond in a hand-to-hand combat scenario. Instead, the film skirts the issue by having Zorin betray May Day, who then commits suicide. In this way, the film conveniently forecloses any opportunity there might have been for Bond to assert the supremacy of his phallic masculinity (227).

Through the character of May Day – who seems to be influenced, in part, by the emerging discourses of third wave feminism – *A View to a Kill* offers a moment of feminist possibility at the height of the franchise's feminist backlash. As a critical movement, the third wave is broadly defined by its prioritization of individuality, its rejection of essentialist notions of womanhood, and its sustained celebration of difference and contradiction (Tong 258). Critical of the "exclusive tendencies" of the feminist discourses that emerged in the 1970s and 1980s, many third wave feminists take issue with the essentialist notion that all women share certain common characteristics which unify them as a group, preferring to investigate the role played by specific social and/or political factors in defining women's individual experiences of oppression (Stone 85–87). "[S]haped by the racial and ethnic diversity of post-boomer generations" (Heywood and Drake 15), the third wave emphasizes racial, ethnic, cultural, and national difference, while pushing for the breakdown of ideological barriers, including gender binaries (Tong 288). This is most notable in the casting of Grace Jones as the first and only black female actor to portray a leading role in the Bond franchise. In

addition, May Day's body performance subverts gender binaries by conflating the strength and muscularity expected of masculinity with the aesthetic beauty associated with femininity. Bond is at once fearful of and attracted to her body, and his competing feelings create confusion in a usually clear-cut narrative.

In order to generate this image of a female identity that cannot be easily understood, categorized, and/or contained, the makers of A View to a Kill treaded heavily on the established star image of Grace Jones. Jones is part of the Brigitte Nielsen-era of action women and is best known for her "hypermasculine" performance of femininity. While feminist critics typically position Aliens (1986) and Terminator 2 (1991) as inaugurating the age of the Hollywood hard woman, the muscular women who feature in the action-fantasies of the early 1980s - such as Sandahl Bergman in Conan the Barbarian (1982), Grace Jones in Conan the Destroyer (1984), and Brigitte Neilsen in Red Sonja (1985) - are typically overlooked.8 In fact, Jones's characterization as Zulu in Conan the Destroyer appears to be transplanted wholesale into A View to a Kill. In the process, Jones's iconic image and celebrity status became embedded within the Bond tradition. Certainly, the makers of the film struggled to adjust Jones's star image to meet the gendered expectations of the franchise while still satisfying her fan base; as a consequence, the film does not establish any definite boundaries for her character. She is initially presented as an "other" in the film: she is wild, animalistic, hypermasculine, hyperviolent, oversexed, and amoral. Portrayed as a sadist, May Day obtains sexual pleasure by inflicting physical pain on her male victims. Her narrative treatment, however, changes when she is betrayed by Zorin. Granted the opportunity to explain her personal history to Bond, May Day reveals her motivations for employing excessive violent force and is, in the process, humanized. May Day then chooses to team up with Bond in order to exact revenge upon Zorin. When the trolley carrying Zorin's bomb malfunctions, Bond abandons the revenge mission in order to find shelter from the impending explosion; May Day, meanwhile, remains to complete the task alone, offering a competing image of heroic competency in the course of her noble death. Although all Bond villains are expected to die, May Day is the only female adversary to determine her own fate, and her character is never contained or punished for her violent and sexual exploits. In the political world of Bond, where codes and conventions clearly demarcate good and evil, May Day is a symbol of transgressive female identity that both upholds and subverts the sexist ideology of the franchise.

Postfeminist villainy

After a 6-year hiatus, the Bond film returned in the mid-1990s, having renegotiated many of its sexist codes. In order to maintain the generic integrity of the series, while still updating its identity politics, Bond producers chose "not to alter Bond's attitude towards women, but rather [altered] the attitude of the women around him" (Chapman 256). Beginning with *GoldenEye* (1995), the franchise began to incorporate postfeminist sentiments into its characterization of violent women.

Although difficult to define in any categorical sense, postfeminism is a cultural phenomena that speaks primarily to the experiences of a white, middle-class "affluent elite" which has benefited substantially from the social and political gains made by second wave feminism in the 1960s and 1970s (Tasker and Negra 2). Distinct from the third wave, postfeminism dismisses the need for continued political activism and tends to gloss over, rather than spotlight, social differences. As Jessica K. Taft observes in relation to "Girl Power", postfeminist declarations of gender equality and female empowerment can work to distract young women from the realities of oppression, ignoring the extent to which forces like racism, classism, and homophobia continue to inform the current social order (73). In this (depoliticized) context, women can lay active claim to their sexuality, and "sexiness" – as we see in the case of the postfeminist Bond villain – can be portrayed without moral judgement (Owen et al. 10–11).

The Bond films of the 1990s feature the collision of Bond's oldfashioned masculinity with the new sexual politics of the late twentieth century. By placing a deliberate focus on gender, the Bond franchise opens up a space for the emergence of new "postfeminist" female villains. These villainous women are invariably played by white American or European actors with pale complexions, shoulder-length brown/black hair, brown eyes, and petite, slender frames. As wealthy characters, their privileged backgrounds are notable through the quality and styling of their clothes, their ownership of consumer goods (like expensive cars and jewellery), and their participation in a variety of exotic leisure activities. In addition, these villains are presented as sexually empowered women who rely on duplicitous means to gain power and mastery over Bond. Recognizing his combined desire for sexual conquest and domestication, they use their bodies to develop emotional connections with Bond that render him vulnerable to attack. In GoldenEye, Bond is intrigued by the dangerous lifestyle and sensuality of Xenia Onatopp (Famke Janssen). She seduces Bond and then attempts to asphyxiate him between her legs during sex, bringing a new and violent meaning to the term "foreplay". In *The World is Not Enough* (1999), Elektra King (Sophie Marceau) wins the affections of Bond by masquerading as a helpless Bond Girl in need of his protection. She sleeps with Bond and enters into a romantic relationship with him, using their intimate connection to cover up her multiple attempts to kill him. Finally, in *Die Another Day* (2002) double agent Miranda Frost (Rosamund Pike) attracts Bond with her frosty and standoffish demeanour. She seduces Bond in order to disarm him by literally stealing the clip out of his gun while they are making love. By retaining his old-fashioned notions of masculinity and conquest, Bond becomes a target for "empowered" 1990s women, who systematically use their bodies to seduce him, render him vulnerable, and then attack him.

If May Day exemplified a species of third wave feminism that prohibited Bond from validating his masculinity, then the "postfeminism" of Onatopp, King, and Frost seems to offer Bond the opportunity for phallic reclamation. This, in turn, opens up space for the reestablishment of the franchise's sexist ideology and the re-subordination of female sexuality. Informed by "postfeminist" claims of gender equality, the franchise no longer restricts Bond from using lethal retaliation against villainous women: he engages in a violent fight sequence with Onatopp – which results, ironically, in her asphyxiation by a rope – and he also enters into a deadly confrontation with King, whom he shoots in the heart at point blank range in order to resist her attempts at sexual manipulation. On both occasions, the film permits Bond's employment of fatal force in self-defence. Although the Bond films of the 1990s explore competing gender politics, then, Bond's old-fashioned masculinity is presented as once again triumphing over dangerous women with liberal sexual identities.

The release of *Casino Royale* (2005) marks a new direction for the Bond franchise. The film reworks many of the conventions that define the genre, not least the heroic model that governs the series. No longer affiliated with the British lover tradition, James Bond is presented through the visual conventions and ideology of Hollywood masculinity. Bond's body, rather than his libido, is the new locus of masculinity, and his heroic competency is now established through the body's success within the space of physical action. By changing the parameters of heroic identity, the franchise has also adjusted the method through which Bond's heroism is tested. Valenka (Ivana Milicevic) is the only female villain to be cast since 2006, and her characterization offers important insights into the gender politics at work in the current phase of the franchise.

In *Casino Royale*, Valenka is the girlfriend of the duplicitous LeChiffre (Mads Mikkelsen), and her identity is inextricably bound up with his: she is never featured on screen without him, she has little dialogue of her own, and she only acts upon his orders. Over the course of the film, she is paraded around in revealing costumes and her semi-nude body is placed on display in order to distract LeChiffre's poker opponents. While alluring, Valenka does not interact sexually with Bond; because she is part of a monogamous relationship, she is already "domesticated" and as such does not represent an adequate sexual challenge to the British agent. When read through the original/presumed ideology of the franchise, Valenka is underestimated as a threat. And yet, she is arguably one of Bond's most threatening adversaries and the only villain to succeed in (temporarily) killing him when she poisons his martini; indeed, Bond only survives this attack because he is resuscitated by Vesper Lynd. ¹⁰

While sexy and dangerous (two characteristics typically associated with female villainy), Valenka is prevailingly disempowered: she is presented as a functionary of, rather than partner to, LeChiffre. Unlike the villainous women of the 1960s who made autonomous decisions while working under the megalomaniacal Blofled, Valenka is defined exclusively in terms of her (hetero)sexual relationship with LeChiffre. Her role in the film represents the trappings of postfeminism, which preferences reclaimed femininity and "sexiness" while overlooking residual gender, race, and class inequalities. This reading is supported by a consideration of Valenka's death in the Casino Royale. While LeChiffre is killed during the climax of the film, Valenka's death occurs off-screen and is only mentioned en passant during a conversation between Bond and M. Her death in the film is presented as a by-product of LeChiffre's failed business transaction with Mr. White (Jesper Christensen) – another male villain of the film – rather than a punishment for her attempt on Bond's life. Characterized as a sexy appendage to LeChiffre, Valenka is dislocated from the film's narrative conflict in a way that facilitates the re-centring of male villainy within the series.

In the late 2000s, the franchise continues to renegotiate the gendered codes of villainy and violent conflict. Although *Quantum of Solace* (2008) exclusively features male villains, the film anticipates the emergence of a new generation of female antagonists. Midway through the film, Bond infiltrates a meeting of Quantum, a secret international organization resembling SPECTRE, which appears to be made up of various members seeking world domination. Although Bond does not uncover the identities of all the key players, he observes two female Quantum members (played by Alexandra Prussa and Uygar Tamer, respectively). Presented as

wealthy, powerful, and attractive middle-aged women, these characters gesture towards a potential new direction for the formulation of female villainy in the series. Motivated by personal ambition, these Quantum members have the capacity to project images of female transgression that are not contingent upon "aberrant" sexual behaviours.

Within the conventions of the Bond franchise, female villainy not only serves to strengthen Bond's heroic masculinity but also offers a perfect opportunity to demonize feminism as lesbian, deviant, threatening, monstrous, excessive, and other. As I have established over the course of this chapter, female villains are often punished for refusing to exchange their liberal sexual identities for domesticated ones, and their bodies are regularly situated as sites at which hegemonic masculinity can be reaffirmed. If the red-haired villains of the 1960s (and Grace Iones's May Day) asserted feminist possibilities that were unpopular and/or underrepresented at the time, they also projected images of individuality, liberal sexuality, female empowerment, and embodied resistance that are far less pronounced in current "postfeminist" constructions of female villainy. In order to recast female villains as strong. challenging, and competent adversaries for Bond, the franchise needs to take urgent account of the ways in which the discourses of postfeminism might work to limit, rather than enhance, women's agency. In this way, the Bond film might continue to engage with the politics of its context by responding to the increasingly complicated intersections of gender and power in the twenty-first century.

Notes

- 1. The Bond franchise is defined by its own, highly specific system of narrative codes and stock characters. While this chapter analyses the Bond film (and its representation of female villainy) as action cinema, its female characters might be further illuminated through reference to the conventions of the spy genre. See Rosie White's *Violent Femmes: Women as Spies in Popular Culture* (2007) and "*Alias*: Quality Television and the New Woman Professional" (in this book).
- 2. Elsewhere I have explored the characterization of cinematic Bond Girls and noted the transcription of Fleming's character template from novel to film. See "From English Partner" (2008).
- 3. SPECTRE stands for Special Executive for Counter-Intelligence, Terror, Revenge and Extortion.
- 4. Relying on an outdated attitude to homosexuality, the Bond franchise frequently contrasted Bond's "healthy" (hetero)normative libido with the "aberrant" and "dysfunctional" (homo)sexuality of his male adversaries. See Black.

- 5. Blofeld is portrayed by Anthony Dawson (1963, 1965), Donald Pleasence (1967), Telly Savalas (1969), Charles Gray (1971), and John Hollis (1981). With respect to Blofeld, the character, and not the actor(s), is considered irreplaceable.
- 6. According to Faludi, the antifeminist backlash was a pre-emptive strike against the increased possibility that women might achieve their goal of social equality (xviii).
- 7. According to Erica Scharrer, hypermasculinity is "characterized by the idealization of stereotypically masculine or macho traits and the rejection of traits perceived as the antithesis of machismo" (160). Manifesting itself, most usually, as sexual and/or physical aggression, hypermasculinity acts as an apt framework for analysing the Grace Jones persona and the representation of May Day in *A View to a Kill*.
- 8. While these films have not been subjected to sustained analysis by feminist scholars, their influence is noted by both Tasker and Inness. The influence of the 1980s "tough woman" is also a point of reference for Purse in her delineation of the "angry woman" in contemporary cinema (in this book).
- As I have argued elsewhere, in 2006 the Bond franchise changed the heroic model on which it turns and thus altered the iconography through which Bond's heroism is envisaged. See "I Know Where You Keep Your Gun" (2011).
- 10. Vesper Lynd is a foreign liaison agent who is dispatched by HM Treasury to monitor Bond's use of the funds allocated to him by MI6. It later transpires that she is actually a double agent working for Quantum.

Works cited

- Amis, Kingsley. The James Bond Dossier. London: Cape, 1965.
- Bennett, Tony, and Janet Woollacott. "The Moments of Bond". *The James Bond Phenomenon: A Critical Reader*. Ed. Christopher Lindner. Manchester: Manchester University Press, 2003. 13–33.
- Black, Jeremy. *The Politics of James Bond: From Fleming's Novels to the Big Screen*. Lincoln: The University of Nebraska Press, 2005.
- Bold, Christine. "'Under the Very Skirts of Britannia': Re-Reading Women in the James Bond Novels". *The James Bond Phenomenon: A Critical Reader.* Ed. Christopher Lindner. Manchester: Manchester University Press, 2003. 169–83.
- Casino Royale. Dir. Martin Campbell. Columbia/MGM, 2006.
- Chapman, James. Licence to Thrill: A Cultural History of the James Bond Films. New York: Columbia University Press, 2000.
- Die Another Day. Dir. Lee Tamahori. MGM/Sony Entertainment, 2002.
- Faludi, Susan. Backlash: The Undeclared War Against American Women. New York: Anchor, 1991.
- For Your Eyes Only. Dir. John Glen. United Artists, 1981.
- From Russia with Love. Dir. Terence Young. United Artists, 1963.
- Funnell, Lisa. "From English Partner to American Action Hero: The Heroic identity and Transnational Appeal of the Bond Girl". *Heroines and Heroes: Symbolism, Embodiment, Narratives and Identities*. Ed. Christopher Hart. Kingswinford, West Midlands: IISE and Midrash, 2008. 61–80.

——" 'I Know Where You Keep Your Gun': Daniel Craig as the Bond-Bond Girl Hybrid in *Casino Royale*". *Journal of Popular Culture* (forthcoming; 2011). *GoldenEye*. Dir. Martin Campbell. United Artists, 1995.

Heckert, Druann Maria, and Amy Best. "Ugly Duckling to Swan: Labeling Theory and the Stigmatization of Red Hair". Symbolic Interaction 20.4 (1997): 365–84.

Heywood, Leslie, and Jennifer Drake. "'It's All About the Benjamins': Economic Determinants of Third Wave Feminism in the United States". *Third Wave Feminism: A Critical Exploration*. Ed. Stacy Gillis, Gillian Howie, and Rebecca Munford. New York: Palgrave MacMillan, 2004. 13–23.

Inness, Sherrie A. *Action Chicks: New Images of Tough Women in Popular Culture.* Basingstoke: Palgrave, 2004.

On Her Majesty's Secret Service. Dir. Peter R. Hunt. United Artists, 1969.

Owen, A. Susan, Sarah R. Stein, and Leah R. Vande Berg. "Introduction: Why We Write". *Bad Girls: Cultural Politics and Media Representations of Transgressive Women*. New York: Peter Lang Publishing, 2007. 1–19.

Quantum of Solace. Dir. Marc Forster. MGM/Columbia Pictures, 2008.

Scharrer, E. "Tough Guys: The Portrayal of Hypermasculinity and Aggression in Televised Police Dramas". *Journal of Broadcasting and Electronic Media* 45 (2001): 613–34.

Stone, Alison. "On the Genealogy of Women: A Defence of Anti-Essentialism". *Third Wave Feminism: A Critical Exploration*. Ed. Stacy Gillis, Gillian Howie, and Rebecca Munford. New York: Palgrave MacMillan, 2004. 85–96.

Taft, Jessica K. "Girl Power Politics: Pop-Cultural Barriers and Organizational Resistance". *All About the Girl: Culture, Power, and Identity.* Ed. Anita Harris. New York: Routledge, 2004. 69–78.

Tasker, Yvonne. Spectacular Bodies: Gender, Genre and the Action Cinema. London and New York: Routledge, 1993.

Tasker, Yvonne, and Diane Negra. "Feminist Politics and Postfeminist Culture". *Interrogating Postfeminism: Gender and the Politics of Popular Culture.* Ed. Yvonne Tasker, and Diane Negra. Durham, NC: Duke University Press, 2007. 1–25.

Thunderball. Dir. Terence Young. United Artists, 1965.

Tolman, Deborah L., and Tracy E. Higgins. "How Being a Good Girl Can Be Bad for Girls". "Bad Girls"/"Good Girls": Women, Sex and Power in the Nineties. Ed. Nan Bauer Maglin, and Donna Perry. New Brunswick, NJ: Rutgers University Press, 1994. 205–25.

Tong, Rosemarie Putnam. *Feminist Thought: A Comprehensive Introduction*. 3rd edn. Colorado: Westview Press, 2008.

White, Rosie. *Violent Femmes: Women as Spies in Popular Culture*. London and New York: Routledge, 2007.

Willis, Ellen. "Villains and Victims: 'Sexual Correctness' and the Repression of Feminism". "Bad Girls"/"Good Girls": Women, Sex and Power in the Nineties. Ed. Nan Bauer Maglin, and Donna Perry. New Brunswick, NJ: Rutgers University Press, 1994. 44–53.

A View to a Kill. Dir. John Glen. MGM/UA Entertainment, 1985.

The World is Not Enough. Dir. Michael Apted. MGM, 1999.

You Only Live Twice. Dir Lewis Gilbert. United Artists, 1967.

14

"A Caligula-like despot": Matriarchal Tyranny in The Sopranos

Anna Gething

"Everybody thought Dad was ruthless", says Tony Soprano in the opening episode of *The Sopranos*, "but I gotta hand it to you: if you'd been born after those feminists, you would've been the real gangster" (1.1). Livia Soprano, the "real gangster" of the above statement, represents a new kind of violent woman in visual culture. The "formidable maternal presence" of David Chase's HBO mafia series *The Sopranos* (1999–2007) is mother to Tony Soprano (James Gandolfini): mob boss, protagonist, and usual subject of critical readings of the show. The focus in this chapter, though, will be on the character and influence of Livia (Nancy Marchand), whose position as an elderly, widowed grandmother carries far greater power than the archetype might suggest. She is in fact a "Caligula-like despot" (Holden 38); "a demon-possessed matriarch" (Simon 4–5) whose authority pervades the violence that underpins *The Sopranos*.

"[W]hat really seems to have attracted feminist critics in recent years", writes Jacinda Read, "is the violent woman or action heroine", a figure whose very representation of femininity is defined by the embodiment of traditionally masculine traits (205). Such films as *Charlie's Angels* (2000), *Crouching Tiger, Hidden Dragon* (2000), *Lara Croft: Tomb Raider* (2001), and *Kill Bill* (2003 and 2004) are marked, says Lisa Coulthard, "by popular appeal, narrational centrality of active female characters, genre hybridity, and sophisticated fight choreography", placing the female at the centre of "genres usually associated with male characters, actors, and audiences" (154). Arguably, these violent women are, to borrow Elizabeth Hills' words, "figurative males", appropriating the macho behaviour of the male action hero (205). Crucially, however, and as both Barbara Creed and Jane Usher have identified, such female

characters combine the threat of violence with one of seduction: these violent heroines are "simultaneously deadly and desirable", offering a "coalescence of female sexuality and malevolence" that fuses the sweeping cultural division of angel/whore into an alluring mix (Usher 2). The likes of Lara Croft, with her impossible vital statistics, present a titilating performance of gender play: an exaggerated physical femininity edged with overtly masculine aggression that hints, too, at the promise of sexual domination.

In Livia Soprano we see a departure from this now-caricatured on-screen woman of violence. Rejecting the comic-book conventions of the fantasy-fuelled action heroine, Chase crafts in Livia a violence that is far more insidious, sly, and grittily realistic. This is, largely, psychological rather than physical violence, bedded in manipulation and exploitation; it is a violence that, in a postfeminist re-rendering of the angry action heroine, actively exploits the archetype of passive, weak femininity as a smokescreen for vengeful malevolence. The move to such psychological, emotional violence seems not unconnected to the condition of old age. Livia, in her seventies, subverts the popular image of the nubile. fertile, eroticized heroine that defines the films mentioned above to project, instead, an image of ageing, asexual womanhood; jaded, resentful, and ascetic, she is the text's anti-heroine, and one who unsettles any gender conventions of desirable, maternal, domestic femininity.² The Sopranos does, however, position its violent woman within a genre that is – like action cinema – "associated with male characters, actors, and audiences", in this case the gangster genre. The first section of this chapter will consider the female appropriation of a traditionally masculine screen genre, examining how The Sopranos works to update and feminize the "explosive virility" of the gangster narrative (Nochimson 2). I will then take a closer look at Livia's strategies of violence and her apparent omnipotence as matriarch, before considering the significance of the active/passive body in the narrative of The Sopranos, with particular reference to the ageing female body.

Feminizing the gangster genre

Martha Nochimson describes the gangster genre as "hypermasculine fare"; a "muscularized" narrative that "displac[es] emotion onto the tumult associated with violence", in contrast to the "feminized and openly emotional" perspective of "what is ordinarily identified as family melodrama" (2, 4). *The Sopranos* overtly aligns itself with this masculinized gangster genre: drugs, sex, gambling, and death loom large and

episodes are peppered with allusions to a rich filmic tradition of mob movies, most explicitly to *The Godfather* trilogy (1972, 1974, 1990). Chase – an Italian-American born in New Jersey – has expressed his long-held enthusiasm for the genre, locating its audience appeal in "a big wish fulfilment" of power, respect, and fear (McCarty 7-8). The allegiance of *The Sopranos* to the inherent "muscularity" of the mafia story is immediately evident in its opening title sequence which, as Nochimson acknowledges, "contains a mass of aggressively virile resonances" (8). The soundtrack's phallic refrain of "got yourself a gun"³ accompanies Tony Soprano on his drive from New York City to his luxurious New Jersey home (itself a comment on upward mobility), and points to the further phallic references made by Tony's cigar and the prominent architectural backdrop. The close-up camera view and Tony's concentrated gaze suggest his all-seeing omniscience as mafia boss, while the soundtrack's recurring final lines and closing pistol shot hint at a sexual crescendo. This undercurrent of sexual assertion continues throughout the series, evident in Tony's and others' extra-marital conquests, as well as in the backdrop of naked women provided by the Bada Bing strip club.

Importantly, however, while explicitly fulfilling this archetypal masculinity, *The Sopranos* seems also to step into that "feminized and openly emotional" perspective of Nochimson's family melodrama. Its very form, as television series rather than film, allows for an arguably more subtle development of character and plot, while the often shocking violence is set against the everyday domesticity of Tony's family life. Those opening credits, while undoubtedly wielding their phallic props, work also to relocate Tony from the testosterone-filled bars and mean streets of New York - the traditional haunts of the cinematic gangster - to the suburban safety of his New Jersey home. Indeed, the melodrama of Tony's family frequently dominates the plot, and their opulent home – most often, the gleaming kitchen – provides an immaculate stage set of idyllic domesticity, one that jars with the bloody mess of Tony's criminal activities. Certainly, if the feminized realm of the domestic is used as an aesthetic screen for the masculinized gangster action, then this screening often takes place at a very literal level, with the polished floors and ornate ceilings of the Soprano home concealing stashes of weapons and cash.

The Sopranos also updates and feminizes the mafia story through its portrayal of women who, as Clare Longrigg notes, "are by no means marginal to the series" (238). In fact, the Soprano women – Tony's wife Carmela, daughter Meadow, sister Janice, and mother Livia – comprise a matriarchy to positively rival the established patriarchy of the gangster genre. In many ways, Carmela Soprano (Edie Falco) fulfils the traditional role of housewife and mother, yet she also maintains an unblinkered perspective on her husband's lifestyle, aware of both his adulterous and criminal affairs. Hers is not a resigned surrender to the position of submissive, silenced wife, but an informed decision to stay in her marriage – a relationship that she, rather than Tony, directs. Livia, for her part, was always sceptical about the stability of Carmela and Tony's partnership, allegedly warning Carmela on her wedding day that her son would quickly grow bored with her. In response, Carmela presents a resilient front, performing her daughter-in-law duties faultlessly, while recognizing Livia as manipulative, insincere, and "terribly dysfunctional" (3.2). Far from marginal, then, Carmela provides a central, stabilizing touchstone for Tony, a secure point of refuge: "Carm, you're not just in my life", he tells her, "you are my life" (1.6). Tony and Carmela's eldest child, Meadow (Jamie-Lynn Sigler), mimics her mother's independence, presenting another model of strong femininity and assuming status as Tony's greatest source of fatherly pride. Smart and shrewd, "Meadow can take care of herself", determines Tony confidently, while directing his concerns towards his meandering son, Anthony Junior (Robert Iler): "I'm supposed to get a vasectomy when this is my male heir?" (2.9). Tony's sister Janice (Aida Turturro) plays a less consistent – if equally compelling - role in the feminized narrative of The Sopranos. Desperate to make a success of her relationship with old flame and former racketeer, Richie Aprile, Janice allows Richie to indulge his fetish of holding a gun to her head during sex - a revelation that shocks Carmela: "I thought you were a feminist?" (2.12), she demands. With a capacity for violence and manipulation which recalls that of her mother, Janice is soon spurred to action by Richie's misogyny: "Put my fucking dinner on the table, and keep your mouth shut", Richie raves, punching her in the mouth when she suggests that his ballroom-dancing son might be gay (2.12). Once recovered, Janice follows up her initial (perceived) assault on Richie's masculinity with another: she coolly shoots her husbandto-be in the chest, killing him outright and fully appropriating the violence of the male gangster.

If *The Sopranos* works to feminize the gangster genre, then it does so most conspicuously, perhaps, through the "openly emotional" narrative of psychoanalysis. This separates *The Sopranos* from its predecessors and achieves what Longrigg calls "the successful updating of the mafia image: the boss in therapy" (238). Tony Soprano is introduced to the viewer in the first episode by the voice of psychiatrist Dr Jennifer Melfi

(Lorraine Bracco), as she calls Tony into her office. Set within this psychoanalytic context, Tony's character is mediated, or even interpreted, for the viewer by the character of Dr Melfi. Arguably, then, it is a feminized narrative that governs the characterization of the show's protagonist, extending the gangster narrative's traditional appeal (to male-dominated audiences) out towards the female viewer. Here, also, there is an inversion of the traditional relationship between the male therapist and the female patient: The Sopranos places Tony, exuding masculinity, in the place of scrutinized subject, while locating the discourse of diagnosis – historically the domain of men – in the character of Jennifer Melfi, another educated, assertive female. This relationship between therapist and patient is further nuanced by the conflicting desires – sexual, maternal, moral – that shape it; the desire aroused in Tony by Melfi's sharp suits and intellect is at odds with the raw, base appeal of the Bada Bing strippers, while Melfi, in an interesting aside to the (non-)maternal narrative prompted by the character of Livia, wrestles with the desire to mother, judge, and lust after her patient. In short, Tony's sessions with the psychiatrist introduce an authoritative female perspective into the generically masculine realm of the gangster genre, providing a forum in which to expose and critique the behaviour and influence of the text's most dominant female character, Livia Soprano.

Power of the mother

The Italian mother "remains a quasi-mythical figure who looms larger than life in the New World, overshadowing the Martha Stewart-type domestic goddess who rules modern America" (Longrigg 241–42). Yet in the character of Livia Soprano, writes Maria Laurino, "David Chase is trying to turn the stereotype of the Italian mother on its head" (41). Upsetting traditional assumptions about maternal or domestic femininity, Livia shatters the myth of the Italian matriarch with a performance of striking emotional coldness. "Your mother", observes Dr Melfi in a session with Tony, "is always talking about infanticide" (1.12). Indeed, the first two seasons of The Sopranos are spiked with Livia's frequent references to acts of maternal violence: "Some woman in Pennsylvania shot her three children ...", she reports with relish over dinner (1.12). Her fascination with such tragic episodes is further darkened by a resentment of her own children: "I gave my life to my children on a silver platter", she spits more than once. This statement, however, is inconsistent with Tony's repressed memories of a childhood marked by Livia's angry outbursts: "You're driving me crazy!" she screams at a schoolboy-aged Tony, "I could stick this fork in your eye!". On another occasion she threatens to "smother" her children "with a pillow", rather than agree to her husband's plans for a move to Nevada (1.7). Any grandmotherly instincts are similarly absent: in Season Three we learn that Livia's *Granny Remembers* books – memory journals given to Livia by Carmela on the birth of Meadow and then Anthony Junior – have remained stubbornly empty (3.2). Her conclusion that "babies are animals...no different from dogs" neatly epitomizes her unmotherly stance (2.12).⁴

Despite these incidents, Tony's resolute denial of his mother's capacity for malevolence protects her from retribution for some time: she remains on her pedestal as revered Soprano matriarch and maintains her status as "a quasi-mythical figure". To Tony, Livia is a harmless "little old lady", an illusion that he defends fiercely to Dr Melfi, whose own character analysis of Tony's mother is rather more accurate:

DR MELFI: Your mother is clearly someone who has great difficulty maintaining a relationship with anyone.

TONY: But she's my mother. You're supposed to take care of your mother. She's a little old lady.

DR MELFI: Not to you. She's very powerful.

TONY: Bullshit.

DR MELFI: You accord this "little old lady" an almost mystical ability to wreak havoc.... There are some people who are not ideal candidates for parenthood.

TONY: Come on! She's an old sweetie pie!

(1.2)

Tony's insistence that his mother is a frail old lady and innocent "sweetie pie" works to underline Livia's successful exploitation of that very archetype of ageing, fragile femininity. Livia's is a performance that embraces the image of victim and trades on the supposedly vulnerable status of the elderly woman: she feigns forgetfulness, denies making spiteful comments, and becomes tearful at will. "I wish the Lord would take me now" is her self-pitying refrain (1.4). Tony, initially, feels only guilt in response to his mother's seemingly helpless demise and suffers the panic attacks that result in his visits to Dr Melfi. Yet, the power that Dr Melfi identifies in Livia is similarly recognized by Tony's wife, Carmela, who confronts her mother-in-law:

CARMELA: I want you to cut the drama...this "poor mother, nobody loves me" victim crap. It is textbook manipulation...and I hate

seeing Tony so upset over it You know your power, and you use it like a pro.

LIVIA: Power! What power? I don't have power....

CARMELA: You are bigger than life! You are his mother!

(1.11)

Such a striking image of the omnipotent, "bigger than life" mother is presented to the viewer from the very first image of the first episode, which sees Tony sitting in the office of Dr Melfi, "completely framed by the legs of a female nude sculpture (recalling his origins in the birth canal and the power of the mother). His curious gaze upward at the nude sculpture is a radical reversal of the conventionally possessive male gaze" (Nochimson 5). From this moment onwards, the power of the mother continues to frame, if not stifle, the plot development of The Sopranos. It comes to dictate not only Tony's personal life, but also the more sinister actions of the New Jersey mob. Occupying "the position of a sort of dowager boss", Livia exerts significant influence over Junior Soprano, brother to Livia's late husband and one-time acting boss of the crime family (Longrigg 241). Junior, Livia believes, is one of the few who treat her with the respect she merits; he pays his sister-in-law frequent visits and seeks her advice on how to deal with traitorous mob members. Preferring to issue her (often life or death) judgements obliquely – with mere assenting silence or trenchant stare - Livia wields considerable authority as the true harbinger of violence. And yet, concurrently, she upholds her unyielding claim to ignorance and a position outside of the gangster narrative: "I'm a babbling idiot", she insists in answer to Junior's comment that she's "got a lot of sense for an old gal" (1.3), while continuing to protest her innocence to Tony: "I don't know that world.... I don't want to get involved" (1.6).

Evidence of Livia's capacity for hostility and violence begins to gather momentum, however, with her racist abuse of the housekeeper whom Tony hires to help her remain in her own home, and the not-quite-clearly-unintentional hospitalization of her best friend, after Livia runs her down on her own driveway. Such incidents escalate, culminating in Livia's ultimate act of violence against her own son. Despite deep feelings of guilt, Tony, concerned about his mother's ability to cope at home alone, proceeds with his plan to place her in the luxurious Green Grove retirement community. For Livia, this is akin to being "abandoned" and her brewing bitterness fuels her decision to condone (and even encourage) Junior's decision to kill off Tony. As Nochimson notes, "Junior and Livia give each other permission to rid themselves of

Tony with such minimalism that the audience is not sure what has transpired between them until the plans to kill Tony are put into action" (4). Livia's chillingly calm endorsement of Junior's hints at violence towards her son marks the understated but pivotal moment at which she severs all associations with the figure of nurturing mother and realizes her fantasies of infanticide. That the attempt on Tony's life is unsuccessful only heightens the politics of their relationship: reluctant to admit his mother's accountability, Tony is struck with confusion and anger when it is proved beyond doubt. Wrestling with emotions of shock and sorrow, he plots revenge in the form of murder, only to bow out in the final moments. He resigns himself instead to the ideological death of the mother he never had: "She's the devil.... She's dead to me" (2.1). And yet, even in the face of such unambiguous iniquity, Tony is unable to relinquish himself of responsibility; the power of the mother holds fast: "What sort of person must I be when my mother wants me dead?" (1.13).

Bodies

The viewer's first introduction to Livia Soprano comes early in the first episode, when Tony enters her house, wafts the air with his hand and mutters, "Jeez, Ma. Get some air in here" (1.1). This, combined with Livia's unkempt hair, shapeless mis-buttoned dressing gown, and distracted grumblings, gives the immediate impression of stale old age. Following this early whiff of senility, however, Livia's physicality receives little narrative attention, and it is this absence, this lack of emphasis on her physicality, that itself takes on significance in a discussion of her violence. As mentioned above, the violent heroine of popular culture conventionally combines danger with desirability; the synthesis of physical aggression with sexuality is a recurring trait in contemporary representations of the violent woman. In contrast, Livia Soprano presents an image of faded, desiccated femaleness. Notwithstanding unconvincing hints at something more than a platonic relationship between Livia and Junior, Livia's is a character of almost androgynous greyness. "In Western society", says Usher, "the ageing reproductive body is the epitome of the abject - with none of the redeeming features of youth or maternal femininity . . . Older women", she continues, "are all but invisible within both high and popular culture - with the post-menopausal woman represented as the crone, the hag, or the dried-up grandmother figure, her body covered, and her sexuality long left behind" (126). The character of Livia seems both to fulfil and test

this archetype: she is the dried-up grandmother figure of forgotten femininity and yet, almost by her very impression of innocuous invisibility, she remains a dominant, ever-present force within The Sopranos' narrative. Arguably, her very lack of physical presence – her ominous consenting silences, tacit stares, and absence from any of the violent acts she condones – is in itself more unsettling than the overt violence of the traditional action heroine. Hers is a private, pervasive violence, a considered disguise that conceals an "explosive virility" all of her own.

Corporeality is, however, central to the traditional gangster narrative, where "almost all the action is written onto the bodies of the gangsters in a subgenre that places great emphasis on physical touch in general, on drinking, and sometimes on food" (Nochimson 6). Food, certainly, plays a major role in The Sopranos: the kitchen and dining table provide the focal points for family dramas, while frequent references to traditional Italian dishes are effective reminders of the family's heritage. Food and copious cups of coffee facilitate many of Tony's "business" meetings and, significantly, Tony's first panic attack occurs as he prepares a family barbecue (an association that we later learn harks back to a violent incident he witnessed as a child involving a meat cleaver). Against this gastronomical abundance, however, is Livia's stock rejection of food offerings, most conspicuously those brought to her in the retirement home by Tony. Nochimson suggests that Tony "expresses affection with food in a way that also expresses his power" (60); in turn, Livia's refusal of his food offerings implies an unwillingness to relinquish any authority to her son. Similarly, Livia acts to withhold food on several occasions. In the first episode of the series she declines, sulkily, to attend Anthony Junior's birthday party in an act of premeditated emotional blackmail. Her absence is most visibly marked by the consequent lack of her "baked ziti", a dish that Tony specifically requested she bring. As an object of exchange, then, food in *The Sopranos* carries symbolic resonances of control, and Livia's reluctance both to receive and to give food reflects her quest for power, as well as her physical and emotional coldness. In contrast to Carmela's well-stocked fridge and investment in family mealtimes, Livia's meagre attitude to food further accentuates her lack of maternal warmth.

Emphasis on the body is instead transferred to Tony, whose "rich physicality is a particularly important part of his characterization" (Nochimson 6). In contrast to Livia's lack of physical presence, Tony oozes excess, solidity, and charisma. While Livia shakes off her son's demonstrative attempts to dance with her (1.1), Tony himself receives and imparts physical affection readily, unreservedly kissing and

embracing his men - although, like his food offerings, these displays of warmth and affection are arguably expressions of power. His sexual escapades also carry their own mix of passion and detachment: the naked dancers of the Bada Bing strip club, for example, seem desexualized, losing any notes of desire as they fade to the familiar wallpaper of mob meetings. Likewise, Tony's extra-marital affairs are conducted with almost mechanical aloofness. Reinforced by acts of callous violence, Tony's image of robust, self-possessed physicality is threatened only, in fact, by events that are traceable - directly or indirectly - to Livia. The panic attacks, triggered by anxiety about his mother, strike Tony down; trembling and sweating, he loses his all-seeing authority as his vision blurs and he collapses to the ground: Livia literally, if temporarily, disables her son's claim to status. She also endeavours to fell Tony's authority in a more permanent way: the attempt on his life hospitalizes Tony, exposing his vulnerability and drawing attention to his mortality. It is, then, Tony's body, and not his mother's, that is most subject to medicalization. Livia once again flouts the archetype of the ageing, ailing female, seemingly exploiting the opportunity of medical diagnoses only when it suits, while her son struggles with anxiety, cries at ducks, and collects prescriptions for anti-depressants. Such medicalization extends, indeed, to the other male characters of The Sopranos. It is the men who are the most frequent victims of violent behaviour and bloodshed, but it is also the male bodies that are the most pathologized - with depression, suicide, cancer, and chronic illness running rife amongst the gangster fraternity. Here, the discourse of diagnosis that has historically contained and classified femaleness within the patriarchal language of medicine - that, in Foucault's terms, "integrated" the female body "into the sphere of medical practices, by reason of a pathology intrinsic to it" (104) - is subverted. In The Sopranos it is the male body that is exposed and made medical, and which is, moreover, contained and classified by the feminized discourse of diagnosis represented by Dr Melfi.

Conclusion

Livia Soprano's reign continues until her death, from "a massive stroke", in Season Three of *The Sopranos*. Tellingly, her character's finale was originally planned for the end of the first series but was delayed, in part, because Marchand "made her hatefulness so indelible" (Rosenberg 2). Tony's response to his mother's belated death seems to be overwhelmingly one of relief. His visceral reaction – registered at a visual level in his sweating and bewilderment – is akin to the onset of a panic attack, yet

it subsides into a state of calm composure. He confesses this sense of liberation in his next session with Dr Melfi: "All right, here's the thing. I'm glad she's dead. Not just glad. I wished she'd die. Wished". Any shame at these feelings is fleeting: "Is that right, wishing her dead? Is that being a good son?... You're right. Why the fuck should I be a good son to that fucking demented old bat – that fucking selfish, miserable cunt?" (3.2). The dramatic transformation of Livia in Tony's eyes from "little old lady" and "sweetie pie" to "demented old bat" - from revered matriarch to reviled monster – carries fairytale connotations: the wicked (step)mother exposed and revenged; the wolf in granny's clothing. Livia, then, is the storybook villain. She is a woman "who spread no cheer at all", an antiheroine whose significance in a discussion of women and violence is defined by her sheer denial of that violence, as well as her discord with contemporary representations of female aggression (3.2). Rather than assuming the overt and masculine aggression of the popular action heroine, Chase's violent woman adopts the passivity traditionally associated with meek and mild femininity and contorts it into something far more sinister: a considered disguise of falsified vulnerability. In contrast to the comic-book carnage of the mainstream action film, the matriarch of The Sopranos confronts the ultimate taboo act of violence: filicide. Rewriting the narratives of motherhood, of ageing femaleness, and of the male-dominated gangster genre, Livia Soprano questions what it is to be "feminine" and offers a striking antidote to the now homogeneous model of the violent woman that circulates in visual culture.

Notes

- 1. Dr Melfi, The Sopranos (1.1).
- 2. Livia's rejection of the domestic, maternal femininity that is so abundantly embodied by her daughter-in-law, Carmela, invites consideration alongside the forms of intergenerational conflict that Shellev Cobb examines in "'I'm nothing like you!': Postfeminist Generationalism and Female Stardom in the Contemporary Chick Flick" (in this book).
- 3. From "Woke Up This Morning" (1997) by the British band Alabama 3.
- 4. The malevolent (and potentially murderous) mother is a feature of other quality television series, such as Prison Break (2005-09) and Alias (2001-06). See Rosie White "Alias: Quality Television and the New Woman Professional" (in this book).

Works cited

Coulthard, Lisa. "Killing Bill: Rethinking Feminism and Film Violence". Interrogating Postfeminism: Gender and the Politics of Popular Culture. Ed. Yvonne Tasker, and Diane Negra. Durham and London: Duke University Press, 2007. 153–75.

Creed, Barbara. The Monstrous Feminine: Film, Feminism, Psychoanalysis. London, New York: Routledge, 1993.

Foucault, Michel. *The Will to Knowledge: The History of Sexuality: Volume 1.* Trans. Robert Hurley. London: Penguin, 1998. Trans. of *La Volonté de Savoir.* 1976.

Hills, Elizabeth. "From 'Figurative Males' to Action Heroines: Further Thoughts on Active Women in the Cinema". *Screen* 40.1 (1999): 38–50.

Holden, Stephen. "The Sopranos: An Introduction". The New York Times on The Sopranos. New York: ibooks, 2000. 37–45.

Laurino, Maria. Were You Always an Italian? New York: Norton, 2000.

Longrigg, Clare. "Women in Organized Crime in the United States". Women and the Mafia. Ed. Giovanni Fiandaca. Trans. Stephen Jackson. New York: Springer, 2007. 235–82.

McCarty, John. Bullets Over Hollywood. Cambridge, MA: Da Capo, 2004.

Nochimson, Martha P. "Waddaya Lookin' At? Re-Reading the Gangster Genre through *The Sopranos*". Film Quarterly 56.2 (Winter 2002–03): 2–13.

Read, Jacinda. "'Once Upon a Time There Were Three Little Girls...': Girls, Violence, and *Charlie's Angels*". *New Hollywood Violence*. Ed. Steven Jay Schnelder. Manchester: Manchester University Press, 2004. 205–29.

Rosenberg, Howard. "Excellence, From 'Marty' to the Mafia". Los Angeles Times June 21, 2000 http://articles.latimes.com/2000/jun/21/entertainment/ca-43052. [Accessed January 20, 2010].

Simon, David. Tony Soprano's America: The Criminal Side of the American Dream. Oxford: Westview, 2004.

The Sopranos. HBO, 1999-2007.

- 1.1. "Pilot". Dir. David Chase. January 10, 1999.
- 1.2. "46 Long". Dir. Dan Attias. January 17, 1999.
- 1.3. "Denial, Anger, Acceptance". Dir. Nick Gomez. January 24, 1999.
- 1.4. "Meadowlands". Dir. John Patterson. January 31, 1999.
- 1.6. "Pax Soprana". Dir. Alan Taylor. February 14, 1999.
- 1.7. "Down Neck". Dir. Lorraine Senna Ferrara. February 21, 1999.
- 1.11. "Nobody Knows Anything". Dir. Henry J. Bronchtein. March 21, 1999.
- 1.12. "Isabella". Dir. Allen Coulter. March 28, 1999.
- 1.13. "I Dream of Jeannie Cusamano". Dir. John Patterson. April 4, 1999.
- "Guy Walks Into A Psychiatrist's Office". Dir. Allen Coulter. January 16, 2000.
- 2.9. "From Where to Eternity". Dir. Henry J. Bronchtein. March 12, 2000.
- 2.12. "A Knight in White Satin Armor". Dir. Allen Coulter. April 2, 2000.
- 3.2. "Proshai, Livushka". Dir. Tim Van Patten. March 4, 2001.

Usher, Jane M. Managing the Monstrous Feminine: Regulating the Reproductive Body. London and New York: Routledge, 2006.

15

A Pathological Romance: Authority, Expert Knowledge and the Postfeminist Profiler

Lindsay Steenberg

Since the late 1980s, behavioural science has become a key element in telling stories about crime. The pseudo-scientific system of profiling, in which the crime scene and personal history of the suspect are used to hypothesize violent behaviour, is so ubiquitous that it has become a cultural commonplace. Profiling's cultural currency depends on truths which are formulated and gendered in ways that might be described as "postfeminist", and this is rendered especially apparent in the characterization of the female criminal profiler. This figure, after all, embodies an expert knowledge that she uses to combat an archetypal postmodern villain: the serial killer. This chapter examines the gender politics of the now-conventional relationship between the postfeminist female investigator and the male serial killer - two figures who are inextricably connected in the popular imaginary. This sexualized and romanticized coupling simultaneously constructs and challenges the female investigator's expertise, making wider pathological observations about female experts whose professional struggles are effectively and implicitly reduced to a tension between their female bodies and their ability to do their jobs.

While the number of women in law enforcement remains small, and most celebrity FBI profilers are men, a large percentage of profilers on film and television are female.² Moreover, female profilers have been part of some of the more financially successful and critically acclaimed stories about murder and serial killers. Agent Clarice Starling (Jodie Foster) in *The Silence of the Lambs* (1991) is the most famous cinematic incarnation of this iconic expert. In a testimony to her popular status, the portrayal of the female profiler is significantly consistent: she is as much a type as the serial killer she pursues. This chapter focuses on

Special Agent Illeana Scott (Angelina Jolie), the central character of the 2004 thriller, *Taking Lives*. The film follows her as she travels to Montréal to consult on a case where a serial killer is killing men and stealing their identities. In the process she becomes romantically involved with a key witness who is later revealed to be the serial killer, Martin Asher. As a consequence, Illeana is professionally humiliated. We later learn that her dismissal is a ruse that, along with a faked pregnancy, Illeana uses to lure the killer into the open. The film is typical in its preoccupation with the profiler's sexuality and in imagining a female expert who is white, middle class, educated, and incapable of forming healthy personal relationships because of her dedication to her profession.

In postfeminist fashion, the female profiler's career successes take the opportunities won by second wave feminism as a given. Likewise, these narratives invest heavily in the concept of choice: one can choose to be a victim, or choose to be a gun-wielding FBI profiler. These women's stories celebrate an "empowered", informed individualism and are noticeably suspicious of the concept of the "victim", as well as the feminist analyses that such a designation demands. On the other hand, these characters' severe psychic trauma and lack of a healthy "work/life balance" (so key to postfeminist therapeutic culture) imply that feminism has done damage to women, as well as good. This circular logic is manifest in profiler-led fictions wherein female profilers, like Illeana. start out as deeply unhappy women; indeed, this is usually what leads them to a career in law enforcement. Furthermore, their careers keep them unhappy, because they are constantly investigating horrific sexualized violence. Thus, the characterization of the female investigator and the stories in which she appears are marked by a version of what Angela McRobbie terms postfeminist culture's "double entanglement" with second wave feminism (28). The profiler's career successes, authority, and expertise are made possible by the politicized efforts of second wave feminism, yet such positive gains are mediated by the fact that she remains unhappy because of her extreme dedication to a job which constantly exposes her to the serial killer's misogynist violence.

Despite the crime film's equal investment in stable gender roles, postfeminist popular culture is usually discussed in terms of more traditionally "feminine" genres, such as the romantic comedy or the melodrama. These genres share some of the same context and concerns as crime films, but the stakes are very different. As Linda Mizejewski insists,

[t]he crime film is a genre in which violence is the central trope of relationships between the sexes and in which the transgressive woman...has long served as a register for anxieties about female sexuality and power. It is the genre most likely to expose both the limitations of the postfeminist heroine and the nasty sex and gender issues that her presence supposedly precludes. (2005, 125)

Almost all of these "nasty sex and gender issues" are played out through the relationship between the female profiler and the serial killer – a relationship that stems from a disturbing combination of mutual trauma, a similar expertise (based on shared experiences of violence), a grudging professional admiration, and, most directly, a sexualized and romanticized attraction. With Taking Lives as its representative example, this chapter questions the unstable ways in which postfeminist visual culture informs the crime film and its representation of female power, expertise, and authority.

A profile of the profiler

In Taking Lives, Special Agent Illeana Scott is a respected profiler, wellestablished in her career. She has no personal life, does not date, and wears a fake wedding ring to discourage sexual attention in the workplace. Her work is framed as the most important part of her life and she is deeply dedicated to her job: her every spare moment is spent looking at crime scene photographs. She shares this intensity with the serial killer she hunts and with other cinematic and televisual profilers. This commitment to profiling is a distinctly gendered phenomenon. Male profilers, such as Will Graham in Manhunter (1986), Jack Crawford in The Silence of the Lambs, or the protagonists of the CBS series Criminal Minds (2005–), are framed as dangerously similar to the killers themselves. By projecting themselves into the killer's mindset in order to catch him, they risk being psychologically damaged, as happens to Will Graham. Where the male profiler is doubled with the killer and in danger of becoming like him, the female profiler is positioned as being dangerously attracted to the killer. Profilers like Clarice Starling in the Hannibal Lecter series, Agent Sara Moore in Mindhunters (2004), and Illeana Scott in Taking Lives are in danger of losing their critical distance, their professional standing, and even their lives because of their inextricable entanglement with the serial killer.

The expertise of the female profiler is founded on the assumption that the serial killer is a mobile sexual predator, unlike any others that have come before. This definition originated in the Behavioural Science Unit

of the FBI, and was first brought to public attention in a 1983 Justice Department Press Conference (Schmid 77). This conference simultaneously constructed the serial killer as an immediate and real predator and championed the FBI as the source of experts best suited to capturing him. According to David Schmid, the press conference, and the flurry of popular press that followed, emphasized certain significant elements in their definition. They focused on the mobility of the serial killer, skewed the scope of his crimes, and – perhaps most significantly – considered serial killing to be essentially sexual in nature.³ These three elements, taken up at the expense of all others, remain the basis for the expertise of behavioural scientists such as Illeana. Her relationship to the serial killer, Martin Asher, depends upon his ubiquitous, threatening nature and his sexual obsession with her. As part of the Behavioural Science Unit, Illeana's expertise, like that of all profilers in popular visual culture, is dependent on a perception of the serial killer as a dangerous sexual predator; her ability and willingness to stand against such a predator gives her credibility and further sexualizes her criminal investigations.

Sharing trauma and expertise

Despite her heroic and authoritative position in the film, Illeana is a deeply traumatized individual. This is clear in her pathological dedication to her work, and in her confession that she accidentally killed a prowler when she was a child. The film frames this formative moment as the reason why she chose law enforcement as a career. Illeana channels these traumatic experiences into her professional performance, and they allow her to identify other traumatized and traumatizing individuals. The mutual experience of trauma ties the serial killer to the female profiler. Serial killer Martin Asher struggles to deal with the legacy of a troubled childhood in which he was hated by his mother and overshadowed by his twin brother (whose death he witnessed and may have accidentally caused). Where Illeana deals with her experience of violence by becoming a profiler, Martin distances himself from his trauma by violently assuming other men's identities. It is, then, Illeana's psychological damage that not only drives her to excel at work but also offers her an insight into the troubled world of the serial killer.

Illeana and Martin's shared experience of childhoods marked by violence contributes to their remarkably similar knowledge base – a database built up around an eclectic collection of facts and disciplines. The expertise of the profiler (like that of the serial killer) draws on

multiple and disparate sources, including psychology, forensics, and intuition. The feedback loop of cliché (Seltzer 126) that informs the serial killer is equally important to the profiler and her expertise. Both profiler and killer are experts in the subject of mediated violence, having equal experience of violence and the mediated translation of psychological pain into pathological action. They are both able to read, reproduce, and reflect on patterns of violence and trauma, and this shared referencing system is the primary method of interaction between them. It is at the crime scene that this communication takes place - through the killer's staging and the profiler's semiotic analysis. In her ability to read the mise-en-scene of the crime scene, and because of the scope of her knowledge, Illeana's insight into the killer's mind is unmatched, enhancing her status in the eyes of her colleagues and the eyes of the killer.

As soon as Martin meets Illeana he begins to communicate with her in his disguise as a murder witness, and also through his violent acts and the clues he leaves at the crime scenes. Once Illeana discovers his true identity, Martin tries to persuade her that she has been attracted to the killer in him all along; that in him she has found a true equal partner. Pointing to her habit of posting crime scene photographs all over her room and her ability to internalize her crime scene analysis, Martin demands that Illeana recognize their shared experiences of violence and thus their deep (romantic) connection and comparable worldview. He insists, as do many profiler-led fictions, that their growing relationship is one characterized by a mutual and grudging respect for each other's expertise in violence - a reciprocal recognition of each other's intelligence and panache. The "perfect partnership" established in profiler fictions highlights not only the similarities between two conventional character types, but also the fact that both rely equally on violence for their careers, authority, and even celebrity.

The grudgingly respectful partnership between profiler and serial killer is common to many serial killer narratives, regardless of the investigator's gender. However, the female profiler's relationship to the killer is sexualized, and the parameters of her expert knowledge are defined explicitly by her embodied experience of the world. In the novel The Bone Collector, 4 which tells the story of a young woman's induction into forensics, the expert investigator is described as "a renaissance man":

He's got to know botany, ballistics, medicine, chemistry, literature, engineering. If he knows facts - that ash with high strontium content probably came from a highway flare, that faca is Portuguese for "knife", that Ethiopian diners use no utensils...[then] he may just make the connection that places an unsub at the crime scene. (132)

Like the "renaissance man" of *The Bone Collector*, the female expert's authority as a profiler is augmented by her mastery of other kinds of specialized knowledge; in particular, she possesses a "woman's intuition" that allows her to make unique connections. These connections tend to hinge on her experience as a woman (and thus her insider knowledge of the genre's predominantly female victims), as well as her comprehensive understanding of postfeminist culture and its central preoccupations: fashion, celebrity, and self-help rhetoric.

Clarice Starling, for example, is able to tell that a woman wearing glittery nail varnish is not from the small town in which her body was found, and Illeana is able to communicate with (and profile) Martin Asher's mother much more successfully than the French-Canadian police officers with whom she is partnered. Like other postfeminist investigators, such as criminalist Catherine Willows in CSI: Crime Scene Investigation (2000–) and Samantha Waters in The Profiler (1996–2000), Illeana is familiar with traditionally feminine areas of expertise: fashion and consumer culture. The female investigator notices these overlooked details, particularly in relation to female victims, and applies this unofficial knowledge where her male counterparts would not. Similarly, the serial killer does not consider the factor of "women's intuition" when he is staging the crime scene, despite the knowledge base he shares with the female expert. Often, then, the female profiler's awareness of postfeminist culture allows her to get ahead of the killer she hunts.

"That's my Girl!": Investigating the serial killer romance

As a woman, Illeana is singularly able to identify the sexual charge of the male killer's violence. She tells her colleagues, "there's a sexual element to all this... the strangling from behind, cutting off the hands, smashing in the face. It's tactile. It's immediate. It's what turns him on". Thus, the communication via the crime scene is something that the female profiler is able to read with a greater degree of accuracy than the male profiler. Because she reads with such accuracy, especially with regard to the sexual nature of the crime, Illeana's relationship to the serial killer is both sexualized and romanticized. These terms are not interchangeable. Crime narratives focus on violent sexualized acts committed by the

serial killer, and he is framed as sexually (and compulsively) attracted to the female profiler. But their relationship is also framed as romantic. This is, for the most part, down to the high cultural status that characterizes many representations of the serial killer (from Hannibal Lector to Martin Asher). His knowledge of art, history, and poetry frequently signals and taps into (postfeminist) notions of romance and chivalry. Furthermore, serial killers, like Martin Asher, consider the female profiler as an equal/partner, as the one person who can read his violent acts and decipher their deeper significance. This is certainly true of the profiler/serial killer relationships in The Silence of the Lambs, Mindhunters, and the television series *The Profiler*. The serial killer Jack (Dennis Christopher) in The Profiler leaves red roses at crime scenes to communicate with profiler Samantha Waters. Like Illeana Scott, Agent Sara Moore is in love with the (then unknown) serial killer in Mindhunters. In Hannibal (2001) Lector kidnaps Clarice Starling. He drugs her and, in the process of trying to convince her to join him in a cannibalistic feast, gives her a makeover. When Clarice resists him and fights him at every step, he responds with admiration, at one point commenting, "that's my girl". This statement of both approval and ownership is representative of the eroticized and romanticized relationship that exists between the female profiler and the male serial killer. However, where the intimate nature of this connection is only implied in a film like *Hannibal*, it is rendered deliberately explicit in the sexual relationship that develops between Martin Asher and Illeana in Taking Lives.

Despite contributing to the female profiler's authority, her relationship to the serial killer also delegitimizes her professionalism. Illeana's inability to identify her sexual/romantic partner as the killer puts her in physical danger and undermines her professional authority. After Martin's true identity is revealed, Illeana faints. Later Joseph Paquette (Olivier Martinez), one of her fellow officers, publicly slaps her and she is fired from the job to which she is so dedicated. Here, Illeana's credibility and expertise are not only questioned as a result of her sexual(ized) relationship with the serial killer, but also as a result of her sexuality itself. The film implies that Illeana brings sex into the workplace simply because she is an attractive woman. She creates problems for fellow officers, especially Paquette, who regards Illeana as alternately attractive and suspicious. Expending his energies on flirting with and/or berating Illeana, Paquette is incapable of focusing fully on his job; he chooses, moreover, to blame Illeana for his feelings, and for the professional inefficiency they produce.

This sexualized disruption extends to the crime scene. Our first view of Agent Scott has her lying in a victim's grave. She is framed in close-up via a slow tracking shot along her body and is lit with soft low-key lighting more appropriate to a love scene. She gazes at the crime scene photographs pasted in her hotel room in a shot/reverse shot pattern – with the photographs taking the place of an interlocutor. Placed in the bedroom, the bathtub, and at the dinner table, the photograph-person appears to assume the position of a lover.

The sexualization of violent serial crime, especially given the FBI's pervasive definition, remains a key factor in most stories about crime. The female profiler brings another layer of sexuality to the crime scene, connecting the sexual nature of the violent act to the sexual characterization of the female investigator. This is made clear in Illeana's sexual reading of the killer's violence at the crime scene. Illeana brings sex into a place where it is inseparable from violence. This, by extension, pathologizes her sexuality. Illeana's co-workers, and the film itself, insinuate that she sexualizes violence simply because she is investigating it. Taken a step further, through the pathological romance between serial killer and female profiler, these films suggest that there is something fundamentally unsettling about a woman investigating serial crime.

Philip L. Simpson has suggested that the serial killer is often sent as punishment for the "original sin" of the profiler (24) – almost as punishment for the profiler's faults and shortcomings. This is germane given the characterization of male profilers as isolated, antisocial, compulsive, and often traumatized (for example, Will Graham in *Manhunter* and Detective Somerset in *Se7en* [1995]). This is more sinister when considering female profilers such as Illeana Scott, since she is not being punished for inappropriate behaviour exclusively, but for her gender as well. In this sense, the female profiler becomes defined and marked by the "original sin" of her body. She is unable to escape her gendered body or the pathological sexual relationship to which it commits her. The female profiler must build her authority *despite* her body, rather than through it. Consequently, Illeana faces violence, humiliation, and professional discredit to an extent that male profilers, such as Will Graham, do not.

Yet, undoubtedly, there is spectatorial pleasure to be had from these fictions. One of the key pleasures offered by crime films is the construction of the female investigator as a scientific expert and veteran professional. This plays out through her relationship to the unambiguously evil killer. While this relationship necessarily foregrounds the nuances of

the investigative role, this role is always and already complex, as Ronald Thomas observes in his history of forensic science's relationship to the detective:

At stake is not just the identification of a dead victim or an unknown suspect, but the demonstration of the power invested in certain forensic devices embodied in the figure of the...detective. (2)

The relationship between the serial killer and the female expert allows the latter to dazzle audiences and co-workers with her command of technology, her mental database, and her familiarity with violence and trauma. Still, the pleasure in these texts is ultimately short-lived, as the female investigator is simultaneously discredited and victimized.

In his book on serial killers, Mark Seltzer describes violence primarily as an identity-building tool:

In cases of serial sexual homicide, the withering of self-distinction is channelled in the direction of a distinctly gendered violence: as if the violent reaffirmation of sexual difference were one way, in our culture the most emphatic way, of securing or reaffirming self-difference as such. (144)

Seltzer further discusses this violence as a literal battle of the sexes. He describes the identity-tension of postmodernity (and post-industrial alienation, in particular) as "find[ing] its path of least resistance along the lines of sexual difference" (146). At first glance such a consideration of sexualized violence recalls feminist criminology's linkages of patriarchal structures with serial sexual murder - linkages which inform feminist descriptions of serial crime as "femicide" (Jenkins 139). Criminologists such as Deborah Cameron and Elizabeth Frazer have suggested that serial sexual murder (and arguably the more general sexualized nature of violence in crime fiction) can be placed on a continuum, with seemingly innocuous sexism - such as sexist jokes - on one side, and serial sexual murder as the terminal end point (164). Seltzer and Philip Jenkins dismiss such feminist interpretations of serial murder and its representations.⁵ Seltzer describes feminist arguments as "self-evident, even tautological" (143), and Jenkins believes them to be exaggerations (141-42). Imagining masculinity as essentially (and psychically) sadistic, violent, and misogynist cannot adequately or fully account for the romanticized partnership between the expert female

investigator and the male serial killer. However, it would also be an oversight not to acknowledge what postfeminist culture stands to gain by dramatizing a romance between a profiler and a serial killer – a disciplinary tactic that pathologizes female expertise and professional women who are unable to reconcile that expertise with their femininity.

In as much as the figure of the serial killer can be read as symptomatic of postmodernity, as Seltzer claims, I argue that both he and the female profiler by whom he is hunted speak to the concerns and preoccupations of postfeminist culture. Their pathological romance champions many of the same principles as the more traditionally feminine products of postfeminist media culture, such as the romantic comedy. Like the romantic comedy, profiler/serial killer fictions, such as *Taking Lives*, present a cautionary tale of a professional woman who fails to combine a career with "appropriate" femininity. Still, the violent nature of her profession differentiates the investigator from other postfeminist career women; she is, after all, punished violently for her involvement with the serial killer and for her criminal profiling, even as this showcases her authority.

It is tempting to read the relationship between the serial killer and the female investigator as a literal embodiment of the 1980s backlash against second wave feminism, given that it is historically continuous with the FBI's definition of, and popular culture's fascination with, the serial killer. The serial killer is a sexual predator who hunts victims predominantly women - in public places with no obvious motivation. other than the fact that he confuses violence for sex. Just as the Gothic monster has been theorized as the product of fears about modernization, the serial killer could be read as a representative of a punitive and anxious postfeminist masculinity. The serial killer/profiler relationship is much more complex than a simple embodiment of backlash.⁶ It registers anxieties about female professionalism and authority, about shifting perceptions of risk in postmodernity, about the construction of expertise, and about the violent articulation of sexuality. Linnie Blake argues that in the "improbable union of Hannibal Lecter and Clarice Starling we can...see a range of popular cultural discourses coming together in a deliciously satisfying synthesis" (208). There is, unfortunately, nothing "improbable" about the union between male serial killer and female profiler. Given contemporary postfeminist culture's suspicion of female authority and sexualization of violence, it is disturbingly inevitable.

Notes

- 1. With very few exemptions, the serial killer is represented as a man. While exceptional figures, such as Aileen Wuornos, are certainly significant, this article looks to the much more typical male killers. For a more detailed analysis of the female serial killer (and Aileen Wuornos's representation in Monster [2003]), see Lisa Purse's "Return of the 'Angry Woman': Authenticating Female Physical Action in Contemporary Cinema" (in this collection).
- 2. Linda Mizejewski puts the number of women working in law enforcement at approximately 10 per cent as of 2005 (123).
- 3. David Schmid concludes that "since 1983, the assumption that serial murder can be unproblematically equated solely with sexual homicide can be found in more or less explicit form in practically any discussion of serial murder, whether in the mass media, an academic treatise, a public policy document, or a psychological study of an individual offender" (78).
- 4. The film of The Bone Collector was made in 1999. Like Taking Lives, it features Angelina Jolie in the role of an expert investigator.
- 5. See Seltzer 142–44 and Jenkins 139–50.
- 6. It is likewise tempting to read the serial killer as the embodiment of the muchdiscussed crisis in masculinity. Still, such allegorical readings cannot account for the complexity of these representations, or for the consistency with which the serial killer/profiler relationship is implicated in the construction of an "empowered" postfeminist femininity.

Works cited

Blake, Linnie. "Whoever Fights Monsters: Serial Killers, the FBI and America's Last Frontier". The Devil Himself: Villain in Detective Fiction and Film. Ed. Stacy Gillis, and Philippa Gates. Westport: Greenwood Press, 2002. 196-210.

Cameron, Deborah, and Elizabeth Frazer. The Lust to Kill: A Feminist Investigation of Sexual Murder. Cambridge: Polity Basil Blackwell, 1987.

Deaver, Jeffrey. The Bone Collector. London: Hodder & Stoughton Ltd., 2006. Hannibal. Dir. Ridley Scott. MGM/Universal, 2001.

Jenkins, Philip. Using Murder: The Social Construction of Serial Homicide. Hawthorne: Aldine de Gruyter, 1994.

McRobbie, Angela. "Postfeminism and Popular Culture: Bridget Jones and the New Gender Regime". Interrogating Postfeminism: Gender and the Politics of Popular Culture. Ed. Yvonne Tasker, and Diane Negra. Durham: Duke University Press, 2007. 27-39.

Mizejewski, Linda. "Dressed to Kill: Postfeminist Noir". Cinema Journal 44.2 (2005): 121–27.

Schmid, David. Natural Born Celebrities: Serial Killers in American Culture. Chicago: University of Chicago Press, 2005.

Seltzer, Mark. Serial Killers: Life and Death in America's Wound Culture. New York: Routledge, 1998.

The Silence of the Lambs. Dir. Jonathan Demme. Orion, 1991.

Simpson, Philip L. *Psycho Paths: Tracking the Serial Killer Through Contemporary American Film and Fiction*. Carbondale: Southern Illinois University Press, 2000. *Taking Lives*. Dir. D. J. Caruso. Warner Bros, 2004.

Thomas, Ronald R. *Detective Fiction and the Rise of Forensic Science*. Cambridge: Cambridge University Press, 2003.

Index

ABC, 50, 66, 92 action cinema, 185-98 action television, 45-57 Aeon Flux, 185-6, 189, 192 Akass, Kim, 91 Alias, 45-8, 51-5, 187 Aliens, 186, 187, 206 Ally McBeal, 45 AMC, 64 American Princess, 138-51 America's Next Top Model, 145 "angry women," 185-96 Annie Hall, 20 anti-social behaviour orders (ASBOs), 153 Australian Princess, 138-51

Baby Boom, 17, 18-9, 20-1, 25 backlash against feminism, 3, 38, 199 Balsamo, Anne, 129-30 Banet-Weiser, Sarah, 127, 130 Barnes, Elizabeth, 46-7 Bartky, Sandra Lee, 124 Bashir, Samiya, 91 Baumgardner, Jennifer., 83 BBC, 105, 137, 169 Becker, Ron, 106 Bell, David, 133n Bennett, Tony, 200, 204 Best, Amy, 201 black women, 36, 91-100, 205-6, 208, 210 - 1Black, Jeremy, 199, 205, 210 Black Widow, 78 Blade: Trinity, 186, 187 Blake, Linnie, 234 Blum, Virginia L., 130-1 Body Heat, 78 Bold, Christine, 200, 203 Bond, (James), franchise, 199-212

Bone Collector, The, 229-30

Bordo, Susan, 86, 130

Bourdieu, Pierre, 143-4 Boyle, Karen, 58-9 Brand New You, 126, 128, 131 Brave One, The, 186, 195 Breakfast at Tiffany's, 176 Breakfast Club, The, 78 Brick, 78 Britain's Next Top Model, 143 Broke-Smith, Jean, 142, 145-50 Brown, Maggie, 105-6 Brunsdon, Charlotte, 2, 27, 155, 165, 168, 178 Bruzzi, Stella, 167 Buffy the Vampire Slayer, 45, 68, 187 Burrell, Paul, 142, 145-50 Butler, J., 90, 94, 100, 142-3, 145, 167, 179 Buttafuoco, J., 77

Caged Heat, 188 Cagney and Lacey, 20 Cameron, Deborah, 233 Cartmell, Deborah, 173 Casino Royale, 208-9 Castle, Terry, 58 CBS, 50, 68, 227 Celebrity Fit Club, 141 Channel 4 Corporation, 103-18 lesbian teens on, 109-18 public service and queer broadcasting on, 104-9 Charlie's Angels, 186, 187, 188, 189, 190, 213 Chase, David, 213, 217 "chick flicks," 31-42 Ciasullo, Ann M., 94, 106 Cinderella narrative, 172 Cinderella Story, A, 169, 178 class, 7, 13, 47, 48, 124, 127, 136-8, 141, 143, 144-7, 154, 156-60, 164, 165n, 170, 175, 176, 188, 189, 191, 193

Clover, Carol, 195 Clueless, 178 Collis, Rose, 103 colonialism, 136, 138-9, 140, 147 Coming Home, 33 consumerism, 125-6, 129-32, 154-5, 157, 162 Cook, Pam, 168, 176, 188, 193, 197 cosmetic surgery, 123-32 Coulthard, Lisa, 213 Creed, Barbara, 61, 69, 71, 213 crime narratives, 226-7, 230-1 criminality, 79, 153 Criminal Minds, 227 Cruel Intentions, 80-7 Crush, The, 78, 80 CSI: Crime Scene Investigations, 50, 230

Daly, Mary, 124, 133 Damages, 59 Davis, Glyn, 107-8 Davis, Kathy, 131 Day, Katy, 153 de Beauvoir, Simone, 6, 14 Deer Hunter, The, 39 Desert Hearts, 92, 111 Desperate Housewives, 60, 64, 66-7, 68 Devil in the Flesh, 79 Devil Wears Prada, The, 31, 32, 38, 39, 59 Dickinson, Kay, 107 Die Another Day, 208 Disclosure, 46 Doane, Mary Ann, 171-2 Dr. No, 200 documentary, 128, 141, 154 Dodd, Alan, 34, 35 domesticity, 6, 9, 11, 21-3, 25, 29n, 36, 38, 58–71, 154, 158, 161, 214-5, 217, 223n Douglas, Susan J., 48-9, 126, 175 Dow, Bonnie, 108 Down With Love, 26 Drake, Jennifer, 175, 205 Driscoll, Catherine, 78, 85–6 Driver, Susan, 108 Durden-Smith, Mark, 143, 146

Dyer, Richard, 33, 100

Ebert, Teresa, 130 E4, 105 Elektra, 186, 189 Ellen, 92, 103 Ellis, Kate Ferguson, 70 ER, 49 exploitation films, 188 Extreme Makeover, 126

Faculty, The, 78 Faludi, Susan, 3, 38, 155, 204, 211 family, 8, 10, 21, 29n, 31, 32, 46-7, 54, 59, 62, 64–70, 79, 109–12, 200 Fantastic Four, 186, 189 Fatal Attraction, 50, 78, 178 Father of the Bride, 20 femininity, 2-13, 19, 21, 25, 38, 46, 54-5, 201 active, 52, 186-91, 193, 206, 213-4 ageing, 217-8, 220, 221, 223 appearance and, 123-32 as commodity, 22, 132, 191, 230 authenticity and, 124-5, 127-8, 130, 132 domestic, 58-76 empowerment and, 125, 216 ethnicity and, 34 heterosexuality and, 46 "hyper", 18, 92 neotraditional, 155-64 performance of, 96, 112-3, 117, 138, 168-79, 206 popular culture and, 27 postfeminism and, 22, 31, 42, 125, 155-6, 209, 226, 234 race and, 37, 47, 93, 100n, 127 second wave feminism and, 35 teen, 79, 81-2, 84-6, 88 work and, 46, 50, 234 feminism accounts of, 3-4, 62, 123 as commodity, 78 backlash against, 3, 38, 155, 204-5, 211n caricatures of, 31-2, 35-6, 38-42, 138, 168, 170, 174, 210 empowerment and, 79, 174, 178, 226

femininity and, 1–3, 7, 9, 21, 35, 60, Gok's Fashion Fix, 167, 168, 169 62, 123-5, 129-30, 132, 164, 171 GoldenEye, 207 generational conflict and, 7-9, Goldman, Robert, 188-9 31-43, 58, 123-4 Gordon, Avery, 58 popular, 4, 17-9, 27-8 Gorton, Kristyn, 18 popular culture and, 4-7, 33, 99, Gove, Ben, 107 103-4, 109, 133n, 199, 206, Granada Entertainment, 141, 157 Grand, Sarah, 47 213, 216 second wave, 3, 5-6, 8-9, 11, 18, 20, Greer, Germaine, 6, 14 27-8, 31, 35, 37, 47, 49, 58-9, Grossman, Julie, 88n 83, 123, 154-5, 179n, 188, 207, Guardian, The, 3, 143 226, 234 third wave, 205, 208 Halberstam, Judith, 92, 100 femme fatale, 77-88 Hancock, 189, 195, 196 Film4, 105 Hannibal, 231 Fisher, Amy, 77, 79 Hard Candy, 186, 194-5 Fiske, John, 130 Hardt, Michael, 139–40 Flesh Wounds, 130-1 Hathaway, Anne, 39-40 Fonda, Jane, 8, 32–9, 42–3 HBO, 45, 91, 213 Forces of Nature, 20 Heckerling, Amy, 78 Ford, Elizabeth, 168, 172, 174, 178 Heckert, Druann. M., 201 For Your Eyes Only, 204 Hell's Kitchen, 137, 141 Foucault, Michel, 131 Hepburn, Audrey, 168, 173, 176–7, Fradley, Martin, 34, 35 179 Hesford, Victoria, 59 Frazer, Deborah, 233 Freud, Sigmund, 23, 60-2, 65, 197 heterosexuality, 18-22, 24-5, 28, 37, Friedan, Betty, 6, 60-4, 66, 70, 124 92-3, 94, 95, 106, 108, 110-1, From Russia with Love, 201, 203 124, 127, 160, 164, 167–8, 173, Funny Face, 169, 173, 177 177, 178, 191, 199, 203, 209 Furedi, Frank, 162 Heyes, Cressida, 129 Heywood, Leslie, 175, 205 gangster genre, 214-7 Hobson, Dorothy, 105 Garner, Jennifer, 52–3 Holden, Stephen, 213 Holiday, The, 17, 26 gay programming, 106 Ghost Whisperer, 60, 68-70, 71 Holliday, Ruth, 129 Ghost World, 168 Hollows, Joanne, 1, 5-6, 133, 156 Gill, Rosalind, 22, 28, 104, 127 Holmes, Su, 133, 154 Gillespie, Rosemary, 10, 132 homosexuality, 92, 94-9, 104, 106-18, Gillis, Stacy, 7, 43 203, 210, 210n "Girl Power," 4, 10, 11, 83, 153–6, Honeymoon in Bali, 25

> information, computer technologies, and telecommunications (ICT), 48 Irigaray, Luce, 50–52, 55–6, 62 *Ironwood*, 39

How to Look Good Naked, 128, 169

Hope Floats, 21

Hunt, Helen, 19

Humbert, Brigine E., 82

163-5, 169, 207

as lesbians, 108–18 as "Lolitas", 77–8, 80–1, 86

"in crisis", 86-8

as femme fatales, 77–87 as ladettes, 153–64, 165n

violence and, 194-5, 197n

identity of, 171, 173, 176, 178, 179n

girls

I Spit On Your Grave, 193 It's Complicated, 17, 26–7 ITV, 105, 141, 154, 157

Jackson, Stevi, 27 Jancovich, Mark, 55 Jardine, Alice, 47 Jenkins, Patty, 191, 233, 235 Jermyn, Deborah, 154 Jersey Girl, 34 Joan of Arcadia, 68 Jolie, Angelina, 189, 226 Jones, Amelia, 46–7, 50 Jones, Grace, 205–6, 208, 210

Katrak, Ketu H., 140 Keaton, Diane, 18–9 Kehily, Mary Jane, 87 Kill Bill, 189, 195–6, 213 Kissing Jessica Stein, 111 Klute, 33 Kramer vs. Kramer, 38, 41

ladettes, 155-6 Ladette to Lady, 138, 143, 153-65 "Lady Power," 155, 156-7 Lara Croft: Tomb Raider, 186, 187, 189, 213 Laurino, Maria, 217 Lauzen, Martha L., 26 lesbianism, 90-102, 103-20 black lesbians, 91–5, 97–100 butch/femme, 91-4, 97-100, 112, 118n teen lesbians, 109-18 visibility, 103-4, 106 Lethal Lolita, 77 Leverette, Marc, 91 Levy, Ariel, 5, 58, 88, 153 Live and Let Die, 204 Living Daylights, The, 204 Longrigg, Clare, 215-17, 219 Lopez, Jennifer, 34, 35 Los Angeles Times, The, 39, 40, 42 Love with a Vengeance, 61 Lury, Karen, 107 L Word, The, 91, 92-3, 95, 103, 112 Lyons, James, 55

Mad Men, 60, 64-6, 67, 68 Maid in Manhattan, 34, 169, 170 makeovers, 123-34, 136-51, 153-63, 165n, 167-78 male gaze, 52 male-identified beauty, 123 male promiscuity, 85 Mallan, Kerry, 80 Manhattan, 39 Manhunter, 227, 232 Man with the Golden Gun, The, 204 marriage, 19-20, 25, 35-6, 46-7, 139, 144, 163 Matrix, 189 McCabe, Janet, 91 McCarty, John, 215 McClintock, Anne, 147 McRobbie, Angela, 1, 31, 37, 46, 58, 104, 125, 156, 164-5, 167, 178, 226 Mean Girls, 169, 178 Medium, 60, 68-70 Meyers. Nancy, 8, 17-29 Millett, Kate, 6, 14 Mindhunters, 227, 231 Miss America beauty pageant, 123, 124 Mitchell, Deborah, 168, 172, 174, 178 Mr. and Mrs. Smith, 187, 189, 195 Mizejewski, Linda, 172, 226, 235 Modleski, Tania, 56, 61 "mommy track," 48-9 Monster, 186, 191-6 Monster-in-Law, 31, 32-3, 34-8, 59 Moonraker, 204 Morgan, Kathryn P., 131 Moseley, Rachel, 5-6, 136, 164, 174, 178 - 9mothers, 21, 22, 34, 36, 38, 47-8, 51, 61, 63-4, 176-7, 189, 213-23, 228 Mulvey, Laura, 5, 52 Mummy, The, 186 Munford, Rebecca, 7, 43, 79 My Fair Lady, 167, 168 Nanny 911, 137, 141 Nayak, Anoop, 87

NBC, 49

Negra, Diane, 1, 4, 7, 21, 28, 31, 61, 156, 207

Negri, Antonio, 139–40
neoliberalism, 28
"New Economy," 48–9, 50
"new woman professional", 45–56
New York Radical Women's group, 123

Nochimson, Martha P., 214–15, 219, 221

Now Voyager, 167–71, 173

objectification, 188
O'Day, Marc, 188
On Her Majesty's Secret Service,
201, 203
Opposite of Sex, The, 78
Orenstein, Peggy, 88, 151
Out of Africa, 39
Out of Sight, 34
Owen, Susan, A., 207

Page, Ellen, 194 Palmer, Gareth, 129, 143-4 Pearce, Sharyn, 80 Perkins, Tessa, 33, 43 Perrons, Diane, 49, 56n Point Pleasant, 68 Poison Ivy, 78, 79, 80 popular feminism, 17–28 Portwood-Stacer, Laura, 127, 130 post-documentary culture, 154 postfeminism, 1, 3–14, 17–29, 31–2, 34-8, 40-2, 46, 55, 58-62, 71, 78-81, 83, 86-7, 104, 125-7, 129, 132, 136, 153–5, 157, 163–5, 167-71, 174-5, 177-8, 187-90, 197, 200, 207–10, 214, 225–7, 230, 231, 234, 235 post-lesbian space, 104, 109 Presumed Innocent, 46, 47, 50 Pretty in Pink, 78, 168 Pretty Persuasion, 80-7 Pretty Woman, 167, 168, 169, 170, 172, 177 - 8Prime, 31 Prince Charming, 144, 148, 151 Prince & Me, The, 145

Princess Diana, 142, 143

Princess Diaries, The, 40, 145
Princess Elizabeth, 142
princesses, 138, 140–5, 147–50
Princess shows, 144–5, 148–9
Private Benjamin, 17, 18, 19–20, 21
Probyn, Elspeth, 155, 165
Profiler, The, 230, 231
Projansky, Sarah, 155, 165, 188
Project Runway, 145
Pygmalion narrative, 168, 172

Quantum of Solace, 209 Queer as Folk, 92, 106

race, 7, 9, 37, 47, 48, 49, 91–5, 96, 97-100, 136, 138, 140-2, 188-9, 191, 205, 207 Radner, Hilary, 47, 49, 56 rape-revenge narratives, 187–8, 192–4, 197n Read, Jacinda, 213 reality TV, 128, 132, 137, 140-3, 145, 147, 149, 154, 157, 165n Rebecca, 173 Red Sonja, 206 Resident Evil, 187, 189, 195 Richards, Amy, 83 Richardson, Niall, 154 Rixon, Paul, 91 Roberts, Chadwick, 42 Roberts, Martin, 129, 132, 134, 158, 165 Robins, Kevin, 91 Roe v. Wade, 35 Roripaugh, Lee, 109, 118 Rosenberg, Howard, 222 royalty, 138, 139, 143-3, 145-6 Runaway Bride, 20

Save the Last Dance, 168, 178
Schilt, Kristen, 93
Schlafly, Phyllis, 38
Schmid, David, 228, 235
Sedgwick, Eve Kosofsky, 92
Seltzer, Mark, 229, 233–5
serial killer romance, 225–34
Sex and the City, 26, 45, 91, 92, 168

sexuality, 7, 9, 47, 50, 68, 69, 75–120 deviance and, 199-203, 210 empowerment and, 47, 78-87, 185, 187-9, 195, 207, 226-7 female, 45, 50, 51, 52, 54, 66, 68, 69, 78-87, 199-201, 207, 208, 210, 214, 226–7 promiscuity and, 156, 157, 159, 165n violence and, 193-5, 202, 206-8, 226-34, 235n Shary, Timothy, 78, 171 Shea, Katt, 78 She's All That, 168, 169-78 Shyer, Charles, 17, 28 Silence of the Lambs, The, 225, 227, 231 Silkwood, 39 Simon, David, 213 Simpson, Philip L., 232 Sin City, 186 Six Feet Under, 66 Skeggs, Beverley, 156, 158 Skins, 103-4, 106-18 Sliding Doors, 173 Smith, Anna Marie, 26, 91-2 Smith, Sharon L., 188 Something's Gotta Give, 17, 26 Sophie's Choice, 39 Sopranos, The, 213-23 Spy Who Loved Me, The, 204 Stacey, Jackie, 92 Stanworth, Celia, 48–49 Steele, Valerie, 174 Stone, Alison, 205 Storey, John, 134 Straayer, Chris, 81 Streep, Meryl, 32, 38-42 Sugar Rush, 103-4, 106-18 Swan, The, 126 Sweet Home Alabama, 21 Swimfan, 79

Taft, Jessica K., 207
Tait, Sue, 126, 132
Takacs, Stacy, 48–49
Taking Lives, 226, 227–8, 231
Tasker, Yvonne, 1, 7, 29, 31, 47, 52, 88, 187, 207, 211
Taylor, Jacqueline Sanchez, 129, 175–7, 179

Teacher's Pet, 79 10 Years Younger, 126, 167 Terminator 2: Judgment Day, 47, 186-7, Thelma and Louise, 187 Theron, Charlize, 185, 191 Thunderball, 201, 202 Tolman, Deborah L., 200 Tong, Rosemarie Putnam., 205 Torres, Sasha, 90 transgenderism, 92-3, 97 Travers, Peter, 27 Trinity, 187 Trinny and Susannah Undress, 137 Tru Calling, 68 True Blood, 68 Twilight Zone, The, 63-4, 71 Tyler, Imogen, 32, 36, 38, 41

Ugly Betty, 59 Ultraviolet, 186 Underworld, 186, 188 Usher, Jane, 213–14, 220

Valenti, Jessica, 88

View to a Kill, A, 205–6

violence, 215
female embodiment and, 190–5
feminism and, 199–210
matriarchal tyranny and, 213–23
physical action and, 185–96
sexualized, 227, 230, 232–4
trauma and, 228–9, 233
visual culture, 5

Vogue magazine, 39

Walter, Natasha, 5, 59, 174–5
Wanted, 187, 188, 189–90
Wearing, Sadie, 32, 129, 133
Wedding Crashers, 20
Wedding Planner, The, 34
Wedding SOS, 137
What Not to Wear, 126, 128, 137, 167, 168, 169
What Women Want, 17, 18, 19, 22–5, 26

Whelehan, Imelda, 1, 4, 79–80, 155, 157, 164
Wild Things, 78, 79

Williams, Linda R., 78
Williams, Rachel, 126
Willis, Ellen, 83, 202
Wilson, Elizabeth, 177, 179
Wire, The, 91, 93–9
Without a Trace, 50
Wolfe, Susan J., 109, 118
Wolf, Naomi, 5, 123
Woman of the Year, 25
Wood, Robin, 174, 197
Woollacott, Janet, 200, 204
Working Girl, 178

World is Not Enough, The, 208 Wright, Leigh Adams, 54 Wuornos, Aileen, 191 Wurtzel, Elizabeth, 77 Wylie, Philip, 71

Xena: Warrior Princess, 187 X-Men, 186, 190

You Are What You Eat, 137 You Only Live Twice, 201, 203 Young, Iris Marion, 125